NEW VAMPIRE CINEMA

KEN GELDER

A BFI book published by Palgrave Macmillan

© Ken Gelder 2012

First published in 2012 by
PALGRAVE MACMILLAN

on behalf of the

BRITISH FILM INSTITUTE
21 Stephen Street, London W1T 1LN
www.bfi.org.uk
There's more to discover about film and television through the BFI.
Our world-renowned archive, cinemas, festivals, films, publications and learning resources are here to inspire you.

Palgrave Macmillan in the UK is an imprint of Macmillan Publishers Limited, registered in England, company number 785998, of Houndmills, Basingstoke, Hampshire RG21 6XS. Palgrave Macmillan in the US is a division of St Martin's Press LLC, 175 Fifth Avenue, New York, NY 10010. Palgrave Macmillan is the global academic imprint of the above companies and has companies and representatives throughout the world. Palgrave® and Macmillan® are registered trademarks in the United States, the United Kingdom, Europe and other countries.

Cover design: Julia Soboleva
Designed by couch
Set by Cambrian Typesetters, Camberley, Surrey
Printed in China

This book is printed on paper suitable for recycling and made from fully managed and sustained forest sources. Logging, pulping and manufacturing processes are expected to conform to the environmental regulations of the country of origin.

British Library Cataloguing-in-Publication Data
A catalogue record for this book is available from the British Library
A catalog record for this book is available from the Library of Congress
10 9 8 7 6 5 4 3 2 1
21 20 19 18 17 16 15 14 13 12

ISBN 978–1–84457–440–7 (pb)
ISBN 978–1–84457–441–4 (hb)

Contents

Acknowledgments

This book was written in Melbourne and Edinburgh in 2011. I am grateful to the Faculty of Arts at the University of Melbourne for providing me with study leave assistance to get it completed. Special thanks to Romana Byrne, who collected commentaries on many of the films for this book in its early stages. Thanks to Kerry Biram for her work towards the index. I also want to thank all those academic staff and graduate students in Edinburgh, London, Lancaster and Sydney who listened patiently to extracts from this book and offered useful, important comments and suggestions. I am especially grateful to James Loxley at the University of Edinburgh, Catherine Spooner at Lancaster University, Chris Danta at the University of New South Wales and Natalya Lusty at the University of Sydney, as well as Simon Bacon who organised and invited me to a large conference on vampirish things at University College, London, in November 2011. Rebecca Barden at the British Film Institute has been wonderfully encouraging and I am so pleased to have worked with her again. Thanks, too, go to Sophia Contento and Belinda Latchford for getting this book into shape. Of course, thanks must finally go once more to Hannah and my two sons, for putting up with this project, talking it through, watching vampire films with me, reading and listening to bits and pieces of the book, and offering as much support and reassurance as anybody could want.

An earlier part of Chapter 2 appeared in Caroline Joan S. Picart and John Edgar Browning (eds), *Speaking of Monsters: A Teratological Anthology* (Palgrave Macmillan, 2012), and an earlier part of Chapter 3 appeared in Tabish Khair and Johan Hoglund (eds), *Dark Blood: Transnational and Postcolonial Vampires* (Palgrave Macmillan, 2012).

Preface

This book is not a history of vampire films from their earliest times, nor is it one of those 'anthropological' surveys that lists (with brief comments, plot summaries, film posters, some stills, etc.) pretty much every vampire film ever made — useful as these compendiums can be.[1] It is instead a reasonably close analysis of a selection of vampire films from across the last twenty years or so, and its aim is simply to try to make some sense of what these films do and why they seem to do it over and over. It begins in 1992 with Francis Ford Coppola's *Bram Stoker's Dracula* and Fran Rubel Kuzui's *Buffy the Vampire Slayer*, two films that could not be more different from one another. It is as if vampire films at this moment went in completely opposite directions, one of them attempting an 'authentic' recreation of one of vampire cinema's urtexts — Bram Stoker's 1897 novel — and the other throwing authenticity to the winds as a high-school cheerleader embraces her destiny as a vampire slayer in contemporary Southern California. In fact, as I shall note in Chapter 1, *Buffy the Vampire Slayer* seems to parody everything that Coppola's film aspires to. Even so, *Buffy* is still recognisably a 'vampire film'. It is in many respects remote from Coppola's film, certainly — and other vampire films, too, as well as Stoker's novel — and yet it is also close to these things, all too aware of them, and aware above all that it is obliged (as all vampire films are) to negotiate some sort of relationship *to* them. The simultaneity of remoteness and closeness or proximity turns out to be important to vampire films as both a theme (the vampire's distance from/closeness to the victim is the thing that instils the narrative with suspense) and the means by which the genre perpetuates itself as a genre. Even though they mark out their various distinctions and differences, vampire films always speak to other vampire films, and of course, to that urtext of Stoker's which still, remarkably, seems to exert some sort of pressure on them, holding them in its grasp or perhaps letting them slip through its fingers.

The question of 'origins' is thus always important to vampire films, something to mobilise and react to (or against), and something that also makes vampire films what they are. So many vampire films, as I shall note, begin with an opening historical moment that literally returns to some sort of originating event: the excavation and awakening of a vampire, the turning of someone *into* a vampire, a birth, a new arrival, a summons or invitation of some kind. Building themselves around this originating event, vampire films then often work hard to create their own mythologies, as do, for example, the Russian films *Night Watch* (2004) and *Day Watch* (2006) or the New Zealand film *Perfect Creature* (2006) or the American *Twilight* films

(2008–). In fact, we can say that *every* vampire film creates its own vampire mythologies, insisting on the possibility that things are being done here a little bit differently (different origins, different trajectories) to some other vampire film from somewhere else. The following chapters are precisely a response to this insistence, looking at the ways that different vampire films do indeed do things differently. But from another perspective, every awakening of the vampire is also a reawakening, a recasting of the mythologies that are already there in the genre. The vampire film is peculiar as a film genre in that it is tied to a set of archaic 'laws', or folklores, about vampires that even the most recent vampire films are obliged to acknowledge: whether their vampires can be killed by crosses or garlic or holy water; whether they burn in the sun or can walk in the sun; whether a stake through the heart will or won't kill a vampire; whether they have to be invited in before they can enter someone's home or apartment; and so on. In so many vampire films, the folklore attached to vampires will become a point of discussion or debate. Someone will say 'Forget what you've seen in the movies' before letting everyone else know that vampires are still out there; which is also a way of saying *remember what you've seen in the movies* because each vampire film is required to take a relational position (reproducing something, disavowing something else) to everything that has generically gone before. More than any other kind of popular narrative form, the vampire film is bound to its urtexts, no matter how remote from them it might be. We shall see this not only with Stoker's novel, but with F. W. Murnau's early film *Nosferatu* (1922), which can seem to continue to inhabit even the most recent kind of vampire cinema. The opening account of Coppola's *Bram Stoker's Dracula* in Chapter 1 sits alongside a discussion of *Shadow of the Vampire* (2000), which chronicles the making (or, a fantasy about the making) of Murnau's film, as if the lure of this particular urtext is simply irresistible. The vampire film is therefore always derivative, paying a kind of perpetual tribute or homage to itself. It is a very particular kind of genre that – for all its fascination with origins – is condemned at the same time to re-make and recycle, to copy, to plagiarise, to cite and re-cite; and we shall see many examples of this in this book. The execution of these things helps to make vampire films recognisable as vampire films. Recognition is itself something that these films thematise, building it into their narrative trajectory. Every vampire film has its key moments of recognition. To recognise a vampire 'for what it is' turns out to be crucial to a character's wellbeing or otherwise; it is also simply a way of saying, *this is a vampire film*.

The films discussed in this book all bring their vampires into the modern world, building their narratives around the vampire's capacity not just to create a disturbance but to endure it and survive. Of course, all vampire films bring their vampires into the modern world. But I want to suggest that over the last twenty years or so the question of the vampire's capacity to make this journey and live through it is now paramount. Vampire films stage an encounter between something old and something new, something ancient and something modern; the arrival of the vampire (which is invariably from somewhere else) brings with it both excitement, and catastrophe. The sense that the vampire *excites* is important to this book, which has a lot to say about the way vampire films from across the last two decades present their vampire encounters. Excitement suggests that something is set into motion, that one is being transported, taken to some other place. I use the word *citation* in this book in a similar sense: for example, to account for the way that one's encounter with a vampire is also an encounter with other vampire films, with urtexts like Stoker's novel and *Nosferatu*, and so on. All films are systems of citation, referencing other films; but vampire films do this in a particularly visible, performative way, invoking their

precedents, living under their shadows, returning to them over and over, literally re-citing them as *Shadow of the Vampire* does with *Nosferatu*. The encounter with a vampire is indeed an encounter with something old, as if – even as the vampire enters the modern world – those who encounter it are drawn into some other world altogether. But it is not an encounter with something authentic. As I note in Chapter 1, vampires come into the modern world with nothing less than the weight of their own inauthenticity – and the weight of their citations – on their shoulders. All of this can make vampires now seem increasingly self-aware, self-reflexive, self-conscious; a predicament that places them at odds with the modern world even as it makes them 'typical', a kind of modern symptom. In vampire films across the last twenty years, vampires are still usually very strong and very fast. But they also seem close to exhaustion, having in some cases slowed almost to a standstill, as if the genre itself has worn them down: so that by the time we get to the *Twilight* films, vampires (no matter how quickly they can move around) live at much the same pace as everybody else but at one remove, in a sort of self-effacing, diminishing, domestic economy. It is as if vampires are not quite themselves any more, despite the fact that they are still just as recognisable as vampires as they ever were. Perhaps they are in mourning for the loss of an authenticity they never actually had. If we can put aside their ferocity and bloodlust for a moment, the prevailing mood of the vampire in the films I discuss in this book – from Coppola's film to *The Addiction* (1995) to *Let the Right One In* (2008) and beyond – is melancholy.

This book reads around forty vampire films from a number of different places: Sweden, Russia, South Korea, Japan, the United States, France, New Zealand, Australia. No doubt the issue of my own remoteness from (or proximity to) some of these films will become apparent as the chapters unfold. A bit like a vampire – and they are often cast as equally parasitical – film critics stage an encounter with something that is indeed remote from them, as any film, local or otherwise, must in some sense always be. Just like vampires again, critics have to negotiate even the slightest differences in time and place in the thing they encounter; something has to be said about these differences in order for criticism to proceed. Against the odds, perhaps, the idea is to bring that film closer, to make it more legible, a little more comprehensible, to viewers today. Although I think there are things to say about vampire films at a general, generic level, I have also wanted to honour the historical and regional distinctiveness of these films, their cinematic specificity, to affirm that they certainly can do things differently. The question of reading the vampire as a 'metaphor' always comes up when this happens, and I have a lot to say in this book about what it might mean to treat some of these films as national or political allegories, as films that speak to their historical, regional predicaments. Some vampires carry the weight of allegorisation on their shoulders, too. Others, on the other hand, might shrug it off, shirking their allegorical responsibilities or at least striking up some sort of generic distance from them. The vampire film is a frivolous genre in so many respects, but, depending on the case, it can also mobilise a certain 'seriousness' that is reflected through the vampire itself and the various encounters it has. Vampires present a way of being in the world, determined by the prevailing logics of the genre but also reflecting the various imperatives of their predicament, their historico-political situation. Along these lines we can certainly think about what Annette Kuhn once called a film's 'cultural instrumentality'.[2] At the same time, it would be difficult to reduce even the most highly charged vampire film to the level of allegory. As I note in a number of chapters, vampire films can often invest themselves with some level of national or political representation – or citation – even as they might

dissolve those connections away; which means that the (national) allegorising impulses of film commentators, and even film directors, can often be frustrated.

This predicament may also have something to do with the *transnational* aspects of many of these films. As mobile as their vampires might sometimes seem to be, vampire films are not exactly global phenomena. But they do play out various kinds of transnational encounters: American directors who adapt an Irish novel or 'remake' a German film, French directors who hire a Chinese Hong Kong actor or shoot a live-action remake of a Japanese anime, a Mexican director who shoots a film about a black American vampire slayer on location in Prague or casts an Argentinian actor as a vampire in Mexico City and so on. The South Korean vampire film *Thirst* (2009) bases the latter part of its narrative on a French novel published in 1867; the Japanese vampire anime *Blood: The Last Vampire* (2000) unfolds on a US airbase in Japan and ends with images from the Vietnam War; while the vampire in *Nadja* (1994) – like the actor who plays her – is a Romanian immigrant in New York, relishing the 'excitement' of this American city even as she yearns for her homeland. These kinds of encounters can make it difficult to think of vampire films solely in terms of national cinemas. Indeed, even in terms of film distribution, these films aspire to be somewhere else, viewed by others elsewhere. I have been mindful of the often unstable relationship between the national and the transnational in the vampire films I discuss in this book, and the ways in which many vampire films – those from Russia, Japan, South Korea, Australia, Sweden and so on – mobilise a notion of 'national cinema' even as they undo this by taking up the cultural and economic logics of international distribution, especially distribution into the English-speaking West. All of this nevertheless makes me a little more proximate to these films than I might otherwise have been. In the chapters that follow, I try to offer readings of vampire films from around the world that respond to these often complicated predicaments. Chapter 1 looks at the kinds of journeys vampires take in five American vampire films that are each at the same time not exactly 'American'. (The last of them, *Queen of the Damned* [2002], is in fact directed by an Australian.) Chapter 2 looks at two Swedish vampire films – one of which was subsequently remade, and relocated, by an American film director – and two Russian vampire films: to think in particular about a national cinema's preoccupation with difference and otherness and its triggering of a notion of the vampire-as-neighbour, as something that one can indeed, for better or worse, be proximate to. Chapter 3 looks specifically at transnational or East–West 'citations' in vampire films from Japan and Korea, as well as a French film (with its Chinese Hong Kong actor-protagonist) that is *almost* a vampire film but not quite. Chapter 4 returns to the American vampire film to open up the notion of what might count as 'American' here: covering a range of different cinemas, from low-budget New York-based arthouse films to various lowbrow Mexican-American ('Tex Mex') encounters to the phenomenally successful *Twilight* series, the only American films to put their vampires into proximity with something 'indigenous'. Chapter 5 turns to films that imagine vampires as a kind of diminishing species, condemned to continue to regenerate and spread themselves virally around the world (some parts of it, at least) even as they stage their exhaustion and decline. By this time – by which I mean, the period I cover in this book – vampire films have folded their originating moment into their final gasp ('the last vampire', etc.), as if the two things are now indistinguishable. The notion of the film sequel (the *Blade* series, the *Underworld* series) is therefore important to this chapter. It allows these films to give the vampire renewed force as a metaphor for capitalism itself, unable to stop doing what it does even as it knows it cannot go on (forever).

It is always worth bearing in mind that vampires are ushered into the modern world by nothing less than cinema itself, the cinematic apparatus. This is another reason why this book begins with a discussion of Coppola's *Bram Stoker's Dracula*: because this film knows very well that vampires are, and always have been, cinematic creatures, brought to life by cinema and made both modern and redundant by it: given substance (and sustenance), and made insubstantial, simultaneously. A significant number of vampire films after 1992 take their vampires into the cinema or give them a comparable 'cinematographic' moment, as if to underscore this point. This can mean, naturally enough, that to talk about the vampire film is also to talk about cinema itself. The vampire is a kind of special effect, mobilised by cinema in part as a way of mystifying what it – cinema, and the vampire – is or would like to be. I have wanted to demystify the vampire only to a degree as a consequence, not least because – against the grain of so many of the vampire films discussed in this book – I want the vampire to continue to live, to continue to be animated, and reanimated, by the cinematic frame. In terms of critical method, I have therefore been influenced by Robert B. Ray's comment (although I dislike his metaphor), that film studies 'should penetrate the movies' veil while retaining their hallucinatory quality'.[3] Tom Gunning has said something similar: that 'the work of interpretation should involve the progressive discovery and uncovering of a film's structures as well as an unfolding of its surfaces – and all of this must be filled with surprises'.[4] I have certainly wanted to think about the surfaces and structures of the various vampire films I examine in this book. If there are one or two surprises to be found in the following chapters – and if, despite everything (not least, the derivative, constrained nature of the genre), the hallucinatory quality of vampire films remains evident to the end – then I could not ask for much more.

INAUTHENTIC VAMPIRES

Bram Stoker's Dracula
Shadow of the Vampire
Buffy the Vampire Slayer
Interview with the Vampire and
 Queen of the Damned

Bram Stoker's Dracula

Bram Stoker's Dracula (1992) is sometimes seen as the film that brought Francis Ford Coppola back from the dead. In June and July 1992 he had filed for personal and corporate bankruptcy; his company, Zoetrope Studios (later, American Zoetrope), had in fact also filed for bankruptcy two years earlier after debts accrued from other films, in particular the box-office disaster, *One from the Heart* (1982). Coppola was in the later stages of his career, an ageing director with his best work far behind him. But he invested in a made-for-television screenplay about Dracula by James V. Hart, who had previously adapted J. M. Barrie's *Peter Pan* for Steven Spielberg's movie, *Hook* (1991) and who went on to become the new film's co-producer. In the event, *Bram Stoker's Dracula* grossed US$82 million in the USA – more than double its budget – and a total of over $200 million worldwide; its success meant that American Zoetrope 'was healthy once more'.[1] For some commentators, however, the success of the film seemed only to confirm the fact of Coppola's declining reputation. In a devastating essay, 'The Fall of Francis Coppola' (1993) Christopher Sharrett saw *Bram Stoker's Dracula* as 'the last nail in the coffin' for a director whose career is 'a parable about the "New Hollywood" – a hyper-commercial industry that privileges spectacle over substance and confuses artiness with a genuine sensibility'.[2] For Vincent Canby in the *New York Times*, the film was something close to a parable about Coppola himself:

> One ... way to interpret *Dracula* is to say that it's about a man disconnected from the world on which he remains dependent. That has also appeared to be the director's problem for some time. After *Apocalypse Now*, everything Mr. Coppola touched seemed a bit puny, either light of weight or more technically innovative than emotionally involving.[3]

The film's three Academy Awards, for sound editing (Leslie Schatz), costume design (Japanese designer Eiko Ishioka) and make-up (Michelle Burke), only seemed to lend support to the view that *Bram Stoker's Dracula* was simply about 'look' and technique. Other film reviewers went on to argue that, by giving itself up to the exhilaration of the spectacle, the film emptied itself of meaningful content. For David Denby, Coppola's vampire film in fact took the director towards something close to incomprehensibility: 'The day Francis Coppola abandoned realism for artifice has to rank among the saddest in modern film history His *Bram Stoker's Dracula* is an unholy mess, a bombastic kitschfest of whirling, decomposing photography, writhing women, and spurting blood.'[4] In this account, Coppola's decline is read generically: the problem is to do with the turn from (what is conventionally

understood as) the restraints and precisions of realism to the excess and spectacle – and simplicity – of fantasy. Jonathan Romney gave the same sort of reading in his *New Statesman & Society* film review. *Bram Stoker's Dracula*, he writes, is 'exactly like a theme-park ride that you zip through too fast to look at anything':

> You can tell Coppola had fun, but now that he's restored his box-office fortunes and earned his blood money, perhaps he could try a return to the mathematically precise (and soulful as hell) finesse of his real masterpiece, *The Conversation* [1974].[5]

Film criticism came to Coppola's rescue, however, offering more generous, situated readings of this lurid, breathless vampire film. For Grant Edmond in *Films in Review*, *Bram Stoker's Dracula* is both 'primitive and hypermodern … the most vividly sumptuous horror film to come our way since Kubrick's *The Shining*': 'Stoker's name may adorn the title', he writes, 'but the real auteur behind this work is Francis Ford Coppola, the most visionary director-for-hire in Hollywood today.'[6] In one of the best (and most positive) essays on this film, Thomas Elsaesser agrees, describing Coppola as American cinema's 'most maverick of charismatic producer-director-auteurs'.[7] Elsaesser situates Coppola in the wake of 'New Hollywood', but his view of this extended moment in cinema production is the complete opposite of Sharrett's. 'New Hollywood' cinema from the late 1960s to the end of the 1970s is generally associated with auteur-directors like Coppola, Stanley Kubrick, Martin Scorsese and Robert Altman, influenced to varying degrees by European 'new wave' auteurs like Godard and Truffaut. Coppola's *Apocalypse Now* (1979) and Kubrick's *The Shining* (1980) are often taken as 'the last gasp' of this innovative wave of film-making;[8] what follows is a 'new' 'New Hollywood' that ushers in commercially savvy directors like George Lucas and Steven Spielberg who turn to globally distributed big-budget blockbusters linked to multimedia franchises. For Elsaesser, Coppola's *Bram Stoker's Dracula* knowingly straddles these two moments; but it also reaches back to earlier Hollywood directors like John Ford (think of the 'Western' horseback chase and shootout towards the end of the film) and Orson Welles. Elsaesser's view of the film couldn't be further away from the one that saw it as a late-career disaster. It seems instead, he writes, like

> a professionally confident, shrewdly calculated and supremely self-reflexive piece of filmmaking, fully aware that it stands at the crossroads of major changes in the art and industry of Hollywood: looking back as well as forward, while staking out a ground all its own.[9]

Like Canby, Elsaesser reads *Bram Stoker's Dracula* as a sort of parable for Coppola himself, a reflection of the Coppola 'myth': about a man 'obsessed with control, and highly skilled in the devious ways of wielding it … an overreacher and a gambler, a man who takes immoderate risks, leaving a trail of destruction as likely as fabulous success and spectacular achievements'.[10]

It is as if Coppola and Dracula somehow reflect *each other* in this account, which goes on to understand the film in a peculiarly vampiric way. The 'New Hollywood' as Elsaesser describes it is both modern, and old. It projects a future for American cinema, but at the same time it revives old genres like the horror film, 'minor genres and debased modes': making 'self-conscious use of the old mythology'.[11] It behaves, in other words, a bit like a vampire, or a vampire film. *Bram Stoker's Dracula* is a kind of symptom of all this, a 'new' 'New Hollywood' piece of cinema that simultaneously reaches back into the cinematic

vaults. For Elsaesser, the film is classical (character-centred, 'organised according to a clear cause and effect chain'), post-classical (challenging 'character consistency' and linear temporality) and 'postmodern' (camp, disorienting, pastiched) all at once: as if it can indeed live in both the past and the present. Like all cinema, *Bram Stoker's Dracula* is in a certain sense immortal, able to be summoned at any time, anywhere. On the other hand, this film in turn summons the origins of cinema itself, setting an important seduction scene not (like so many vampire films) in the bedroom but in the simulated space of a London cinematograph in the year '1897', the same year that Stoker's novel was published: which makes this date a citation, rather than an actual year. *Bram Stoker's Dracula* is therefore as much about cinema as it is about vampires (or Stoker's novel). Or rather, just like Coppola/Dracula, cinema and vampires inhabit each other's space. For Elsaesser, the audience's encounter with this film is 'thus an end in itself, rather than a means to an end, political, representational or otherwise'.[12] This is a film about vampires, and it is also a vampire film about cinema. 'In this respect at least', Elsaesser suggests, '*Bram Stoker's Dracula* is an authentic enactment of the myth: the true Dracula of cinema − once more risen from the grave of the (much debated) "death of cinema" and the (box-office) "death of Coppola" to haunt us all.'[13]

It is, of course, just as accurate to say that *Bram Stoker's Dracula* is an *inauthentic* enactment of the myth. Authenticity is a kind of special effect in Coppola's film, one among others. It is often noted, for example, that it made little use of computer-generated animation in order to keep faith with its ties to the origins of cinema. Coppola's son Roman, in charge of visual effects, is said to have browsed specialist shops for 'old FX paraphernalia', using a series of 'naïve' processes to recreate 'early-cinema morph effects':[14] double or multiple exposure, the superimposition of images (like the imprint of the map that appears on Jonathan Harker's [Keanu Reeves] face as he travels by train to Transylvania), the use of miniatures (like the train itself in one scene), reverse shooting (when Lucy [Sadie Frost] climbs into the coffin, for example), the use of old camera equipment, and so on. In her book, *Victorian Vogue: British Novels on Screen* (2009), Dianne F. Sadoff suggests that 'the film's extravagant visual and special effects identify morph aesthetics, so named in the early 1990s, as central to picturing the vampire's power'.[15] Here again, it is as if the vampire owes as much to cinema in the 1990s as it does to cinema a century before. Perhaps unsurprisingly, the sequence of scenes in the London cinematograph in *Bram Stoker's Dracula* is self-consciously citational as far as the early history of cinema is concerned. By this time, Dracula (Gary Oldman) has arrived in England. The sequence begins during daylight as he bursts out of his box of earth in Carfax Abbey, a young(ish) man. 'Contrary to some beliefs', says his nemesis Van Helsing (Anthony Hopkins), who provides a number of voiceover moments in the film, 'the vampire, like any other night creature, can move about by day, though it is not his natural time and his powers are weak'. A series of grainy newspaper headlines follow, each dated 7 July 1897, followed by a London street scene that begins in grainy black and white but is quickly colourised. Dracula, now finely dressed in a grey suit and top hat (with blue sunglasses), walks along the crowded street in the quirky fast-motion manner of early cinema, the whirr of an old Pathé camera adding to the authenticity effect. Off screen, a hawker is shouting, 'See the amazing cinematograph, a wonder of modern civilization, the latest sensation …'. Suddenly Dracula recognises Mina (Winona Ryder) from across the street, and stops to gaze at her; Mina seems to 'feel' his gaze and stops to look at him in turn. In the midst of the crowd − there is even a street 'idler', an Edgar Allan Poe-like 'man of the crowd' who blends in even

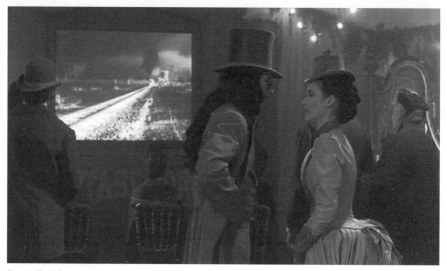

Francis Ford Coppola,
Bram Stoker's Dracula
(1992): Mina and
Dracula in the
cinematograph

as he is positioned to one side – these two figures are made to stand out, to seem excep-
tional. A woman behind Dracula underscores the point, unable to stop staring at the vam-
pire. Soon, Mina and Dracula meet. 'I am only looking for the cinematograph', he tells her,
mimicking the hawker, 'I understand it is a wonder of the civilized world.' Mina is uncon-
vinced: 'If you seek culture', she tells him, 'then visit a museum.' Someone walks by with a
poster advertising Henry Irving as *Hamlet* at the Lyceum Theatre. Bram Stoker was the
Lyceum's manager at this time and a close friend of Irving's, who may also have been a
model for the character of Dracula;[16] in which case, the scene self-reflexively puts Stoker,
Dracula, theatre, the origins of cinema and Coppola's film into a sort of mutually citational
loop.

The sequence resumes inside the cinematograph as an audience of men watch a
black-and-white erotic film, the first example of early cinema that we see. A man enter-
tains two scantily clad women who sit on his lap, but is then surprised to be holding his
wife, whom he callously pushes away. The 'morph aesthetics' of the scene slides from fan-
tasy (arousing) to realism (disappointing). 'Astounding', Dracula says to Mina, knowing
which side he is on. 'There are no limits to science.' Mina is naturally unimpressed ('How
can you call this science?'), maintaining a critical, gendered distance. The film on the cin-
ematograph screen changes to what looks like a darker impression of the Lumière broth-
ers' *L'arrivée d'un train en gare de La Ciotat* (1895) where, in this case, the train never
seems to get to the station. Mina's seduction begins in front of this film: she is indifferent
to it and yet literally carried away by it as Dracula draws her to another part of the cine-
matograph. It is as if she has also been transported back in time – another screen shows
the silhouetted battle scene where Dracula's army fights the Turks in '1462', played out in
the preface to Coppola's film. Or rather, it is as if cinema itself has provided the illusion of
transportation, reaching back in time even as it stays in exactly the same place. This is also
the moment during which Mina recognises Dracula for what he is ('I know you!'); which is

another way of saying it is the moment during which she recognises she is in a vampire movie.

In his important essay, 'An Aesthetic of Astonishment: Early Film and the (In)Credulous Spectator' (1995), Tom Gunning looks at the received notion that early cinema audiences must have panicked at the spectacle of a train coming towards them in the Lumière brothers' film. Although Mina actually pays no attention to that piece of cinema (and the audience around her also seems unperturbed), nevertheless it heralds her breathless surrender to Dracula and her entry into his world – which, for the moment, is a little space in a corner of the cinematograph that, as a wolf appears and draws their interest, also already seems to recognise the vampire film genre for what it is or, at least, for where it came from. Gunning's account of early silent cinema sees it as 'a series of visual shocks', a 'cinema of instants, rather than developing situations'. The 'scenography' of this pre-classical 'cinema of attractions', as he calls it, brings with it 'an undisguised awareness of (and delight in) film's illusionistic capabilities'.[17] For Gunning, this kind of early cinema 'persists' in modern film as an 'underground current flowing beneath narrative logic and diegetic realism'.[18] But in *Bram Stoker's Dracula* that underground current becomes a veritable flood that drenches the film from top to bottom. It is as if the new and the old in cinema cannot be properly distinguished any more.

The 'narrative logic' of this film is in many respects conventional and familiar; it is arguably even more conventional than Stoker's novel. Beginning in '1462', it casts Dracula as a cruel warrior who, in a fit of rage after learning of the tragic death of his beloved wife, violently renounces his Christian faith. Shifting to 'London 1897' (the film spells out the difference for the mathematically challenged: 'FOUR CENTURIES LATER'), it traces Jonathan Harker's train journey to Transylvania, his experiences at Dracula's castle, Dracula's journey to England, his influence over Lucy and Mina, Van Helsing's mobilisation of the 'Crew of Light' against the vampire, their pursuit of him as he returns to Transylvania, and finally, his death: ending exactly where the film had begun, in the chapel in Dracula's castle. And yet each part of this narrative is fissured with the kinds of 'visual shocks' and cinematic 'instants' that Gunning describes. A striking example begins after Van Helsing (just like Mina in the cinematograph) suddenly recognises Dracula for what he is and, carried away in turn, laughingly tells Quincey Morris (Billy Campbell) that Lucy is 'the devil's concubine' – leaving Morris on guard outside Lucy's bedroom as he promptly goes off to dinner. The scene cuts to what Sadoff calls 'rapid montage':[19] a gun is taken from its case (by Holmwood [Cary Elwes], who is at Lucy's bedside); a red rose quickly wilts in the garden; there is a POV shot of the foot of a statue as the camera focuses on an insect; Holmwood sits beside Lucy's bed as she sleeps; the low POV tracking shots continue as Dracula makes his way through the undergrowth and up some stairs towards a gardener, who is instantly killed (close-ups of his face, his eye and the blood on his hand); Holmwood falls asleep and drops his glass (close-up of his hand); there is a longer shot of Morris patrolling outside the house (front, rear and side views); a close-up of Lucy opening her eyes; and then the beginning of several intercut scenes that show Jonathan and Mina's wedding in an Orthodox Church in Eastern Europe as Dracula moves quickly towards Morris and enters Lucy's bedroom, pushing Holmwood back and standing both inside and outside the bedroom as Lucy writhes (in a red gown) on her bed, then bursting through her bedroom window as a wolf and ravishing/biting her. For Sadoff, the film's ability 'to move viewers through delirious kinetic experiences of motion, headlong rush, and rapid transformation creates – and spoofs – spectatorial affects of dizziness, shock,

and amazement'.[20] Thomas Elsaesser uses the term 'engulfment' to describe this experi-
ence, arguing that 'instead of voyeurism and fetishistic fixation, there is spatial disorienta-
tion; instead of the logic of the "scene", it is semantic clusters, mental maps, spatial
metaphors that organize comprehension and narrative transformation'.[21] Of course, these
things are not mutually exclusive: there is also a great deal of 'fetishistic fixation' (the wilt-
ing roses, the repeated image of the eye and especially, the gushing redness of blood) and
a fair amount of 'voyeurism' in the film, too, something the cinematograph scenes with
their various glimpses of near-naked women are well aware of. There is certainly a 'deliri-
ous' aspect to the several seduction scenes in particular, which also put 'morphing' effects
into play. But the scene I have just outlined moves away from 'rapid montage' into a
prolonged series of intercut scenes that work to produce a striking but straightforward jux-
taposition of themes. As the bestialised Dracula bursts into Lucy's bedroom and assaults
her, turning her into a vampire ('I condemn you to living death ...'), Mina and Harker are
going through an elaborate marriage ceremony under the watchful guidance of the church
patriarchs. The raw, unleashed lust of the vampire is contrasted to the sanctioned,
'orthodox' wedding; biting and tearing are set beside Mina's unveiling and a long, affec-
tionate kiss with her husband. It is as if these two events are both opposites and reflec-
tions of each other. The sequence ends with buckets of red blood thrown over Lucy's bed,
her scream flowing over Mina and Harker as they embrace, the scene closing conven-
tionally by fading to black.

The vision of scarlet blood splashing over Lucy's bed – as well as Lucy's writhing body,
etc. – probably owes something to the 'symphonic', camp/apocalyptic set pieces found in
the lurid horror films of Ken Russell, particularly *Gothic* (1986) and *The Lair of the White
Worm* (1988), an adaptation of another, lesser-known novel by Bram Stoker.[22] A later
scene, in which the vampire Lucy sits up, turns and vomits red blood over Van Helsing,
comically references William Friedkin's *The Exorcist* (1973) with Van Helsing momentarily
imitating that film's Father Merrin (Max von Sydow) ('I bring you from shadow into light! I
cast you out, the prince of darkness ... into hell!'). In Coppola's film blood-red and black
soak through the screen, so much so that Lisa Hopkins, in her book *Screening the Gothic*
(2005), is drawn to compare *Bram Stoker's Dracula* to Stendhal's famous novel, *Le Rouge
et le Noir* (1830), the story of an intense love affair which also, incidentally, ends with the
hero's decapitation.[23] Lucy's flowing red nightgowns and Mina's red dress in the 'absinthe'
scene all signify the extent of their possession by the vampire. The final credits are also in
red, against a black background, typical of so many vampire films. The use of black and
lurid reds is common to the 'look' of vampire films broadly speaking, one of the things that
can most immediately identify them generically: especially after the British Hammer vam-
pire films of the 1960s and 1970s. *Bram Stoker's Dracula* does open up a suite of other
colours that both exceed this generic identity and further embed it. In some scenes the
night skies are also dark blue, and the 'blue flame' that appears near Dracula's castle is
supposed to be the film's only computer-generated special effect. Elsewhere, Dracula
enters Mina's bedroom as a bright green mist. In the 'absinthe' scene, where Dracula (who
interestingly pronounces the drink 'absence') continues to seduce Mina, green competes
with red and then flows into it as the bubbles in the drink turn into a circle of quivering red
blood corpuscles. Red – or 'capillary red' – is certainly the colour that binds this film
together, however, from the opening gush of blood out of the crucifix in Dracula's chapel
to those closing credits; and black is the film's primary background. Or rather, black is pro-
jected *onto* the film's background, since one of the key images in the film is the shadow.

In the 'absinthe' scene, shadows moving on the glazed window resemble images on the cinematograph screen, as well as the silhouetted figures in the '1462' battle tableau. David Denby's review of *Bram Stoker's Dracula* complains, 'If the characters matter, why drape them in impenetrable blue-gray shadows?'[24] But this is a vampire film and in vampire films character and shadow work upon one another symbiotically. Dracula's shadow is especially animated, moving across walls of its own accord, acting out the vampire's 'true' intentions, and so on. Under attack, Dracula retreats into the shadows, emerging in a different form altogether. Shadows are where the 'morph aesthetics' of this film reveal themselves. Dracula's red eyes thus shine out of the shadows, looking back at characters who stand exposed in the light. Shadow and light play with each other across the film; we shall see more of this shortly in the discussion of E. Elias Merhige's *Shadow of the Vampire* (2000) below.

Blood is the key fetish of Coppola's film, right down to its 'microscopic' images of those blood corpuscles. This image opens Van Helsing's lecture to medical students, where he tells them about 'Blood! The diseases of the blood ... such as syphilis ... that concern us here' – and is bitten on the finger by a caged vampire bat. His academic interest in the modern-day 'sex problem' is followed by a scene in Dracula's castle where Harker is imprisoned with three beautiful, near-naked vampire women – one of them played by Italian sex symbol Monica Bellucci – who 'drain my blood to keep me weak'. At dinner later, Van Helsing asks him, in front of Mina, 'did you for one instant taste of their blood?' 'No ...' says Harker, as Van Helsing drains his drink until the glass is empty. The sheer prevalence of blood in the film as it spurts, splashes, drips and flows, and the anxieties over who has tasted it and who hasn't (after being ravished by Dracula, Lucy complains, 'I still have the taste of his blood on my mouth!'), have naturally led to various 'allegorical' readings of the film as a comment on the AIDS 'crisis' and the campaigns for safe sex at this time. For Frank Rich in an essay titled 'The New Blood Culture' (1992), published in the *New York Times*, Coppola's film is nothing less than a symptom of America in the early 1990s, its 'orgy of bloodsucking, bloodletting and blood poisoning' inciting fears of 'further AIDS invasions of the national bloodstream'.[25] It can seem as if *Bram Stoker's Dracula* is simply a moral fable about the dangers of sexual promiscuity. For Janet L. Beizer, however, all this is hardly new anyway: the 'eroticized terror of fusion, infusion, and transfusion Rich associates with "the new blood culture" ostensibly provoked by the AIDS virus already pervades Stoker's 1897 novel'.[26] It can certainly be difficult to distinguish between the urtext and the remake here, not least because in Coppola's film the investment in '1897' as an authenticity effect runs the continual risk of cancelling out 1992 (the film's actual historical moment) pretty much altogether. Blood is turned into a spectacle in *Bram Stoker's Dracula*; 'syphilis' and AIDS are citations that lend meaning to that spectacle, but whatever meaning they carry is constrained, and determined, by the film's generic identity and the source it draws upon. As I have been suggesting, however, the film also allows itself a great deal of licence as an adaptation. For example, the consummate 'blood-exchange' between Dracula and Mina is turned into a prolonged, romantic (and shadowy) scene between two lovers in Coppola's film: quite different to its treatment in Stoker's novel as a moonlit moment of sheer horror for one of the narrators, Seward, who witnesses the event. Margaret Montalbano notes that in earlier 'classic' Stoker adaptations like Tod Browning's *Dracula* (1931), this scene is never shown. Here, on the other hand, it is the film's 'erotic climax'.[27] Mina is married to Harker at this point; even so, she gives herself to Dracula ('I want to be what you are'), willingly drinking blood from the wound that he opens in his chest as the vampire moans orgasmically. For Montalbano, Mina is not submissive in

this scene but an active, passionate 'desiring subject': she *wants* to be promiscuous, summoning Dracula as much as he summons her.[28]

The film unleashes sexual desire in a variety of other eroticised forms, too. Harker is seduced by the three vampire women, who caress, lick, strip and bite him; Mina and Lucy giggle over illustrations of sexual positions in a copy of Richard Burton's *Arabian Nights*; Lucy erotically teases Morris, Holmwood and Seward (Richard E. Grant) ('Please let me touch it!' she says, when Quincey takes out his bowie knife); Mina and Lucy kiss each other in the rain; a bestialised Dracula mounts Lucy on a large stone slab in her garden, as Mina watches ('No, do not see me!' Dracula cries, ashamed of his lust and appearance); the cinematograph incites erotic fantasies on its screens; much later, as Mina falls under Dracula's influence, she wantonly kisses Van Helsing, who kisses her back. In spite of all this, or perhaps because of it, some critics have regarded Coppola's Dracula as sexually 'normalized', less 'polymorphous' than he might once have been, and 'stabilized inside a firmly heterosexual frame'.[29] The film certainly has nothing at all to do with the erotics of male homosexuality: in this respect it is quite different to Neil Jordan's *Interview with the Vampire* (1994), as I shall note below. But *Bram Stoker's Dracula* both incites, and excites. Barbara Creed rightly notes the prevalence of 'animal sex, sadism, oral sex, biting, masochism, blood and satiety' in Coppola's film, along with Dracula's 'sexually ambiguous' appearance in full Gustav Klimt-influenced Kabuki dress and 'overblown feminine wig' as if he is some kind of 'dowager Empress'.[30] It unleashes a voyeuristic range of lusts that fissure the monogamous, ordinary conventions of romance. The film ends by forgetting altogether about Mina's marriage to Harker, turning instead to the illicit, driven romance she has with Dracula – and divorcing itself entirely from Stoker's novel as Mina brings the dying vampire into the chapel, kisses his bestial face, redeems him, then stabs him through the heart and cuts off his head.

Is *Bram Stoker's Dracula* really a vampire film? The question might seem an odd one to ask. On the other hand, as Thomas Austin notes, some of the cast went on to disavow the film's generic identity. For Winona Ryder, it is a 'real love story It's not really a vampire movie'; for Gary Oldman, whose performance as Dracula was wonderfully excessive, it seemed to owe more to Jean Cocteau's *La Belle et la bête* (1946) than anything else.[31] Coppola's film certainly tied itself to a romance narrative that presented love as both illicit and 'eternal', involving Dracula and Mina and New Age notions of destiny and reincarnation. The closing credits play out to Annie Lennox's slow, dreamy 'Love Song for a Vampire', a hit with Columbia Records and one of many product tie-ins with the film. These things also helped the film expand its market, nationally and globally. Austin comments that *Bram Stoker's Dracula* is a big-budget 'costume horror' that was 'aimed at broader markets than the "low horror" slashers and gore pictures which served the video sector in the late 1980s and early 1990s'.[32] Horror enthusiasts were thus often critical of it; specialist horror magazines disparaged the film as 'Mills and Boon Gothic' or '*Gone with the Wind* with fangs', as if its identity as a vampire film seemed secondary.[33] Literary critics could be just as dismissive, complaining that Coppola's romantic Dracula is no longer threatening in the way he once was, changing from an 'invading Other' to a 'more universal and sympathetic character attempting to reunite with his reincarnated wife'.[34] The casting of younger stars like Ryder and Reeves (Coppola had reservations about the latter, who gave a woeful performance as Harker) alongside Oldman (at the height of his acting career and a leading member of the 'Brit Pack') and the highly regarded Anthony Hopkins (who had recently gained some horror credibility through his role as Hannibal Lecter in

The Silence of the Lambs [1991]) helped to secure mainstream, cross-generational, transatlantic interest for the film, spreading, rather than concentrating, its appeal. At the same time, however, the film embedded its generic identity as a 'classic' vampire film, not least through its relatively faithful reproduction of key bits of dialogue from Stoker's novel: for example, 'Listen to them, the children of the night, what [sweet] music they make.' Some of Dracula's speeches had already become iconic through earlier films, however, free of Stoker's urtext. Dracula's remark to Harker, 'I never drink … wine', has its source in Bela Lugosi from Browning's *Dracula*, thus also referencing what Robert Spadoni defines as one of two movies (the other is James Whale's *Frankenstein* [1931]) 'that mark the dawn of the horror film as a Hollywood genre'.[35] The many examples of Dracula's stretching arm, hand and fingers – usually as a shadow, although not always – reference another foundational vampire film, F. W. Murnau's *Nosferatu*. We can perhaps think of these as *vertical* citations that all help to make the vampire film generically recognisable or familiar. For Thomas Elsaesser, however, the film's citational range also stretches *horizontally. Bram Stoker's Dracula*, he suggests, is 'replete with citations to other films … at the last count, no less than sixty titles': films by Cocteau, Ken Russell, Friedkin, John Ford, the Lumière brothers, Akira Kurosawa's *Throne of Blood* (1957) and so on.[36] For a film that loudly announces its marriage to a single *fin-de-siècle* novel, *Bram Stoker's Dracula* turns out to be citationally promiscuous, too.

Shadow of the Vampire

F. W. Murnau's *Nosferatu* is as much an urtext for subsequent vampire films as Stoker's 1897 novel, its iconic imagery (the predatory vampire in the bedroom, the shadow of its elongated arm and talons, etc.) invoked, or cited, over and over. The film itself was already inauthentic, however, an early cinematic adaptation of Stoker's *Dracula* that was successfully sued for copyright violation by Stoker's widow despite the various changes it made to the names of its characters, the settings and so on. E. Elias Merhige's *Shadow of the Vampire* knows this very well. Although it is just as faithful to its source, this is not an adaptation, like *Bram Stoker's Dracula*. It is instead a film about the *making* of *Nosferatu*, built around the character of Murnau himself (John Malkovich) and his cast and crew – including the actor he hires to play Nosferatu, the sinister Max Schreck (Willem Dafoe). In this respect, *Shadow of the Vampire* might recall Olivier Assayas's film *Irma Vep* (1996), which I shall discuss in Chapter 3; in fact, it references that film in a couple of scenes, such as when Schreck creeps through the corridors of a hotel, trying to get into one of the rooms. *Shadow of the Vampire* and *Irma Vep* are both about the making, or remaking, of a 'classic' work of cinema.; they both incorporate actual footage from those original works, while at the same time they recreate or mimic (or re-vamp) a number of scenes from these works in precise, homage-like detail. The film directors in these films are both obsessive characters who, for various, obscure reasons, hire principal actors from elsewhere, from some remote location: Eastern Europe in one case, East Asia in the other. When they arrive, the actors exert a strange influence over the cast and crew (fascination, horror, excitement); they also immerse themselves into the parts they play, as if they actually become their characters, as much on the film set as off it. In both cases, the conventional distinctions between actor and role ('Max Schreck', 'Maggie Cheung') are conflated and confused.

Brooklyn-born Merhige's previous film, *Begotten* (1991), was a strange, obsessive, desolate piece of black-and-white horror cinema about death and rebirth, with no dialogue, comparable in some ways to David Lynch's *Eraserhead* (1977). Susan Sontag called it 'one of the ten most important films of modern times';[37] it also impressed the actor Nicolas Cage, Coppola's nephew, who had recently established his own company, Saturn Films. Cage is supposed to have been inspired by the original Schreck's Count Orlok in *Nosferatu* for his own role as the New York-based vampire wannabe Peter Loew in *Vampire's Kiss* (1988), which I shall discuss briefly in Chapter 4. He had seen Steven Katz's screenplay for *Shadow of the Vampire*, and offered it to Merhige. Like Cage, Katz – who later worked on the script of *Interview with the Vampire* – was also fascinated by Schreck's Count Orlok and in fact wrote the part of Schreck with Willem Dafoe in mind. (Interestingly, Dafoe had also auditioned for Gary Oldman's role as Dracula in Coppola's film.) For Katz, bringing a scriptwriter's slightly disenchanted perspective to bear on the issue, the vampire film is a very particular kind of genre, not exactly an 'art film' but not exactly at home in Hollywood either:

> I have this theory that Hollywood is incapable of making a truly great vampire movie. They always seem to produce really awful ones. I thought *Interview with a* [*sic*] *Vampire* turned out okay, but I don't think it was as good as it could have been. *Bram Stoker's Dracula* didn't work for me, though it was promising ... [38]

His experience with Merhige was inevitably a compromised one, as if his generically pure view of what a vampire film should be was simply unable to translate:

> The director, Elias Merhige, came out of doing experimental films and MTV stuff, and he ... didn't really know a lot about vampire movies or genre movies. We used to fight like hell when I'd say it was a vampire movie, and he'd say, 'No, it's not.' So when they started shooting it, he and producer Nic Cage, with a lot of influence from John Malkovich who plays Murnau, shifted the thrust of the movie. I had originally wanted it to be just a really great vampire flick, the way [Coppola's] *The Godfather* was just a great gangster movie. But they stripped away a lot of the layers of horror I had and made it a sort of an art film about the nature of creativity and the relationship between the director and his film, which I had in the script, but as subtext only.[39]

The problem for Katz is that, as far as *Shadow of the Vampire* is concerned, the 'really great vampire flick' has already been made. *Nosferatu* works in Merhige's film as a kind of prolonged citation, the thing that brings it into being in the first place; although from another perspective, its relationship to *Nosferatu* is strictly parasitical (like a vampire). Like *Bram Stoker's Dracula*, *Shadow of the Vampire* transports itself back to an 'original' cinematic moment in order to manufacture an authenticity effect which in this case is a kind of macabre tribute to Murnau and silent film-making. After a dreamy, ominous opening sequence that tracks through a series of Art Deco sepia-toned murals of dragons, eyes, faces, shadows, knights on horseback, battle scenes and so on (resembling in some respects the designs on playing cards), *Shadow of the Vampire* finally announces its setting ('Jofa Studios, Berlin, 1921') and its topic, in black and white, against the sound of a film crew on set:

> Brilliant German filmmaker Friedrich Wilhelm Murnau is refused permission by Bram Stoker's estate to film his novel *Dracula*

Murnau simply changes the name calling his vampire Count Orlok and his film ...
NOSFERATU
F. W. Murnau then creates the most realistic vampire film ever made and establishes himself
amongst the greatest directors of all time.

The film then cuts to a close-up of Murnau's eye, followed by the camera lens. Murnau is a character in this film, and there are some autobiographical features that the film hints at but does not develop: his anti-Semitism, for example (which is momentarily unleashed in a Tourette Syndrome-like tirade against Schreck towards the end), or his bisexuality or homosexuality. The latter in particular remains incidental to the film. In an interview, Merhige has said,

> It was important to me ... not to reduce Murnau just to his sexuality. Sometimes a film that
> deals with a gay protagonist gets stuck in that realm of his sexuality Really, the fever that
> my Murnau has is his obsession with creativity, with making the ultimate work of art[40]

Shadow of the Vampire is almost strictly about Murnau's role as a film-maker. As Katz notes, the film does indeed portray 'the relationship between a director and his film'. More specifically, though, it is about the relationship between a director, a vampire film and a vampire. The conceit of this film – too obvious for some reviewers, but interesting for others – is that Max Schreck, the actor cast as Count Orlok in Murnau's film, really *is* a vampire. It turns out that Murnau has made an arrangement with Schreck, that if he acts in his film then he can feed on Greta (Catherine McCormack), the actor who plays Ellen (the equivalent of Stoker's Mina) in *Nosferatu*. To explain the way Schreck seems to resemble Count Orlok all the time – in full costume on and off the set – Murnau tells his cast and crew that the actor is thoroughly immersed in his role. 'Just leave the man alone', he tells his producer and financier, Albin Grau (Udo Kier). 'He will be completely authentic.' Grau, incidentally, was an occultist and was later a member of the Fraternitas Saturni, the Brotherhood of Saturn; he co-founded Prana Film, which produced the original *Nosferatu*, and in fact the idea of making this vampire film was Grau's. Udo Kier, of course, had himself played a vampire in Paul Morrissey's *Blood for Dracula* (1974); he did it again later on, in Stephen Norrington's *Blade* (1998), which I shall discuss in Chapter 5.

In *Shadow of the Vampire* Murnau's aim is to make the fantasy of *Nosferatu* completely realistic, or rather, to generate what he calls a 'realistic effect': which is why a vampire is cast as a vampire. But the character of Max Schreck/Count Orlok is an enigma in the film. 'He was in the Reinhardt company', Murnau tells his crew, giving him theatrical respectability. Murnau takes his cast and crew to Czechoslovakia – 'I thought Dracula lived in Transylvania', one of them replies – in order to film Schreck on location, travelling east on a train called *Charon*. (Compare Harker's journey on a train to Transylvania in *Bram Stoker's Dracula*; or Dracula travelling west on a ship called *Demeter*.) Setting up a scene on location outside Orlok's castle, Murnau calls out instructions to Hutter (Eddie Izzard) – Harker's equivalent in *Nosferatu*, who is married to Ellen. As the door opens, Murnau directs him towards 'a dark hole, that has been unexplored, untouched, for a long, long time ... you must follow him into the tunnel ... yes ... going in ... make your way down ... and ... end!' The links here between train and tunnel, the 'unexplored' place, and so on give us the opposite cinematic experience to the one associated with the Lumière brothers' *L'arrivée d'un train en gare de La Ciotat*: not the adventure of arrival, but the fear of

disappearance. It would not be difficult to give this a psychoanalytical reading, too, since the scene indicates a certain fear of something now repressed ('untouched, for a long, long time'). Hutter is naturally reluctant to enter this 'dark hole'; there is also some level of homosexual panic registered in the scene. 'I understand … we are going to be neighbours', Schreck tells Hutter. 'Are you happy to be his neighbour?' Murnau asks, inflaming the kind of anxiety to do with one's proximity to the vampire that I shall look into in more detail in Chapter 2. Later, Murnau films Hutter as he eats at a table with Schreck. 'How does it feel to be eating next to him', Murnau asks, prompting Hutter for a reaction, 'knowing that you're spending the night with him in the castle, alone?' Schreck himself is already excited; and when Hutter cuts his finger with a knife (also prompted by Murnau), he tries to drink his blood. Afterwards, Albin and Henrik Galeen (Aden Gillett) − who had written the screenplay for *Nosferatu* for Murnau − get the chance to talk to Schreck off the set, outside. 'When did you become a vampire?' they ask, indulging what they still think is a matter of role-play. 'I can't recall', Schreck replies. 'Where were you born?' 'I can't remember.' They ask him about Stoker's novel, *Dracula*. 'It made me sad', he says, reminding him of his past glories and what he is now reduced to. 'Then how did you become a vampire?' they ask. 'It was a woman', Schreck replies. 'We were together in the night, then she left me …'. Now, he tells them, he has forgotten all about her, as if she, too − or the memory of her − has been 'untouched, for a long, long time'.

From one perspective, *Bram Stoker's Dracula* and *Shadow of the Vampire* have this in common: they both blame the vampire's predicament on a woman. But whereas Coppola's film gives its vampire an explicit point of origin ('1462'), Merhige's film obscures it. Schreck is unable to create new vampires; he talks about himself as old, and weak. Looking at Hutter's miniature of Ellen, he quotes from Tennyson's famous poem, 'Tithonus' (1860), about the Trojan who asked for immortality but forgot to ask for eternal youth: 'But thy strong Hours indignant worked their wills,/And beat me down and marred me and wasted me,/And though they could not end me, left me maimed/To dwell in presence of immortal youth,/Immortal age beside immortal youth,/And all I was, in ashes …'.[41] Later on, Murnau says to his photographer, Wagner (Cary Elwes), 'There is no Max Schreck.' He discovered him, he explains, 'in a book'; then he says that he found Schreck in an 'old monastery', and arranged 'that he would play the part of an actor playing the part of a vampire acting in a movie'. It is as if the vampire is at the end of his life here, his origins almost forgotten (real or fictional), his existence as a vampire similarly 'untouched, for a long, long time'. The thing that brings him back to life is 'acting in a movie': cinema. It also ends up being the thing that kills him.

Bram Stoker's Dracula and *Shadow of the Vampire* also have in common their ontological association of vampires with cinema. As the film director, Murnau is himself vampirish, bringing his cast to life, sucking the life out of them, ruthlessly exploiting them for various special effects. Sadoff suggests in *Victorian Vogue* that *Shadow of the Vampire* presents the making of *Nosferatu* as a power struggle between Schreck and Murnau:

> During the film … vampire and director gradually exchange places. The film director is 'not so different', 'Max Schreck' sneers, from the vampire, who seizes control as he kills off the crew: 'This is hardly your picture any longer.'[42]

Of course, the joke in Schreck's comment is no doubt to do with the fact that *Shadow of the Vampire* is a revamping of a vampire film that plagiarises a vampire novel − with a kind of vampire as a film director, and a vampire as the principal actor. In his essay 'No End to

Nosferatu' (2009), Thomas Elsaesser notes that the suggestion that Max Schreck was a vampire was in fact made some time before Merhige's film by the French film-maker and writer Ado Kyrou, who comments on Murnau's *Nosferatu* in his book, *Le Surréalisme au cinéma* (1952):

> In the role of the vampire the credits name the music-hall actor Max Schreck, but it is well known that this attribution is a deliberate cover-up No one has ever been willing to reveal the identity of the extraordinary actor whom brilliant make-up renders absolutely unrecognizable. There have been several guesses, some even mentioning Murnau Who hides behind the character of *Nosferatu*? Maybe Nosferatu himself?[43]

In Merhige's film, this conceit goes in two opposing directions. On the one hand, it turns Schreck into a fantasy or phantasm, as if the character of the vampire – a character brought to life by cinema – is all there is. 'There is no Max Schreck': this simply means that Schreck himself is in a permanent cinematic state, as if already condemned always to act out the role that *Nosferatu* (that is, Merhige's film) has written for him. 'If it's not in frame', Murnau says at one point, 'it doesn't exist!' He could, of course, be talking about the vampire here, in all its radical inauthenticity. In the final scene of the film, the film director allows Schreck to feed on Greta as she lies, drugged, in her bed. After a struggle, a gate is opened and the sunlight streams in; and as Schreck dies, his body melting like a piece of celluloid, Murnau keeps on filming. In an earlier scene, Schreck is left alone on the film set and begins to crank the handle of the film projector, watching as the bright sky is projected onto a curtain. He puts his hand across the front of the lens and looks at the shadow of his outstretched talons against the illuminated screen. Then he kneels down in front of the camera and, still turning the handle, projects the bright sky directly into his eyes, as if he is absorbing the light or as if the screen is now his face. The scene then cuts to the black-and-white image of sunlight above the water. Schreck is a vampire who casts no reflection; instead, he casts a shadow across the film even as he serves as the screen onto which it is projected. In discussions of F. W. Murnau's German films, the link (and struggle) between cinema and shadow is often emphasised. For example, Jacques Rancière – and he is talking about Murnau's later film, *Tartuffe* (1926) – suggests that cinema 'tells the stories of substantial and beguiling shadows that have to be destroyed But dissipating shadows is a tall order for the cinema, since it excels at doing exactly the opposite, at giving shadows substance ...'.[44] This is where we find the second trajectory of Merhige's conceit. Schreck is a shadow, a piece of melting celluloid, a fabrication, a revamp of something that is already inauthentic or derivative. On the other hand, it is cinema itself that gives him 'substance'. Elsaesser brings these opposing things together with these remarks about *Shadow of the Vampire*:

> with its conflation of actor and vampire, the film only appropriates what lies ready-made in the filmographies not only of Murnau but of German Expressionist cinema in general, with its ubiquitous ventriloquists' dummies, waxworks coming to life, warning shadows, Golems – all caught in the confusion between art and life, or rather of art as more truthful, more youthful and more authentic than life. Why is – with Francis Ford Coppola's *Bram Stoker's Dracula* ... or *Shadow of a Vampire* – this standard trope of movie lore making a comeback? Perhaps it is the old problem of realism, mimesis, and art that needs to be revived in the digital age, where the fake looks more real than the real thing but where we have also become deeply suspicious of authenticity.[45]

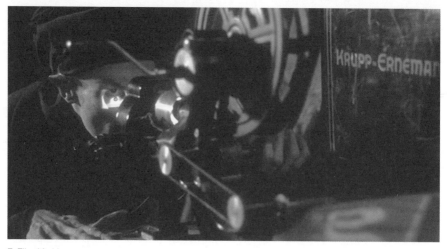

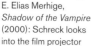
E. Elias Merhige,
Shadow of the Vampire
(2000): Schreck looks
into the film projector

A discussion in the film about illusion and reality has Schreck tell the crew, 'reality is the thing in the first place … that casts the shadow'. But what would a vampire – whose origins are already a distant memory – know about reality? The problem of distinguishing between reality and cinema itself is, of course, embedded in this discussion. Several commentators have in fact focused on the scene in *Shadow of the Vampire* in which Schreck cranks the film projector, inevitably reading Merhige's film as 'postmodern' or 'late-postmodern', a self-conscious reflection on its own technological apparatus.[46] But this scene is duly noted and read in completely the opposite way by the Lacanian theorist Slavoj Zizek, who has this to say:

> the film's premiss is that the actor Max Schreck … who played Nosferatu, really was a vampire, and was simply playing himself – hence the terrifying power of his performance. The most sublime moment is the scene where, in the middle of the night, when everyone else is asleep, the vampire starts to play with the cinema projector, observing the shadow his own hand projects on to the screen when he puts it between the projector's light and the wall, and so on, as if recognising that this domain of ethereal spectral apparitions is his home territory, his own domain. Vampires, these figures of the Real if ever there were, are at the same time not figures of our bodily reality, but entities which belong to the pre-ontological domain of spectral apparitions.[47]

We have already seen commentaries on vampire films that tie them to pre-classical, classical, post-classical and 'postmodern' cinema. We have also seen vampire films that fold vampires into the apparatus of cinema itself, as if they are both as real as cinema, and just as insubstantial. Zizek's comment goes one step further, as if he believes in Merhige's film wholeheartedly. Vampires are cinematic and yet so old as to be *pre*-cinematic, emerging out of the prehistory of cinema, another 'dark hole' that has been 'untouched, for a long, long time': just like the deepest recesses of the unconscious, this melodramatic psychoanalytical account seems to suggest. In this sort of reading – and we shall see versions

of it again – vampires are modern and yet also archaic, ancient. They have nothing much to do with reality at all, because they are Real. Only a methodological framework like psychoanalysis could lead a critic to read a scene in which a curious vampire puts his hand in front of a camera as this film's 'most sublime moment'. *Shadow of the Vampire*'s own particular 'cinematographic' scene couldn't be made any more profound or meaningful.

Buffy the Vampire Slayer

Zizek's flourish notwithstanding, the vampire begins the 1990s with the weight of its own (in)authenticity on its shoulders. The same year *Bram Stoker's Dracula* was released, another film took vampires in a direction that gaily threw authenticity to the wind and, almost in spite of itself, had a much more long-lasting effect on the decade. Fran Rubel Kuzui's *Buffy the Vampire Slayer* (1992) was of no interest at all either to film critics or to Lacanian philosophers and social theorists; no one would think to celebrate it for its various 'sublime moments'. But it worked as a gleeful parody of pretty much everything that Coppola's film – and later vampire homages like *Shadow of the Vampire* – stood for. In fact, even the fan communities and the various cultural studies commentators who came to adore the later, much more successful television series (1997–2003) barely seemed to notice this film. Because of the television series, the character of Buffy is irrevocably tied to Sarah Michelle Gellar. Very few commentators seem to remember Kristy Swanson as Buffy in Kuzui's film, although one reviewer has monumentalised her, more or less, by suggesting that she is 'perhaps the first movie personality ever to master a comic style that can only be described as pertly deadpan'.[48] At the time, Kuzui had developed her business interests as a film distributor, showing Japanese films in the US and US films in Japan. Her first feature film, *Tokyo Pop* (1988), about an American girl who travels east to Japan and falls in love, getting involved in Japanese pop music, reflected exactly this kind of cinematic Pacific rim circulation. *Buffy* was her first 'system' film, made for Twentieth Century-Fox for around US$7 million, a fraction of *Bram Stoker's Dracula*'s budget. Kuzui used a screenplay by a relatively unknown Joss Whedon, who had not written for cinema before. But Whedon, who went on to win critical and fan acclaim with the television series of *Buffy*, was disappointed with the film: rather like Steven Katz and *Shadow of the Vampire*. In an interview, Whedon suggested that Kuzui took the project of the film even less seriously than he did, complaining that

> my vision was not going to be the same as Fran's. She was interested in making more a sort of head-on comedy, and I wanted to make an action horror movie that was funny. And we had different sensibilities.[49]

Critics, fans, the scriptwriter himself: no one seems to have a good word to say about the 'original' *Buffy*, a film that triggered off the influential and long-lasting television series, only to be buried by it and almost entirely forgotten.

Even so, there is a case to be made for Kuzui's *Buffy* as a sharply tuned parody of – and a kind of alternative universe to – Coppola's *Bram Stoker's Dracula*. Coppola's film had begun in '1462' at a critical moment in Dracula's European past, witnessed by an old priest (Anthony Hopkins), who provides the voiceover and goes on to play Van Helsing as the film jumps to its present day in '1897'. Kuzui's *Buffy* begins with a kind

of faux-medieval, sepia-toned village setting that announces: 'Europe: The Dark Ages'. A watcher (Donald Sutherland) hands a stake to a young woman, telling her that 'a slayer is born'. A voiceover (not Sutherland's) ominously says that 'one slayer dies, and the next is chosen', and as the young woman holds the stake up high, the scene suddenly cuts to a cheerleader's pom pom in an American high school gym in the present day. The next heading announces, tongue in cheek: 'Southern California: The Lite Ages'. In Coppola's film, the juxtaposition of light and darkness or shadow is central to its atmospherics and its presentation of the vampire as an intrinsically cinematic creature. In Kuzui's film, on the other hand, the opposite of darkness is 'lite'. From one point of view, this is a resolutely *uncinematic* vampire film. But *Buffy* parodically maps out its distance from the kind of serious, historically aware – *dark*? – sense of cinema that informs *Bram Stoker's Dracula*, *Shadow of the Vampire* and the various commentaries on these films that I have discussed above. The film introduces Buffy and her three 'valley girl' friends as they go into a shopping mall, a fashion-conscious clique of upwardly mobile airhead SoCal girls who anticipate by several years the equally likeable but irritating Cher (Alicia Silverstone) and her chic Californian in-group in Amy Heckerling's *Clueless* (1995).[50] The first thing they talk about is in fact cinema. These girls are difficult to please, going through the local cinemas one by one and criticising them: 'They don't even have Dolby!'; 'They show previews for foreign movies!' When they do see a movie at the 'Hollywood Galaxy', they chatter all the way through it: as if cinema itself is incidental to their lives, mere background noise. The scene is worth comparing to the 'cinematograph' scene in Coppola's film: there is even a kind of *anti*-seduction moment in it as the girls reprimand some boys sitting behind them, distancing themselves from (male) cinephilic tastes. Soon afterwards, *Buffy* gives us another sepia/black-and-white scene from the 'Dark Ages' in which a gang of four vampires – another kind of in-group – walk towards the slayer. One of them, with her pointy ears and robes and soft black hat, is dressed to look just like Murnau's Count Orlok. But this is also incidental, just a fleeting, in-joke appearance, and we never see that vampire again. This is about as close to *Buffy* as the vampire film's cinematic origins – those 'foreign movies' – are allowed to get.

At the same time – and in the framework of its playful 'liteness' – the film asks Buffy to get serious about vampires, even as it has fun showing off her disarming naivety about serious world issues ('Excuse me for not knowing about El Salvador. Like I'm ever going to Spain anyway!' etc.). It does this by putting her in touch with someone old: not authentic, just old. The watcher from the 'Dark Ages', Merrick, suddenly appears in front of the girls outside a lift in the mall. 'What a homeless!' one of them sneers. Later, Merrick watches Buffy as she practises cartwheels on her own in the gym. 'You have been chosen, Buffy … to stop the vampires', he tells her, and she takes the news remarkably well. One of the odd, but rather charming, things about this film is the bond that is quickly created between Buffy and a rather creepy old man in a raincoat who more or less stalks her. (It is worth comparing to the relationship between Eli [Lina Leandersson] and Hakan [Per Ragnar] in *Let the Right One In* [2008]: see Chapter 2.) Buffy tells her girlfriends that she 'met this guy … he's like, old … he's fifty!' – a piece of news that helps divide her from her social group for whom (with fashion comments like 'Please! So five minutes ago!') the new and the old are to be strictly distinguished from one another. A rough equivalent to Van Helsing in Coppola's film, Merrick is effectively a surrogate father for her. At home, the only parent is her mother (Candy Clark), a remote, distracted figure who leaves Buffy to her own devices. Merrick knows that Buffy dreams about the vampire Lothos (Rutger Hauer), and he also knows about the menstrual cramps that she experiences when she fights.

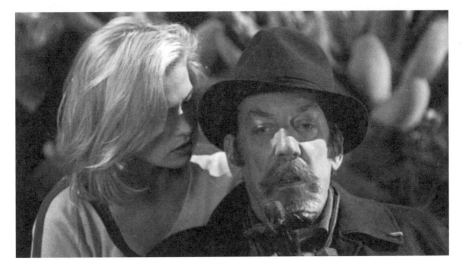

Fran Rubel Kuzui,
*Buffy the Vampire
Slayer* (1992): Buffy
comforts the dying
Merrick

'You're going to be able to use that to track them', he tells her. 'Great', she replies, 'my secret weapon is PMS!' Kuzui's film is a coming-of-age story about a girl who takes on the duties of an adult and in doing so develops a responsible view of her own femininity. Buffy herself is roughly equivalent to Mina here, with two ageing men, Merrick and Lothos, struggling over her body. (She also has a jock boyfriend who is the equivalent of Keanu Reeves's Jonathan Harker.) At home, Buffy gets ready for bed, tying a red ribbon around her hair, her teddy bear beside her. Lothos is already in the bedroom although she cannot see him, and when she climbs into bed she lies back against him and he puts his arms around her. This is *Buffy*'s version of the 'vampire-in-the-bedroom' scene in Coppola's film where Dracula enters Mina's bedroom as a green mist and kneels before her; or, in *Shadow of the Vampire*, where Nosferatu stands over Ellen as she sleeps. In Buffy's case, nothing much happens; soon afterwards, though, she wakes up with a start and pulls the symbol-laden red ribbon out of her hair. Merrick, however, has a paternal, protective kind of intimacy with her. When she forgets to meet with him, he scolds her: 'You have missed years of training, and you are undisciplined, frivolous … quite probably, the most vacuous choice in my …'. 'Okay, okay, I think we both get the point!' she says, still drawn to her life as a SoCal valley girl.

> I don't want to be the chosen one. I don't want to spend the rest of my life chasing after vampires. All I want to do is graduate from high school, go to Europe, marry Christian Slater, and die!

When Merrick is finally killed by Lothos, his dying moments with Buffy are genuinely touching: a moment of depth of feeling in the midst of frivolity. 'You do everything wrong', he gently tells her. 'No … do it wrong … don't play *our* game.' His advice gives Buffy's character extra licence to enjoy her inauthenticity. Merrick's last words – 'when the music stops, the rest is silence' – perhaps surprisingly echo the last words of Shakespeare's

Inauthentic Vampires

Hamlet. Naturally, Buffy doesn't recognise the citation (although it is worth comparing this to the moment in *Clueless* when the only person to recognise a different quotation from *Hamlet* is the valley girl Cher). Instead, Buffy takes it literally and, in the final fight with Lothos, it saves her life.

Kristy Swanson performs her own 'martial arts' in *Buffy*: there is even a generically typical and exhilarating training sequence in the gym, to the rock soundtrack of the Divinyls' 'I Ain't Gonna Eat Out My Heart Anymore' (a song about a girl's decision not to put up with her boyfriend any longer).[51] One of the jokes in the film is that Buffy's training as a cheerleader is inadvertently the thing that makes her an effective slayer. In fact, her valley girl experience is also useful: when she confronts Lothos with a cross and he sets fire to it, she sprays it with hairspray and burns him, paying tribute to her 'keen fashion sense'. It is commonplace to talk about Buffy as a 'post-feminist' icon of female empowerment, but it is also worth remembering that the 1992 film was one of the first Hollywood examples of a young woman using martial arts in combat – although the fight sequences themselves are disappointingly brief and a bit lame. American martial-arts films during the 1980s had mostly showcased hard, masculine bodies like Jean-Claude Van Damme's. John G. Avildsen's *The Karate Kid* (1984) reconfigured all this, however, by turning to a small, cute Italian-American schoolboy who, bullied at school by some tough-guy karate fighters, is trained to fight back by an ageing, deeply traditional Japanese-American man, Mr Miyagi (Pat Morita), another surrogate father. This is a different affiliation of the old and the young to the catastrophic one that plays out with the vampire and its victim: here, it produces self-discipline and self-belief. Replacing teenage boys with teenage girls, *Buffy the Vampire Slayer* and the fourth film in the 'Karate Kid' series – Christopher Cain's *The Next Karate Kid* (1994) – reconfigure this arrangement yet again and have been identified as 'Hollywood's first girl-power movies'.[52] Interestingly, the actor Hilary Swank – who played Kimberly, one of Buffy's more critical friends in Kuzui's film – went on to play Julie, the protagonist of *The Next Karate Kid*. Both films work through the same narrative trajectory: a young girl is trained by an elderly man (although Buffy has done most of her training already as a cheerleader); she rescues her boyfriend from bullies, or vampires; and she fights in a white dress at a showdown that takes place during the high school's prom night. In *Generation Multiplex: The Image of Youth in Contemporary American Cinema* (2002), Timothy Shary discusses *The Next Karate Kid* and sees the prom night – a significant, often climactic coming-of-age event in a number of American teen films – as the moment during which a tomboy both wins the fight and is made to recover her 'feminine' appearance.[53] This is probably also true of *Buffy*, which ends at the high school prom with the vampires dispatched and Buffy in the arms of her new boyfriend Pike (Luke Perry). But the film also systematically emasculates its male characters: the high school jocks, for example ('I can take care of myself!' she shouts at them). The vampires themselves are more or less without menace and easily defeated, although Amilyn – a vampire played by Paul Reubens, one of several small parts he took after his arrest for indecent exposure in Florida in 1991 – is still performing his comical death throes even at the very end. (Vampires don't turn into dust in this film: they die as if they are on a stage in the theatre.) Buffy's involvement with Pike, a car mechanic, reflects a social readjustment that accompanies her battle with vampires, as if she is no longer hostage to the confines and shallow aspirations of her class. But even Pike is emasculated by her. When she saves him from vampires in the woods, he falls helplessly into her arms. Chasing a vampire through a boys' basketball game ('Hey! There's a girl on the

court!'), she steals a biker's powerful motorcycle; Pike follows her on his weedy little trail bike. 'Are you calling me a man?' he asks her later, anxiously. After she kills Lothos and the other vampires, he asks, 'Did I do all that?' 'No', she tells him, shutting his masculinity down with a single word. The film ends with a series of television interviews with townsfolk about the vampires. One of the still-frightened high school jocks tells a reporter, making perhaps the best joke of the film (and its only attempt to be 'political'), 'They had this look in their eyes, totally animal. I think they were young Republicans.'

Interview with the Vampire and Queen of the Damned

The Irish-Catholic film-maker Neil Jordan's *Interview with the Vampire* (1994) — a belated adaptation of Anne Rice's 1976 bestselling novel — took the vampire about as far away from the grotesque decrepitude of Nosferatu as it was possible to go: giving us instead a prolonged celebration of youthful, white, male beauty. In *Shadow of the Vampire*, the joke is that the principal actor has always been a vampire and is simply being true to his actual, off-screen nature. But in Jordan's film, the star personas of heartthrobs Tom Cruise, Brad Pitt and Antonio Banderas could not have been more remote from the vampire roles they were hired to play. Christian Slater — the actor Buffy had wanted to marry — is also in this film and is offered the 'choice' to become yet another beautiful young vampire at the end. But the film's panegyric to male beauty is built entirely around Cruise, Pitt and Banderas, all of whom were by this time either major or emerging Hollywood celebrities. Of course, this may be precisely why casting them as creatures of the night made perfect sense. As Jordan himself has noted,

> The world of the vampire is not that different from the world of a massive Hollywood star You're kept from the harsh daylight, you live in a strange kind of seclusion, every time you emerge a kind of ripple runs through people.[54]

The sense of the star/vampire emerging from a strange kind of seclusion provided a further level of meaning for this film that immediately became definitive. *Interview with the Vampire* is about male-to-male adoration, a film that pays a feverish tribute to a young man's encounter with another young man who happens to be a vampire. It is a thinly disguised 'coming-out' movie, beginning with a sudden, exhilarating sequence that sees the still-human Louis (Brad Pitt) literally carried away by the vampire Lestat (Tom Cruise), who embraces him and lifts him into the air, biting him as he holds him in his arms, and then — as the rush of the experience becomes overwhelming — dropping him unceremoniously into the water below to cool off. Harry M. Benshoff has called the film 'a parody of a gay "coming out" story, in which the first-person narrator Louis learns to come to terms with his new-found lifestyle, at first hating himself, then eventually finding solace and companionship with others of his kind'.[55] This is indeed a film about male-to-male love and companionship, although Benshoff's account of Louis is misleading: he doesn't find solace with Lestat at all and in fact tries to kill him several times over, before going on either to kill or abandon all the other vampires he comes across (one of which, Santiago [Stephen Rea], is spectacularly decapitated). Louis's narrative is in fact a prolonged rejection of male companionship — perhaps a kind of homosexual panic — that sees him disappear from the film at the end, 'empty' and alone. Even so, the unusual thing about *Interview with*

Neil Jordan, *Interview with the Vampire* (1994): Lestat embraces Louis

the Vampire is that it is essentially a study of a vampire's relationship to its own kind. It is as if vampires are the only things that matter (to each other) – which makes issues of companionship and compatibility central to the film. As Benshoff notes, 'the bulk of the film's running time is devoted to the vampires' exploring their own queer identities, not trying to outsmart some Van Helsing figure to whom they eventually succumb'.[56] No one persecutes these vampires; when their relationships fail, they only have themselves to blame.

The explicit homosexual subtexts of the film made the casting of Cruise, Pitt and Banderas all the more interesting, and surprising. *Interview with the Vampire*'s star power no doubt contributed to its success as a mainstream film: costing around US$60 million to produce, it went on to gross more than US$220 million worldwide. But while other vampire films suppressed or marginalised the queer aspects of their narratives – leaving it up to various cultural studies or film critics to draw them out later on – *Interview with the Vampire* encouraged viewers to make precise ontological comparisons between vampires and gay men – and actors. This didn't seem to disturb mainstream audiences in the least; and it was celebrated by many gay and lesbian commentators. For the American LBGT magazine the *Advocate*'s Anne Stockwell, this is a matter of recognition that is triggered even during the film's opening credits, where a long tracking shot enables audiences to 'float above the shadows of the Golden Gate Bridge' in modern-day, nocturnal San Francisco before finally coming down to earth to look at two men together in a hotel room. 'It may not be politically correct', Stockwell writes,

> but the legend of the vampire speaks in special ways to gay people. Like those other creatures of the night, we've been hounded and despised. We've primped to the fangs and hunted flesh after midnight. And on countless mornings we've returned to the silence of our own coffin – the closet.[57]

Interview with the Vampire made explicit the association of vampires and gay men that was latent or covert in a number of earlier vampire films: Tom Holland's *Fright Night* (1985), for example, or Joel Schumacher's *The Lost Boys* (1987).[58] Louis and Lestat come together as two pale, beautiful, long-haired young men, their vampire appearance a matter of what Stockwell calls 'restraint': with barely visible 'little varicose veins in their faces – as if they used moisturiser with a blue-cheese base'.[59] If they stand out in a crowd, it is

New Vampire Cinema

because of their beauty, not because they are vampires. Or rather, the two things are made inseparable here. After their ecstatic embrace in the air, Lestat appears in Louis's bedroom in a gay version of the stereotypical vampire-human seduction scene we have seen above with Dracula and Mina or Orlok and Ellen. Later on, Louis meets Armand (Antonio Banderas) in Paris and is again an object of male adoration: 'You are beautiful, my friend', Armand tells him. At one point the two men feed on the blood of a beautiful, willing young boy. For Benshoff, the 'most terrifying moment' in the film occurs soon afterwards when Louis holds Armand's face close to his lips and several times over almost kisses him, before finally refusing Armand's 'invitation' and letting him go: another example of Louis's homosexual panic after a prolonged tease. The 'moment of terror is averted', Benshoff writes, 'and the audience breathes a sigh of relief – at least until the next time a handsome male vampire makes eyes at another man'.[60] *Interview with the Vampire* is therefore the complete opposite of *Bram Stoker's Dracula*. There is no romance between a man and a woman in this film. In fact, women only make fleeting appearances, usually only in order to be killed or disposed of – which means the film also runs the risk of appearing misogynistic.

These various erotic male encounters no doubt made casting a problem for this film, as Benshoff also notes: 'Well-known Hollywood actors were supposedly afraid to play the parts of Louis and Lestat, worried that the characters' implicit homosexuality might tarnish their chances for future heterosexual roles.'[61] Although Lestat is only in about a third of the film, the focus was on the casting of Tom Cruise in particular, the star of Tony Scott's hardware-action films *Top Gun* (1986) and *Days of Thunder* (1990) and Rob Reiner's military court thriller, *A Few Good Men* (1992): roles that played out modern American myths of struggle and redemption, celebrating individual triumph over setbacks and failure. For David Denby, Cruise's star persona is the embodiment of 'the spirit of corporate resurrection', where 'winning' is what counts in the end.[62] No doubt intentionally, Cruise – unlike Schreck in *Shadow of the Vampire* – is *miscast* as a vampire, although there is an argument to be made that Lestat also manages to triumph over setbacks and failure (he is poisoned, buried in a swamp, burned, etc.), resurrected intact at the end of the film with a triumphant peal of laughter. Lestat was an especially important character for the novelist Anne Rice, who had waited almost twenty years to see her novel adapted to film; he was also important to her many readers and fans. Rice had her own views about who should, or could, play this cruel, callous and immensely arrogant vampire and listed her choices in an interview in *Movieline*: Jeremy Irons, Peter Weller, John Malkovich and Alexander Gudunov, a Russian ballet dancer and actor who had defected to the United States in 1979.[63] When Cruise was cast as Lestat, Rice then made her disappointment public: 'Cruise is no more my vampire Lestat than Edward G. Robinson is Rhett Butler', she said in the *Los Angeles Times*.[64] Having seen the film, however, she did a complete about-face, taking out a two-page advertisement in *Variety* to declare her support for the casting, giving the film itself her authorial approval:

> I loved the film. I simply loved it. I loved it from start to finish … . But most personally, I was honoured and stunned to discover how faithful this film was to the spirit, the content, and the ambience of the novel, *Interview with the Vampire* … . I was shocked to discover that Neil Jordan had given this work a new and distinctive incarnation in film without destroying the aspects of it which I hold so dear … . The charm, the humour and invincible innocence which I cherish in my beloved Lestat are all alive in Tom Cruise's courageous performance.[65]

Cruise is certainly impressive in the film, his previous clean-cut star persona left behind by his ability to impersonate the dissolute Lestat.[66] But the focus of the film — its fetish object — is Brad Pitt as Louis, and the film is littered with lingering close-ups of his handsome/feminine face. It begins in the Hotel St Mark, San Francisco, with Louis telling his story to a biographer of some kind (a 'collector of lives'), Malloy (Christian Slater). Another distinctive feature of this film is its interest in the vampire's point of view, in what it means to be a vampire. It is the first vampire film to be narrated by a vampire, installing him at the centre of the film right from the outset, as if he has always been there (he doesn't have to be invited in, journeyed towards, etc.). As Louis talks to Malloy about his life the film works as a kind of confessional, offering a 'truth' about the way vampires really are, generating an authenticity effect that Malloy, a sort of idealised listener or viewer, finds compelling. In spite of these distinctive features, however — and despite the fact that it announces it has no interest in Stoker's *Dracula* at all (Louis dismisses the novel as the fantasy of 'a demented Irishman', in a bid to make his own story even more authentic) — the narrative of *Interview with the Vampire* is surprisingly similar to Coppola's film. Louis begins his story by similarly returning to an historical point of origin: the moment 'when I was born to darkness, as I call it ... 1791 was the year it happened'. The location is New Orleans, Louisiana, where Louis is a wealthy plantation owner and slaver. Unlike *Bram Stoker's Dracula* — and *Buffy the Vampire Slayer*, for that matter — *Interview with the Vampire* tries to honour (rather than just invoke) its historical referent, giving romantic expression to the decadent, revolutionary sensibilities of the time. Mourning his dead wife and child, Louis is 'saved' from a predatory pimp and his whore by Lestat and turned into a vampire. Lestat's various indiscriminate killings — slaves, aristocrats, men, women — frighten the diasporic slave community on the plantation, which tries to protect itself through voodoo rituals. History is 'occulted' here, something we shall see again in Chapter 2. Killing a house servant, Yvette (Thandie Newton), Louis is distraught: as if the reality of his predicament as both a slave owner and vampire is suddenly brought home to him. Undergoing a kind of Pauline moment of conversion, he burns his property, frees his slaves and leaves, bitterly resenting Lestat's Nietzschean influence. Later, as a plague spreads through New Orleans, Louis offers comfort to a young girl, Claudia (Kirsten Dunst), whose dead mother sits beside her. Overcome by his vampire nature, he bites the girl's neck; Lestat arrives, dances with the mother's corpse, and turns Claudia into a vampire. 'I want some more', she says, greedily sucking blood from Lestat's wrist like a ravenous Oliver Twist. This interesting scene is a revamping of Mina's seduction in *Bram Stoker's Dracula*, which it also unpacks, even contradicts: refusing any erotic attraction between male vampire and female victim, for example. Louis and Lestat instead adopt Claudia as their 'daughter', although Louis is dismayed to see that, as a vampire, she is also a ruthless killer. The film gives us the predicament of two incompatible men parenting an unruly child who exceeds them, murdering and feeding even more indiscriminately than Lestat. We shall see another example of the ruthless/loving/marauding child vampire with Eli in Tomas Alfredson's *Let the Right One In*, and in fact these two characters have a lot in common — the scene with Claudia alone and crying in the street before killing a woman who comes to comfort her is referenced in Alfredson's film. Just as Eli kills her 'father', Hakan, so Claudia turns on Lestat, slitting his throat and then paraphrasing Horatio from *Hamlet* ('Good night, sweet prince ... may flights of devils wing you to your rest') as she watches him bleed. But Claudia is also a kind of detour in *Interview with the Vampire*, which creates her only to destroy her later on just when she finds a female companion she can depend upon.

As far as Louis is concerned, *Interview with the Vampire* is about the loss of loved ones: he remains perpetually in mourning for his dead wife and child, and later on for Claudia. He is a Freudian melancholic, unable to let go of his lost objects. Even so, the film drags him into the modern world – but not before another major detour that sees Louis and Claudia leave New Orleans and sail to Europe (the 'Old World') to search for other vampires like themselves. The journey by ship references – and reverses – the journeys Nosferatu and Dracula take as they head west towards the modern metropolis: 'Though the ship was blessedly free of rats', Louis says, 'a strange plague nonetheless struck its passengers.' But the film also self-consciously rejects its earlier sources, with no vampires to be found in Eastern Europe. It shifts forward in time with Louis and Claudia arriving in Paris in September 1870: in fact, the beginning of the siege of Paris by Prussian forces, although the film is no longer interested in invoking historical frameworks. Instead, some vampires – Armand and Santiago – invite Louis and Claudia to the theatre. Theatre is important to *Interview with the Vampire*, with the stage and the balcony already a part of earlier scenes (such as when Lestat first watches Louis) and much of the dialogue theatrically delivered. Stephen Rea is himself best known for his work in theatre, although he has also been principal actor in a number of Neil Jordan films. Rea's character Santiago is the principal actor in the Theatre des Vampires, playing Death and putting on a performance in front of an enthralled audience that sees a 'mortal girl' callously stripped and killed on stage by Armand and the other vampires in the troupe.[67] Watching from the balcony, Louis is already a disillusioned spectator: 'Vampires who pretend to be humans, pretending to be vampires', he says dismissively, anticipating Murnau's comment about Max Schreck in *Shadow of the Vampire*. Armand recognises that Louis's distance from their theatrical world reflects his modernity: 'Two vampires from the New World come to guide us into the modern era, as all we love slowly rots and fades away.' Modernity, too, is defined by loss in this film, something that Claudia's death (she could not grow up) also underscores. 'I'm at odds with everything', Louis tells Armand. 'That is the very spirit of your age', Armand replies. 'You reflect its broken heart.' Taking his revenge on the Parisian vampires, Louis abandons Europe and returns to 'my America', still melancholy but embracing the modern age.

This is where the narrative of *Interview with the Vampire* once again intersects with *Bram Stoker's Dracula*. As with Dracula in London in Coppola's film, cinema is precisely the thing that is made to signify Louis's modernity. In America, he tells Malloy, 'a mechanical wonder allowed me to see the sun rise for the first time … . And what sunrises, seen as the human eyes can never see them, silver at first then as the years progressed tones of purple, red, and my long lost blue.' Inside a cinema, Louis watches a massively condensed history of film, beginning – interestingly enough – with the opening title of F. W. Murnau's *Sunrise: A Song of Two Humans* (1927), as well as the image of a train from that film, then a short sequence from Murnau's *Nosferatu*: as if the origins of American cinema can be properly traced to this German film-maker. A fleeting glimpse from *Gone with the Wind* (1939) follows, and then a brightly lit scene from *Superman* (1978) as the caped superhero watches the sun appear above the earth. This is *Interview with the Vampire*'s 'cinematograph' moment, with Murnau as its source; except that there is no seduction scene here and there are no shadows. It works simply as a way of ushering Louis into the modern world. It ushers him into the world of modern, commercial Hollywood cinema, too: when he emerges from what is in fact the actual Coliseum Theatre building in New Orleans in '1988' – it isn't entirely clear why the film chooses this year over the year of its

release, 1994 (and the Coliseum had in fact closed in 1976) – Robert Towne's *Tequila Sunrise* is the main attraction, a Warner Bros. film just like *Interview with the Vampire*. In New Orleans, Louis comes across Lestat again, who is hiding in a mausoleum: an agoraphobic vampire who seems frightened by the noises of the modern world outside. The film jumps at last to 1994 as Louis concludes his story in San Francisco, only to find that Malloy now wants to become his 'companion'. Enraged – more homosexual panic – Louis effectively disappears from the film. Malloy drives off in a panic, but as he crosses the Golden Gate Bridge where the film began, Lestat suddenly arrives – as if he has spontaneously 'come out' – bites him, and offers him the chance to become a creature of the night, just like Louis. *Interview with the Vampire* ends with Lestat literally at the wheel, laughing, as Guns N' Roses' 1994 version of the Rolling Stones' 'Sympathy for the Devil' plays on the car's cassette machine: a copy, rather than the original, significantly enough, but a modern song that is also completely at odds with Elliot Goldenthal's musical score for the rest of the film, which had emphasised period instruments, boy choirs and liturgical chants.

The juxtaposition of old and new is, of course, central to vampire films broadly speaking, which so often gain their dramatic power through the narratives they build around an ageing or archaic vampire's experiences in the modern world. His temporary bout of agoraphobia notwithstanding, it certainly seems as if the older Lestat is better equipped to enjoy modern life than the melancholy Louis. In the Australian director Michael Rymer's *Queen of the Damned* (2002) – a loose kind of sequel to Jordan's film – Lestat wakes from a long sleep in a New Orleans cemetery (as if the ending of *Interview with the Vampire* had never happened) to the sound of 'nu metal', the beginning of a relentlessly uniform Goth rock soundtrack written by Korn's Jonathan Davis. Inexplicably, perhaps, all this 'noise' draws Lestat out into the modern world once again, this time as a ready-made, Jim Morrison lookalike glam rock star: an old vampire who looks perpetually young and is surprisingly in touch with current musical trends, etc. *Queen of the Damned* is a kind of prolonged, self-aware MTV clip, built around a series of rock concerts performed in different 'extreme' parts of California (Death Valley, etc.) and elsewhere – although the film was in fact shot on location entirely in and around Melbourne, Australia. Even so, it immediately makes what is now the obligatory nod to something older, the nu-metal film clip during the fade-to-red opening credits unfolding in black and white and recreating tableaus from Robert Wiene's German Expressionist horror masterpiece, *The Cabinet of Dr Caligari* (1920). This is, however, about as far as this film's 'cinematograph' moment gets, a mere citation; Lestat himself is oblivious to it as he goes about making himself into a modern rock star.

Very few reviewers are nice to *Queen of the Damned*.[68] Anne Rice had nothing to do with this sequel; the screenplay is by Scott Abbott and another Australian, Michael Petroni. Lestat is now played by Irish actor Stuart Townsend as a narcissistic brat, with none of the charisma and gallows humour that Cruise had brought to the role. It is as if Lestat has now himself become inauthentic. But the stark juxtaposition of the old and the new that is so typical of vampire films is evoked here in some interesting ways. Effortlessly becoming a rock star, Lestat naturally and willingly draws attention to himself: he stands out, rather than blends in. Self-promotion, rather than self-effacement, is cast as the modern malaise in this film, and Lestat encourages other vampires to make themselves equally visible. His irritating refrain, 'come out, come out, wherever you are', has nothing to do with the vampire/gay association we saw in Jordan's film; it seems to want

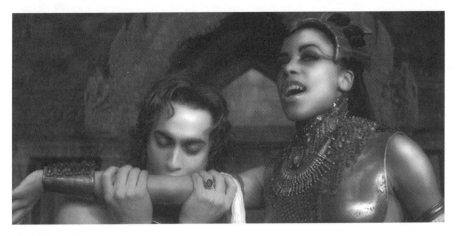

Michael Rymer, *Queen of the Damned* (2002): Lestat feeds on Akasha

vampires simply to be seen as vampires, something that would be further developed a few years later in the *True Blood* television series (2008–). In the meantime, Jesse (Marguerite Moreau), who works for an investigative paranormal centre in London, has come across Lestat's journal and is learning more about him. *Queen of the Damned* then flashes back to a Mediterranean island in 1788, its point of origin (like '1462' in *Bram Stoker's Dracula*): interestingly, for this Australian film, the year in which Australia was officially possessed by the British. Here, Lestat is himself possessed by Marius (Vincent Perez), who turns him into a vampire and 'educates' him as if he is his son. For Marius – 'the closest we've come to the original vampire' – it is important that vampires 'remain in the shadows'. Later, Lestat recognises that vampires like Marius are 'frightened of the light I was directing on all their kind'. But Lestat – a bit like Claudia in Jordan's film – is difficult to manage. In an underground mausoleum he finds two statues, of a king and queen. Playing the violin (one of so many little things left unaccounted for in this film), he awakens the queen, Akasha: played by the young African American R&B artist Aaliyah, who was killed in an airplane crash just before this film was released. Much older than Marius, Akasha has 'the purest blood from the oldest of things'. Dressed in faux-Egyptian gold breastplates and lavish gold adornments (in Rice's novel, she is Egyptian), she functions as a kind of pop culture embodiment of 'black Athena', a manifestation of Martin Bernal's controversial thesis, developed through the 1990s, that northern Africa was the source of classical, European civilisation. Through Akasha *Queen of the Damned* shifts the origins of the vampire away from Europe, against the grain of *Bram Stoker's Dracula* (although Coppola's film does orientalise Dracula to a degree) and *Shadow of the Vampire*. It also introduces racial difference into a vampire film that, like *Interview with the Vampire*, has otherwise taken the whiteness of its vampires for granted. But having raised racial difference from the dead, *Queen of the Damned* doesn't seem to know what to do with it. Akasha is unleashed into the modern world, killing humans – she refuses to 'co-exist' with them – and destroying almost every vampire she comes across. She seems drawn to Lestat ('I know that you crave to have the world at your feet'), although how she can help him become even more adored is unclear, not least because she is so wantonly destructive. Akasha's racial difference is cast as radically excessive, something 'primal' that cannot be assimilated.

Lestat is appalled by her, having by this time discovered his 'human' side: he is reluctant to turn Jesse into a vampire, for example, even though she wants him to. After a climactic rock concert in 'Death Valley', attended by a vast crowd of Goth-metal fans drawn from Melbourne's local subcultures, Lestat conspires with Marius and other vampires (part of a 'great family') to kill Akasha. Given her brief but spectacular appearance, Akasha's death is disappointingly conventional for a vampire film: turning black, she becomes skeletal and then crumbles into dust.

In her book *Celluloid Vampires* (2007), Stacey Abbott turns to *Queen of the Damned* as part of a concluding argument about the 'borderless world' of modern vampires in contemporary cinema:

> *Queen of the Damned* is incredibly precise about the movements of its vampires. Each change of setting begins with a caption indicating the change of location over an elaborate establishing shot as the camera flies over the city and its surrounding landscape. As the vampires in this film are attributed with the power of flight, these sweeping camera movements evoke the ease and speed of vampire travel and the resulting meaninglessness of distance and global separation While the human Lestat was of French noble birth, his transformation into a vampire suggests that he has equally been transformed into a member of a global elite, able to ignore national boundaries and travel across the globe with ease.[69]

Queen of the Damned certainly gives the impression of freedom of mobility, even as its various sites all turn out to have been filmed in the one place. But the view of the modern vampire as 'global' is a limited one. In fact – as I hope the discussion of the various vampire films in this chapter has already suggested – there is an argument to be made that the modern vampire is immensely constrained in terms of movement and adaptability. In *Bram Stoker's Dracula*, for example, the vampire's journey from Eastern Europe to London marks the beginning of his demise, as if he is simply unable to survive his entry into the modern world. National identities are reasserted in this film, driving Dracula back to where he came from. The 'cinematograph' moments in this film and in Merhige's *Shadow of the Vampire* are there partly to underscore this point: that the vampire is both brought into being by modernity and erased or undone by it: made substantial and insubstantial simultaneously. Even *Buffy the Vampire Slayer* knows this: that although they take ages to die, vampires really have no place in modern California. In *Interview with the Vampire*, Louis's journey from New Orleans to Paris and back again both ushers him into the modern world and removes him from it. These are, incidentally, not 'global' movements at all; they chart instead a very particular kind of trajectory between New Worlds and Old Worlds that reference and reconfigure previous vampire narratives. In *Queen of the Damned*, Lestat's various nu-metal rock concerts in California, Hollywood and so on are conjoined to the insatiable appetites of the oldest vampire in the world, who is also singularly unfit to be modern. Rather than demonstrate the 'ease' of contemporary movement, the film ties it to a binary of excess (the modern) and restraint (which may also be modern, since it is something Lestat comes to learn about) that it is unable to resolve. At the end of *Queen of the Damned*, Akasha has dissolved away and Lestat is absorbed back into a 'great family' of vampires that prefers to remain hidden in the shadows. As for the suggestion that to be transformed into a vampire means that one somehow joins a 'global elite': by the time we get to Louis in *Interview with the Vampire*, this could not be any less true. As we shall see in Chapter 2 and elsewhere in this book, becoming a vampire in the modern world –

notwithstanding the various excesses it can unleash — brings with it a set of often incapacitating restrictions and restraints. It is not a guarantee of freedom of movement at all; it isn't even a guarantee of immortality. Quite the opposite: to be transformed into a vampire in the modern world can mean little more than an agonising sense of just how difficult being modern can be.

OUR VAMPIRES, OUR NEIGHBOURS

Frostbitten, *Let the Right One In* and *Let Me In*
Night Watch and *Day Watch*

Vampire films constitute a genre, but in cinema studies the notion of genre has troubled critics for some considerable time. Genre works as a way of tying identifiably similar groups of films together, but in what ways are they then recognised and understood? For Andrew Tudor, films themselves enable genre recognition to occur by invoking and exploiting key conventions (or 'principal characteristics') sometimes even to the point of self-parody.[1] But in order to be recognized, those conventions must already be in circulation. Genre recognition is therefore just as much about audiences and the levels of cultural capital they bring to the cinema. 'Genre', Tudor went on to say, 'is what we collectively believe it to be.'[2] I agree with this, but the point also runs the risk of spreading recognition out too smoothly and abstractly. Particular genre conventions are assembled at particular times, for particular reasons. Local film industries might take a particular generic 'turn', like the 'vampire comedies' that were produced in Hong Kong in the 1980s and early 1990s but more or less ignored in the West, no doubt partly because of their 'heavy dependence on Cantonese dialogical gags' and often outlandishly bizarre slapstick scenes.[3] Sites (and histories) of production can therefore set limits on the capacity for genre recognition: every film commentator, myself included, who tries to comprehend cinema from 'remote' locations (culturally, socially, geographically, historically) must in some way register this problem. Like films, audiences are also always situated. Drawing on their own, uneven levels of cultural capital, they perform various disagreements and disputes about genre conventions, rather than collectively 'believe' in them. As Rick Altman has noted, 'genre tells us what to notice ... and some spectators know the genre better than others'.[4] Genre conventions – and the knowledges that enable them to be both produced and understood – are also a matter of shifts in industrial policy and capacity, changes in available cinematic technologies, modes of marketing and distribution, practices of collection and assemblage and so on. Peter Hutchings offers an interesting example of some of this in relation to the horror film broadly speaking, beginning with a 'personal encounter' with the genre in a DVD shop and then wondering about the way it is remembered, reassembled and reconstituted through a series of films chosen for inclusion in Universal's Monster Legacy Collection.[5] Elsewhere, Hutchings has emphasised the contingent nature of horror film as 'surely one of the more protean of the mainstream genres';[6] even so, it is always understood as the outcome of a relationship between the conventions it gives expression to, and the ways in which those conventions (their effects, etc.) are recognised and registered at the time and place of their consumption.

In this chapter, I want to look at the issue of genre a little differently and no doubt more in line with my own background as a literary and cultural

critic. There are many kinds of vampire films, and they certainly have their particular moments of historical concentration and local expression, one of which happened in Sweden not long ago, and I shall look into this shortly. But first I simply want to affirm a couple of key characteristics that hold vampire films together as a genre in terms of what Altman has called its 'semantic' and 'syntactic' features: that is, in terms of its various 'building blocks' (the basic elements of meaning and identification that a genre mobilises) and the ways in which these things are 'arranged', thematised and narrativised.[7] Altman has elsewhere emphasised diverse and sometimes competing audience or 'user group' responses in his ongoing revision of how a film genre might be understood. But he never-theless acknowledges the active role a genre plays in 'regulating and coordinating' those responses as if, alongside its many particularities and contingencies, there are always some aspects of a genre that can indeed be collectively or universally recognised.[8] This may be especially easy to do with vampire films. Fairly obviously, they always revolve in some way around at least one vampire, which then solicits and excites the attention (hos-tile, frightened, romantic, erotic, and so on) of characters who come into its proximity. This is as true of Bram Stoker's early vampire novel *Dracula* as it is of any of the films exam-ined in this book. Some vampires attract, others repel; some do both. In syntactic terms, vampire films stage an encounter that brings the vampire ever closer, steadily (or sud-denly) increasing the range and intensity of its influence. But it is often a very specific kind of encounter: usually putting someone young into proximity with something quite old, with catastrophic consequences.

Vampire films can be especially effective at regulating their audiences' responses, not least because — as I have already suggested — they are so self-citational. It is almost impossible for one vampire film not to cite or invoke another vampire film or a vampire novel, like Stoker's (or Browning's) *Dracula* or Murnau's *Nosferatu*. Every vampire film is to some degree a self-conscious remake or sequel or restaging of other vampire films that have preceded it, which is why so many commentators (and no doubt many audi-ences too) have such a low tolerance threshold for the genre's irritating capacity to so often appear to do what other vampire films have done already. It is true that some vam-pire films have generated remarkable levels of excitement and audience commitment, and I shall look at examples of these in this book. But they can also routinely be written off by commentators who feel as if they've seen it all many times before. It can therefore seem as if vampire films are all *too* recognisable. But recognition is important to vampire cin-ema, which self-consciously foregrounds the most familiar aspects of its generic 'look': for example, in movie posters and DVD covers that mix black shadows and lurid red colour, penetrating looks, bared teeth, yellow eyes and so on. Recognition — recognising the vam-pire (film) for what it is — is also a process that these films often literally thematise. In a certain sense, characters in vampire films are asked precisely to recognise and under-stand the laws of the genre of which they are a constitutive part. Their lives may even depend on it: audiences watch as characters are sometimes 'shocked' into recognition, rapidly absorbing the appropriate levels of cultural capital needed in order not just to see the vampire for what it is, but to prevent themselves from becoming one in turn. In his essay, 'The Idea of Genre in the American Cinema', Edward Buscombe begins by won-dering: 'Do genres in the cinema really exist?'[9] This is, of course, precisely a question of recognition. But it is also a version of a question typically staged in vampire films them-selves. 'Do you want me to believe you're a vampire?' Annika (Petra Nielsen) asks Dr Beckert (Carl-Ake Eriksson) in the Swedish vampire film, *Frostbitten* (2006), directed by

Anders Banke, which I shall discuss below. The answer is inevitably yes, as both Annika and Buscombe soon come to realise; although their affirmations will always sit alongside other characters', and commentators', scepticism and denial. At the end of his essay, Buscombe in fact seems to require the metaphor of the vampire in order to enable him to recognise genre for what it would seem to be. A genre, he writes, 'is not a mere collection of dead images waiting for a director to animate it, but a tradition with a life of its own'.[10]

Vampire films do indeed have traditions that they often refer back to, in order both to stabilise themselves generically and to (re-)animate what they do (all over again). But genres are never quite as pure as this monogamous notion of a 'tradition' might suggest. They can be understood vertically, but they also radiate out horizontally to touch other genres and be touched by them in turn. A genre has a certain loyalty to itself, inhabiting and often paying extensive homages to the traditions to which it owes its existence. But genres are also routinely inhabited by other genres, producing what can sometimes seem like an arbitrary range of affiliations that can run the risk of undoing them – as genres – altogether. They are monogamous in some respects, and promiscuous in others. Perhaps unsurprisingly given her topic, Linda Ruth Williams sees cinematic genres mostly in the latter way in her study of the 'erotic thriller'. 'There are very few entirely uncontentious genres', she suggests, 'and for most recent writers the more promiscuous a genre term becomes, sliding into bed with any and perhaps all of its neighbours, the more interesting it is.'[11] Here, it is as if the erotic thriller provides the language through which all genres can come to be understood: a matter of balancing 'the desire for familiar and repeated satisfaction with the excitement of experiment', and so on.[12] In cinema studies, this is itself a familiar position on genre, in particular Williams's link between levels of generic promiscuity and levels of interestingness. Almost no one speaks up for 'pure' genres any more, for a genre's monogamy. Genre, Susan Hayward notes, is 'a shifting and slippery term'; 'generally speaking a film is rarely generically pure', and since 'genres also produce sub-genres, so again clarity is proscribed'.[13] In this account, a genre is both promiscuous and fertile, mingling with its neighbours and watching as its various progeny (if I can paraphrase Mary Shelley's famous thoughts about the future of her Gothic novel, *Frankenstein* [1818]) go forth and prosper across the cinematic world. The genre itself may still be recognisable; but it will also pick up characteristics – principal and peripheral – that can seem as if they have come from somewhere else altogether. In an influential discussion of 'the law of genre', Jacques Derrida once noted that genre typically insists that 'one must respect a norm, one must not cross a line of demarcation, one must not risk impurity, anomaly, or monstrosity'.[14] But he also thought that a genre contains a 'clause' of some kind that pushes it across this line – that makes it lose its purity by sliding into bed with its neighbours – regardless. What is worth noting here, however, is that when Derrida tries to give this 'clause' some sort of identifiable embodiment or definition he invokes (even more graphically than Buscombe) the fantasy of the vampire:

> The clause or floodgate of genre … tolls the knell of genealogy or of genericity, which it how-
> ever also brings forth to the light of day. Putting to death the very thing that it engenders, it
> cuts a strange figure; a formless form, it remains nearly invisible, it neither sees the day nor
> brings itself to light. Without it, neither genre or literature come to light, but as soon as there
> is this blinking of an eye, this clause or this floodgate of genre, at the very moment that a genre
> or a literature is broached, at that very moment, degenerescence has begun, the end begins.[15]

This rather melodramatic account is part of what John Frow has described as Derrida's 'participation in … a familiar post-Romantic resistance to genre as a prescriptive taxonomy'.[16] Participation is important for Derrida, as Frow notes: texts, films and so on don't belong to genres but participate in them and across them. The 'law of genre' is precisely this, a 'sort of participation without belonging – a taking part in without being a part of'.[17] It is, interestingly, a bit like the sociologist Georg Simmel's figure of the 'stranger', inhabiting a world but never quite belonging to it, simultaneously close and remote, neighbourly and yet always at the same time from somewhere else.[18] Perhaps it is also a bit like a vampire. Certainly Derrida's remarks above tell us something about vampire films *as a genre*, which are built around precisely the points at which 'lines of demarcation' are crossed, 'monstrosity' is risked, something is brought 'to the light of day' and (as 'degenerescence' inevitably takes hold) 'the end begins'. These are the things that an encounter with a vampire – and a vampire's encounter with others – set into motion.

Frostbitten, Let the Right One In and Let Me In

Two contemporary Swedish vampire films – Anders Banke's *Frostbitten* (2006) and Tomas Alfredson's *Let the Right One In* (2008) – are precisely about the various 'lines of demarcation' that are jeopardised through a prolonged encounter with vampires. Although they have some things in common, *Frostbitten* was eclipsed by the global success of *Let the Right One In* two years later; on the other hand, Sweden's first vampire film (as it was publicised) sold to around forty-five different countries and is supposed to have become a cult favourite in Russia. Banke is a Swedish film director who had studied film-making in Moscow; after *Frostbitten*, he went on to direct *Newsmakers* (2009), a Russian-based remake of Johnnie To's Hong Kong police drama, *Breaking News* (2004). *Frostbitten* itself opens in the snowscaped forests of Ukraine in 1944, playing out another kind of transnational dislocation – and appearing, for a moment, to have nothing to do with vampires at all. Here, a Scandinavian volunteer army division is fighting on the side of the Germans. Under fire from the Russian enemy, the few remaining soldiers from the SS Panzer Division Viking run into the forest and lose themselves. They stumble across an old, abandoned hut and go inside, cold and hungry. Later on, the soldiers wonder how the former inhabitants of the hut managed to escape, because the doors and windows are jammed shut by the deep snow outside. Something attacks them: a monstrous peasant woman, it seems. One of the soldiers, Gerhard Beckert, goes into a cellar and finds a number of mutilated corpses, along with a small box with the name 'Maria' imprinted on it. The nails in each corner suddenly begin to push out and guttural growls are heard from inside. In a comic-horror scene, Beckert pushes the nails back in and the soldiers finally weight the box down and bury it. The camera then goes out of the hut and glides across the forest and up into the sky, to reveal a full moon – which introduces the opening titles and credits to the film.

Vampire films often carry deep histories within them, some merely working as floating signifiers of ancientness or age, others working profoundly to shape whatever modern events later unfold. *Frostbitten* takes a repressed moment from Sweden's military past and brings it into proximity with the present day, in a small town in Norrbotten country in the far north of Sweden, for reasons that (to a 'remote' viewer like myself, at least) can seem obscure. A couple of years before the film was released, however, Thorolf Hillblad's

account of the Swedish SS Panzer Division Vikings, *Twilight of the Gods*, was reprinted. (It was first published in Buenos Aires just after World War II.) This is a triumphalist, unapologetically partisan account of Swedish–German wartime collaboration and the collaborators' campaigns against the Russian army, 'the barbaric masses from the east'.[19] It goes entirely against the grain of the received sense of Sweden's wartime neutrality. *Frostbitten* might very well have drawn directly on one of Hillblad's opening descriptions of a Nordic New Year's Eve mission in 1944–5 in German-occupied Courland:

> In the reflected whiteness of the cold, sparkling snow, all outlines appeared razor sharp. A group of trees, riddled by bullets and shells, with their splintered trunks and twisted network of branches, reminded me of grotesque figures in a fairy-tale about brownies and hobgoblins.
>
> The village, or small town, or what once had been something like that, looked more ghost-like than usual … . No life was visible in the ruins. But if the alarm should go, warning of an enemy attack, swarms of 'creatures' would leap up among them, because under the ground, in the cellars of the damaged houses, there were soldiers everywhere.[20]

This is a remarkable passage to find in a book about Swedish–German collaboration: one that turns foreign occupation into a vivid Gothic trope, displacing the war (and history itself) into a fantasy landscape. For Banke, the opening Ukraine sequence of *Frostbitten* is partly there to provide some depth of meaning to a modern Sweden that is 'one of the more secular, and maybe not as fun and exciting places in the world'.[21] It also works to displace viewer expectations, because after the opening credits the film shifts from Ukraine in 1944 to Sweden in the present day, turning into a riotous teen horror-comedy that demonstrates the influence of the early splatter-gore New Zealand films of Peter Jackson. The teenage protagonists are oblivious to the idiosyncrasies of Swedish wartime history, even though they register the last, disturbing traces of its effects. Banke offers another explanation for the opening scenes in Ukraine worth adding here, one that is simply about colour and contrast, specific to vampire films, winter vampires films especially: he likes 'the concept of the red blood against white snow'.[22]

In the present day of *Frostbitten*, the Swedish–German wartime collaborator Beckert is now a famous, apparently ageing genetic scientist who works in the town's local hospital: like Simmel's stranger, simultaneously proximate and remote. Divorced mother Annika and her daughter Saga (Grete Havneskold) are also strangers, new arrivals in town as darkness falls: 'No daylight for a month', Saga says to Annika, 'I should have moved in with Dad instead.' *Frostbitten*'s narrative is the opposite to that of David Slade's film, *30 Days of Night* (2007) – another winter vampire film, set this time in the far north of Alaska, which sees feral vampires from somewhere else invade a small town at the beginning of a similarly extended period of natural darkness. In *Frostbitten*, however, the vampires are already there, one of them lying comatose and dormant in Beckert's hospital where Annika now works. The reanimation of something (or someone) comatose – releasing it into an otherwise oblivious community, which then experiences it as a kind of radical or absurd dislocation – provides a familiar narrative trajectory for vampire films (although other horror films can share this, too). It is a version of the juxtaposition of something old, remote and slow, and something young, active and temporal that I noted above: where the yet-to-be-animated vampire might seem a bit like the famous German experiment on the tick that Giorgio Agamben describes in *The Open: Man and Animal* (2004), an insect kept alive for eighteen years in suspended animation, sinking into a 'dreamlike state of waiting' as if 'the

world seems to stop':[23] but is nevertheless able to reinhabit that world at a moment's notice. Annika is curious about Beckert's comatose patient and examines her; suddenly (but unsurprisingly), the patient awakens, rises up and bites her arm. Beckert realises what has happened and takes Annika prisoner. Revealing himself as a vampire, he tells her about events in the Ukraine forest during the war. He had taken the dead peasant woman outside to burn her body, but she had also risen up, biting his leg. Turning into a vampire and killing all his comrades, he releases Maria from her grave and takes her with him back to Sweden. 'That was my last night as a human being', he says, becoming — like the tick — a single-minded, bloodsucking creature. The hospital is full of tubes of vampire blood and red pills, as Beckert conducts his experiments like a crazed Nazi doctor, the outcome of his collaboration with the Germans during the war. 'I'm close to perfection', he tells Annika, who is slowly becoming a vampire herself. 'When I'm done, our kind will rule over all of you!'

Frostbitten takes a curious form of revenge against this Swedish–German war collaborator, putting him into a vampire film and allowing that repressed moment of Swedish wartime history to occupy and finally overrun the present day, the snowy streets of the town now bearing witness to strange, threatening events and disappearances: more red blood against white snow. The film follows two other narratives, one about Saga as she meets a Goth girl at the local school, and the other involving Sebastian (Jonas Karlstrom), a young medical student at the hospital. Sebastian's narrative unleashes a series of comic-grotesque events. Taking some of Beckert's red pills, he finds himself in a dialogue with his girlfriend's dog: 'You're going to burn!' it tells him. Visiting his girlfriend's parents for dinner — her father is a priest — he bites into their pet rabbit and retreats into the bathroom, where his transformation into a vampire is reflected in the mirror. Soon, his reflection begins to fade: at which point Sebastian recognises the conventions of the genre he now inhabits. In the meantime, the Goth girl, Vega (Emma Aberg), invites Saga to a New Year's Eve party: 'I'm inviting you now. There, you're invited!' The question of who one should invite into one's home preoccupies Alfredson's *Let the Right One In*, too, and lends the encounter with a vampire (or with new arrivals) a neighbourly, ethical dimension. Annika and Saga are also dislocated and the problem for them, having just moved into their apartment, is how to properly assimilate. 'It's great you got to know people already', Annika proudly tells her daughter. But Beckert's red pills are now circulating through the town and soon the teenage partygoers are popping them down like ecstasy, rapidly turning as more of them become infected with vampire blood. The film collapses into a pitched battle between the local police and blood-crazed suburban teenagers already tuned into heavy metal and fast cars — although the 'explanation' for their rampage is not really social or cultural at all, but remote and fantastic. 'I can't sleep', complains a neighbour, 'they're even climbing the walls!' Saga soon recognises the vampires around her for what they are; when Vega becomes a vampire and attacks her, Saga defends herself and finally kills the girl who had welcomed her into the neighbourhood in the first place. Far from being able to assimilate, Saga and her mother find themselves under attack by a town that is rapidly experiencing 'degenerescence'. As she is carried out of town in an ambulance, Saga suddenly sees another, younger girl sitting beside her. 'My name's Maria', the girl tells her. 'Mother says we'll be sisters and we will always be together. You'll never be alone.'

In terms of the genre of the vampire film, *Frostbitten* is both conventionally recognisable and almost incoherent. In particular, the connection it draws between its origins (the Swedish SS Panzer Division in the Ukrainian forests in 1944) and its destination (a

teenage New Year's party in an undistinguished satellite town in northern Sweden) remains opaque and eccentric – in a film that itself becomes increasingly eccentric as it goes along. But the narrative of Annika and Saga provides a set of tropes that Sweden's second vampire film, Tomas Alfredson's *Let the Right One In*, invests in heavily. In *Frostbitten*, the mother and daughter, part of a separated family, move into an apartment in a new neighbourhood which then solicits and transforms them, finally bonding Saga to an uncanny vampire kid 'sister', with Beckert – a stranger who has claimed Annika for himself and introduced Maria into the family circle – acting finally as a kind of surrogate father. At the beginning of *Let the Right One In*, a young girl, Eli and what seems like her father have just arrived outside a block of apartments in a dark, snow-covered satellite suburb of Stockholm called Blackeberg: more strangers, who do things differently. Their arrival is secretly watched by a pale, blond boy, Oskar (Kare Hedebrant), who stands at the window of his apartment. *Let the Right One In* is an adaptation of the novel of the same name by John Ajvide Lindqvist, who also wrote the film's screenplay. Lindqvist grew up in Blackeberg and his novel introduces the Swedish suburb in the following way:

> When this story begins, Blackeberg the suburb had been in existence for thirty years. One can imagine that it had fostered a pioneer spirit. The *Mayflower*, an unknown land. Yes. One can imagine all those empty buildings waiting for their occupants … . Where the three-storeyed apartment buildings now stood there had been only forest before.
>
> You were beyond the grasp of the mysteries of the past; there wasn't even a church. Nine thousand inhabitants and no church.
>
> That tells you something about the modernity of the place, its rationality.
>
> It tells you something of how free they were from the ghosts of history and of terror.
>
> It explains in part how unprepared they were.[24]

This description is pretty close to Anders Banke's account of Sweden as 'one of the more secular … places in the world'. It is worth contrasting the passage to the one quoted above from *Twilight of the Gods*: whereas the landscape in the latter is both occulted and historical (and desecrated), the world of *Let the Right One In* is perpetually and optimistically tied to the realism of its present day. The arrival of the vampire, of course, conventionally brings a kind of occulted history into a modern neighbourhood, just as Beckert does in *Frostbitten*, and as Dracula had done in Stoker's novel and Coppola's film when he arrives

in London. Something similar happens in *Let the Right One In*, too, as Eli arrives in Blackeberg with her elderly guardian Hakan and moves into the apartment next door to Oskar and his mother – except that it is not always clear what kind of occulted history it is that she brings with her.

Bullied by a group of boys at school, Oskar plays alone in a bleak, snow-covered space outside his apartment block. Even his mother – separated, like Annika, from her husband – doesn't watch him. The neighbourhood in *Let the Right One In* is socially atomised and emptied of content. As far as neighbourhoods go, it is quite different in kind to – for example – the bustling, colourful and revealing space that picturesquely unfolds under James Stewart's character's watchful gaze in Hitchcock's exemplary 'neighbourhood watch' film, *Rear Window* (1954). In *Let the Right One In*, the 'modern neighbourhood ' is not panop-tic,[25] nor is it reassuringly familiar. The school provides the only sociality available to the town's younger inhabitants. There are no teenage parties in this film, only a displaced, tiny community of older men who drink together in a desolate café, the ironically titled 'Sun Palace'. 'Join us and have a laugh', they tell Hakan as he sits alone nearby; he refuses what little sociality there is on offer, and leaves. Outside, characters make their way through poorly lit streets; murders go unsolved; strange events in the forests nearby go unnoticed. But Eli notices Oskar, and as he plays below the apartment block she comes down to join him. *Let the Right One In* puts a boy and a vampire into proximity with each other, as if for a moment they are the same: from broken families, equally friendless, and so on. They even seem to be the same age. But Oskar is twelve and knows his exact time of birth, while Eli is twelve 'more or less', later telling him that 'I've been twelve for a long time.'

She may in fact be around 200 years old; interestingly, Leandersson's voice was over-dubbed in the film by an older voice actor, Elif Ceylan, to make it less childlike. New life is once again proximate to old life in this vampire film, which also asks Oskar to come to recognise Eli for what she is. But what is she? When she says, 'Oskar, I'm not a girl' and 'If I wasn't a girl, would you like me?' one might think she means she is really a vampire. But as John Calhoun notes, she may also mean she is literally not a girl. The novel is in fact much clearer about her human origins as a boy, but the film offers some support to this as well by providing a fleeting glimpse of 'a scar where presumably something else was', witnessed by Oskar as he looks into his mother's bedroom and watches Eli putting on his mother's dress.[26] For Calhoun, *Let the Right One In* is not so much a vampire film, as a film about troubled, creepy children that adults imagine to be 'possessed': this is the genre he privileges in his discussion, sliding Alfredson's film into bed with Henry James's novella, *The Turn of the Screw* (1898), and Jack Clayton's film adaptation, *The Innocents* (1961). But Oskar's recognition of Eli as a vampire is crucial to his self-development, and self-empowerment. In fact, when she returns unexpectedly at the end to kill the school bullies who torment him, she is also crucial to his survival. Eli is both remote from him – reflected as Oskar remains underwater in the swimming pool as she kills the bullies, able only to hear muffled sounds and see occasional body parts fall into the water around him – and intimate with him. But although she agrees to 'go steady' and slides naked into *his* bed, their relationship is not sexual. In a certain, precise sense, the relationship between Eli and Oskar might simply be described as neighbourly. The title of the film, *Let the Right One In* – with its ethical overtone – resonates throughout their various exchanges. When he realises that Eli is a vampire, Oskar goes to her apartment and knocks on the door. Later, he tells her, 'I want to go home now. If you'll let me.' Reversing this sequence, Eli then knocks on Oskar's front door. 'You have to invite me in', she tells him, effectively

Tomas Alfredson,
Let the Right One In
(2008): Oskar lets Eli in

anticipating the moment at which the genre literally crosses its own 'line of demarcation'. 'What happens if I don't?' Oskar asks, sceptically, perhaps still not quite recognising vampires for what they are. 'What happens if you walk in anyway? Is there something in the way?' Eli walks in and suddenly begins to shake uncontrollably, bleeding from the ears and eyes, from her nose and forehead. Overcome with sympathy for her ('You can come in!), Oskar takes her into his arms. When he asks her once again who she is, Eli replies: 'I'm like you …'. The scene brings them together through their neighbourliness, as if their apartments are now interchangeable and they can move freely between them – as if the genre, having crossed its line of demarcation, has become 'pure' all over again. 'Be me for a while … Oskar … be me', Eli tells him, and it seems as if the differences between boy, girl and vampire have, for a moment at least, evaporated.

But Oskar is never bitten: he never does actually become like Eli, a vampire. In contrast to so many other vampire films, *Let the Right One In* refuses to relish the transformation of new life into something ancient, something that can live (barely) in suspended animation, like Agamben's tick or, presumably, like Eli herself. Or perhaps it defers that transformation. The relationship between Eli and Oskar is sympathetic, but not empathetic; they are intimate with each other but they are differentiated and sometimes coldly remote from one another as well. Simmel says something similar about the stranger: 'A trace of strangeness easily enters … the most intimate of relationships.'[27] This 'trace of strangeness' inhabits Eli and Oskar's neighbourliness, shown through the way Oskar listens to the muffled noises from Eli's apartment through his bedroom wall, disturbed yet intrigued by them and not quite knowing what he is hearing – and his attempt to resolve this by teaching her to communicate with him through the walls by using Morse code. More disturbingly, their relationship is uncannily reflected through the role of Eli's older guardian, Hakan. John Calhoun wonders about this odd, unsettling couple, asking: 'What is their relationship, exactly?'[28] This couple who live next door and yet don't belong there (like Annika and Saga in *Frostbitten*, they have no furniture, etc.) seem also to share both the intimacy and the coldness already manifesting itself between Eli and Oskar. Hakan warns Eli to stay away from Oskar, as if he sees the young boy as a rival for Eli's affections, or, as if he sees himself as he once was. As Hakan becomes less and less able to supply Eli with human blood – his incompetent attempt to kill one of the locals, hang him upside down and drain his blood into a bottle turns into low farce as a curious poodle comes along – her attentions turn instead to the boy next door. Eli's bid for companionship is thus also predatory, a bid to secure her own survival. By the end of the film, Oskar has indeed taken Hakan's place, travelling on the train away from Blackeberg with Eli hiding inside a large crate

beside him – almost exactly like Maria in the box in the opening scenes of *Frostbitten*. For the moment, Oskar seems secure and confident, even dominant, communicating with Eli by tapping on the crate in Morse code as if she is still his neighbour, but clearly relishing the fact that he now has someone to look after and be close to. But if Oskar finally takes Hakan's place, his fate is also already apparent: to grow old, to fail, to cease to be loved, to have his identity literally effaced (as Hakan does when he pours acid over his face, fearing discovery by locals as another attempt to kill someone goes wrong), and to die unrecognised and unrecognisable. Eli visits Hakan as he lies alone in his hospital ward, entering through the outside window ('Can I come in?'), drinking his blood one last time and then casually pulling him out of the window so that he falls to his death. There is no peaceful deathbed scene here for Hakan: the vampire cycle of neighbourliness, companionship, intimacy and remoteness, neglect and death is condemned to be repeated over and over. Other relationships in the film mimic this one. One of the most touching scenes in the film therefore occurs when Oskar tearfully rejects his distraught mother, locking her out of his bedroom; earlier, the mother had in fact supplied Matt Reeves's 2010 American remake with its title, as she knocks on the apartment door and calls to Oskar, 'Let me in!' In *Let the Right One In*, a deserted mother is replaced by an orphaned vampire. As for Oskar's father, he has long since departed, his house in rural Sweden cohabited by another unidentified male companion ('We have a guest') whose presence – is his father gay? – effectively drives Oskar back to Blackeberg and his more accommodating vampire neighbour.

Let the Right One In was almost universally praised as a 'different' kind of vampire film, not least because of the preternatural aspects of the child actors Leandersson and Hedebrant. Their amateurism – it was the first time either had appeared in a film – seems only to add to the delicate intensity of their relationship. The stark, frozen landscape also enhances the chilling effect; so do what Anthony Quinn calls the various 'reaction shots', like that of the poodle noted above, or a group of cats when a recently bitten local woman enters a house, or schoolgirls when they discover a corpse at the edge of the forest.[29] The film is at times serene and beautiful, brutally violent, darkly comical, and strangely touching. By contrast, very few film reviewers had a good word to say about Reeves's *Let Me In* the following year, which relocates the Swedish setting of *Let the Right One In* to a snowbound Los Alamos in New Mexico. For Ryan Gilbey in the *New Statesman*, *Let Me In* is 'reconstituted cinema, a computer's idea of what made the original tick and click'.[30] For Terrence Rafferty in the *New York Times*, 'All remakes feed guiltily on the blood of their originals.' But whereas Gilbey is flatly dismissive (refusing even to acknowledge that the film has a director), Rafferty is much more curious about Reeves's project. He notes the *Cloverfield* (2008) director's 'willingness to explore his own confused, ambivalent relationship to a story that attracts him', and adds, sagely: 'No matter how old a story is ... all you can do is invite it into your own imagination and, for better or worse, try to live with it.'[31] Here, it is as if Reeves's relation to *Let the Right One In* is exactly like Oskar's relation to Eli: neighbourly, and vampiric. Reeves not only shifts the location of the remake to the United States, he also makes its historical moment more exact: March 1983. *Let the Right One In*'s passing reference to Leonid Brezhnev during a news broadcast, and its evocation of a modern, secular Sweden during the last decade of the Cold War, are answered in the opening scenes of *Let Me In* by an extended television citation of President Ronald Reagan's famous anti-Soviet speech delivered at exactly this time: a speech that noted the deep religious commitments of Americans and saw America as having always to deal

with, and overcome, 'the doctrine of sin'. Conscious of the racial divide in America, Reagan also invoked the Biblical commandment, 'Thou shalt love thy neighbour as thyself.' The national framework for *Let Me In* is therefore pretty much the opposite to that of Alfredson's film, overdetermined by an occulted history rather than floating free from it. The young boy – now called Owen (Kodi Smit-McPhee) – once again lives with his separated mother, but she is a devout Christian and a blurred, remote presence in their apartment. The film begins as Hakan's character from Alfredson's film – cast as 'the father' in *Let Me In* – is rushed to hospital, his face horribly burnt with acid. A police detective asks, 'Are you a Satanist?' Reagan's speech continues on television ('Our nation, too, has a legacy of evil with which it must deal …') as the detective talks on the phone and is told about a 'little girl'. A nurse's screams from the hospital ward send him running back, to find that the 'father' has fallen to his death onto the snow outside. A note beside the bed flaps in the breeze: 'I'm sorry, Abby.'

Like *Let the Right One In*, *Let Me In* activates some level of national sentiment – even, a national 'politics' – which frames the events that follow while at the same time being apparently irrelevant to them. The police detective is completely bewildered by his investigation; later on, he substitutes for one of the inquisitive locals in Alfredson's film as he breaks into Abby's apartment and is summarily bitten and killed by her, having no further part to play in the drama. Abby (Eli in *Let the Right One In*) is played by Chloë Grace Moretz, well known for her controversial role as Hit Girl in the brutal comic-action film, *Kick-Ass* (2010). Interestingly, her role as the child vampire in *Let Me In* once again sees her intimately and sentimentally tied to a father figure and capable of vicious brutality. Owen watches Abby and her 'father' arrive at his apartment block after he has been spying on his various neighbours through a telescope: which makes this film a little closer in kind than Alfredson's to Hitchcock's *Rear Window*, panoptically speaking. (Later, Owen even watches the police through his telescope, as they investigate the neighbourhood.) As Abby and Owen get to know each other, Reeves's film follows *Let the Right One In* in some respects, and departs from it in others. Shakespeare's *Romeo and Juliet* is cited several times over as a kind of parallel for Owen and Abby's underage relationship; after she undresses and slips into bed with him, their chaste night together concludes with a note she leaves in the morning that quotes from the play, 'I must be gone and live or stay and die.' The citations also work to stabilise the heterosexuality of their awkwardly tender affair; we shall see the play invoked again in one of the *Twilight* films. When Owen asks Abby to be his girlfriend, she replies: 'I'm not a girl … I'm nothing.' The suggestion in *Let*

the Right One In that this young vampire might once have been a boy is not made in Reeves's film. Like Oskar with Eli, Owen learns what happens to Abby if he refuses to 'invite her in' to his apartment; after he rescinds and she washes the blood from her body, she effectively replaces the mother he is so remote from ('you can borrow one of my mum's dresses, if you want'). Owen doesn't so much lock his mother out in this film as let Abby in − the film's title conveying the sense of an urgent imperative, rather than the need for ethical direction. *Let Me In* offers a more intensely registered relationship between Owen and Abby, but − as with Oskar and Eli − it also keeps them apart through their structural position as neighbours. Owen obsessively listens through the adjoining wall, hearing muffled noises, growls, the sounds of an argument. Teaching Abby Morse code, he tells her: 'we can talk to each other through the wall'. As in Alfredson's film, their neighbourly proximity makes them both intimate with, and distant from, each other. After Abby kills the police detective, she comes out − still wearing Owen's mother's dress − and embraces him. Soon afterwards, he watches tearfully as she leaves by taxi, as if it really is his mother who is now abandoning *him. Let Me In* − just like *Let the Right One In* − plays with the fragile distinction between intimacy and remoteness, in the framework of children in broken, dysfunctional families. Abby's 'father' is unable to provide for her; she has no mother. Owen's father (in contrast to Eli's father in *Let the Right One In*) is never seen; he is just a voice on the telephone who can't reply when Owen tells him he loves him. Effectively without parents, the children become their own mother and father: Abby in the mother's dress, and Owen replacing the dead 'father' when he leaves town with Abby at the end, already planning how to provide for her future (he sings, 'eat some now, save some for later').

Nina Auerbach's important study of vampire stories and films, *Our Vampires, Ourselves* (1995), ends with a critical analysis of American vampire films during the Reagan years. She focuses in particular on Kathryn Bigelow's *Near Dark* (1987), seeing this film as completely fissured by Reaganite ideology, a total product of its political climate:

> *Near Dark* is the best vampire film to come out of the Reaganesque years ... because, like *Dracula*, it tries so strenuously to submerge its vampires in paternalistic morality that it makes us cry out for something new'.[32]

Reeves's *Let Me In* returns to the Reagan years to completely undo this sort of 'paternalistic morality', emptying it of content. It offers instead a vision of the vampire as an unsettling sort of companion, empowering and draining simultaneously. Auerbach has this to say about the notion of the vampire-as-companion and the sense of being bonded to it in some intimate, peculiar way:

> as a species vampires have been our companions for so long that it is hard to imagine living without them. They promise escape from our dull lives and the pressure of our times, but they matter because when properly understood, they make us see that our lives are implicated in theirs and our times are inescapable.[33]

This may be true enough; but it is just as hard to imagine living *with* vampires, which is precisely the point made in *Let Me In*, and *Let the Right One In*. Perhaps neighbourliness is about the best that can happen here. But can neighbours be lived with, or even loved? In *Civilization and Its Discontents* (1930), Sigmund Freud certainly didn't think so. Rejecting

the Christian imperative to 'love thy neighbour' belatedly invoked in Ronald Reagan's 1983 speech, he suggests something utterly different: 'Not merely is this stranger in general unworthy of my love; I must honestly confess that he has more claim to my hostility and even my hatred.'[34] Emphasising human aggression and instinct over 'gentleness', Freud goes on pretty much to capture the kind of toxic relationship that exists between Owen and the boys who bully him at school in *Let Me In*, which Abby recognises and incites ('You have to hit back hard … . Hit them harder than you dare!'):

> men are not gentle creatures who want to be loved, and who at the most can defend them-
> selves if they are attacked; they are, on the contrary, creatures among whose instinctual
> endowments is to be reckoned a powerful share of aggressiveness. As a result, their neigh-
> bour is for them not only a potential helper or sexual object, but also someone who tempts
> them to satisfy their aggressiveness on him, to exploit his capacity for work without compen-
> sation, to use him sexually without his consent, to seize his possessions, to humiliate him, to
> cause him pain, to torture and to kill him. *Homo homini lupus* [Man is a wolf to man].[35]

Some vampire films – and we shall see examples of them in later chapters – do indeed reduce their vampires down to ciphers of pure aggression, pure instinct: bad neighbours, neighbours as wolves. But *Let the Right One In* and *Let Me In* are quite different to these Manichaean vampire films. Of course, Abby and Eli are wolfish too as they climb a tree, growling as Maria had growled in *Frostbitten*, waiting in the same way for someone in the neighbourhood to walk past, as prey to be feasted upon. But these films put the capacity for pure instinct into proximity with neighbourliness, with the sheer, realistic fact of living next door to someone else: to the extent that the imperative to 'love thy neighbour', in all its ambivalence, can for a moment cancel out even a child's love for his mother.

'The Vampire Next Door' is the subtitle of Jules Zanger's essay 'Metaphor into Metonymy' (1997), which had complained that the modern vampire has lost its earlier, 'metaphysical' and 'religious' features to become, 'in our concerned awareness for multi-culturalism, merely ethnic, a victim of heredity, like being Sicilian or Jewish.'[36] 'This new, demystified vampire', he writes, 'might as well be our next door neighbour, as Dracula, by origin, appearance, caste, and speech, could never pretend to be.'[37] As far as Stoker's novel is concerned, it is worth noting that Dracula, as he migrates to London and buys property there, had also wanted to be neighbourly: to blend in, to go through the streets unrecognised. But for Zanger, the modern vampire has lost its 'otherness'. It circulates out-side of the Judeo-Christian tradition, a 'diminished' secular creature that is now 'socialized and humanized',[38] although no less single-minded and ravenous: something that would seem to have no place at all in Reagan's occulted America, although it may be perfectly at home in Banke's Sweden. In *Let the Right One In* and in Reeves's remake, there is no doubt that the vampire is in some respects an 'ordinary', secular monster. But if the vam-pire really does live next door, then its otherness is perhaps more unsettling than it ever was. In the field of 'political theology', there has been much recent interest in the figure of the neighbour, and in the Judeo-Christian imperative to love that figure unconditionally. The Slovenian Lacanian and cinema critic Slavoj Zizek naturally (for those familiar with the various inversions, ironies, contradictions, etc. that pepper his work) turns the literalness of this imperative on its head, invoking the Danish philosopher Søren Kierkegaard. 'Kierkegaard', he writes, 'develops the claim that … the only good neighbour is a dead neighbour.'[39] This is because, in order to be perfect, the object of one's love must be

deprived of all distinctions, any hint of 'annoying excess' that might make the act of love self-conscious: the 'annoying excess' of ethnicity, for example, as if every neighbour must somehow be the same in order to be treated in the same way: undistinguished and undistinguishable. One must therefore be, in a certain, precise sense, indifferent to the neighbour in order to love the neighbour, remote and intimate simultaneously. For Zizek, loving the neighbour in this 'non-pathological' way thus leads both to purity and promiscuity, since these are merely different sides of the same coin: both types of love wipe out the 'idiosyncrasies' of the love object. Whether Eli is undistinguished or undistinguishable in *Let the Right One In* is, however, probably open to debate. She might, for example, have a trace of the 'annoying excess' of ethnicity about her (with her black hair, and her recent arrival in the suburb, suggesting an identity as an 'immigrant', etc.), which would mean, in the local, Swedish framework of the film, that she could very well stand out, rather than blend in: like a stranger. But *Let the Right One In* mobilises this merely as a possibility, while saying nothing more about it. People in this Swedish suburb *do* seem 'indifferent' to her, barely registering her presence; which makes her relationship to Oskar all the more unique even as it remains typical (of the neighbour).

To focus just on this film for a moment: in this context, is Eli's love for Oskar – and Oskar's love for Eli – pathological or non-pathological? Is it pure and unconditional? Or – from Eli's perspective in particular – is it merely instrumental, one event in a promiscuous and arbitrary chain of events that sees Oskar functioning simply as a replacement for the now useless and casually disposed-of Hakan? Of course, Eli is not exactly a 'dead neighbour': she is *undead*. For the idiosyncratic kind of Judeo-Christian political theology developed over the last few years by Zizek as well as the American critic Eric Santner, undeadness is a condition defined by lack, a form of psychic paralysis: death-in-life.[40] Their messianic vitalism, producing a series of links that put Walter Benjamin, Kafka, Sebald and others into genealogical (generic) proximity with St Paul and revelatory Christianity, sees undeadness as a kind of 'petrified unrest': which Santner, interestingly, has also characterised as 'creaturely life'.[41] But 'undeadness' is also unstable. It can be 'reanimated', brought into life all over again through its unexpected encounters with otherness. Like Zizek, Santner's psychoanalytical version of political theology regards the encounter with otherness as both self-enlivening and self-alienating, a form of excess or '*ex-citation*'.[42] This last word is important to hang on to when we look at vampires, and I shall return to it again in the following chapter and elsewhere in this book. It links the encounter with otherness to the practice of citation itself, in so far as the citation/encounter occupies (or preoccupies) the self and at the same time takes it somewhere else altogether. The word *citation* comes from the Latin *citare*, which means: to set in motion, to move. To cite is already to excite, to be in some way aroused or animated. Citation is a self-transforming process, as scholars know when they read other people's work and allow it to imprint itself upon them, falling under its spell, its influence: so that, when one cites another's work, one quite literally becomes someone else. It also carries another set of meanings, again noted by Santner: to summon (before a court of law), to call out, to produce 'a form of address or interpellation'.[43] In *Let the Right One In*, it is hard to know whether Oskar summons Eli, or Eli summons Oskar: they *let each other in* to their respective apartments, touching each other, moving away, touching again: sliding into bed, slipping out, returning as if by 'instinct' when needed. The vampire in this film, and in Reeves's remake, thus both cites and excites. We might say that this vampire is citational by nature: summoning and being summoned, setting things into motion, occupying and preoccupying, transforming, arousing,

moving on, arriving somewhere else altogether (Abby evasively tells Owen, when he wonders why she came to Los Alamos: 'We move around a lot'). The kind of encounter with otherness that Santner talks about in the framework of political theology therefore also produces a crisis of legitimation for those involved. For someone who only mentions vampires once or twice in passing, Santner in fact gets pretty close to capturing a key generic feature of the vampire film, one that – contrary to Zanger – brings a certain kind of 'metaphysical' monstrosity right back into the picture. It all depends on one's receptiveness to the proximity of otherness, it seems. 'What I am calling "undeadness"', Santner writes, 'is thus correlative to the encounter – above all in the life of the child – with the Other's desire and the seemingly endless drama of legitimation it inaugurates.'[44] From one point of view, *Let the Right One In* and *Let Me In* are precisely a rehearsal of this kind of drama, turning as they do on the question of who a child decides to open his or her front door to, and what is risked when whatever it is that enters (human or vampire, or stranger) is allowed to cross that 'line of demarcation' and come inside.

Night Watch and *Day Watch*

Timur Bekmambetov's *Night Watch* (2004) and *Day Watch* (2006) are two vampire films from a projected trilogy that – at the time of writing this book, at least – remains incomplete: there is still no *Twilight Watch*. The two films are adapted from the prolific Russian writer Sergei Lukyanenko's novel, *Night Watch* (1998), the first of a bestselling tetralogy of elaborate works of fantasy that was followed with (to give the English titles) *Day Watch* (2000), *Twilight Watch* (2003) and *Final Watch* (2006) – which makes the films themselves slightly out of synch with the way the novels are sequenced. Kazakhstan-born Bekmambetov's film-making experience had come primarily from commercials and pop-music videos, as well as a television miniseries, *Our 90s* (1999). But he had also directed a grim, politically inflected early film shot in Kazakhstan, *Peshawar Waltz* (1993), about Soviet troops held prisoner in Afghanistan – later re-edited, dubbed (poorly) and distributed by Roger Corman under the title, *Escape from Afghanistan* (2002) – as well as *The Arena* (2001), a lurid narrative about female Amazon slaves forced to be gladiators in Rome, which Corman co-produced. *Night Watch* and *Day Watch* were remarkable box-office successes. Costing only US$4 million and US$5 million respectively, the films did better than Peter Jackson's *The Lord of the Rings* trilogy (2001–3) in Russia; they also quickly secured international distribution. *Night Watch* earned around US$34 million worldwide; *Day Watch* made over US$20 million in the first nine days of its local release,[45] and went on to earn over US$38 million worldwide. Bekmambetov has credited Corman, as well as Ridley Scott, James Cameron and Quentin Tarantino as influences, tying himself to Hollywood blockbuster films but also to grittier kinds of action cinema. Russian cinema appears to hold little interest for him; he is cast instead as a Russian film director who can out-Hollywood Hollywood itself. For John Lyttle in the *Economist*, Bekmambetov's success came from his 'commercial savvy', from conspicuous product placements in the films (Aeroflot protested against the use of its logo in the international release of *Night Watch* because of the implied instability of the passenger aircraft), a tie-in with Lukyanenko's novel, and 'an organized marketing campaign' with Russian co-financer Channel One.[46] For Bekmambetov, film-making is a matter of being contemporary, international in orientation, even postmodern. But at the same time there is still something

identifiably 'Russian' in these vampire films. In an interview, he captures this sense of folding Russia into a global cinematic network, which also means representing Russia to the world at one level while disavowing the burden of local representation in another:

> I don't have any ambitions to represent this country, I represent myself. Russian directors like Eisenstein and Tarkovsky are the same to me as James Cameron and Roman Polanski – I feel their influence because it's in my background. But what I feel now is that the world has to understand Russia, somehow, and my films offer a very interesting way for them to understand Russia … . And if folks will help us distribute this film around the world, I think a lot of young people will like the look of Russia. They'll think it's cool. It's the place.[47]

How 'cool' Russia – or Moscow – is in these two vampire films is probably an open question, especially for viewers from some other place altogether. Nevertheless, *Night Watch* and *Day Watch* do indeed attempt to create something identifiably local, folding the everyday life of Muscovites into a visually striking set of fantasy events that involve an eternal struggle between the forces of light (the 'nightwatch') and the forces of darkness (the 'daywatch'), both of which play out a kind of *détente* as they try to preserve the peace. An otherwise dismissive review in the *New Yorker* tries at least to anchor these films in a recognisable Russian narrative tradition, their spectacularity as blockbusters invoking at the same time 'a blanket of shabbiness and shadow beneath which the characters … measure out their lives in avenues and apartments not so far from the battered world of Gogol'.[48] The atmosphere of the films is a sort of cluttered shabby chic, continually fissured by fast cutting between scenes that lurch from one place to another, sometimes indiscriminately. In *Night Watch*'s opening historical scene, a panoramic CGI medieval battle on a bridge comes to a halt and suddenly cuts to Moscow in 1992 – significantly, the beginning of Russia's post-Soviet independence – through a close-up of a finger on a doorbell, a fly buzzing nearby, and a strobe-lit tracking shot that follows the noise of the doorbell through the wall along the connecting wire, as the nightwatch protagonist, Anton Gorodetsky (Konstantin Khabenskiy), stands outside the apartment door of an elderly, dishevelled witch. The apartment itself is full of bric-a-brac, water boiling on the stove, tins of food, a flesh-coloured doll on a sideboard (that later grows spider-like legs), the television on, coloured pictures pasted randomly over the wall – including the sixteenth-century Italian painter Giuseppe Arcimboldo's *Vertumnus*, an iconic fruit-and-vegetable portrait of the shape-changing Roman god. Clutter, speed and shape-changing typify the *mise en scène* of these films: a congested underground train, crowds on the street, offices full of busy employees, apartments loaded with stuff, butchers' warehouses full of meat. This is very different indeed to the emptied-out apartment blocks and dimly lit, vacant streets of *Let the Right One In*, although all these films share an investment in the ordinary grubbiness of suburban life. As the witch's spell takes effect on Anton, the space around him is more cluttered still as he sees for the first time as a vampire (more or less) and finds himself staring into the Gloom, a fantasy space that exists as a kind of permanent neighbour to modern Muscovite reality. Flies and mosquitoes buzz around; liquids spill out of bottles; characters appear out of nowhere. In *Day Watch*, the Gloom is like a fast-motion streetscape at rush hour, littered with rubbish and debris; when Anton and his nightwatch colleague Sveta (Mariya Poroshina) are ejected from it, they find themselves in the middle of a highway with speeding cars all around them, as if fantasy and reality are not really all that different from one another.

Reviewers have responded in different ways to the shabby-chic chaos of Bekmambetov's two films: relishing their difference from slicker Hollywood blockbusters, but finding themselves bewildered by the frenetic pace and the confusing nature of their narratives, and so on. The red, animated subtitles to the international releases have drawn particular interest, as active participants in the filmscape rather than mere superimposed, static translations.[49] A number of scenes are there simply to trace elaborate, idiosyncratic connections between fantasy occurrences and everyday life: such as the moment in *Night Watch* when a crow flies into a passenger aeroplane's engine and a bolt comes loose, its trajectory tracked as it plummets through the night sky and is squeezed through a vent in the roof of a block of apartments, continuing to fall through the building's airshaft and pausing outside the vent that looks into Sveta's apartment — where it bounces through the grille and promptly splashes into the cup of coffee she is stirring. *Night Watch* and *Day Watch* are generally seen as fascinating in some ways, incoherent in others: touching, comical, Gothic, kitchen-sink, 'cheesy', preposterous, a kind of elaborate, inscrutable and incomplete folly. Some reviewers have therefore naturally wanted to stabilise events by reading the films as national allegories, triggered by the citation of 'Moscow 1992' at the beginning of *Night Watch*, when Anton's son Yegor (Dmitriy Martynov) is born — and again at the end of *Day Watch*, when Anton undoes the witch's spell and effectively erases everything that has transpired across the two films (so that 'the end begins', to recall Derrida's phrase, at the beginning). James Hoberman in the *Village Voice* perceptively notes that the Manichaean struggle between the nightwatch and the daywatch is more or less a reflection of Soviet and post-Soviet differences, apparent even at the level of casting: for example, the ageing head of the Moscow division of the nightwatch, Geser, is played by Soviet-born Vladimir Menshov, director of several Soviet-era films including *Moscow Does Not Believe in Tears* (1979).[50] The nightwatch occupy various sections at the City Light Company (the 'Analytical Department', etc.), going about their community-minded business in an old-fashioned, bureaucratic way, their earnest workers wearing overalls and driving old yellow trucks: all of which no doubt signifies pre-1992 Soviet life. In fact, the struggle between the nightwatch and the daywatch is primarily a bureaucratic one, built around licences to operate and regulations that no one is supposed to transgress. The daywatch people, by contrast, are more Westernised, colourful, vulgar: like Alisa/Alice, a young, glamorous post-punk vampire who is introduced in *Night Watch* as a singer at a pop concert, played by Zhanna Friske, the well-known singer of the all-girl Russian pop group, Blestyashchie ('The Shining Ones'). Later, Alice drives her fast red sports car across the front of Moscow's famous Cosmos Hotel, built in 1980 for the Moscow Olympics — which is where the videogame-loving leader of the daywatch, Zavulon (Viktor Verzhibitskiy), occupies a series of opulent offices. Towards the end of *Day Watch*, Zavulon holds a birthday party for Anton's son Yegor in a huge ballroom at the Cosmos, the hotel coming to signify both a newer kind of post-Soviet extravagance (the party is populated by actual Russian celebrities, as well as paparazzi) and the 'cosmological' ambitions of the fantasy world of the film. The contrast between the quaint, older Soviet world of the nightwatch and the newer, hard-edge post-Soviet world of the daywatch is beautifully rendered as one of the small yellow trucks races towards the hotel and struggles to keep going alongside a huge black juggernaut that is trying to push it off the road. Eventually, the yellow truck drives right through the juggernaut and comes out the other side, its engine exposed but still cranking over.

The contemporary narrative of *Night Watch* begins with Anton's 1992 encounter with a witch, when he opens the door of her apartment and literally crosses a 'line of demarcation'

as he steps inside. He has a domestic problem: his wife has left him for another man, she is pregnant and he wants her back. For this to happen, the witch advises, the unborn child – she tells Anton it isn't his – must be killed. Perhaps rather casually, Anton agrees to take the sin of killing an 'innocent' upon himself, and the witch begins to cast the spell, mixing a few drops of Anton's blood with some vodka and lemonade in a glass (the flow of blood into other liquids is a repeated motif in these, and other, vampire films). But the nightwatch workers, who have been waiting beside their yellow truck outside the building, rush into the apartment and prevent both the spell and the miscarriage from happening. As they arrest and process the witch, filling out their forms ('Article 13, Paragraph B') while she sits beside them, they realise that Anton, who can see them, is an Other: a kind of vampire, although he drinks only animal blood and has difficulty keeping it down. This is a film about a father who chooses to kill a son that turns out to be his. As he crosses this particular 'line of demarcation', he, too, becomes monstrous. *Night Watch* then moves twelve years into the future, when the boy, Yegor, is exactly the same age as Oskar in *Let the Right One In*. Yegor also has a choice to make, about whether or not he joins his father's nightwatch. In the meantime, Anton has been trying to protect his son from a young vampire woman who has been ordered to draw Yegor over to the daywatch. In the closing scenes of this film, a struggle over Yegor – who is now a 'Chosen One', a kind of symbol of post-Soviet Russia's future – takes place on the roof of an apartment block, played out alongside the 'eternal' medieval battle between the forces of light and darkness. Yegor realises his father once wanted to kill him; losing his faith in what Nina Auerbach had called 'paternalistic morality', he chooses the forces of darkness and grimly binds himself to Zavulon and the daywatch.

Vlad Strukov's essay, 'The Forces of Kinship: Timur Bekmambetov's *Night Watch* Cinematic Trilogy' (2010), also reads Yegor as a symbol of Russia's 'post-Soviet generation', seeing Bekmambetov's two vampire films as narratives that represent 'the nation's future' through the troubled relationship between a father, Anton, and his son.[51] In fact, a number of intergenerational relationships are troubled in these films: for example, Sveta, under a curse that is self-imposed, thinks that she is responsible for the death of her mother. For Strukov, the combination of national allegory and domestic conflict encourages a psychoanalytic reading that puts a different slant on the choice Yegor makes about his future:

> To Egor [*sic*], the Day Watch constitutes the pleasure principle (ironically manifested in the realm of the everyday as a lavish lifestyle) … . Anton, and with him the Night Watch, opposes it with the reality principle that carries the burden of the imperatives of culture.[52]

From this perspective, Anton and the nightwatch – as characters that throw back to an earlier Soviet era – function a bit like the return of the repressed in modern Russia, its guilty conscience.

Strukov's reading is persuasive in some ways, but overwrought in others as he goes on to give literal Freudian meanings to pretty much everything that happens (a bone used lethally in *Day Watch* is 'a phallic symbol', etc.). Even so, the relationship between fathers and sons does seem to structure events in Bekmambetov's two films. The leaders of the nightwatch and the daywatch, Geser and Zavulon, themselves function as father substitutes, the latter luring Yegor away from Anton and triggering off his darker, destructive urges. Anton's fraught connection to his son is also mirrored through the relationship between a young daywatch vampire, Kostya (Aleksey Chadov), and his elderly father, a vampire who works as a local butcher (beautifully played by the venerated Russian actor,

Valeri Zolotukhin). Kostya is Anton's neighbour – he lives in the apartment across the hall – but in spite of their differences he is the first person Anton turns to for help in *Night Watch*. His father offers Anton some freshly killed pig's blood to drink: 'We like you very much', he reassures him. 'Our family … . Me and Kostya.' Later on, Anton brings a shape-shifting owl to his apartment, nervously turning his back as it changes into a woman, Olga (Galina Tyunina), who – having covered the room with her feathers – goes into the bath-room to cleanse herself. When she asks for some clothes to put on, Anton again goes to his neighbour for help – their front doors linked together, one inside the other, in a medium long shot, followed by a reverse angle shot from behind Kostya's shadowed head as he answers the doorbell. 'You got any women's clothes, by chance?' Anton asks him. This is, of course, another encounter with the vampire-as-neighbour. Getting no response, Anton goes back to his apartment and looks at the contents of his wardrobe. His own doorbell rings this time, and Kostya is standing outside with a suitcase full of his late mother's clothes: a gift from the vampire next door that Anton gives to Olga to put on after her bath. The exchange of clothes might recall – or anticipate – the scene in *Let the Right One In* when Eli puts on Oskar's mother's dress after she washes herself in Oskar's apartment. Wearing the clothes of a neighbour's deceased mother also helps to situate Olga – as a nightwatch colleague who helps Anton – in a Soviet-era moment ('Are these clothes in style?'). But the gift confuses the relationship between Anton and Kostya, as neighbours who are supposed to be on opposite sides of the good/evil divide. Afterwards, Anton invites Kostya into his apartment; Kostya refuses; Anton pulls him inside and they argue heatedly about a rogue vampire that Anton had killed earlier. When Kostya finally leaves, Anton tells Olga: 'He's my friend.' She dutifully reminds, and confuses, him, 'He's a vam-pire … . He's an enemy.'

Anton goes through a prolonged crisis of legitimation as both a nightwatch hunter and a father – a predicament triggered off by his various encounters with his son, and his neigh-bours. A scene in *Day Watch* where Anton momentarily thinks he is reconciled to his son is followed by a scene in which Kostya and his father laugh together in their apartment as Kostya does the laundry – removing his father's trousers to wash them. As they hang their wet clothes in the bathroom, the doorbell rings; it is Sveta, looking for their neighbour, Anton. Kostya is aggressive (a bad neighbour) and reveals himself as a vampire, red vapour flowing from his eyes. His father, tied to the rules and protocols of an older Soviet era, tries to restrain him, apologising for his son's outburst. Later on, Kostya tells his father, 'I just can't live like this. Scared to death of shadows. Fearing every phone call!' It is difficult to tell in these films whether vampires stand out or blend in; it can seem as if they have lived next door, unrecognised, for ages (or at least, since 1992). Harassed by the laws and conven-tions his father seems to live by, Kostya runs out of the building into the street, exhilarated; his father remains behind, alone, in the apartment. It turns out that Kostya's father had turned his son into a vampire: unleashing him at one level, and then trying to restrain him at another. *Night Watch* and *Day Watch* themselves follow the laws and conventions of the vampire film by putting someone young and someone old into close proximity with one another: rather like the scene (a citation) from *Buffy the Vampire Slayer* that Yegor watches on television in his mother's apartment as Anton approaches, excerpted from an episode in which Buffy meets Count Dracula.[53] The result is indeed catastrophic, transforming the fil-ial bond between father and son into irreconcilable estrangement.

These relationships recall the combination of intimacy and remoteness we had seen with Eli and Oskar in *Let the Right One In*: as if sons are neighbours to their fathers.

Timur Bekmambetov,
Night Watch (2004):
the forces of darkness
take over Moscow

Apartments are central sites of activity in Bekmambetov's films, which frame apartment blocks in atmospheric long shots (as crows circle overhead) and go all the way inside, along corridors, up staircases, into rooms, through vents and wires, down cracks and crevices. Doorbells buzz, doors open and close, vampires step inside, lines of demarcation are crossed. Towards the end of *Day Watch*, Anton makes his way to the Cosmos Hotel, kicking a door off its hinges and going into a dark room that — when the lights come on — turns out to be full of Zavulon's guests at a party celebrating Yegor's twelfth birthday. In a certain precise sense, Anton is *summoned* to the event: which also puts him on trial, just like a court of law. Kostya's father turns up soon afterwards, still without his trousers. The two fathers bond for a moment, and then Anton publicly denounces his neighbour as a murderer. It is as if Slavoj Zizek's Kierkegaardian imperative ('the only good neighbour is a dead neighbour') is literally to be played out here, as Kostya's father attacks Anton with a sharpened bone (Strukov's 'phallic symbol'), only to be restrained in turn by his son. Neighbours want to murder each other, and also save each other. Vampire sons are unleashed but restrain their vampire fathers. A further series of catastrophes follows that sees Kostya killed by Zavulon (a bad father) and Yegor (a bad son) unleashing his destructive powers on both the hotel, and the entire city of Moscow. Buildings collapse around Anton as he struggles with Yegor and Sveta. A sheet of glass falls from a crevice high above, the sharp end fast approaching Anton's head. Suddenly Geser appears, disguised as one of the paparazzi at the party, and illuminated from behind like an angel. He takes a photograph and, as the camera flashes, everything around Anton is immediately stilled. 'What a mess you've made', Geser says, speaking perhaps on behalf of the shabby-chic chaos of the films themselves, which have devolved into a dusty apocalypse of Russian rubble and ruin. Against the background still of the camera shot, Anton rushes out to what remains of the witch's apartment and uses the 'chalk of fate' to write 'HET' ('no') on her kitchen wall. The word erases everything that has occurred in *Night Watch* and *Day Watch*, returning Anton to a moment before the two films, and the mess he creates, actually begin. It is 1992 all over again, the beginning of the Yeltsin years. The leaders of the nightwatch and the daywatch, Geser and Zavulon, are sitting on a park bench and watch as Anton and Sveta walk past, wondering if they will recognise each other (which in fact they do, sort of). From one perspective, the ending of this dark, shambolic fantasy film couldn't be any neater or sunnier, with all its curses and horrors now laid to rest as if they had literally never happened. From another, however, its political commentary has already been made.

New Vampire Cinema

Timur Bekmambetov,
Day Watch (2006):
Anton writes on the wall

The forces of light and the forces of darkness can indeed seem like opposites, remote from each other; on the other hand, here they are at the start of the post-Soviet era sitting together like friendly fathers, or neighbours, still unable properly to distinguish between the laws, conventions and restraints they have put into place, and the things they have unleashed.

3

CITATIONAL VAMPIRES

Irma Vep
Vampire Hunter D: Blood Lust and
 Blood: The Last Vampire
Thirst

Irma Vep

One of the problems with viewing and analysing cinema from remote locations can be getting to what Meaghan Morris has called the 'local levels of language community and affective mobilization'.[1] Naturally, there is always a sense that cinema from other places – cinema that is no doubt best understood through its local frameworks of production and consumption, its local traditions, points of reference and so on – will always exceed the understanding of critics who remain geographically and culturally distanced from these things. This is exactly my own predicament in this chapter – more so, perhaps, than in others – as I come to read some fascinating vampire films from France, Japan and Korea. On the other hand, these films are also already transnational, designed among other things to *interrogate* one's assumptions about cultural and geographical distance, and difference. *Vampire Hunter D: Blood Lust* (2000) was globally distributed by the Los Angeles-based Urban Vision Entertainment Inc., and is credited as the first Japanese anime to be originally recorded in English, drawing on a cast of British and American actors that included the US comedian Michael McShane who plays 'Lefthand'. Like the other films under discussion here, it is both local and something else besides. To this end, it puts the local and the remote into proximity with each other, juxtaposing them but also drawing them close to the extent that they come to inhabit each other. In fact, the films under discussion here stage an encounter between these two otherwise distinct domains – which turns the remote viewer's experience of this into, effectively, an encounter with an encounter that has already taken place. An encounter with something remote is, of course, a key generic feature of vampire films. I have talked about this already as a mode of citation or *ex*-citation: a way of setting something in motion, of summoning something (or of being summoned *by* something), and of being taken out of one's self. This is why I have decided to begin this chapter with a discussion of Olivier Assayas's film, *Irma Vep* (1996). *Irma Vep* is not quite a vampire film; we might say that it puts itself *into proximity* with vampire films, that it cites them, summons them and draws them in (but also keeps them at bay). It does this by triggering off a sequence of other encounters between the local and the remote, all in the framework of thinking about the contemporary nature of cinema itself: both in terms of its 'local levels of language community and affective mobilization', and in terms of transnational circulation and distribution.

Irma Vep is a French film about the process of remaking a set of much earlier French films, Louis Feuillade's 1915–16 ten-part silent serial, *Les Vampires* – which had starred a French actress, Jeanne Roques, who performed under the name Musidora. *Les Vampires* introduces a criminal gang

in Paris that plans and carries out a series of elaborate robberies; Musidora plays an arch-villainess called Irma Vep (an anagram for 'vampire') who works for the gang and is, among other things, an expert impersonator, pretending at various points to be a maid, a bank clerk and a boy. As she goes about her robberies, she wears a tight, black silk costume and mask: 'more suited', as Vicki Callahan puts it, 'to her erotic adventures'.[2] Assayas's film takes its title from this character, but the cinephilic film director in this film who is trying to remake *Les Vampires*, René Vidal (Jean-Pierre Léaud), unexpectedly hires the Chinese Hong Kong actor Maggie Cheung to play this central role. 'No French actress can be Irma Vep after Musidora', he tells her. 'It's impossible. It's blasphemy.' For Vidal, *Les Vampires* can only be remade by taking it out of its localness, by generating a particular kind of citation that unties it from its French origins and gestures in this case (perhaps inexplicably) to East Asia. Even so, he insists on some likeness between the two actors, something ineffable that holds them together even though they are geographically and historically remote from one another. 'You are magic like her', he tells Maggie Cheung, 'and you are modern. I want a modern Irma Vep.'

Cheung (by which I mean: the character of 'Maggie Cheung' in the film *Irma Vep*) arrives at the film director's offices in Paris and immediately provokes a series of reactions: she literally ex-cites the French people she meets. It is worth noting that Assayas has himself played out a fascination with Cheung, making a short film about her – *Man Yuk: A Portrait of Maggie Cheung* (1997) – that watches her make herself up in preparation for a role; and in fact, he married her not long after *Irma Vep* was released, although the marriage only lasted three years. In an essay about her titled 'Regarding Maggie' (1997), included with the film notes for the Zeitgeist Video DVD release, he describes her in a way that interestingly adds to René Vidal's comments quoted above and at the same time expresses a characteristic often associated with the vampire: 'she carried in her', he writes, 'something of the magic of cinema itself … something at once very old and completely modern'.[3] We have seen exactly this kind of juxtaposition/enfolding before, in the vampire films discussed in previous chapters. It might seem as if French cinema and the kind of Hong Kong action cinema that Maggie Cheung has starred in are completely remote from each other; this is something the young, excited interviewer in *Irma Vep* insists on when he talks to Cheung and – enthralled by her newness – dismisses French cinema as 'old cinema', made redundant by the emergent transnational action films from East Asia. But an interesting article by Adrian Martin thinks about some of the historical overlaps between East Asian action cinema and French 'experimental cinema', also reminding us that Assayas's cinephilic fascination with Hong Kong and East Asian cinema was already apparent in his work as a critic for *Cahiers du cinéma* more than a decade earlier. Martin writes,

> I went back and read the special, groundbreaking *Cahiers du cinéma* issue from 1984 on Hong Kong – still an essential, indispensible reference – and followed along the various interview remarks, catalogue notes and occasional writings of several figures associated with that project, like critic-turned-film-maker Olivier Assayas.[4]

Here, the localness of French cinema (its 'local levels of language', etc.) is already coming undone; it can seem from this perspective as if Maggie Cheung's arrival in Paris and her own encounter with the remake of an old piece of French cinema is more a matter of proximity than remoteness, as if these things have somehow already inhabited her.

Vidal's project, to remake *Les Vampires* all over again, is also an elaborate act of re-citation, something that troubles some of the characters in *Irma Vep*. Zoe (Nathalie Richard), the costume designer, says: 'It's been done. Why do it again?' She says the same thing to Maggie Cheung in a conversation about the pernicious influence of American films on French cinema: 'Why do we do what's already been done?' Cheung is even more dismissive of sequels, copies and remakes, similarly distancing herself from the influence of popular Hollywood cinema: this is what a Hong Kong actor also has in common with French cinema. Even though the costume she wears and comes to enjoy when she plays the character of Irma Vep – made of black latex this time – draws its inspiration from Michelle Pfeiffer's Catwoman in Tim Burton's *Batman Returns* (1992), Cheung is flatly dismissive of the source: 'The first film was bad enough ...'. Vidal's remake of *Les Vampires* is more accommodating, however, more porous, less insistent on the need for local authenticity – inhabited, as it is, by a Hong Kong actor wearing a costume inspired by a Hollywood sequel.[5] But the project is also fragile, easily undone. Citation always carries the risk that one's self will be obliterated by the thing one is citing; the dark side of citation is that it brings with it a version of what W. J. T. Mitchell has called 'clonophobia', the 'irrational fear' (and yet at the same time, the irresistible desire) that accompanies the process of remaking oneself in the image of something else altogether.[6] As Vidal goes about the process of remaking *Les Vampires*, he finds himself in exactly this position; so does Maggie Cheung as she relishes her latex costume and 'becomes' Irma Vep/Musidora. The film returns a number of times to a scene from episode six of *Les Vampires*, titled 'Les Yeux qui Fascinent' ('the eyes that fascinate'; or, 'the hypnotic gaze'). This is a scene that Vidal tries to remake, reproducing it as faithfully as he can with a Hong Kong actor in the primary role. In the original, Musidora – as Irma Vep, the seductive villainess or vamp – is creeping stealthily through a hotel corridor when suddenly she is kidnapped by a rival criminal, Juan-José Moreno (Olivier Torres), who unmasks her and chloroforms her; later he will hypnotise her and get her to kill the 'Great Vampire', the leader of her gang, and he will push Irma Vep out of the hotel window (although this is not quite the end of her). Assayas's film returns to this scene again and again, citing it, remaking it, reanimating it. It is literally *re-vamped* through the casting of Maggie Cheung, as if her modern East Asian cinematic identity will somehow reach back in time and breathe new life into it. Vidal's attempts to remake the scene are filmed over and over, never quite able to get the perfection they want: with characters laughing, bickering and so on. When Vidal looks at the rushes he is dismayed. 'It sucks!' he shouts, making the standard joke about trashy vampire films. Later on, the young French actor who is playing Moreno rehearses the scene with Maggie Cheung, pretending to hypnotise and drug her – as a way of asserting his domination over her (he wants her to look 'scared'), but also as a way of becoming intimate with her, almost kissing her before the rehearsal is interrupted and comes to nothing. These moments of excitement come and go, a sequence of arousals and disappointments. The remake of the episode then descends into crisis when Vidal has a violent argument with his wife and mysteriously disappears.

A new film director takes over: interestingly named José Murano (Lou Castel). His name is itself a citation, recalling the criminal who kidnaps and hypnotises Irma Vep in episode six of *Les Vampires*. In Assayas's film, Murano is a down-on-his luck film director on welfare, a comical, ranting figure who refuses to remake himself, to modernise. He first task is to dismiss Maggie Cheung and to hire a French actor (Cheung's body double, Laure) to play Irma Vep. For Murano, Irma Vep's character invokes a particularly *local* set

of references or (to recall Morris's phrase) 'affective mobilizations': 'Irma Vep is Paris', he says. 'She's the Paris underworld. She's working-class Paris. She's Arletty [a French singer and actor who notoriously had an affair with a German officer during the occupation of Paris in the Second World War].' These various local citations turn Irma Vep into an allegorical figure, something Vidal had refused to do. They seal the project off from any remote, foreign influences and make it impossible for Maggie Cheung to play the part. 'She'll understand', Murano says, reaffirming the local distinctiveness – and the allegorical imperatives – of his kind of French cinema. 'She'll go back to Hong Kong.' In the event, Maggie has already left Paris. She doesn't return to Hong Kong at all but, according to another actor, heads further west to New York (to meet Ridley Scott) and then Los Angeles. In the meantime, episode six of *Les Vampires* – 'the eyes that fascinate' – is playing on Murano's television and a copy of the novelisation of this episode is open on Murano's lap. (Feuillade's series was novelised at the time by Georges Meirs, published in seven volumes by Tallandier in 1916.) The film director himself, however, is fast asleep: already bored, perhaps, by this early example of French cinema that he otherwise venerates.

Preoccupied (and occupied) by Feuillade's *Les Vampires*, *Irma Vep* is a film that brings together exactly the qualities that Assayas had seen in Maggie Cheung: 'something at once very old and completely modern'. It is the juxtaposition/enfolding together of these two things that, I've suggested, makes *Irma Vep* almost a vampire film. Naturally enough, the critical discussion about this film revolves around the casting of Maggie Cheung as a kind of revamped Irma Vep eighty years on. In her book *The Chinese Exotic* (2007), Olivia Khoo produces a compelling reading of Cheung's character as a copy that slips through and exceeds the cultural logics of its East Asian origins: turning Musidora's original Irma Vep into a 'modern diasporic femininity' that is itself performative, deflecting 'the Western gaze with a countering "vampiric" look' and yet also inviting 'a translation of old exotic tropes' as a Chinese Hong Kong woman in Paris.[7] This reading is, of course, consistent with Assayas's view of Maggie Cheung above, as both modern and 'very old'. In an article in the journal *Screen*, Dale Hudson draws a more straightforward contrast between the older French cinematic world of *Les Vampires* – as a point of origin for cinema itself – and the contemporary aspects of Assayas's *Irma Vep*, which is 'a film about addressing the present, specifically the place of France within the global economy'.[8] But the old and the new are never completely distinguished from one another in *Irma Vep*, which returns over and over to the scene in *Les Vampires* that it tries to revamp, without success. *Les Vampires* inhabits *Irma Vep* and claims its attention: it summons the newer film and as it does so, it produces a crisis of legitimation for it. *Irma Vep* always runs the risk of being too inhabited, too *pre*occupied by the thing it cites. For his part, René Vidal is not sure whether the remake repeats the original ('You must respect the silence') or changes it; in order to enable change to occur, he directs Maggie Cheung to 'be yourself'. But he also wants Cheung to perform, to masquerade in the latex costume Zoe helps to design for her. 'I have this idea of you', he tells her, 'in this part, in this costume … . I thought it was very exciting, you know … it's like a fantasy.' It often looks as if Maggie Cheung is non-committal about her role, as if it is 'like a game': 'you know', she tells Mireille (Bulle Ogier), 'it's like cartoon characters, fantasy'. Her two-dimensional view of what fantasy might be is quite different to Vidal's, although it can be hard to tell who gives fantasy the greater significance in the film. 'You think you are at the core of the scene', Vidal tells her, 'but in fact, you are just on the surface.' In the meantime, Cheung is increasingly drawn to her costume, excited by it. Zoe tells a friend, 'It's like she was poured into it … . It seemed to

Olivier Assayas,
Irma Vep (1996):
Maggie Cheung on the
rooftop, in the rain

turn her on In fact, she asked if she could buy it after the shoot.' The thought that Cheung is excited by her costume excites Zoe in turn. She tells Mireille that Cheung wants the costume, and that she's alone in Paris, 'She has no one.' Mireille replies: 'Analyse the situation. It's obvious. It means "I'm into it."'

There are two, radically different vampirish, or vampish, citations in *Irma Vep*: Feuillade's *Les Vampires*, and 'Maggie Cheung'. Both citations are revamped in the film with varying degrees of success; but both summon the film in turn, inhabiting it to such an extent that they produce a crisis of legitimation for it (e.g. the legitimation of 'French cinema' in a 'global economy', the legitimation of a remake and so on) as well as a crisis of representation. Mireille's reading of what Maggie Cheung's excitement about her costume might mean ('It means "I'm into it"') is only partially correct: Cheung is into her costume, but not into Zoe, abandoning her later on in the film outside a rave warehouse party in the Paris suburbs, preferring instead to wander Paris on her own. For Dale Hudson, Maggie Cheung finds it difficult to play the role of Irma Vep, as if she is somehow less authentic than the local/original Musidora:

> Maggie performs the role of Irma Vep with uncertainty. She has watched Musidora's perfor-
> mance of the character in a videotape copy of *Les Vampires*, but Maggie's performance does
> not include the silent-era gestures of Musidora's performance Whereas Musidora's move-
> ments are forceful, exaggerated by the faster film speed on the silent film stock ... Maggie's
> movements are hesitant and perplexed.[9]

But this reading could not be more wrong: Cheung's performance as Irma Vep in the film is in fact fluid, graceful, confident, mobile. After Vidal collapses, Cheung leaves through the window. Later, in the hotel, she is wearing the latex costume that Zoe has revamped for her: literally patching it up at one point after it is torn (from the old meaning of *revamp*, to repair). She follows a maid into one of the rooms, imitating the scene in episode six of *Les Vampires* except that the soundtrack is now post-punk ('You are never going any-where ...'). Hiding in the room after the maid leaves, she eavesdrops on the guest, a naked woman who is talking on the phone on her bed. This scene is just one or two removes from the stereotypical vampire seduction, where a vampire makes its way into a woman's

bedroom, etc. a scene made iconic in Murnau's *Nosferatu* and reproduced almost as a matter of generic fidelity in all sorts of vampire films, including many under discussion in this book. But in this case, as with Zoe, the possibility of (woman/woman) seduction is not allowed: the 'vampire' looks but doesn't touch, detached rather than desiring. Like Maggie Cheung, the woman in the bedroom is a visitor to Paris; but she is also the opposite to Cheung, naked (rather than masked and costumed), confined to her room (rather than moving unhindered through the hotel, and through Paris itself), watched rather than watching, and miserable rather than elated. 'I don't know a single soul and I've seen every fucking movie in town', she says to her boyfriend on the phone, 'and that includes a Steven Seagal movie. I'll never forgive you for this.' There is no excitement to be had in this room, we might say, no 'erotic adventure'; and no opportunity for citation, either, from a woman who is as bored by globalised Hollywood movies as the cinephilic Murano is by the scene in *Les Vampires* he falls asleep in front of. Perhaps as a reaction to this act of bad faith, Cheung, seeing a necklace on the dressing table, steals it and leaves the room, making her way onto the hotel rooftop. In the night rain, she seems exhilarated: moving freely and stealthily across the roof and finally dropping the necklace over the edge, letting it go: as if the excitement produced by her immersion in the role of Irma Vep has for a moment completely overtaken her, as an end in itself. Hudson is probably right to say that, in Assayas's film, Maggie Cheung is 'somehow extradiegetic, somehow beyond what the film's narrative can contain'[10] – although this kind of remark is routinely made about femme fatale figures in film noir and elsewhere. For Jonathan Rosenbaum, Cheung is simply there to excite those around her: 'as a rule', he says, 'she seems to exist independently of the forces that seem to plague everyone else'.[11] But does she stand out, or blend in? Characters in the film assume that she cannot speak French, but she can, and does. She is closer to Paris, and to French cinema, than we might at first think. As if to demonstrate this, her character is finally absorbed into the silent world of *Les Vampires* as if the old serial finally overtakes her, her body fissured and scratched in the black-and-white closing frames, her eyes covered with black circles and little squares. It is difficult to tell whether she is in the film, or out of it: a citation or an excitation, or both.

It can seem as if Feuillade's *Les Vampires* functions in *Irma Vep* only in order to excite: to trigger off desires, pleasures, disputes, disappearances. As with the citation

called 'Maggie Cheung', it only has meaning for those who cite it or are excited by it: like Zoe, or like the film director René Vidal, or Assayas himself. It is never actually clear why Vidal wants to remake *Les Vampires* or why Assayas builds an entire film around this process. What does it represent for Vidal, and for *Irma Vep* itself? Perhaps it has something to do with the apparatus of cinema, and the status and influence of local cinematic affiliations, since something of that influence is allowed to spread over the closing frames of *Irma Vep*. But the local frames of reference here are selective. *Irma Vep*'s fascination with *Les Vampires* is self-conscious; it allows it at the same time to distance itself from a more politically inflected cinematic tradition. At one point, the film interrupts a moment in which characters watch a scene from the post-'68 Medvedkin Groups' *Classe de lutte* (1969), showing this film's political manifesto ('Cinema is not magic. It's a technique and a science. A technique born of science and at the service of a will. The will of the workers to free themselves') and then unceremoniously cutting to a light-hearted dinner party. This example of French 'militant cinema' seems as remote from contemporary life in Paris as *Les Vampires* (or Maggie Cheung). As for Feuillade's serial, it seems only to have a phantasmal, citational relationship to Assayas's film. Perhaps *Les Vampires* is indeed remote from everyday life, although we've seen that for the more insistently local Murano it could not carry a greater representative weight: 'Irma Vep is Paris … . She is working-class Paris', and so on. Elizabeth Ezra has noted that, although it was shot between 1915 and 1916, *Les Vampires* 'makes no explicit mention of the war that was slaughtering millions'.[12] On the one hand, it can seem as if World War I is both nowhere and everywhere in this extended work of Parisian fantasy. 'The Great War's presence is in fact encrypted in Feuillade's serial', Ezra writes, 'which invites its own decoding in a series of clues offered to viewers.'[13] The sheer insubstantiality of *Les Vampires* testifies to a sense that it was made during the Great War, which both inhabits this serial and turns it into something phantasmagorical, magical. The various examples of masquerade and impersonation among the actors and characters in Irma Vep's 'vampire' gang are themselves citations of nothing less than the absent presence of the war itself, as Ezra suggests:

> If these vampires do not suck blood and have no use for fangs, coffins, graveyards, castles or even immortality, they do display a predilection for inhabiting other characters' bodies … . Between them, the various members of the vampire gang … impersonate some twenty different people, sometimes more than one at a time. In episode six Irma Vep herself is impersonated by a servant working for a couple of American thieves who are in turn impersonating other Americans. The rash of substitutions effected at the level of the diegesis thus mirrors the substitutions among the actors necessitated by the war.[14]

There is nothing of this kind of reading of the serial in *Irma Vep*, however, which cuts *Les Vampires* away from whatever encrypted historical referent it might have had and instead deploys it as an ex-citation, an encounter with something *purely* phantasmagorical. *Irma Vep* is about the effects of an encounter: it charts the way something historically remote (*Les Vampires*) and something geographically remote (Maggie Cheung) come to be defined primarily by the effects they have on those they are now proximate to. This is what the old revamped French serial has in common with the modern-but-ancient Chinese Hong Kong actor Maggie Cheung, and this is why *Irma Vep* is almost a vampire film, but not quite.

Vampire Hunter D: Blood Lust and Blood: The Last Vampire

Vampires have managed to populate contemporary Japanese anime (animation), especially through serials made for television that are often based on comics or graphic novels or 'light novels': *Hellsing* (2002), *Trinity Blood* (2005), *Black Blood Brothers* (2006), *Vampire Knight* (2008) and so on. Hiroyuki Kitakubo's *Blood: The Last Vampire* (2000) has itself spawned a made-for-television series, *Blood+* (2005–6), which ran for fifty episodes; it has also seen the tie-in production of videogames, manga, light novel adaptations, and a live action remake that I shall also discuss below. This section will look at *Blood: The Last Vampire* alongside another, equally striking anime vampire film, Yoshiaki Kawajiri's *Vampire Hunter D: Blood Lust* (2000). Although they were released during the same year, these films could not be more different. It is as if the end of the millennium sends them in opposite directions: back to Japan in the mid-1960s in one case, and into the 'distant future' in the other. It is commonplace now to think of post-World War II Japanese horror cinema as a series of stylised responses to Hiroshima and Nagasaki: the atomic bombing of Japanese cities and the prolonged aftermath of death, defeat, trauma and Allied occupation.[15] To think in this way means to consider (once again) what we mean by a national cinema, and in this case, how Japanese cinema – horror cinema, in this case – has articulated Japan's traumas and its 'occupied' predicament. This is what Adam Lowenstein does in his book, *Shocking Representation: Historical Trauma, National Cinema and the Modern Horror Film* (2005), which distinguishes between realist and 'allegorical' cinema through their respective capacity to represent nationally registered experiences. Lowenstein looks at some examples of national cinema tied to epic trauma-producing events: Japanese film and Hiroshima, for example, or American cinema and Vietnam. As he notes, 'allegorical' films – many horror films, in particular – are routinely criticised for turning to fantasy at the expense of engaging with real historical experience. His account of Kaneto Shindo's *Onibaba* (1964), an art-horror film set in fourteenth-century rural Japan, sees things differently: remote as its setting may be, the film allegorises the disjunctures and continuities of Japan's postwar predicament, engaging with 'official narratives of war responsibility', linking its 'images of solar eclipse' to the experience of 'atomic destruction' and so on.[16] Lowenstein is right to insist that representational imperatives of 'allegorical' cinema can work just as effectively, if not more so, as realist cinema. But he runs the risk of allegorising and localising pretty much every aspect of all the (horror) films he reads, as if they are condemned always to be understood as – to borrow Fredric Jameson's controversial description of 'third world literature' – a matter of national allegory.[17] I want to say something different in this book: namely, that vampire films can very well be read in terms of their national/historical/political frameworks, their 'local levels of language community' and so on (which I shall try to do), but that they are at the same time *systems of citation*. For example, a vampire film is at the same time also a kind of structural, generic encounter with other vampire films; it invokes them and animates them as a way of generating both recognition (at the level of character and narrative) and excitement. As it does so, however, its ties to the cultural logics of a national cinema, and to the specifics of place ('the local levels of language community', etc.), are loosened and become problematic.

They are not undone completely, however. Although they can get pretty close to it sometimes, I would not want to accuse vampire films of what Eric Santner has called 'narrative fetishism': where a film might 'expunge the traces of the trauma or loss that called that narrative into being in the first place', by displacing the site of trauma to some other place altogether.[18] For Santner, this is what fantasy does, although he means the unconscious or ideological condition, not the cinematic genre. But representation is always a matter of displacement, no matter what the genre: and as Lowenstein notes, displacement is itself quite capable of generating affect and meaning. *Vampire Hunter D: Blood Lust* could not be any more displaced, set in some distant future AD. It is even more remote from the present than *Onibaba*. Its world, however, is a devastated, post-nuclear one, where even the vampires – who once ruled the earth – are facing extinction, their numbers 'dwindling'. *Blood Lust* is a conventional Japanese horror anime in this respect, 'allegorising' Japan's atomic destruction. Outside of this, however, there are two striking and in some ways perplexing things about the film: the fact that it is about vampires at all, and its style. *Blood Lust* is 'paint and ink' animation, based on the opulent, ornate drawings of Yoshitaka Amano, a prolific and immensely successful Japanese illustrator who has also worked with Hideyuki Kikuchi on a series of Vampire Hunter D light novels. (*Blood Lust* is based on the third novel in the series, *Demon Deathchase*, first published in 1985.) Amano's heavily stylised fantasy characters, with their flowing hair and fabrics, draw their influences from the British book illustrator Arthur Rackham, and the art nouveau paintings and drawings of Gustav Klimt, Egon Schiele and Aubrey Beardsley (who had himself cultivated a 'Japanese' style). American superhero comic books have also been influential, with 'D' sometimes described as Japan's Batman – a comparison the anime encourages with its silhouette of D, his cloak flowing in the wind, in the foreground of a large full moon.[19] *Blood Lust* is a rather late-in-the-day sequel to *Vampire Hunter D* (1985), where Amano is credited as character designer. Although the narrative is relatively complex, this is a much more crudely drawn, lurid anime; even so, it similarly invests in its post-nuclear future-fantasy landscape by introducing D in the bright glare of what resembles an atomic explosion.

How 'allegorical' all this is, is another question. Amano has spent around twenty years drawing vampires in a kind of neo-Schielean style: but why vampires? In the earlier *Vampire Hunter D*, Count Magnus Lee takes his surname from Christopher Lee, well known as Count Dracula in British 'Hammer Horror' films from the 1960s and 1970s. The first novel in the original series, published in Japan in 1983, is in fact dedicated to 'Terence Fisher, Jimmy Sangster, Bernard Robinson, Christopher Lee, Peter Cushing, and the entire cast and crew of *Horror of Dracula* ('58)', as if the Hammer vampire films are its principal point of reference. In *Blood Lust*, however, the vampire is more obscurely named Meier Link. The anime opens with an image of ruins, and a cemetery; it crosses to a townscape that might very well be in feudal Europe, with crosses on every rooftop. A carriage drawn by red-eyed black horses speeds through the streets. Crosses wilt, water freezes over in the town fountains. Suddenly Link appears in the bedroom of a sleeping girl, Charlotte: a stereotypical vampire-film seduction scene, as I have already noted, which in this case also references (through the dying roses, etc.) Coppola's *Bram Stoker's Dracula*, except for the fact that Charlotte, unlike Lucy, is not sexually aroused. (Encounters in this anime are romantic, not sexual.) After the opening credits events shift to a sunlit space in and around a ruined building, in what now looks more like Mexico than Japan. Charlotte's brother and father – who sits outside in a chair – summon D to bring back their daughter, offering him

a huge amount of money. They also hire the Markus brothers, three strong men with various weapon skills. Much of *Blood Lust* then unfolds as a kind of anime spaghetti Western (or Eastern), referencing the *Sabata* (1969, 1971) and *Django* (1966) films and perhaps even Sam Peckinpah's *Bring Me the Head of Alfredo Garcia* (1974). The Marcus brothers' armoured train references any number of spaghetti Westerns, and the brothers themselves recall (for example) specialist fighters like James Coburn's switchblade character in John Sturges's *The Magnificent Seven* (1960), one of a number of killers hired by Mexican villagers; this film was of course itself a remake of Akira Kurosawa's *Seven Samurai* (1954), already demonstrating East–West cinematic influences and encounters. D himself is a slender, dark figure in a large hat who says very little, not entirely unlike *Sabata*'s black-suited lone gunman Lee van Cleef.

The East–West citations here are certainly entangled. In the 2001 DVD release's film extra about the making of *Blood Lust*, director Yoshiaki Kawajiri has said, 'I like Western movies very much': noting that the horse stable scene, where D purchases a cyborg horse from a local mechanic in a town with a sheriff, 'is a very typical scene in a Western movie'. On the other hand, audio postsupervisor Terri d'Ambrosio adds that the director gave them some 'old, traditional Japanese films' to help them 'get the sound of a samurai sword' when D is fighting: 'we would never have interpreted that on our own', she says. A Japanese anime film that seems utterly remote from Japan recovers something local and 'authentic' here through the careful selection of a particular sound effect. But the anime's citations mostly have little to do with Japan, even at an 'allegorical' level. The huge creatures that rise up out of the desert as D begins his journey to Meier Link's castle recall the sandworms in David Lynch's *Dune* (1984). D is a 'Dunpeal': the word owes something to 'dhampir', which comes from Southeastern European folklore and describes someone who, like D, is half-vampire, half-human. D's abbreviated name no doubt references Dracula, too, and his character is supposed to be the son of a 'Vampire King'. Link's castle is also inhabited by Carmilla, who takes her name from the Irish writer Sheridan Le Fanu's famous 1872 vampire story.

It is certainly worth wondering why *Blood Lust* builds its vision of a remote, post-Hiroshima/post-nuclear Japan around a series of vampiric characters and citations. D's journey takes him through the underground world of the Barbarois, where a creepy, wizened old man on a unicycle threatens him even as he is erotically mesmerised by D's

'beauty' and apparent youth. The anime invests heavily in the decadent opulence of its vampire world, effectively co-opting a European *fin-de-siècle* narrative/aesthetic of degeneration and world-weariness to 'allegorise' its postwar Japanese predicament, but also to distance or displace itself from it. When D at last finds Charlotte, she tells him she is in love with Link; when the vampire finally bites her, the moment is accompanied by rousing choral music. Link has built a spaceship to take them towards the stars and to 'freedom'. Defeated by their love, D and a young woman fighter who has accompanied the Marcus brothers, Leila, watch them leave in a melancholy scene that honours the passing of an ageing vampire in the way some Japanese films might honour the passing of traditional samurai. The film ends sentimentally, with the perpetually young D – much later on – bringing flowers to Leila's grave and finding himself in the company of her granddaughter ('You're not so bad after all'). Going completely against the grain of its striking visual extravagance – and its exhaustion and sheer sense of decadence and decay – this vampire anime ends with an unexpected gesture towards a hopeful future where children live without fear in a green, replenished, post-post-nuclear natural world.

Hiroyuki Kitakubo's *Blood: The Last Vampire* is a very different kind of anime: not 'paint and ink', but a combination of analogue animation and state-of-the-art digital technology, conveying a much smoother sense of camera movement than is usual with this medium by allowing many more frames per second. The detailed level of rendering is striking, built around character lines, background, shadows, subtleties of colour, movement and velocity. What is also striking is that, in *Blood*, the site of trauma is not Hiroshima, the conventional historical referent for postwar Japanese horror cinema; it is in fact Vietnam. Or rather, it is a kind of phantasmagorical Vietnam. This short film is set at a specifically identified historical moment in the near past, October–November 1966: close to Halloween in that year, during the early stages of the Vietnam War. It introduces Saya, apparently a teenage girl, who is employed to kill chiropterans – vampire-like demons – by US agents working for a secretive CIA-like organisation. Saya herself is the 'last vampire', an orphaned, solitary figure who is also difficult to manage: a bit like D, but much sulkier. It turns out that chiropterans are masquerading as humans and infiltrating the Yokota US airbase in the western Tokyo district. Yokota is an actual US airbase in Japan, originally built by the Imperial Japanese Army in 1940 but taken over by the US after the war, where it became an operational airfield, sending fighters and B-52 bombers out on raids during the Vietnam War. In *Blood*, there is a high school on the airbase for American teenagers, and Saya reluctantly agrees to go there undercover, putting on an unusually modest school uniform (given the fetish for these costumes in Japanese erotica) which then makes her stand out even more since the American students don't wear school uniforms at all.

Structurally, Saya's position in the American high school is similar to Maggie Cheung's position among the French film crew in Paris: she stands out as radically different in the midst of it all, both immersed in and remote from her surroundings ('Leave me alone', she tells a curious student). Her school uniform is a version of Maggie Cheung's latex suit, but much less arousing (and self-arousing). One difference is that Saya is not foreign but apparently local and indigenous, initially cast as an 'original' vampire from Japan – a bit like D in *Blood Lust*. When she goes into the American airbase's school, she literally plays out a citational role by setting things into motion, summoning the chiropterans, and producing a series of encounters that run the risk of obliterating her. The strange thing about these encounters, however, is that none of the American students – and none of the American soldiers on the airbase – actually sees them. The students are preparing for a

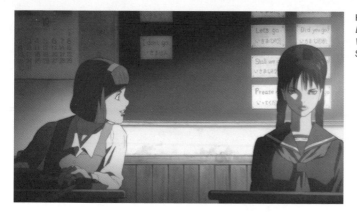

Hiroyuki Kitakubo, *Blood: The Last Vampire* (2000): Saya in the classroom

Halloween ball; some of them even dress up as vampires, citing Dracula and so on. In the meantime, two chiropterans are masquerading as schoolgirls, trying to blend in. Saya chases them into the hospital; they rise up in front of a nurse, the only other character in the film who comes to see the chiropterans for what they are; Saya kills one of them, breaking her sword, and chases the other through the Halloween ball which is now underway. The demon vampire mingles unseen with the costumed American students, and only Saya and the nurse seem able to notice its blood on the dancehall floor. The nurse is apparently the only other character on the US airbase to speak Japanese; on the other hand, Saya can speak English here just as Maggie Cheung could speak both English and French in Paris. One of the generic features of some vampire films is precisely to do with the vampire's capacity to adapt to the predicament of his or her destination; the question is often to do with whether a vampire stands out or blends in, and how easy it can be to slide from the one to the other. Just before she confronts the chiropterans (who blend in), Saya (who stands out but wants to blend in) in fact attends a class in English literature, sitting sullenly at the back on her own. A set of citations unfold on the blackboard as the English teacher concludes his lesson:

> The American horror film and the influence of German Expressionism 1930–1940
> Frankenstein – Mary Wollstonecraft (Goldwen) Shelly
> father William Shelly (famous writer)
> "grisaille" – painting in grey monotone
> w/o attention to precise details
> [These notes are followed by a list of characters in *Frankenstein*]

The blackboard fleetingly summons a series of reference points and releases them into the space of this animated vampire film. Invoking the American horror film 1930–40 and German Expressionism might only make sense in the space of the classroom itself, to American students who remain tied to Euro-American genres; certainly they don't seem to have much of a role to play in shaping this *Japanese* animation. Viewers who notice these various bits of text might pause at the line 'w/o attention to precise details' and congratulate themselves for doing the opposite: rather like Saya and the nurse who are the only characters to notice blood on the floor. They would also see that the Shelleys' names

New Vampire Cinema

Hiroyuki Kitakubo,
*Blood: The Last
Vampire* (2000):
the English teacher

are misspelt, as if the teacher himself isn't quite paying attention to the details of text he is citing. *Frankenstein* itself also doesn't have much of a role to play in this film: it is a citation that is not really activated, at least not in any specific, determining way: no one, the American students especially, seems excited by it. The most opaque citation on the blackboard is the note about 'grisaille', a French term used to describe painting mostly in grey monochromes. Although *Blood* is often heavily shaded, there are only two moments in the film that might properly be described as *grisaille*. The first occurs towards the end, when the nurse – who has lived through her own traumatic moment as she sees Saya fight with the chiropterans – is interviewed by one of the officials on the US airbase. By this time, Saya has disappeared. The nurse is unable to process the terrible events she has witnessed and wonders where Saya might have gone. No one recognises her description of Saya, and it seems as if she never existed. But then an official holds up an old photograph, in muted black and white: a picture of Saya, so it appears, in what looks like an old-fashioned European dress, standing in the midst of an old-fashioned European family: with the date '1892' and the word 'vampire' written across the top. It looks as if Saya might not be local and indigenous after all, tied instead to a deeper historical moment elsewhere that is more appropriate to Western, rather than Japanese, vampire narratives. The nurse – who speaks Japanese even to herself, but doesn't look Japanese – remains traumatised and perhaps also a little melancholy, mourning the loss of someone she thinks she sees once more, fleetingly, as she returns to the hospital. 'I never understood what I saw', she reflects, picking up a tiny cross,

> That girl Saya and the creatures she killed all remained a mystery … . Could she still be somewhere around the base? Is she still fighting those creatures? Just as we humans continue to kill each other. That beautiful, yet dangerous living thing.

Saya becomes phantasmagorical here, the trace of an image preserved in *grisaille* and written onto the blackboard through a citation. The film closes shortly afterwards, as an American B-52 bomber takes off, presumably for Vietnam. When the final credits begin, coloured blood-red, the film then gives us a second *grisaille* moment: actual, but blurred, images of American bombers and soldiers fighting in the Vietnam War, ending with shots of soldiers' faces and images of crosses on top of burial sites. These images also seem

phantasmagorical and, like Saya in the old photograph, they seem somehow connected to that brief, opaque note about *grisaille* on the English teacher's blackboard. There is no doubt a comparison to draw here with the closing silent, black-and-white scenes in *Irma Vep*. In their final moments, both films are written over, even obliterated, by images generated through their citations: where in the case of *Blood* what is remote (the Vietnam War) becomes suddenly proximate, to the extent that it is as if the animation itself, just like Saya, had never existed.

In an excellent essay on this Japanese vampire anime, Christopher Bolton argues for a clear distinction to be made between the finely drawn animation that foregrounds Saya's adventure and the 'photorealistic' rendering that occurs whenever the Yokota airbase's American bombers take off in the background. The animated characters remain 'two-dimensional' in this account – rather like Maggie Cheung's view of her role as Irma Vep ('It's like cartoon characters, fantasy') – while the American bombers 'are rendered as more photorealistic three-dimensional forms'.[20] As one part of this realism/fantasy distinction, the airbase therefore contrasts and competes with Saya and the chiropterans for recognition, in a modern Japan occupied here by both the United States and vampires. In Bolton's reading, the airbase signifies the far greater horror, while the animation itself is a bit like Santner's 'narrative fetishism', that is, a displacement of the scene of horror into some other fantasy space alongside it – or rather, flowing through it. Thus the American bombers, he writes,

> disrupt the film's fantasy by evoking the realities of Vietnam, realities that are in many ways more frightening than any ghost story. But at the same time, the planes have a ghostly quality of their own that makes them much more complex signifiers … the F-4 Phantoms and other planes are the film's true ghosts, spookier and scarier than the chiropterans; they haunt us with the return of an uncomfortable reality – not just an everyday reality we set aside when we enter the theater but political truths we have suppressed in our everyday lives.[21]

In this account, it is as if the anime puts itself up against its own limits as animation, putting everything that it is not into the background of its frames, and then bringing all this into the foreground during the final credits. The anime recognises the US airbase for 'what it is'; the airbase itself, on the other hand, doesn't seem to notice the chiropterans or Saya at all, until the official shows the faded photograph of her at the end. For Bolton, Saya therefore plays out an allegorical role that carries political significance in contemporary Japan, directly addressing Japan's post-World War II complicity with the United States as well as its very real, ongoing anxieties about US airbases on its soil.

> So while Saya's character has the elements of a sexual fantasy cobbled together from fetishistic images, she is more importantly a fantasy of national agency and identity … . Her physical power and presence represent the hope for a force that can cut through the perceived inaction and paralysis of Japanese politics … . There is an ironic, even tongue-in-cheek quality to the film's idea that Japan's saviour will take the form of a sword-wielding vampire schoolgirl in a sailor suit.[22]

There is, however, a kind of bottom-line national/political investment in Saya here – as 'Japan's saviour', etc. – that might recall José Murano's equally localised, allegorical

Chris Nahon, *Blood: The Last Vampire* (2009): Saya and her sword

reading of *Les Vampires*' Irma Vep in Assayas's film ('Irma Vep is Paris'). How much national allegory can an animated character carry? *Blood* is unusual among contemporary Japanese vampire films for the way it invokes a referent in contemporary Japan (the US airbase) and a destination that gestures to some other place to which it is nevertheless structurally tied (Vietnam). In doing so, it does indeed convey a political message about Japan's postwar occupation by the US. But as it unfolds its animated narrative about a vampire girl who plays out yet another stage in an eternal battle against chiropterans, it also runs the risk of turning the images it offers of the Vietnam War into an example of Santner's 'narrative fetishism', a displacement of the site of trauma into the anime's background or into the black-and-white coda at the end. Which has the most citational resonance in this film, Saya or Vietnam? In the framework of this anime film, these two phantasmagorical things barely notice each other. For Bolton, Saya's task is in fact to keep them apart, a task she performs when she stops one of the flying chiropterans from catching up to an American bomber just as it is about to take off:

> If the chiropterans represent an awakening Japanese militarism, the fear of renewed Japanese intervention abroad is figured as the threat that the monster will escape Japan's shores on America's back and reach out as far as Vietnam … . This is the catastrophe Saya averts … . She has succeeded in keeping the creature in her own two-dimensional world.[23]

It can seem here as if Saya's role is to protect not so much the US airbase as the anime itself: to make sure it isn't obliterated by the far greater horror of the war images it gestures towards. At the same time, the animated characters are made to represent particular national predicaments ('awakening Japanese militarism', 'Japan's saviour', and so on). In this reading, Saya is therefore both 'two-dimensional' and excessively real, perhaps even (to recall Hudson's account of Maggie Cheung in *Irma Vep*) 'extra-diegetic'. Bolton concludes his reading of *Blood: The Last Vampire* with some sense of this, responding to Saya as a character who literally ex-cites but who is also remote, opaque, phantasmagorical: 'the sexual and political fantasies that Saya represents', he writes,

> both remain unattainable. Anime bodies and beings can certainly provoke sexual desire in the viewer, but without even an actor or actress to stand in for the character in our fantasies, that desire for the anime body must be tinged with a particular hopelessness.[24]

In this interesting but perhaps idiosyncratic comment, a male viewer mourns over the impossibility of a 'two-dimensional' female character ever being able to carry the burdens of representation imposed upon her: as if she is a failed citation, ex-citing but unable to satisfy. Of course, this kind of complaint may have little to do with actual animation at all: Bolton's reading recalls René Vidal's comment to the equally unattainable Maggie Cheung in *Irma Vep*, 'You think you are at the core of the scene, but in fact, you are just on the surface.'

In the event − as if prompted by Bolton's complaint − *Blood: The Last Vampire* was remade as a live action film nine years later by the French director Chris Nahon, with actors and actresses standing in for the anime characters. Costing around US$30 million, this Hong Kong-British-French co-production was a box-office failure; but it has some interesting features, worth remarking on. Notably, it cast the South Korean actor Gianna Jun as the sullen, samurai sword-wielding Japanese vampire/slayer Saya − the first time this actor used her Westernized name in a film. The film shifts forward in time to 1970, towards the end of the Vietnam War, renaming its US airbase in Japan as Kanto (which is not the name of an actual airbase). It goes on to smooth over the issue of Japan's post-World War II US occupation by playing out a Japanese−US alliance that begins as Alice (Allison Miller), the daughter of an American officer, watches Saya kill two of the school-girl-impersonating chiropterans in the school gym (wonderfully choreographed to the soundtrack of Deep Purple's 'Space Truckin'', although this song was not released until 1972). Alice is given a privileged view of Saya and her various battles that, in the anima-tion, Americans were never able to witness. Later, Alice even saves Saya's life − offering some of her own blood to her − and then accompanies her on a journey to avenge the death of Saya's father, Kato (Yasuaki Kurata). 'It's our war now', Alice tells her, as they leave the US airbase behind and find themselves fighting together in a live action fantasy space − completely displaced from the rest of the film, and a long way away from the US airbase now − where Saya confronts and finally kills her own rogue mother, Onigen (Koyuki). The story here is now personal rather than political, gripping in some respects and a bit incomprehensible in others, with the fatal dispute between Saya's mother and father poorly accounted for. Afterwards, when Saya has disappeared without a trace, Alice is interrogated by US officials, just as the nurse was in the earlier animation. As before, the officials seem to have noticed Saya: 'We believe she's not even Japanese', one of them tells Alice, capturing the transnational nature of this live action remake accurately enough (it was also filmed in China and Argentina) but wiping out any sense of local reference in the process. Even though Gianna Jun's performance as Saya is generally much admired, almost no one has a good word to say about Nahon's film. The exercise seems pointless to many reviewers − Zoe's remark in *Irma Vep* comes to mind here, 'Why do we do what's already been done?' − but the remake also seems wilfully to distance itself from whatever capacity for political/national allegory it might have had. For Vadim Rizov in the journal *Sight and Sound*, 'The 1970s setting raises the prospect of a unique Vietnam allegory, one in which Americans are excoriated by "demons" in solidarity with the Vietcong, but … noth-ing much is made of it.'[25] Why a French-directed live action remake of a Japanese anime *should* allegorise the Vietnam War is, to be fair, probably not clear; and there never was any discernible 'solidarity' between the chiropterans and the Vietcong in the earlier anime. But Rizov's complaint is a version of remarks we have seen before, to do with the way fan-tasy films gesture towards national allegory ('Irma Vep is Paris', Saya is 'Japan's saviour', etc.) even as they dissolve those associations away. The transnationality of this live action

remake may even help this process along, allowing the film to cut its ties with identifiable Japanese predicaments, settings and iconography. As far as revampings go, casting Gianna Jun as Saya is not all that far away from casting Maggie Cheung as Irma Vep: where the local and the remote are distinguished from and made to inhabit each other simultaneously.

Thirst

In her book, *Korean Masculinities and Transcultural Consumption* (2010), Sun Jung discusses contemporary South Korean cinema and pop music and introduces the Korean concept of *mugukjeok*, which refers to 'how popular cultural flows enable the mixing of particular cultural elements (national, traditional, and specific) with globally popular cultural elements, which then causes those particular cultural elements to become less culturally specific'.[26] This kind of description – with its emphasis on flows, on mixing and dissolving – is not far away from what routinely happens in transnational vampire cinema, too, as it animates its various citations, radiates them across their surroundings as a set of transformative special effects, and in doing so, produces a 'crisis of legitimation' for the local and traditional ('local levels of language community', etc.) – perhaps even dissolving these things away altogether. Park Chan-Wook is one of several Korean new wave film directors who have made mainstream popular films: beginning in Park's case with *Joint Security Area* (*JSA*) (2000). For Nikki J. Y. Lee, his films 'manifest a cinephilic taste within a mainstream system', the products of a commercially oriented auteur tied to the 'Asia Extreme' brand who has helped to open up new, critically respected markets for Korean cinema across Europe and the US[27] – a contemporary East Asian equivalent to someone like Francis Ford Coppola, perhaps. *JSA* – the first Korean film to use Super-35 – had looked at military tensions along the border between North and South Korea. In another book about Korean film and masculinity, *The Remasculinization of Korean Cinema* (2004), Kim Kyung Hyun reads *JSA* as a national allegory through its representation of a 'severely traumatized' male protagonist who transgresses the North–South border and thus lives out a condition of 'shock and schizophrenia'.[28] Masculinity is important to Park's vampire film, *Thirst* (2009), too; on the other hand, it doesn't seem to have any local political referent and is much more difficult to read as a national allegory. Shot in Korea and Australia, it was also 'co-financed from the pre-production stage by a Hollywood major studio, Universal Pictures',[29] although its US$5 million budget was small indeed by American standards. *Thirst* begins in Africa, where a Korean priest, Sang-hyun (Song Kang-ho), is working at a remote Catholic mission. Park himself grew up as a Catholic in South Korea; Catholicism, an introduced religion, has a long history of persecution there, but around 10 per cent of Koreans are Catholic today and there are indeed a small number of Korean Catholic missionaries in Africa. So *Thirst* draws attention to a particular kind of cultural circulation: a religion introduced into Korea from the West that is then reactivated somewhere else. There is a biochemical laboratory some distance from the mission that has been investigating a lethal virus that seems mostly to be killing male Asian and Caucasian missionaries – but not Africans (as if the virus is wilfully transnational, drawn only to people who are not local or indigenous). Sang-hyun in the meantime has been talking to various patients in the hospital, the mission and elsewhere: recalling an obese boy who had talked selflessly about sharing his cake with starving children, talking to a nun who wants

to commit suicide. The question of suicide – of giving up on life – and the more life-affirming but equally sacrificial capacity to help and even save others in distress are themes that haunt this film. Disaffected by what he sees at the mission, Sang-hyun brings these two opposing positions together by offering himself up as a human test case for the virus's vaccine, which is injected into his body. As his skin begins to blister in the sun, he retreats to his room where, on his flute, he plays Bach's Cantata No. 82, *Ich habe genug* ('I have enough') – suggesting exactly this paradoxical combination of world-weariness and utter fulfilment. Blood suddenly flows through the openings of the flute and the music chokingly stops: this marks the spectacular beginning of Sang-hyun's transformation into a vampire. He dies and is reborn. Later on, he makes his way back to Korea where he is celebrated as a saint.

In an interview for *Sight and Sound*, Park has said,

> As far as I'm aware, there is no vampire folklore in Korea. It's only stories imported from the West that constitute the basis of this modern myth. That's why I wanted to turn *Thirst* into a story about imported culture and objects. In the film, Sang-hyun goes overseas and, by having a blood transfusion while he's there, returns as a vampire. He is … like a foreign object … . How will something that has made its way in from the outside be accepted? Will it be rejected or integrated?[30]

Thirst therefore presents a variation on the kind of character flow we have already seen in *Irma Vep* and *Blood: The Last Vampire* with Maggie Cheung in Paris and Saya at the US airbase. Sang-hyun is a Korean who is no longer Korean (he's now a vampire), who therefore returns to Korea as an 'imported … object', someone who stands out, rather than blends in. A solitary, orphaned figure – rather like Saya again – Sang-hyun is then adopted by a local family who knew him as a child: a dominant mother, Lady Ra (Kim Hae-sook), her spoilt, simple-minded son, Kang-woo (Shin Ha-kyun), and his demor- alised wife Tae-ju (Kim Ok-bin), another orphaned, adopted character. The film blends genres together as it turns to Sang-hyun and Tae-ju's illicit romance amidst the day-to- day drudgery of a domestic routine that is brightened only by regular kitchen table games of mahjong with a few friends, including a Philippine woman, Evelyn (Mercedes Cabral), who is also a devout Catholic. Sang-hyun beats himself as he listens to Kang- woo and Tae-ju make love in the neighbouring room; later, Tae-ju and Sang-hyun begin awkwardly to initiate sex together; gaining confidence, they soon flirt with each other in front of the family. It is now well known that this part of *Thirst*'s narrative is effectively a prolonged remake or revamp of Émile Zola's nineteenth-century novel, *Thérèse Raquin* (1867): as if, just like vampire folklore from Europe or like Catholicism, this French piece of literature has also been imported into Korea as a 'foreign object' to be 'rejected or integrated'. Tae-ju plays out the role of Thérèse, while Madame Raquin is cited through Lady Ra's abbreviated name. In Zola's novel, the family play dominoes with friends, not mahjong. The priestly vampire Sang-hyun is like Zola's Laurent, except that whereas Laurent is a man of excess (decadent, riotous, visiting prostitutes and so on) Sang-hyun tries to restrain his desires by, for example, drinking the blood he needs from the obese young man in the hospital who has fallen into a coma ('He loved helping the hungry'). Sang-hyun is appalled when he thinks that Tae-ju is being hurt by her husband Kang- woo, and as they become more intimate with each other they decide to kill him: taking him out on a boat trip, just as Thérèse and Laurent had done with Thérèse's husband,

Camille. After Kang-woo's drowning, they see him again and again in the home, his wet body even getting between them as they lie together in bed. Their visions of him add to the escalating melodramatics of this peculiar domestic scene. After a while Tae-ju comes to realise that Sang-hyun is a vampire; appalled at first, she is later intrigued. Lady Ra falls into a catatonic state after her son's murder, her eyes staring across the room. The visions of the dead son haunt Tae-ju, who becomes increasingly distraught and crazed, finally turning on her vampire lover. 'We were a happy family of three until you infested us!' she tells him, wanting to die. Sang-hyun loses control of himself and beats her violently in front of Lady Ra; unable to stop himself, he kills her, weeps over her and drinks her blood, returning her to life as a vampire. Tae-ju relishes her new-found power, killing indiscriminately and taunting Sang-hyun when he tries to stop her. 'Kill me or save me', she says, 'you'll regret anyway.'

Tae-ju's character is played by the young South Korean actor Kim Ok-bin, who was cast alongside the older Song Kang-ho, one of the most popular and experienced actors in South Korea who, a few years earlier, had starred in the successful, globally acclaimed monster film, The Host (2006) – a film that also had something to say about the presence of US troops in South Korea. In her account of the 2009 Cannes Film Festival – where Thirst won the Jury Prize – Amy Taubin writes that

> Kim Ok-bin, a former beauty queen with very little acting experience, uses her angelic face to advantage as a sullen Cinderella turned lascivious bloodsucker who wreaks havoc on the family that has abused her when she gets a dose of 'bad blood' from a vampire priest. Stealing the film from Song Kang-ho, one of Korea's biggest stars, Kim owns the screen, so excited is her character by her ravenous hunger and erotic power. Hers was the most thrilling performance in Cannes and probably of the year.[31]

This account of Kim Ok-bin as 'excited' by her character might recall Maggie Cheung's immersion into the character (and the costume) of Irma Vep. Her character in Thirst, Tae-ju, is certainly unleashed when she turns into a vampire and realises her power, and her desires. She growls and slurps and screams, running amok and killing indiscriminately: among others, she kills the friends who come to Lady Ra's house to play mahjong, with Sang-hyun able only to save Evelyn, the Philippine Catholic woman. When Kim Ok-bin wanted direction on how to play her role as a vampire, Park got her to look at Isabelle Adjani's remarkable performance in Andrzej Zulawksi's strange, vicious horror film, Possession (1981), a French/West German co-production by a Polish director shot in English and set in Germany, with French and New Zealand (a young Sam Neill) lead actors. In a homage to Adjani, Kim Ok-bin is even supposed to have worn her blue dress in the final scene.[32] As we saw with Maggie Cheung in the costume of Irma Vep, a citation triggers ex-citation ('so excited is her character …'). Zulawksi's Possession is built around the relationship between a repressed man and his increasingly deranged, murderous wife in Berlin, and their marriage is often read as a national allegory about the Wall that divided East and West Germany.[33] At one point the husband, Mark, violently beats his wife, who runs out into the street, her face bloodied. This is one of several scenes that Thirst in fact revamps, staging a similar structural connection between a generally restrained male lover – the vampire priest, Sang-hyun – and a woman who spirals out of (his) control. Sang-hyun is both a saviour and a destroyer here (he has already killed an older priest), increasingly loathing himself as his thirst takes him over.

Park Chan-Wook, *Thirst*
(2009): Sang-hyun and
Tae-ju face the coming
sunrise

As noted above, Kim Kyung Hyun is one of several local film critics who has talked about contemporary South Korean cinema in terms of a crisis in Korean masculinity that speaks to this country's national condition – especially in terms of the way it has responded to its history of military occupation. He writes,

Just as Hollywood has used the Vietnam War as a springboard for what Susan Jeffords describes as the 'remasculinization of American culture', South Korean cinema renegotiated its traumatic modern history in ways that reaffirm masculinity and the relations of dominance.[34]

For Kim, male trauma 'drives the narratives' of South Korean cinema in the wake of Korea's occupation by Japan and, after the war, the United States. Male characters in South Korean cinema register a 'lack' that is triggered off by Korea's history of military regimes, making it difficult for them to reaffirm their masculinity and integrate into society. Interesting, as it is, however, this framework runs the risk of allegorising every Korean film in exactly the same way. *Thirst* is not so much about 'lack' as about *excess*: the impossibility of living a restrained, selfless life, the overwhelming effects of self-interest and desire, the fissuring and reassembling of ordinary lives under extreme pressures. The question of integration is certainly important here, but it plays itself out in the context of a family household that takes its structure not from other Korean films at all, but from Zola's mid-nineteenth-century novel. With *Irma Vep*, we saw 'old' French cinema modernise itself through its encounter with an East Asian actor; with *Thirst*, we see a modern East Asian film made archaic through its encounter with an old work of French literature. The relationship between Sang-hyun and Tae-ju doesn't allegorise any local military predicaments, not even the North Korea–South Korea divide: if it exists at all, any such allegory of national division is buried deep inside *Thirst*'s other European citation, Zulawski's *Possession*. *Thirst* is a South Korean curiosity, mobilising a transnational, viral, phantasmagorical effect and unleashing this into a local, dysfunctional family it then remakes according to the narrative logics and performances of Zola's novel and Zulawski's film. In the process, the entire family is destroyed and any possibility of what Kim calls 'post-traumatic recovery' is completely ruled out. In the final scene, Sang-hyun drives Tae-ju and Lady Ra (who sits silently in the back of the car) to the top of a cliff above the ocean, shortly before the morning sun comes up. Tae-ju realises what is about to happen, and panics and screams and weeps as she tries to find some shelter, to no avail. Finally, she sits with Sang-hyun on the bonnet of the car, leaning against him and gently correcting his Catholic faith. 'When you're dead, you're dead', she says, as Bach's Cantata no. 82 (*Ich*

habe genug) is repreived, 'It's been fun, father.' It is as if she speaks for the film itself, shutting it down with an affectionate aside, knowing that in this case there will be no remakes, no reanimations. The film ends, as so many vampire films do, with the dissolving away of its transformed, excitable protagonists, leaving the mother alone in the car, staring blankly out to sea.

VAMPIRES IN THE AMERICAS

Nadja, *The Addiction*, *Habit*, *Vampire in Brooklyn*
Twilight, *New Moon*, *Eclipse*
Cronos
The *From Dusk Till Dawn* trilogy, the *John Carpenter's
Vampires* trilogy

Nina Auerbach's *Our Vampires, Ourselves* (1995) is a book that splits itself in two, looking at vampire fiction in Britain in the nineteenth century, and then vampire films in America in the twentieth century. 'Vampires go where the power is', she suggests; 'when, in the nineteenth century, England dominated the West, British vampires ruled the popular imagination, but with the birth of film, they migrated to America in time for the American century.'[1] The association of vampires, America and 'the birth of film' might simply reflect Auerbach's disposition as an American cultural critic; as we have seen, films like *Blood: The Last Vampire*, *Thirst* and *Frostbitten* offer quite different national/cinematic genealogies for these creatures. Of course, vampires could well have something to do with the origins of *commercial* cinema in America: think of Tod Browning's *Dracula*. But as Auerbach also notes, vampires are 'imports', belated arrivals, migrants: not original at all, but involved in the business of 'resettling in twentieth-century America'.[2] The United States' most famous vampire-immigrant was Bela Lugosi – Count Dracula in Browning's iconic 1931 film – who took his surname from his birthplace in Romania, Lugos. A theatrical actor, Lugosi fled Budapest during the Hungarian Revolution, arriving in New Orleans in 1920 and moving to New York the following year – performing on stage in New Jersey, Manhattan and elsewhere, before moving to California in 1928. This chapter begins by looking at some New York-based vampire films from the mid-1990s, including Michael Almereyda's *Nadja* (1994), released the same year as Neil Jordan's *Interview with the Vampire*. Elina Lowensohn plays the title role in this film, a female vampire – Dracula's daughter – who has left 'the shadow of the Carpathian mountains' to come to modern New York. Both *Nadja* and Browning's *Dracula*, then, are films about a vampire from Eastern Europe who migrates to the West. Interestingly, just like Lugosi, Lowensohn was herself from Romania, born in Bucharest; her family fled Ceausescu and defected to the United States in 1971, settling in New York. It can seem as if Lugosi and Lowensohn got the chance to reconfigure, as vampires in their films, their own, actual immigrant trajectories. Lowensohn went on to study theatre at New York University's Playwrights Horizon Theatre School; later, she would play the romantic interest of a London-based vampire (Jude Law) in Po-Chih Leong's *The Wisdom of Crocodiles* (1998).

The 'New York vampire film' properly begins in the 1980s with Tony Scott's stylish, MTV-influenced *The Hunger* (1983), a loose adaptation of Whitley Strieber's 1981 novel of the same name, and Robert Bierman's *Vampire's Kiss* (1988). These films precisely span the Ronald Reagan presidency (1981–9) that is also important to Auerbach's study, central to her argument that vampire films in contemporary America reflect a sense of social and political decline, gaining power and losing power simultaneously.

'When Ronald Reagan's powerful persona took control of the American imagination in the 1980s', she writes, 'vampires began to die. Intimidated by ideological reaction and the AIDS epidemic, they mutated, as a species, into unprecedented mortality'[3] This perceptive observation does indeed seem to be borne out in *The Hunger*, where two glamorous vampires – one from ancient Egypt, the other from eighteenth-century France – live an opulent Manhattan lifestyle, preying on New Yorkers at night at various hip nightclubs. The film is often tied to the rise of the 1980s Reaganite yuppie, to affluence, 'style' and excessive consumption, promiscuity and anonymous sexual encounters, and sheer human disposability;[4] it juxtaposes all this, however, to the vampires' inexpressible horror of ageing and dying. *Vampire's Kiss* plays out the exhaustion of this cycle, sitting midway between Scott's film and the vampire films I shall shortly discuss from the 1990s. Distributed by the British independent Hemdale Film Corporation, the film steeps itself in the anonymity of New York, with its repeated shots of skyscrapers and skylines, street scenes and traffic and busy pedestrians. Peter Loew (Nicolas Cage) is a successful literary agent who is misogynistic and promiscuous, and in therapy; he has been in New York for ten years, which makes him a relative newcomer to the city. Picking up Rachel (Jennifer Beals) at a mixed-race club, he takes her back to his apartment where she bites his neck while they have sex. Another relationship, with Jackie – played by the African-American film director and actor Kasi Lemmons – begins to fall apart. In the meantime, Peter is trying to find a missing file, harassing an office secretary, Alva (Maria Conchita Alonso). Soon, the missing file becomes a maddening obsession. Imagining that he is turning into a vampire, Peter increasingly loses control over his life. Rachel enslaves him, and emasculates him. Attempting to rape Alva later on, he takes her gun and tries to shoot himself; not realising that the bullets are blanks, he thinks he is immortal. At a nightclub, he murders a white woman; later, he fantasises about another white woman, Sharon (Jessica Lundy), who momentarily allows him to imagine a suitably literary yuppie future ('Hi', she says. 'I like poetry, horseback riding, Vivaldi, and long weekends in the country'). *Vampire's Kiss* systematically wrecks a New York yuppie's life, fissuring any dreams of immortality with an overwhelming wish to end it all and die. The excesses of Cage's performance themselves became notorious: he eats a live cockroach at one point, trashes his apartment several times over and speaks in a 'maddeningly pretentious accent'[5] that strangely anticipates Ben Stiller's character Derek in *Zoolander* (2001). His model for vampiric behaviour is Orlok in Murnau's *Nosferatu*, which plays on the television at one point in the film – even though Peter's sexual positioning in relation to Rachel increasingly resembles that of Ellen in *Nosferatu*, bitten rather than biting, dominated rather than dominant. The casting of Jennifer Beals – of African-American parentage – alongside Kasi Lemmons and the Cuban/Venezuelan Maria Conchita Alonso also means that *Vampire's Kiss* is racially signposted in ways that distinguish it from the glowing Euro-whiteness of *The Hunger*. Dale Hudson calls Rachel a 'biracial vampire' and reads Peter's sexual desire for 'women of colour' critically, as an expression of his 'fear of miscegenation'.[6] Since he is drawn to these women (and is distraught when Jackie leaves him), this seems unlikely; nor is it likely that, as his character disintegrates under the delusion of being a vampire, the film 'positions audience identification with Peter'.[7] Being a vampire in this film is a symptom of a particular 1980s yuppie male condition, diagnosed as squalid and self-deluded. Unlike the vampires in *The Hunger*, Peter's death is quick and miserable; nobody mourns him.

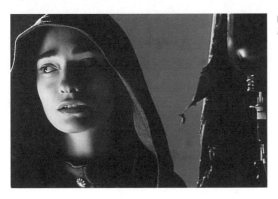

Michael Almereyda,
Nadja (1994): Nadja

Nadja, The Addiction, Habit, Vampire in Brooklyn

Although he reads *Vampire's Kiss* austerely, Hudson is right to note that it is one of several American vampire films about 'thwarted immigration and failed assimilation'.[8] Certainly, as I have already noted, the vampire's problem has often been a matter of whether to blend in, or stand out, in some other, different place. In *Nadja* – a black-and-white independent film produced by David Lynch – it is winter in New York. Like Miriam Blaylock (Catherine Deneuve) in *The Hunger* and Peter in *Vampire's Kiss*, Nadja prowls the nightclubs and bars, picking up prey. Her foreignness is striking, but she casually dismisses her homeland and appears to have adjusted perfectly to nocturnal life in this modern American city. 'Europe is a village', she tells her first victim. 'Here, you feel so many things rushing together. It even gets more exciting *after* midnight.' As Nadja – with her high forehead, tightly drawn-back hair and large, elongated lips – Lowensohn strikingly resembles the German actor Udo Kier's vampire in Paul Morrissey's *Blood for Dracula* (1974). *Nadja*'s deadpan/camp delivery owes a great deal to this earlier film, too. Roger Ebert has noted that *Nadja* is

> an example of a genre we can call Deadpan Noir. It's the kind of movie that deals with unspeakable subjects while keeping a certain ironic distance, and using dialogue that seems funny, although the characters never seem in on the joke. David Lynch (who appears in *Nadja* as a morgue attendant) practised this genre in films like *Blue Velvet* and *Wild at Heart*[9]

The murky greyness of a black-and-white New York adds to the deadpan sensibility, accompanied by spacey music from rock bands Portishead and My Bloody Valentine. Some sequences in the film – some of Nadja's POV, for example – are shot with a Fisher-Price PXL (Pixelvision) 2000 camera, producing grainy, out-of-focus images that are both eerie and irritating. This is a film that self-consciously invokes its vampire genealogies, just like *Vampire's Kiss*: images from *Nosferatu* are scattered through Nadja's killing of her first victim, as if Murnau's shadowy film is now indispensible to modern low-budget New York vampire cinema (*Nadja*'s budget was around US$1 million). Nadja's father, Dracula, has been killed by a modern-day Van Helsing (Peter Fonda), an ageing obsessive who rides through the city streets on a bicycle. The death of her father makes Nadja want to 'change my life' and 'start over'. She meets a disillusioned married woman, Lucy (Galaxy Craze), in a bar and they have an

affair: 'I haven't been interested in a woman for a long time', Nadja confesses to her servant, Renfield (Karl Geary). She tells Lucy about her sickly brother Edgar (Jared Harris), who is being cared for by a nurse, Cassandra (Suzy Amis). In the meantime, Van Helsing is discussing vampires with his nephew Jim (Martin Donovan), Lucy's husband. Dracula, it seems, was in terminal decline, exhausted. 'He was like Elvis in the end', Van Helsing says. 'The magic was gone.' Even so, the vampire has spawned many children. 'These creatures are everywhere', he tells Jim. 'The streets are full of them. Any major city. They just blend in.'

Nadja is partly about the dissolution of a New York marriage, as Lucy is increasingly possessed by Nadja. Lucy and Jim are not exactly yuppies: she is a downgraded version of Alva in *Vampire's Kiss*, bent over the photocopier at Village Copier, bored and aimless. Copying, reproduction, citation: these things are foregrounded in *Nadja* and help to characterise it as a 'postmodern' vampire film, equally aimless at one level while condemned to replicate the foundational features of the genre at another. The encounter with a vampire both fractures the marriage and brings the couple closer together, as Jim and Van Helsing pursue Nadja, blaming her for Lucy's condition. A shot of the New York skyline is followed with a map of Transylvania and the superimposed image of a toy vampire – a parody, surely, of the equivalent scene in Coppola's *Bram Stoker's Dracula* during Harker's travels – as Nadja leaves the city and returns home. 'I guess I was homesick', she says. 'America was getting somehow too confusing … too many choices, too many possibilities. Here you have to narrow yourself.' In fact, as the film reproduces familiar generic features (Van Helsing and the others go to Dracula's castle to kill the vampire, etc.), it does indeed narrow its range, flaunting its inauthenticity as it does so. The old, ruined castle and the sounds of howling wolves are now the merest of citations; the shot of a young boy wearing Mickey Mouse ears beside a 'Transylvanian' forest in fact leads Catherine Spooner to note that 'We are no longer in Europe, but in Euro Disney.'[10] There is a prevailing view that *Nadja* 'loses … coherence' towards the end.[11] In fact, as Nadja is staked in her castle and the film turns to negative, it becomes all too familiar, a copy of a copy. It is as if the vampire genre is the only sure thing this film has; without it, it has no content, nowhere else to go. Cassandra expresses exactly this urban malaise: 'We feel empty. We have a huge hole in ourselves. I don't know anyone who doesn't have a huge emptiness in their lives.' In Transylvania, Lucy – like Nadja in New York – simply wants to start all over again: 'I wanna be over this. I wanna stop smoking … .' Jim is still wondering how to prolong their marriage. 'Maybe we should have children', he suggests, as if further replication is the only thing that can save them. Like *Vampire's Kiss*, this film is both apocalyptic and banal, its dogged pursuit of the vampire superimposed across the aimlessness and emptiness of its characters' modern American lives. Auerbach's remark that vampires 'died' in Reagan's America is borne out in this film and extended into the 1990s. After her death, Nadja occupies Cassandra's body, at last becoming an American: literally blending in, and filling up Cassandra's emptiness. 'We are all animals', she says in a final voiceover (the vampire has the last word, just like Rachel in *Vampire's Kiss*), 'but there is a better way to live.' This is as close as the film gets to a 'political' position: a gesture towards some other modern (or postmodern) predicament the film is unable to realise.

Auerbach's *Our Vampires, Ourselves* is in fact written *after* Reagan, under the shadow of George H. W. Bush's presidency (1989–93): at a time when, as she writes, 'implacable fears afflicted America'.[12] Vampires and Republicans seem to 'converge' (recall the jock's closing line in *Buffy the Vampire Slayer*, 'They had this look in their eyes, totally animal. I think they were young Republicans'), but they are also radically distinguished from each

other, as if vampires work as a kind of political unconscious, an 'increasingly ghettoized' barometer of the dark side of modern America.[13] Auerbach's book is certainly preoccupied with American presidents, reflecting her feminist interest in patriarchy and power. What is also interesting is that she is haunted by a *dead* president, Franklin D. Roosevelt, who she casts as a long-lost but much-loved father. Her book is written as a 'tribute to the lost patriarch who had cast a beloved aura over my childhood … . The fact that FDR was already dead when I was born made him, for me, incorruptible.'[14] It turns out that the 'lost patriarch' also shadows some of the New York vampire films under discussion here. This is true of *Nadja*, for example, where Dracula is a remote figure who hearkens back to some kind of long-forgotten, absent moment of authenticity ('The magic was gone'). In indie film-maker Larry Fessenden's luridly coloured, ultra-low-budget vampire film *Habit* (1997), Sam – played by Fessenden – has also recently lost his father and is sorting through his papers while preparing a speech for his father's wake. The absence of the father is the thing that presides over his dissolution: he is an alcoholic in a dead-end job, alone in New York. His father's old photographs – pictures of ancient ruins, tombstones, catacombs – provide some solace. Out in the streets on Halloween, he meets Anna (Meredith Snaider); during his brief, intense sex with her, she bites him. The film more or less mimics Peter's crack-up in *Vampire's Kiss*, except that Sam never imagines he is a vampire. When Anna asks him to ride the ferris wheel at a local street festival, he says: 'I'm kinda afraid of heights.' Sam is a timid loner; Anna, on the other hand, is impulsive, confident and predatory. In an interview, Fessenden has said:

> my agenda is to address the melancholy of life, the loss. What's frightening in the world is when that thing you love is taken away from you, be it life's breath, or trust, or an ability to believe in something or losing a loved one through violence, but always – it's about the melancholy. So that's my curse.[15]

In this film, Anna, the vampire, is a kind of symptom or consequence of this melancholic predicament: drawing Sam out of himself in one sense (literally *ex-citing* him) while acting as a constant reminder of what he has lost.

It is difficult to read *Nadja* and *Habit* 'politically'; their registering of loss is really cultural/social, a response to the emptying out of meaningful rituals in secular modern American life. But in another, more ambitious independent New York vampire film released at the same time – Abel Ferrara's *The Addiction* (1995) – a political framework is explicitly evoked and is used to trigger off the trajectory of the narrative. Like *Nadja*, this film is in black and white. Kathy Conklin (Lili Taylor) is a philosophy graduate student at the University of New York; as the film opens, she is in a class watching a film about the American massacre of Vietnamese civilians at My Lai in 1968 which concludes with the narrator's remarks about the presidential response to 'world opinion', the trials of the men responsible, and the 'temporary' sense that 'justice was served'. Walking across the campus, Kathy tells her friend that everyone is implicated in this American crime, not just one or two scapegoats. The film casually cuts from the university campus to the New York streets, with close-ups of the homeless and of young African Americans hanging out, doing deals and so on, to a hip-hop soundtrack – the musical score is by Schooly D, who has contributed to a number of Ferrara's films. Kathy is a little apprehensive as she walks past them, the only white American in the neighbourhood. The scene fades to black and then it is night. An elegantly dressed, older white woman appears – named in the credits

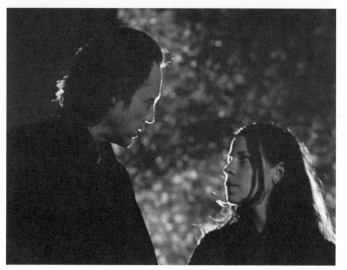

as Casanova (Annabella Sciorra) – makes some small talk with Kathy, and then drags her down a staircase and throws her against a wall, hitting her across the face. 'Tell me to go away', she says. Kathy quickly assumes the role of victim, already surrendering. 'Fucking cunt …' the woman whispers, just before she bites into Kathy's neck. The encounter with Casanova is something like a moral visitation; another predatory female vampire, she is much more selective about her prey than Nadja. When she stops feeding, she wipes her mouth and offers a parting accusation that seems to bear out the point Kathy had made to her friend: 'Collaborator.' As she leaves, she literally expresses her role as a trigger for the narrative that follows. 'Want to know what's gonna happen?' she asks. 'Just wait and see.'

The rest of the film reworks the premise of *Vampire's Kiss*, except that Kathy really does become a vampire. One effect of her change is that she is able to move more freely and confidently through the neighbourhood, no longer intimidated by the sexually aggressive play of the black American hip-hop crew that surrounds her. Later on, she picks up one of the young men ('Booty calls!' he tells his friends, pleased with himself) and takes him to a deserted street, forcing him onto the ground before breaking his wrist and feeding on him: 'Tell me to go', she says, echoing Cassandra. Stacey Abbott has called Kathy and Nadja – and Anna from *Habit* – 'vampire flaneuse', unaccompanied women who are able to face 'the dangers and confrontations inherent in the urban setting and walk the streets of New York's East Village with confidence'.[16] But *The Addiction* also represents Kathy's change into a vampire as an escalating crisis – literally, an addiction – as well as an encounter with the limits (as she sees it) of her own discipline, philosophy. One night she meets Peina (Christopher Walken), a much older vampire who has managed to control his 'habit', fasting for long periods. 'You learn, like the Tibetans', he tells her, 'to survive on a little.' Peina takes Kathy back to his home, a huge, tastefully decorated warehouse somewhere in the city, where he recommends William Burroughs's *Naked Lunch* to her ('he perfectly describes what it's like to go without a fix'), along with Sartre, Beckett and Baudelaire: rather like another one of her patriarchal university professors. For Peina, being a vampire is not about

free, confident movement at all; it is about adjusting to a severely defined set of restraints. 'You can't eat, you can't sleep, you can't even go out to satisfy the urge during the day', he tells Kathy, feeding on her. 'You're a slave to what you are, and you're nothing.' Peina is a remote figure who is also at the film's centre, a vampire who has restrained his habit to the point of being 'almost human'. 'The point is to blend in', he says, typically enough for a vampire in a modern metropolis, 'not to stand out like a sore thumb.' Leaving him, Kathy later completes her philosophy dissertation and invites students and professors, along with the various people she has bitten and turned into vampires, to a celebratory 'get-together'. After a prolonged feeding frenzy that undermines pretty much everything Peina had stood for – and plays out a fantasy of revenge against *all* her teachers, academic and vampire alike – Kathy finds herself in hospital. Wanting to die, she asks the nurse to open the blinds to let the light in, but Casanova suddenly reappears and saves her. 'To find rest', she tells Kathy, 'takes a real genius We *do* evil because we *are* evil, and what choices do such people have?' The film offers Kathy no other option but to continue to live as a vampire; this is her closing revelation, which she seems quietly to accept.

Some film reviewers have ridiculed the philosophical pretensions of *The Addiction* – as 'half-baked', 'straight from Philosophy 101', and so on.[17] But film commentators take it much more seriously. One of the most disturbing and significant things about this film is the series of photographic images it throws up – and returns to over and over as Kathy's vampirism takes hold – of the bodies of victims of war, including Holocaust victims. These images trigger Kathy's vampirism as much as Casanova does; her vampirism is a kind of apocalyptic reaction to the terrible things she has seen, a delirious surrender to the horrors in which she now feels implicated. In a long, interesting essay in *Jump Cut*, Justin Vicari situates the film in the framework of the literary and philosophical traditions it invokes:

> *The Addiction* pursues the same provocative split thinking of many romantic 19th and 20th century writers and philosophers, that an outmoded morality and virtue can only be reanimated by a thorough-going immersion in everything that is opposite to them: in vice, in crime, in madness, in death.[18]

Far from liberating Kathy, however, it imposes upon her 'sudden restrictions' that severely limit her capacity for protest and resistance. For Vicari, in fact, she is a typical student of the 1990s, excessive and inhibited at the same time, unable to recover the 'activist spirit' of the late 1960s even as she lives in its elongated shadow. From one perspective, her transformation into a vampire is precisely an expression of her inability to access the social world of student activism; the students around her don't seem interested in this, either. In vampirism, Vicari writes, Ferrara and his scriptwriter Nicholas St John have therefore found

> a perfect metaphor for the often stillborn energies of anarchic radicalism whenever and wherever those energies arise. The mythological vampire is the great untroubled watcher of history, moving helplessly throughout all time and space, powerless either to change the world or, indeed, to leave it.[19]

This kind of reading once again gets close to treating the vampire allegorically, something already discussed in previous chapters. *The Addiction* is worth comparing to *Blood:*

The Last Vampire, for example, which closes – rather than opens – with images from the Vietnam War (American soldiers, not local victims). *Blood* keeps a kind of structured distance between its vampire and its 'documentary' content, making it difficult for an allegorical reading to properly develop. In *The Addiction*, on the other hand, these things are put into close proximity with each other; they are only too visible. In her book *Weimar Publics/Weimar Subjects* (2010), Kathleen Canning interestingly discusses *The Addiction* alongside Murnau's *Nosferatu*: as if, regardless of whether a newer vampire film cites it or not (*The Addiction* doesn't), Murnau's film is somehow always *there* in the genre. For Canning, both films invoke the 'phantoms' of war, which – because their horror is so difficult to articulate in any direct, unmediated way – are then synecdochally cast through the figure of the vampire. *The Addiction*, she writes, is therefore

> a hybrid film mixing of the horror genre with documentary, destabilizing the boundaries of both: the documentary images of corpses have become phantoms that – as the embodiments of the inexpressible – have entered the student's mind and made her susceptible to vampirism that feeds on violence.[20]

Kathy in effect experiences two kinds of encounters in *The Addiction*: an encounter with America's war history and with global images of the horrors of war, and an encounter with a vampire. Each of these is catastrophic for her, bleeding into each other to the extent that she, too, seems like the traumatised victim of a disaster, collapsing on the street, carried off to hospital, in extreme pain, her body deteriorating, and so on. At the same time, she is the cause of other catastrophes as if bearing out Casanova's point that 'we *are* evil': as if evil is everywhere and Kathy is simply doing what Peina advises, that is, blending into it. Nicole Brenez, in her book on Abel Ferrara, sees the film in exactly this way, as an act of 'double metamorphosis':

> Encountering an image, and encountering a vampire named Casanova … : it is the same scene, first as a documentary and then as allegory, and this conversion will reproduce itself with each new discovery of a documentary image. Vampirism offers a simple, universal, popular iconography for the treatment of a complex and universal political question: how to live with the knowledge of historical evil – the unending chain of genocides, public and private massacres, the reign of injustice, oppression, and corruption?[21]

For Brenez, *The Addiction*'s grad-student vampire is therefore pretty much as allegorical as it is ever possible to be. 'Kathy', she concludes, placing a burden on her that is impossible to sustain, 'absorbs the collective catastrophes of the twentieth century.'[22]

A black-and-white art house horror film like *The Addiction* is in a certain sense already available to serious readings like this, anticipating (even prompting) them through its own existentially bleak disposition, its invocation of documented global horrors and American culpability, its central New York campus location and student protagonist, its various citations of radical philosophy and literature and so on. Other vampire films, as we have seen, are more self-consciously frivolous, distanced from serious issues and, naturally, from serious readings – and less likely to be invested with allegorical significance. In *Nadja* at one point, Nadja tells Lucy about her brother Edgar. 'Does he live in Carpathia?' Lucy asks. 'No. Brooklyn,' she replies. 'I've never been there.' From Nadja's perspective – and indeed, from the perspective of the New York art house vampire film – Wes Craven's horror-comedy

Vampire in Brooklyn (1995) might also seem just as remote as Carpathia. Craven has been directing and producing horror films since the early 1970s, from his early brutal 'allegory' of American traumas over the Vietnam War, *Last House on the Left* (1972)[23] to the 'post-modern' *Scream* films which began their franchise in 1996. *Vampire in Brooklyn* was a relatively low-budget (around US$14 million) mainstream film starring the popular African-American comedian Eddie Murphy. It was Murphy's last film under contract to Paramount Pictures, and in fact it had developed out of a story he wrote with his brothers, Charles Murphy and Vernon Lynch Jr. Murphy plays Maximillian, a vampire from somewhere in the Caribbean, the last of his kind. The film begins with a long voiceover that gives him an interesting, if underdeveloped, genealogy:

> A long, long time ago, Nosferatu, the undead … the race of the vampire were driven from Egypt. Most fled to the Carpathian mountains of Transylvania, but others of better taste, including myself, traveled south through Africa and over the Atlantic to a beautiful island hidden deep in the Bermuda triangle. There, we lived for happy centuries feasting on the blood of unwary travelers, until discovered by the hunters once again. Then the blood that spilt was our own. I alone escaped. But a vampire alone is a vampire doomed. My only chance was to find the one known offspring of our tribe that had been born in a foreign land. A woman somewhere in this place called Brooklyn.

This is another revisionist account of the vampire that fleetingly gestures towards the kind of 'Black Athena' origins that *Queen of the Damned* had reanimated through Akasha. It also charts a particular kind of 'Black Atlantic' route – to draw on Paul Gilroy's evocative term – that sees an African-American vampire journey from ancient Egypt to Africa to the Caribbean and, finally, to the American mainland. *The Hunger*, *Vampire's Kiss*, *Nadja*, *Habit* and *The Addiction* are all vampire films that take the whiteness of their New York protagonists for granted; *The Addiction* registers a black American street culture merely as a troubling background (even as it draws on its 'soundtrack'), something for Kathy to pass through and transcend on her way to higher things (Euro-American existentialism, literature, etc.). But *Vampire in Brooklyn* works in quite the opposite way. It is built entirely around an African-American neighbourhood in New York that is so organically rendered that, when the vampire Maximillian arrives, it doesn't really know what to do with him.

The film begins by restaging the moment of the arrival of Dracula's ship in England that happens midway through Stoker's novel and Coppola's film. Here, the ship Maximillian travels on (all the crew have been killed) crashes into Brooklyn Harbour, disturbing a couple of dock workers, Silas (John Witherspoon) and Julius (Kadeem Hardison), who are eagerly watching white starlets parading on television ('You make me excited!'). Silas and Julius provide the comic energy of the film, spanning two black American generations. Silas is Julius's landlord, completely at home in his neighborhood, while Julius is a wise-cracking, small-time criminal in trouble with the Mafia who operate nearby. Maximillian intervenes when two racist Mafia thugs threaten to kill Julius; he then turns Julius into his 'ghoul' ('You belong to me now …'), as well as his comic foil. Julius is a kind of black American version of Peter in *Vampire's Kiss*, going increasingly crazy as his bitten body falls apart; he even eats a cockroach at one point, in a comic nod to Cage's performance. Maximillian has come to Brooklyn to find a 'half-vampire' woman who turns out to be Rita (Angela Bassett), a policewoman with the NYPD. Rita has a secret history: her mother, an academic, was one of the 'pioneers' of Caribbean Supernatural Studies (a sort of anthropologist, presumably),

Wes Craven, *Vampire in Brooklyn* (1995): Maximillian bites a rich white woman

while her father was a vampire who was later killed on one of the islands. A prolonged attempt at seducing Rita sees Maximillian finally pick her up in his black stretch limo – Julius is the chauffeur – and bring her back to his opulent apartment. Eddie Murphy's vampire is suave but not sophisticated, sexually and comically straight (apart from a couple of lame one-liners). He seems easily irritated: he has all the bling of a black rapper but doesn't like MC Hammer. In the meantime, Rita's NYPD partner Justice (Allen Payne) – also African-American – is falling in love with her. Maximillian kills Rita's promiscuous flatmate Nikki (Simbi Khali), in an attempt to discredit Justice. Later, as Rita falls under his spell, he takes her into the park to hunt at night. A rich white woman (Jerry Hall) takes out her pepper spray when he approaches: 'I want you to know that I understand the Negro people', she tells him. 'I understand how you've been chained down by the oppression of white capitalist society.' 'Then you'll understand this!' he says, attacking and killing her. The film is a kind of belated expression of 'black power', with Maximillian punishing a couple of racists (the Mafia thugs) and a well-heeled white liberal sympathiser – although killing Nikki, a modern version of Lucy in Stoker's novel and Coppola's film, is more to do with misogyny and a prudish morality. Even so, this black Atlantic vampire remains estranged from the Brooklyn neighbourhood, remote and aloof, and divisive. When Rita finally rejects him, he is full of scorn: 'Then … go back to your little shoebox apartment … go back to your job where they laugh at you behind your back!' Rita reclaims her neighbourhood identity, and her partnership with Justice, when she finally kills Maximillian, who turns to smoke, leaving nothing behind but his ring. Later, Julius sits in the back of the limo – Silas is driving this time, in a reversal of generational roles – and puts the ring on his finger. Suddenly turning into a hot-looking black American man, with sunglasses and lots of bling, he declares: 'There's a new vampire in Brooklyn, and his name is Julius Jones!'

This is a difficult film to read in terms of racial politics, and especially in terms of any 'allegorical' function. It casts its black American vampire literally as a kind of local disturbance, someone who doesn't seem to care about neighbourhood values or ordinary black Americans. It makes very little of Maximillian's black Atlantic genealogy and has nothing interesting to say about Rita's mother's academic work in the Caribbean. The white woman's comments in the park seem out of synch with the film, which never otherwise mobilises issues of racial difference. On the other hand, Eddie Murphy is not only Maximillian in the film; a shape-changing vampire, he also plays the role of a Mafia crook called Guido and an evangelical black preacher, Reverend Pauley, who confuses his congregation with the message that 'evil is necessary … evil is good!' For Leslie Tannenbaum, Murphy's different roles in the film signify his 'unstable – and therefore unreadable – black

body': able to occupy different (racial) identities, mocking the idea of 'passing' as a white as Guido, confusing good and evil as the preacher, and so on.[24] At one early point, however, the film offers the possibility of something *more* stable. Julius first recognises that Maximillian is a vampire because he has seen a black American vampire before, in another film. 'You ain't gonna pull that Blacula shit with me, right?' he asks. William Crain's *Blacula* (1972) is the original 'black vampire' film, about an eighteenth-century African vampire called Mamuwalde, who journeys with his wife to Transylvania to try to persuade Dracula to help him abolish the slave trade. Deceived by Dracula (Charles Macaulay) and entombed in a coffin, Mamuwalde – Blacula (William Marshall) – later finds himself in modern Los Angeles where, as he goes on a killing spree, he falls in love with Tina (Vonetta McGee), who he thinks is his reincarnated wife. *Blacula* is one of a number of 'blaxploitation' films from the early 1970s that celebrated a tough, assertive kind of black American masculinity. In an interesting essay on the film, Leerom Medovoi sees Blacula as the embodiment of an 'originary black masculinity' that is specifically linked to a premodern, pre-diasporic Africa: at a time before the black Atlantic. The vampire's problem in Los Angeles (and the thing that so enrages him) is that modern African–American identity seems much less caught up with origins and authenticity, which means that the kind of cultural 'authority' it once commanded has now been lost.[25] The film, in other words, plays out a catastrophic encounter between the ancient and the new that is generically typical of vampire films. For Medovoi, *Blacula* can therefore be read allegorically, as if he carries the weight of (a repressed) history on his shoulders: 'the vampire serves as the sole figure through whom the entire history of black challenges to white injustice is condensed. No broader reference to racial conflict, beyond Blacula himself, can be found in the film.'[26] This is very much like Nicole Brenez's reading of Kathy in *The Addiction*, noted above. In *Vampire in Brooklyn*, however, no such allegorical reading is available. Maximillian's remote ties to a pre-diasporic Africa are emptied of content. The film replaces Blacula's African essentialism with some arbitrary shape-changing, with what Silas (who, when he sees Maximillian turn from a wolf into a vampire, is reminded of a whore he once met in Detroit who turned out to be 'a man') calls 'flip-flopping'. Maximillian is not at war with modern, diasporic America. In fact, with his opulent apartment, his limo and his bling, he seems *less* authentic than everyone else, not more. Like *Blacula*, there are no broader references to racial conflict in this film. *Vampire in Brooklyn* raises the spectre of this film – through Julius's cheeky question – only to lay it to rest and forget about it. As citations go, *Blacula* is a dead one.

Twilight, New Moon, Eclipse

The *Twilight* films are a phenomenon: the most popular and spectacular part of a post-*Buffy* wave of teen and twenty-something vampire romances that also includes newer television series like *True Blood*, which began in 2008, and *The Vampire Diaries*, which began in 2009, a year after the first film in the *Twilight* franchise. In fact, the *Twilight* films – like the mega-selling novels by Stephenie Meyer on which they are based – owe a great deal to *Buffy*, especially the on-off romance between Buffy and Angel (David Boreanaz), a teenage girl and handsome, sensitive, angst-ridden vampire who tries, not always successfully, to restrain his carnal appetites in order not to become monstrous. Of course, the *Twilight* series lacks the perky quick-wittedness of *Buffy*, although it has its moments; and by comparison to it, the romance between Buffy and Angel progresses at lightning speed.

Even so, there are many similarities. Like *Buffy*, the *Twilight* films begin with a teenage girl's arrival at a new high school: not Sunnydale, California, but to the far north in Forks, in Clallam County, Washington State, a small, provincial town on the edge of a forest in the Pacific Northwest, near the Canadian border. Both girls are in single parent families. As with Angel and Buffy, the romance between Bella Swan (Kristen Stewart) and the vampire Edward Cullen (Rob Pattinson) begins almost straight away, after some smouldering looks and long stares. Edward is even made to *look* like an angel when Bella first sees him in class, the white wings of a stuffed owl stretched out behind his head. Just like the *Buffy* series, there are good vampires – the Cullen clan or 'family' – and badass, marauding ones, like Victoria (Rachelle Lefevre) and James (Cam Gigandet) who (if we put aside the fact that they're barely developed as characters and have very little to say) might very well recall *Buffy*'s Drusilla (Juliet Landau) and Spike (James Marsters). *Twilight* even works itself towards a high school prom night finale, one of the early climactic events in the *Buffy* television series and a climactic end-point to the *Buffy* film, too, as I noted in Chapter 1. *Buffy* and *Twilight* are both about American teenagers, their families and friends, their freedoms and their constraints, their anxieties and their desires. Contemporary pop and rock music is as important to the *Twilight* films as it was for the *Buffy* series, as a way of articulating teenage sensibilities: not the pulsing, Goth-oriented nu-metal of *Queen of the Damned*, but various forms of indie/folk music that can either keep steady rhythms flowing through a scene or build up to luscious crescendos. The British band Muse, for example, contributes a song to each of the three *Twilight* films under discussion here: *Twilight* ('Supermassive Black Hole'), *New Moon* ('I Belong to You') and *Eclipse* ('Neutron Star Collision'). Songs play themselves out in the foreground of many of the scenes in these films, often completely replacing the dialogue, standing alone as a way of capturing the mood and the sentiments of particular characters, Bella especially. A significant number of them are sung by women, from bands like Paramore or Florence and the Machine. As in the *Buffy* series, a softer, feminine singing voice (e.g. from Lykke Li, or Sia) often plays over the bleaker, more melancholy scenes, and there are many of them. The soundtracks to these films have themselves been remarkably successful, drawing together a constellation of bands and singers that traverse the indie/mainstream divide. Rob Pattinson himself contributes two dreamy, acoustic songs to the *Twilight* films. But the soundtracks are not all contemporary: a point of identification for Bella and Edward is their mutual love for Debussy's popular, romantic piano piece, *Clair de Lune* ('moonlight'), built diegetically into the film with Pattinson actually playing the piano.

The *Twilight* films are examples of what are often called 'event movies', a term that generally refers to films produced in response to the popular recognition of 'a pre-existing proven commodity'.[27] A significant number of vampire films could be said to fall into this category, those that are adaptations of popular contemporary novels, graphic novels, 'light' novels and so on: *Interview with the Vampire*, *Queen of the Damned*, the *Blade* trilogy, *Vampire Hunter D: Bloodlust*, *30 Days of Night* (2007), *Night Watch* and *Day Watch*, and many others. But as 'pre-existing proven commodities', Meyer's four *Twilight* novels – the first published in 2005 – are of a different order altogether. By 2010 (when an extra novella was added to the series) they had sold more than 100 million copies, dominating the bestseller lists and breaking records held by previous top-selling novelists like J. K. Rowling and Dan Brown. Aimed specifically but not exclusively at a teenage-girl readership, Meyer's use of social networking and online discussion sites helped to establish a

Catherine Hardwicke,
Twilight (2008):
Bella and Edward

wide and committed fan base ('Twihards') for her fiction.[28] Paramount had bought the rights to the novels and spent three years tinkering with them, substantially altering the narratives and characters; remarkably, however, they finally abandoned the franchise, selling it off. A little-known California-based independent, Summit Entertainment, recognised the level of reader loyalty to the novels and subsequently picked them up. *Twilight* was released to midnight screenings across the US in November 2008; costing around US$37 million to produce, it almost recouped that figure on the first night alone, and went on to earn around ten times that amount worldwide: almost US400 million. The second film in the series, *New Moon* (2009), took US$140 million in the first weekend of its North American release, smashing *Twilight's* record (and the records of other major blockbusters like *Harry Potter and the Half-Blood Prince* [2009]).[29] *Eclipse* (2010), the third film in the series, set the 'best ever Wednesday opening' for a film, taking US$68.5 million on its first day across a record number of American cinemas – slightly less than the first day's earnings for *New Moon* at US$72 million, but remarkable enough.[30]

In contrast to Paramount's approach, Summit Entertainment emphasised fidelity to the novel, bringing in Meyer to authorise a screenplay developed by Melissa Rosenberg, who had previously written only for television – but who then went on the write the screenplays for all the sequels. The director of *Twilight* was Catherine Hardwicke, best known previously for her controversial independent cult film about a teenage girl from a broken home, *Thirteen* (2003). Interestingly, Kristen Stewart had herself played teenage girls from broken homes in earlier films – the independent film *The Safety of Objects* (2001), and David Fincher's *Panic Room* (2002) – and her role in the *Twilight* films continues to explore this predicament. The involvement of Meyer, Rosenberg, Stewart and Hardwicke certainly helps to characterise *Twilight* as a film made by women for a primarily female audience. This is the significance of the *Twilight* films, the first especially, and the main reason why they are so routinely disparaged by 'serious' cinema commentators. Whereas Coppola's *Bram Stoker's Dracula* had opened the vampire film up to the deliriously high-speed world of adult erotic romance, the *Twilight* films filter it through the genre of a broken home/high school romance in a way that, by comparison, can seem to proceed at a snail's pace: which is precisely the point. They rely completely on the romantic attraction that develops, slowly and unevenly, between Bella – who has moved to Forks to live with her divorced father – and the two young men she is deeply attracted to, Edward and Jacob Black (Taylor Lautner).

Bella is certainly spoilt for choice here. She is cast as a special kind of girl in a number of ways, not least because she is the only character in the town whose mind Edward cannot

read, which adds to her mystique. But both Lautner and Pattinson are made *spectacular* in the *Twilight* films, directing female viewers to relish – and at times be amused by – their stunning male beauty. In *Twilight* and *New Moon*, Lautner's long, dark hair and soft features bear comparison with Brad Pitt's Louis in *Interview with the Vampire*. When he strips his shirt off in front of Bella, assisting her after she falls off his motorcycle and cuts herself, she is suitably awestruck: 'You're so beautiful!' Lautner spends most of the rest of *New Moon* and *Eclipse* without a shirt, his smooth bare chest gaining increased sexual significance for Bella – who goes on to tell him how 'hot' he is, etc. – and no doubt also for the films' predominantly female audiences. Pattinson is skinny and pale by comparison, but he is literally allowed to 'sparkle' in the films, the sunlight making him radiant (rather than destroying him). Bella is again suitably awestruck: 'You're beautiful!' she tells him, as if he didn't already know. A male model before the *Twilight* films, Pattinson was one of 5,000 boys auditioned for the role of Edward Cullen; he went on to be voted by readers of the celebrity-adoring *Vanity Fair* as 'the most handsome man in the world'.[31] It helped the franchise that Pattinson and Kristen Stewart became romantically involved in real life, their 'secret' entanglement as absorbing to gossip magazines as their girl–vampire romance on screen: much more absorbing than the real-life romance between Anna Paquin and Stephen Moyer, the principal actors in the more explicit, faster-paced television series *True Blood*, to which the *Twilight* films can also be compared (as another smouldering romance between a special girl and a vampire, and so on) and contrasted.

Bella's structural position in the *Twilight* films, as a special girl adored and fought over by two gorgeous young men, is conventional enough in the framework of women's romance. In the *Twilight* films, however, it is stretched in a number of interesting ways, and made unstable. Bella is the daughter of a benign but fairly inept police chief in the town, lower middle class. Edward is a vampire who is, by contrast, extremely rich, his 'family' – the Cullens – living away from the town in a plush, modern house in the forest. The house is another spectacular feature in the films, with its white walls and sheets of glass. In *Twilight* it is actually the so-called Hoke House located to the south in Oregon, designed by Jeff Kovel of Skylab Architecture ('We bring concepts to life', etc.), while in *New Moon* the Cullens are relocated to an Arthur Erickson-designed house in West Vancouver that went on the market at the end of 2009 for US$3.3 million.[32] When Bella is invited to dinner by the Cullens – whereas she eats burgers in the local café, they cook a trendy form of Italian – she is once more suitably awestruck: it is 'so light and open', she tells Edward, recognising immediately that his house is the complete opposite of a vampire's traditional castle. One of the peculiar things about *Twilight* is just how welcoming the Cullens are to Bella, with two exceptions, Rosalie (Nikki Reed, who co-wrote and co-starred in Hardwicke's *Thirteen*) and momentarily, Jasper (Jackson Rathbone), who as a 'newborn' vampire is still difficult to manage. The 'father', Carlisle (Peter Facinelli), is a surgeon, earnestly dedicated to saving lives rather than taking them, blending in and restraining his vampire urges – like an impossibly good version of Peina in *The Addiction*. Alice Cullen (Ashley Greene), who mostly seems to organise social events, embraces Bella as a 'friend'. The family are introduced as 'vegetarians' who only live on the blood of animals. They even play an all-American game of baseball. As far as Bella is concerned, these vampires could not be any less threatening (or any less like vampires). The poor girl/rich boy contrasts are sustained in a number of ways through the films: e.g. through the contrast of Bella's old truck with Edward's brand new cars. Even so, the substantial class barrier between them is casually breached, throwing up one of the films' biggest ideological fantasies. Edward

appears in Bella's bedroom as she sleeps, but he is also nice enough for her to introduce him to her father. She very quickly comes to recognise him as a vampire, something that doesn't seem to trouble her. 'How old are you?" she asks. 'Seventeen', he replies. 'How long have you been seventeen?' 'A while', he says. In fact, Edward is over a hundred years old. (Why he is still in high school remains the film's biggest mystery.)

Bella's encounter with Edward explicitly recalls the encounter of Eli (who doesn't go to school) and Oskar (who does) in *Let the Right One In* – except that the latter are preteens and remain that way for the duration of the film, while Bella is allowed to grow up and come of age. In fact, her problem is not that Edward is much older than she is, but that she will soon be older than *him*: this is what makes their romantic encounter catastrophic. In the *Twilight* films, vampires stay young and beautiful, which is why Bella wants to become one. At the beginning of *New Moon*, she has a frightening vision of herself as an old woman, which makes her all the more determined to get Edward to bite her. As her eighteenth birthday approaches, she is increasingly anxious about ageing: 'You're not going to want me when I look like a grandmother', she tells him. Her father jokes about the grey hairs on her head, only making things worse. Obsessed with ageing, Bella becomes increasingly reckless. By the end of *New Moon*, she is ready to sacrifice herself for Edward, unable to see any future for herself beyond her teenage years. *New Moon*'s various citations of Shakespeare's *Romeo and Juliet* (worth comparing with *Let Me In* in this regard) only work to destabilise their relationship still further, with their emphasis on separation, death and suicide. Bella's voiceover from the play at the beginning of the film ('These violent delights have violent ends …') and Edward's citation in class ('A dateless bargain to engrossing death …') arguably add more darkness to the film than the film itself.

While Edward is remote from Bella in terms of class, Jacob Black is remote from her in terms of ethnicity – although, again, this difference is casually breached as Bella and Jacob become increasingly intimate. A werewolf, Jacob is also a Native American, a Quileute: part of an actual northwest coastal tribe with a long and elaborate local history, some aspects of which are brought into the films. Jacob's father, Billy Black (Gil Birmingham), is a close friend of Bella's father Charlie (Billy Burke) and Jacob is cast as a childhood friend of Bella's before she left the town to live with her mother. In *Eclipse*, Bella is invited to hear the stories of a Quileute elder, just as she was invited into the Cullens' home: another reason to see this young white American girl as special. The Quileute tribe is given a mystical past (with 'magic in our blood') that intrinsically ties them to wolves, something that is also apparent in the real tribe's chronicles of its own mythology.[33] What is interesting in the *Twilight* films is that the relationship between the Quileute

tribespeople and vampires like the Cullens is represented as a story of colonial conquest and its aftermath. The elder's account in *Eclipse* describes the 'cold ones' making landfall, looking rather like the early Spanish colonisers, and massacring the tribe. When a Quileute woman sacrifices herself to save the remaining tribespeople, the vampires withdraw, but there is still a sense that 'something terrible is coming'. In an article on 'race and ethnicity' in a collection of essays on the *Twilight* franchise, Natalie Wilson reads the films 'as a racial allegory' in which 'a white, working class human chooses between an ultra-white, ultra-privileged vampire and a far less privileged wolf of colour'.[34] Although Bella couldn't properly be described as 'working class', the *Twilight* films certainly encourage this kind of reading. The Quileute werewolves resent the vampires just as the colonised resent their colonisers, and both honour a 'treaty' in the films that involves keeping to their own territories: the reservation (where Jacob goes to school) and the rest of America (since the vampires seem to move freely pretty much everywhere except where the Quileutes are situated).

One of the idiosyncratic things about *Twilight* is that Bella comes to learn all about vampires precisely through her contact with Native Americans like Jacob. She googles 'Quileute Legend' in the film – just as I did for this part of the chapter – and then goes to the 'Thunderbird and Whale Book Store' in Port Angeles (actually, a building in St Helens, Oregon) to consult a book on the subject. More googling reveals 'Apotampkin: the cold one', a misspelling of a mythological Native American vampire-like creature, Apotamkin. As she looks through her book, she discovers that vampires exist in many different locations (the list includes China, Egypt, India, Peru, Japan and the Pacific Northwest) and that they are strong, fast, immortal, 'cold-skinned' and drink blood. This is Bella's moment of recognition, the point at which she comes to know that Edward is a vampire. But it comes to her through a piece of Native American (rather than, say, Eastern European) folklore that she is never taught at school, which is more interested in Shakespeare, biological science and so on. To know about vampires, the film suggests, Bella first has to be made to excavate the kind of indigenous traditions that she would otherwise have no interest in at all, even though the reservation itself is not far away. Her task lends *Twilight* a kind of extracurricular pedagogical function; and she carries it out herself, without the usual ancient patriarchal figure (Van Helsing, Merrick in *Buffy*, etc.) to advise or teach or train her. The *Twilight* films are the only vampire films I can think of that establish a deep structural connection between vampires and America's indigenous people, inextricably linking them together through an almost buried coloniser/colonised paradigm. No wonder Edward and Jacob shadow each other so closely, each taking up long periods of screen time when the other is not there. And no wonder – when they *do* see each other – that they react so hysterically, so anxiously.

In this context it is perhaps understandable why Bella takes so long to choose between them, why she vacillates so much, unable to decide where her loyalties really lie as a modern white American girl who would normally have remained sympathetically remote from her country's colonial traumas. Jacob wears his ethnicity and his structural position as a Native American on his sleeve – or he would, if he ever actually wore a shirt. On the beach, Bella sees Jacob approaching. 'What, are you, like, stalking me?' she asks. 'You're on *my* res, remember?' he tells her, reminding Bella that she is indeed, for the moment, on someone else's property. In *New Moon* – where Edward is absent for most of the film – Jacob continually insists on the territorial distinctions between his tribe and the vampires: 'we can't touch your precious little Cullens, unless they violate the treaty'; 'The treaty says we

can only defend our own lands'; and so on. Bella tries to breach these racial divisions: 'You should switch school', she blithely suggests. 'Come and hang out with the pale faces …'. But even as he becomes more intimate with her, Jacob keeps asserting his racial and territorial difference. The antagonisms between vampire and werewolf are part of a race war, as well as a species war; or rather, the two are folded together here. Natalie Wilson is critical of the representation of the Quileute Native Americans as werewolves in the *Twilight* franchise, because it 'perpetuate[s] notions of indigenous people as noble but beastly savages'; she also criticises the use of Quileute legends 'to frame the wolves as Noble Savages who become the assimilated protectors of the Cullens'.[35] It can certainly be tempting to conflate the werewolf and the Quileute tribespeople in the *Twilight* films, but in fact their transformation into wolves is strategic, mostly a way of protecting their territory. There isn't much sense of the Quileute people as 'Noble Savages', just as there isn't a strong case to be made for their 'assimilation'; family members sometimes come into town and mingle with the locals, but they return to the reservation, too, and their distance from the township and the high school is constantly underscored.

On the other hand, Bella is instrumental in bringing Jacob and Edward – colonised and coloniser – together through their mutual determination to protect her. Far from moving freely across borders, Edward more or less keeps to himself, remaining with the Cullens. Jacob behaves in the same way, remaining with his tribe or community. But Bella summons them both, drawing them out of their respective places and putting them into proximity with each other as if for the first time. She literally *excites* them, bringing them out of themselves; and they excite her in turn. In *New Moon*, Jacobs warns her, 'You're about to cross a line, Bella.' 'Then don't draw one', she replies. Her role in the *Twilight* films is thus a transgressive one, bringing people together who should otherwise remain apart. As a consequence, the love triangle between Bella, Edward and Jacob is remarkably fragile and volatile: not *quite* catastrophic ('something terrible is coming'), but close to it at times. She finally chooses Edward, of course – how could her own ethnic, demographic predicament do any differently? – but not before the vampire/coloniser is suitably humiliated by the werewolf/colonised in a fascinating scene in *Eclipse*. Under attack by rogue vampires, Jacob carries Bella through the forest to higher ground, where Edward – who has proposed marriage to her several times over now – has prepared a tent for her to spend the night in. Inside, Bella is freezing cold and can't sleep. 'I am hotter than you', Jacob proudly tells Edward, sliding his body next to hers. His powerful chest and torso bared once more, Jacob holds Bella close against his skin while her vampire fiancé looks miserably on, helpless. 'I really get under that ice cold skin of yours, don't I?' Jacob tells Edward, taunting him

as he literally sleeps with Bella. It is as if the vampire/coloniser is reduced to a kind of impotent voyeur here, his rightful position in this version of the vampire-in-the-bedroom scene (i.e. beside his white American bride-to-be) usurped by a subaltern.

Jacob certainly destabilises the romance between Bella and Edward; the next morning, Bella kisses him passionately against a romantic background of snow-covered mountains, telling him, 'I don't want to lose you … you're too important.' The *Twilight* films keep returning to Jacob as another possible love interest for Bella as if she is drawn to polar opposites (cold/hot, vampires/werewolves, coloniser/colonised) simultaneously. 'I love you more' is the best she can do for Edward, making sure that Jacob remains romantically significant in her life. Both Edward and Jacob play out a citational role in these films, summoning Bella, arousing her, exciting her; but Jacob's notion of 'imprinting' himself on Bella (which seems to be something much more than just sexual influence) is especially interesting in this respect. The *Twilight* franchise is usually seen as advocating a sexually conservative morality: virginity, restraint, fidelity, no sex before marriage, men 'protecting' women, and so on. In *Eclipse*, Edward admits that he is 'old school' about romance and wants to propose to Bella properly, asking her father for permission – but this seems quaint to Bella and gets in the way of her own sexual urges. Both he and Jacob insist on 'protecting' her, but this is also represented in the films as too obsessive, a bit creepy: like 'stalking'. On the one hand, Bella is under Edward's spell, unable to stop thinking about him when he is away from her. On the other hand, she is cast as strong and determined, even wilful. 'Take control', she advises a friend in *Twilight*, 'you're a strong, independent woman.' Even as Edward and Jacob watch over her, Bella takes risks. At her most desolate in *New Moon*, she finally goes to the cinema with her friend Jessica, who provides an informed, humorous commentary on zombie films. Coming out of the cinema afterwards, some bikers call the girls over. Bella walks towards them and one of the bikers takes her for a ride through town. Bella's 'rush of danger' is designed to attract Edward, but she sees it through to the end and in fact becomes interested in motorcycles soon afterwards, helping Jacob to fix them up in his garage. The *Twilight* films constantly trigger the possibility of sexual threats or abuse even as they pursue a chaste, restrained romance between the central characters. When Bella buys her Native American book in *Twilight*, she is followed by some men. 'Don't touch me!' she cries, as they threaten her; she knees one of them in the groin before Edward turns up in his car to whisk her away. 'You don't know the vile, repulsive things they're thinking!' he complains, as if Bella is even more unworldly than he is. Later, Bella is blackmailed and sexually threatened by James, who callously films his abuse of her. Several sub narratives of sexual violence appear elsewhere in the films, too. Rosalie's backstory in *Eclipse* involves her rape by a group of rich young men, for example, including her fiancé; transformed into a vampire in a bridal costume later on, she tells Bella, 'I got my revenge on them, one at a time.' It is rarely noted that the *Twilight* films play host to a rape-and-revenge narrative, which also functions as a cautionary tale for Bella who casually ignores it. Beautiful boys can also be abused in these films. Jasper's backstory involves meeting three ruthless vampire women, one of whom later cruelly uses him to train and kill 'newborns' before they can properly grow up. Again, Bella seems to miss the point of the story.

In *Eclipse*, Jacob forces a kiss from Bella, who punches him in the face and breaks her hand; later on, she *asks* him to kiss her and seems to have forgotten the earlier event altogether. The *Twilight* films put a teenage girl into a series of precarious, contradictory positions: obsessed with a vampire but interested in someone else, vulnerable at times

but determinedly stubborn at others and so on. The first three films in the series under discussion here show a romance between girl and vampire slowly coming together through some of the most clichéd images in romantic cinema – the field full of yellow flowers that Bella and Edward lie in, for example, or their prom night dance that sees them magically isolated from everyone else, the camera swirling around them as if to emphasise the dizzy splendour of the event. Even so, there are things that can surprise and disturb all this, as I hope I have suggested. The vampires themselves are a rough assemblage of wildly disparate features: the impossibly good Cullen family (restrained, self-denying, etc.), various marauding, predatory vampires (James, Victoria), and the Volturi, who are an anomaly in the *Twilight* films, a group of dark, ancient vampires who enforce vampire law from their coven in Tuscany (actually, the town of Montepulciano in *New Moon*, where they first appear). Bella flies to Italy in *New Moon* – there is an amusing product placement for Virgin airlines – to save Edward who seems to think Bella is dead and, Romeo-like, wants the Volturi to execute him. Their leader Aro (Michael Sheen) is impressed with her determination and gives her his blessing, like a sort of grinning priest. The Volturi turn up again in *Eclipse*, where the powerful teenage vampire Jane (Dakota Fanning) – who had already tortured Edward – tortures and kills a young 'newborn' girl. It is as if the chaste romance between Edward and Bella keeps on throwing up other, contrary predicaments that will fold back onto them, reflecting their relationship in some distorted way.

Directed by David Slade – also the director of the Alaska-based 'feral' vampire film, *30 Days of Night* – *Eclipse* is built around Victoria's pursuit of Edward in revenge for the killing of her wayward boyfriend James in *Twilight*. Edward finally kills Victoria: bringing that vampire romance to an end, even as he is immersed in one himself with Bella. As a vampire, Edward is also contradictory, as he often notes: saviour and destroyer, protector and stalker, gentle lover and enraged aggressor. While he is away in Italy in *New Moon*, a besotted boy at school, Michael (Michael Welch), asks Bella to see a film with him at the local cinema. 'No romance', Bella insists, going against the grain of her own genre as well as dampening Michael's hopes. In fact, she wants to see a tougher, more ruthless kind of film: 'How about *Face Punch*', she asks him, 'have you heard of that?' It is as if the title of this make-believe film anticipates what she will do to Jacob when he forcibly kisses her in *Eclipse*. In the event, Jacob joins them in the cinema and the two boys sit on either side of Bella, watching the bloodthirsty action movie as they wait in vain for her to make the first romantic move. The *Twilight* films have very little blood and gore in them, true to their PG rating: when vampires are killed, they seem to turn to statues, for example. Bella is one of the few characters in the films whose flesh is cut several times over. The joke behind this particular sequence is that Bella and the others are watching the exact opposite of the film they are starring in. As they sit together in the cinema, it is as if Michael takes the place of Edward for a moment, competing with Jacob for Bella's affections. But the film proves too much for him: the blood and gore make him rush out of the cinema to throw up, much to Bella and Jacob's disgust. This is the *Twilight* films' 'cinematographic' moment, except that the vampire isn't there (although – recalling Coppola's film – there is a wolf, sort of) and there is no seduction. Just as the *Twilight* films make some space for a rape-and-revenge narrative, so they make space here for a bloodthirsty action movie that is everything the films themselves can't be, or show. Michael is a pale (or, even paler) substitute for Edward, sent packing from the cinema in a laughable scene, leaving Bella alone with Jacob who is now, as she notes, 'really hot … like you have a fever'. It is a rare

moment of self-parody in a franchise built to a considerable degree around the fetishising of a beautiful, banal male vampire. But with Edward literally out of the picture, it is Jacob who usurps his place once again, remaining with this make-believe movie – and Bella – until the end.

Cronos

The American vampire films discussed so far have been about secular life in the north of the United States, about socially displaced characters who find their lives radically changed either through promiscuous, fleeting encounters – what is sometimes called 'stranger intimacy' – or more or less monogamous, prolonged romances. The effect of these encounters works both ways: it changes the vampire (Nadja, Edward, etc.) as much as it changes those characters with whom the vampire comes into contact. The secular, atomised framework of these encounters also means that the films I have discussed so far don't really draw on the kind of religious symbology one might tradition-ally associate with vampire films: churches, crosses and so on. But the further south we go – down to Mexico, for example, the second-largest Catholic community in the world – the more visible Christian iconography becomes as a way of organising and encoding vampire films. Guillermo del Toro's vampire film *Cronos* (1993) is a striking example, with its symbolically named, ageing protagonist, Jesus Gris (Federico Luppi), the owner of a cluttered old antiques shop in Mexico City. Del Toro was born in Guadalajara, Mexico, growing up in a strict Catholic family. *Cronos* was his first written and directed feature film and used the special effects production company he had co-founded, Necropia, for its elaborate instruments and make-up. It took a long time to secure funding from Mexico's National Council for Culture and the Arts and the Mexican Institute of Cinematography, something del Toro blamed on the fact that *Cronos* is a genre film, rather than an 'art film'.[36]

In an interview, del Toro has suggested that horror is a 'brave genre', especially in Mexico; on the other hand, he has also made a point of bringing horror and the 'art film' together:

> I believe horror is art. I believe and I love and I put as much care, calculation, planning, sketch-ing, thinking on horror as other people would put into what is called an 'art film'. I really killed myself over subjects that other people do for a quick buck.[37]

As a part of this process, Catholic imagery is meticulously signposted throughout *Cronos*, integral to the film's carefully arranged set pieces and *mise en scène*. But the film is about an elderly man called Jesus Gris who is resurrected as a vampire, and the clockwork device that turns him into a vampire is concealed inside the statuette of an angel. Religious iconography is therefore folded into this vampire film as if the sacred and the profane are no longer distinguishable. Perhaps this is specific to the *Mexican* vampire film. Del Toro has said that 'in Mexico I was exposed to a lot of brutal images and situations … plus the very gory religious imagery we have in Mexico combined to give me a very inti-mate relationship with death at an early age'.[38] For David Greven, del Toro's films compare to the work of Luis Buñuel in this respect, the Spanish-born film-maker who came to Mexico in the 1940s. 'Like Luis Buñuel', Greven writes,

Del Toro uses Catholic imagery satirically, but his satire has a spiritual dimension. The ache of the past, the longing for more life, the terrible fusion of the divine and demonic – all lie in del Toro's crazy-Catholic horror sensibility.[39]

Interestingly, the actor Claudio Brook, who plays the wealthy, dying capitalist Dieter de la Guardia in *Cronos*, had also been a favourite actor of Buñuel's, starring in a number of his films including *The Exterminating Angel* (1962).

Cronos is a remarkably different kind of vampire film that nevertheless shares certain generic features with many of the vampire films already discussed. It begins, typically (if we think of *Bram Stoker's Dracula*, *Frostbitten*, *Night Watch* and *Day Watch*, *Buffy the Vampire Slayer*, etc.), by staging a deep historical moment that works as a prologue to the modern-day events that follow. The accented voiceover here begins over the ticking of a clock:

> In 1536, fleeing from the Inquisition, the alchemist Uberto Fulcanelli disembarked in Veracruz, Mexico. Appointed official watchmaker to the Viceroy, Fulcanelli was determined to perfect an invention which would provide him with the key to eternal life. He was to name it the Cronos device. Four hundred years later, one night in 1937, part of the vault in a building collapsed. Among the victims was a man of strange skin, the colour of marble in moonlight. His chest mortally pierced, his last words … *Suo tempore* ['at its own time', or, 'everything happens at its own time']. This was the alchemist. The authorities located the residence of the dead man. What they found there was never fully revealed to the public. [The scene cuts to a room in a large house, with bowls of blood on the floor. It pans back to reveal a naked body hanging upside down.] After a brief investigation, the mansion and its contents were sold at public auction. Never on any list or inventory was the Cronos device mentioned. As far as anyone knew, it never existed.

In present-day Mexico City, Jesus Gris lives with his wife Mercedes (Margarita Isabel) and granddaughter Aurora (Tamara Shanath). With Aurora to keep him company in his antiques shop, Jesus is surprised when cockroaches begin to pour out of the eye of an old porcelain angel he had recently unwrapped. He opens the statuette up and finds the Cronos device, a golden, scarab beetle-shaped clockwork object that fascinates him. Winding it up, he puts it on the palm of his hand. Suddenly, sharp legs sprout out of the side of the device and clasp his hand tightly, and a scorpion-like tail pierces his skin.

The embellished Cronos device is clearly meant to carry with it the history outlined in the prologue. Forged during the brutal Spanish conquest of Mexico, no doubt with Aztec gold, it offers a buried (or perhaps, a razor-sharp) image of the blood-inducing vampire/ coloniser that is not all that far away from the Quileute elder's story about the 'cold ones' in *Eclipse*, with both films tracing their vampires back to America's founding colonial moments. But the device is also part of the film's 'crazy-Catholic horror sensibility', a machine that is partly organic, with a large insect at its centre that comes to life when the clockwork is wound up. In the film, the dying capitalist Dieter de la Guardia wants the device for himself, getting his nephew Angel de la Guardia (Ron Perlman) (who turns out to be an exterminating – rather than a guardian – angel) to steal it from Jesus. The ageing De la Guardia owns a working factory in Mexico City, which Angel is set to inherit when he dies. But the old man – who lives down in the factory basement, in a clinical room

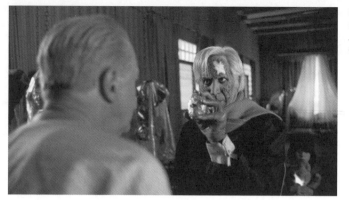

where some of his decaying body parts are preserved in plastic bags – wants the Cronos device to extend his life. He might recall Paul Virilio's description of the later life of Howard Hughes, 'a kind of *technological monk*' hidden away from the world, obsessed with his own (im)mortality.[40] When Jesus visits him, De la Guardia explains the 'strict rules' behind the Cronos device and gives the insect trapped inside it a peculiar religious significance. 'Who says insects aren't God's favourite creatures?' he tells Jesus. 'Christ walked on water just like a mosquito. The resurrection concept is not foreign to ants, or to spiders. They could survive for hundreds of years … until someone comes along and sets them free.' De la Guardia's conceit is a bit like the tick Giorgio Agamben had described – which I noted in Chapter 2 – kept alive for eighteen years in suspended animation as if 'the world seems to stop'. I have noted already that vampires in the modern world in new vampire cinema – far from being able to move about freely and so on – are in fact condemned to a particular form of living that is precisely about registering the loss of one's freedom. Edward in the *Twilight* films is not especially unusual for a modern vampire in this respect: excessive in some ways, but constrained – and *restrained* – in most others. De la Guardia's delusion in *Cronos* is that he thinks the insect in the Cronos device can ultimately be 'set free'. But the insect is itself condemned to live in a particular way over and over, as the device is wound up once more and it is brought grindingly back to life. Del Toro has recognised this defining aspect of the vampire in his own comments on the insect, which also interestingly recall Agamben's example:

> I wanted to show a vampiric chain that went all the way to the insect locked within the device. That's the ultimate vampire and the ultimate victim. It is locked there like a living filter and is at the same time the master and the slave … . [My] entomological fascination goes all the way to the inside of the device, as I wanted to have the point of view of the insect. The insect is based on a prehistoric tick.[41]

In an interesting, dense essay on *Cronos*, John Kraniauskas draws out the implied connection between the mechanical device and the 'colonial plunder' of Mexico, seeing it as a kind of phantasmagorical representation of both the subjected bodies of the oppressed and the developing machinery of modern capitalism. 'The story of Jesus's body', he writes (meaning the film's protagonist),

New Vampire Cinema

is inseparable from that of the Cronos device – made from (presumably Aztec) gold by an alchemist in colonial New Spain, and shot, David Lynch-like, as a 'mini-factory' – and the insect-like organism that inhabits it and lives on blood (the 'real' industrial vampire).[42]

The links between the insect in the machine, Jesus and the body of the vampire form a peculiar symbolic chain that spreads itself through the film. The body of Christ is also invoked here, as is the body of the capitalist; the 'late capitalist' who just seems to get older and older, in an advanced state of 'degeneresence' (to recall Derrida's term in Chapter 2), but persistently refuses to die. De la Guardia is therefore also a kind of ageing vampire, rising up from his veiled bed and hobbling around in his dark dressing gown, as much imprisoned in his own factory basement as the insect is in the clockwork device. 'Half my body is here inside this display case', he tells Jesus, as if he already resembles the insect, master and slave, still giving orders (to Angel) and yet in an advanced state of decay – the blade on the end of his cane also mirroring the Cronos device's scorpion-like sting.

Cronos is about the struggle of two old men – Jesus and De la Guardia – over the limits of their own mortality. Like so many vampire films, it puts both men into a potentially catastrophic relationship with someone much younger: De la Guardia's violent nephew Angel, and Jesus's granddaughter Aurora. Aurora is a delightful character in the film, accompanying Jesus everywhere and silently witnessing his transformation into a vampire. Their relationship might compare with Eli and Hakan in *Let the Right One In*, except that in *Cronos* it is the young who provides for the old, not the other way around. After Angel beats him to death, Jesus rises from the dead and leaves his coffin, returning home. Aurora greets him, realising that sunlight burns his skin. In a wonderful scene, she empties her toy box and lets him climb inside, closing the lid over him; he sleeps there, cuddling one of Aurora's dolls. It is as if the child is intimately tied to the vampire's predicament, calmly acknowledging its ghastly effects, perhaps already recognising them for what they are. Later, she accompanies Jesus to De la Guardia's factory, carrying the Cronos device, her teddy bear and a green fluorescent light (in her mouth). 'I don't want to be eternal', Jesus tells the old arch-capitalist, 'I just want to get out of this!' When De la Guardia stabs him with his blade, Aurora hits him over the head and almost kills him, saving her grandfather's life. Angel returns to finish his uncle off ('Mine, mine … everything is mine!' he cries as he kills him), and then goes in pursuit of Jesus and Aurora in a scene that takes place on the rooftop in front of the factory's large neon sign. When Jesus and Angel fall to their deaths, Aurora puts the Cronos device on her grandfather and once again he rises from the dead. Drawn to her bleeding hand, Jesus kneels over her as if he is about to feed. She speaks for the first time in the film, a single word: *abuelo*, or 'grandfather'. Horrified at what he has become, Jesus destroys the Cronos device and repeats his name over and over as he begins to die. The final scene of the film is beautifully sentimental, with Aurora and Mercedes sitting beside Jesus's deathbed, loving him and mourning him: entirely the opposite of so many vampire films (*Thirst*, for example) where the vampires die alone, consumed, outside the consoling framework of the family circle.

In *Cronos*, Mexico City is a counterpoint to the frenetic kind of New York we saw in *Nadja*, *The Addiction*, *Vampire's Kiss* and so on. This dark, quiet and strikingly underpopulated city is (again typically for many vampire films) introduced panoramically at the beginning of the film, but the street signs we glimpse seem to be in Chinese, English, Russian: not Spanish. For the film reviewer Paul Julian Smith in *Sight and Sound*, *Cronos* invokes 'an eerily deracinated Mexico City where Argentine tangos … collide with Russian

street signs and dialogue alternates between Spanish and English'.[43] The film's principal actors are themselves racially mixed, spread across the Americas: not just Mexico (Tamara Shanath and Margarita Isabel), but also Argentina (Federico Luppi) and Jewish New York (Ron Perlman). Ann Marie Stock notes that Guillermo del Toro works in both Mexico and Hollywood, and that a film like *Cronos* reflects this through its 'migrancy and hybridity' and its use of both Spanish and English in its dialogue.[44] For Tim Lucas, *Cronos* is in fact a plethora of cinematic citations and influences, none of which have anything to do with Mexico at all: referencing, for example, 'any number of David Cronenberg films', or Orson Welles's *The Stranger* (1946), which famously closes with a struggle between two men and a woman in a church clocktower.[45] We might add other films with rooftop struggles to the list, like Hitchcock's *Vertigo* (1958) – del Toro in fact wrote a book about Hitchcock, in Spanish.

Of course, *Cronos* also directly cites several vampire films: the scene where Jesus licks up a tiny puddle of blood from a bathroom floor explicitly recalls a similar moment in Paul Morrissey's *Blood for Dracula*, for example.[46] For some reviewers, all this means that there is in fact nothing particularly 'Mexican' about *Cronos* at all. Jonathan Romney has noted the argument that the film 'is an allegory of Mexico's relations to the US and to Europe', through the Spanish colonial route into Mexico taken by the alchemist and through the 'powerful industrial predators who are presumably American'; but he adds, 'It's hard to buy this internationalist reading … since the film doesn't do much to activate it. Despite the tango music that runs throughout, there's little sense of *Cronos* really being set in Mexico City.'[47] The tango, of course, is not historically associated with Mexico; on the other hand, Claudio Brook, who plays the 'powerful industrial predator' Dieter de la Guardia, was not American at all: he was a Mexican actor, born in Mexico City. If there is an *industrial* struggle in the film (as opposed to a struggle over the Cronos device), it is between the old De la Guardia and the American nephew he completely depends upon to provide him with food and so on, and who finally kills him, inheriting his factory. It might well be possible to read *Cronos* as a national allegory in the light of all this – although such a reading carries with it an often unresolved interpretive problem that I have drawn attention to across a number of other vampire films under discussion elsewhere in this book. Del Toro himself has certainly seen the film in this way, however, and his comments are worth adding here. 'I wanted to show the vampiric relationship between the nephew and the uncle', he has said,

> and of course the vampiric relationship between Mexico and the United States. This is why the date in the movie – which we see on a newspaper – is 1997, even though the film was made in 1993. I wanted it to be set in a post-NAFTA [North American Free Trade Area] Mexico.[48]

Cronos was in fact released on the eve of Mexico's absorption into NAFTA, which was designed to do away with trade barriers between Mexico, the United States and Canada. The struggle between a decrepit old Mexican capitalist, trapped in the basement of his factory, and the violent, narcissistic American nephew who inherits everything does indeed give the film an allegorical, and satirical, edge. The role of Jesus in all this, however, is more obscure. He has nothing to do with the industrial struggle between uncle and nephew; his struggle with De la Guardia is over the Cronos device and eternal life. It is tempting to read Jesus allegorically too, as an emblem of Old Mexico that is finally and sentimentally put to rest at the end of the film – except that he is played by an Argentinian actor. As we have

New Vampire Cinema

seen with other vampire films, the (national) allegorical reading holds together in some respects, and comes undone in others.

The *From Dusk Till Dawn* trilogy, the *John Carpenter's Vampires* trilogy

North America has certainly been striated with vampire films. Even the *Twilight* films – built mostly around home and high school in a small American country town – send Bella right across the country, taking her to her mother in Florida and suggesting in *Eclipse* that she might at one point make her way up to Alaska (a nod, surely, towards the director David Slade's other vampire film, *30 Days of Night*). On the other hand, Bella doesn't get very far on a motorcycle: a couple of short, ill-fated trips down the street is the best she can manage. In the 1980s, films like Joel Schumacher's *The Lost Boys* (1987) and Kathryn Bigelow's *Near Dark* (1987) linked their conflicted teenage American vampires to motorcycle gangs, dusty leather jackets and a badass outlaw life on the road that mixed the swagger of the American wild west ('young guns', etc.) with the romantic legacy of Dennis Hopper's *Easy Rider* (1969). J. S. Cardone's more recent vampire road movie, *The Forsaken* (2001), restages these things all over again, although its bloodthirsty young American vampires are for some reason also connected to eleventh-century French crusaders. Some vampire films continue to journey right across the United States, like Jim Mickle's post-apocalyptic Manichaean vampire film *Stake Land* (2010), which finally allows its persecuted, folksy protagonists to find solace (again, inexplicably) across the border in Canada. A few vampire films take their characters in the opposite direction, however, bringing them down to Mexico. The last section of this chapter looks at a series of what we might call 'Tex Mex' vampire films that literally run these associations between vampires, outlaws, badass behaviour and the old American frontier into the ground. These are drive-in movies, shot in lurid colour with low-level special effects, overloaded with weaponry and action and peppered with gratuitous moments of female nudity and sex. Most of the films I have discussed so far are built around the life and death of a single vampire, or perhaps a small number of them. Here, however, vampires come in hordes, or perhaps swarms; or rather, since they are sometimes first seen in the form of aggressive little bats, as colonies, or clouds (a 'cloud of bats'). Rather than moving inexorably towards a single, climactic death (as in *Cronos*, for example, or *Thirst, Bram Stoker's Dracula, Queen of the Damned* and so on), these 'Tex Mex' vampire films therefore stage more or less continuous scenes of vampire destruction, in all its over-the-top, eye-popping glory: buckets of fake blood and oozing green slime, dismembered limbs, decapitation, stakes through the forehead, mutilation, incineration. These are 'splatter' films, relishing their high levels of gore and graphic violence. With their characters facing the onslaught of one horde of feral vampires after another, they owe a great deal to zombie films like George Romero's trilogy *Night of the Living Dead* (1968), *Dawn of the Dead* (1978) and *Day of the Dead* (1985). They could not be more different from the bloodless, choreographed forest battles of the *Twilight* films; as late-night films, Bella might sit through them, but they would send Michael rushing out of the cinema.

From Dusk Till Dawn (1996) – the title pays tribute to Romero's films – was one of a number of collaborations between Quentin Tarantino, who had written the screenplay six

years earlier, and the Mexican-American, Texan-born director, Robert Rodriguez. Tarantino's reputation as a director is built around a series of 'postmodern' representations of contemporary American outlaw figures as both honourable and deranged, cine-literate and deadpan, passionate about popular culture and social etiquette while capable of breathtakingly brutal violence. His films have routinely been celebrated as the 'cinema of cool',[49] although they also have their detractors. In his article on *The Addiction*, Justin Vicari in fact contrasts Tarantino unfavourably with Abel Ferrara, as less 'authentic', much more 'media-savvy' and self-promoting. 'If Ferrara was rooted in New York', he writes,

> then Tarantino represented the flashy New World of L.A. – glossier, shallower, more plastic. Tarantino's films won over audiences by winking at them. What he often likes to have his characters say, '*Be cool*, suggests a congratulatory message to the audience, as if saying: '*You* are so cool to be here, watching this'. Ferrara, far more immersed in his 'bad-ass' material, never seemed interested in congratulating anyone.[50]

Tarantino's collaboration with Rodriguez took him away from Los Angeles, however, across the border into Mexico: towards something much less 'glossy' but no less inauthentic. In *From Dusk Till Dawn*, he split his generic deranged/honourable character traits in two by casting himself as Richard Gecko, the pathological, nerdy brother of the more thoughtful Seth (George Clooney): this was Clooney's first major Hollywood role. The film begins with a local sheriff in a liquor store chatting to the shop assistant, unaware that Seth and Richard – two bank robbers on the run – are nearby. 'I will turn this place into the fucking Wild Bunch if I think you are fucking with me!', Seth tells the shop assistant as the sheriff leaves for a moment. (He also tells him to 'Be cool.') Sam Peckinpah's ultraviolent *The Wild Bunch* (1969) – filmed on location in Mexico – is certainly an influence on this film. As if taking Seth at his word, Richard executes the sheriff and the scene turns into a frenetic, panic-stricken shootout that ends with the shop assistant's incineration, although he lives on for a few moments through the flames: a scene that gestures towards what is to come.

From Dusk Till Dawn begins as if it is an outlaws-on-the-run film, built around a string of dusty cars, liquor stores, motels and long, straight roads that pass through the overheated Texas badlands. Seth and Richard take three hostages with them: Jacob (Harvey Keitel), a pastor who has lost his faith, and his two teenage children, the slow-talking Kate (Juliette Lewis) and Chinese-American Scott (Ernest Liu). Crossing the border into Mexico, they come across a kind of strip joint/bar called, unsubtly enough, 'Titty Twister', where the bank robbers are to have a rendezvous with Carlos (the Mexican-American comic actor Cheech Marin, who has several roles in the film). The complexion of the film changes completely at this point. The bar is luridly coloured with red neon flames, full of topless female dancers and muscular, tattooed men. An exotic snake dancer appears, Santanico Pandemonium (the Mexican-born Salma Hayek), but during the act Seth and Richard are involved in another shootout. Richard's bloodied hand seems to arouse Santanico; suddenly, she turns into a vampire and bites him on the neck. The sneering bartender Razor Charlie (Danny Trejo, another Mexican-American actor) and the rest of the dancers and bar staff turn into vampires, too, and mayhem ensues. Other outsiders get involved: a murderous African-American Vietnam veteran, for example, played by Fred Williamson, well known for his roles in a number of 'blaxploitation' movies from the 1970s. Bats flood into the bar and as the vampires attack, almost everyone is bitten and turned – and killed – including Jacob and Scott. It is as if the 'Titty Twister' is a kind of giant Venus

New Vampire Cinema

Robert Rodriguez,
From Dusk Till Dawn
(1996): Richard, Seth
and Santanico
Pandemonium in the
'Titty Twister'

flytrap, drawing its Americans in and turning them to liquid, along with almost everybody (or everything) else. When Carlos finally arrives and opens the bar doors, letting sunlight in and killing all the vampires, only Seth and Kate emerge: a couple that might yet be romantically linked. In the final shot of the film, the Mexican bar is shown to be built on the top of an ancient Aztec temple which has sunk into the ground.

It might be surprising to know that *From Dusk Till Dawn* was released by Disney-owned Miramax, which provided its US$18 million budget; interestingly, it was also notorious for using a non-unionised technical crew, which earned it a union boycott. There is something reactionary about this film – and probably all of Tarantino and Rodriguez's films, for that matter – which sees 'Mexico' invoked as a decadent, primitive fantasy space that is literally a dead-end for almost everyone who goes there. There is no 'national allegory' here, no attempt – in spite of the ethnicity of some of its cast – to mobilise any cultural/ political comment on Mexico's relations with the United States, for example. The ancient Aztec temple at the end simply mystifies the strip joint/bar, taking it out of the present day into some distant, 'buried' past: the opposite trajectory of many of the vampire films I have discussed so far. Geoff King has discussed this film purely in terms of genre, making the fairly obvious point that it suddenly changes halfway through from a 'sadistic-comic thriller' to a 'vampire-schlock-horror' film.[51] For King, genre is about a film's 'presumed appeal to viewers', a way of answering their tastes and expectations. 'Splattered gore and explicit violence are not just allowed but expected in the modern horror film', he writes, just a few years before the *Twilight* films took the genre about as far away from these things as it could go. It looks as if King celebrates *From Dusk Till Dawn* for its 'genre bending', something he associates with 'New Hollywood Cinema'. But he also notes that switching genres midstream can frustrate viewers, who are not able to see their commitment to characters through to the end. 'One of the edgy-black-comic-thriller characteristics of *From Dawn to Dusk* [*sic*]', King writes – reflecting the film's generic midterm change in his unconscious reversal of its title – 'is a degree of uncertainty about likely sources of allegiance'.[52] On the other hand, the encounter with vampires in Mexico is *meant* to be catastrophic, with Americans like Jacob – fleeing a broken marriage and the loss of his Christian faith – the least likely to survive. What holds the two otherwise separate parts of *From Dusk Till Dawn* together, though – apart from the 'dirty' guitar music that plays all the way through – is its commitment to a trash or pulp aesthetic that is already associated with its 'Tex Mex' setting. Just as Fred Williamson is there as an overwrought citation from 1970s blaxploitation cinema, so the 'Mexican' part of the film is a prolonged, delirious homage to that country's pulp cultural traditions: to what Doyle Greene has in fact called

Mexploitation cinema, those censorship-testing horror films from Mexico introduced into the United States through the drive-in and late-night television during the 1960s.[53] Mexico is itself a citation in *From Dusk Till Dawn*, a fantasy space that restages, and literally contains, that country's threatening/seductive/lurid pulp aesthetic. Like the strip joint/bar to which it is synecdochally tied, it opens its doors to Americans, good or bad, and summons them inside.

Scott Spiegel's *From Dusk Till Dawn 2: Texas Blood Money* (1998) sees Tarantino and Rodriguez move to the roles of executive producers and the budget substantially reduce, down to around US$5 million. In this film, bats swarm a lift and kill two lawyers in an opening scene that has nothing much to do with the rest of the movie at all, except for the fact that it enjoys the sound of a woman screaming. Buck (Robert Patrick) gathers together a small band of criminals to do one last bank job, although ageing Texas Ranger Otis (Bo Hopkins) soon comes after him. In this likeable but rudimentary sequel, one of the bank robbers is called Jesus (Raymond Cruz): a muscular, crazy young Latino with 'Pit Dog' tattooed on his chest and 'Byt Mee' on his car's numberplate, who could not be more different to his namesake in del Toro's *Cronos*. Bats soon upset the bank robbers' plans: there is even a parodic restaging of the famous shower scene in *Psycho* (1960) in this film, with a bat doing the work of Norman Bates and, as in Hitchcock's film, triggering another woman's prolonged scream (as well as a joke: 'Looks like a goddam bloodbath!' says one of the Texas Rangers afterwards). Before the woman is killed, the bank robbers watch some porn in a hotel room. 'This movie's very bad quality', Jesus says, and others agree. 'When I care more about the characters', someone else adds, 'I care more about the fucking!' It isn't clear from this film if it wants to resemble bad porn or distinguish itself from it, since its own characters are themselves so sketchily drawn. In a brief, digressive story about a boyfriend who storms into a porn-movie set where his girlfriend is the star and kills everyone, Scott Spiegel interestingly casts himself as the porn movie's director: as if he, too, can't quite make up his own mind on the matter. After a long shootout and bloodfest outside a Mexican bank, Buck wonders why the 'Titty Twister' vampires would be so interested in the bank robbers. 'I suppose vampires need money just like anybody else', he tells Otis. This film seems finally to replicate the narrative structure of porn, working itself up to a foamy climax (as vampires decompose and turn to liquid) and then more or less petering out altogether, exhausted, as Buck and Otis smoke and talk and Otis finally drives away.

The well-respected film director P. J. Pesce's *From Dusk Till Dawn 3: The Hangman's Daughter* (2000) is much more interesting, building its outlaw/vampire narrative around an actual historical event: the mysterious disappearance of the American writer Ambrose Bierce, who had travelled to Mexico in 1913 to join the Mexican revolutionary, Pancho (or Francisco) Villa. In this film – the screenplay is by Alvaro Rodriguez – Bierce (Michael Parks) dreams of his own execution by Mexican soldiers. In the meantime, the ruthless but charismatic outlaw Johnny Madrid (Marco Leonardi) is about to be hanged but manages to escape in a shootout, taking the hangman's daughter Esmeralda (Ara Celi) with him. Later on, Madrid and his gang hold up the coach Bierce and a newly married preacher and his wife are travelling on. Abandoned in the desert, Bierce and the couple make their way to a ruined old building which has the name 'la tetilla del diablo' (the devil's nipple) engraved on its wall: this is, of course, an early version of the 'Titty Twister'. Going inside, the place lights up and Razor Charlie appears behind the bar. The preacher and his wife are like the lost young couple in *The Rocky Horror Show* (1975), innocents who are

appalled by what they see; later, however, the preacher is willingly seduced by an older exotic dancer, Quixla (Sonia Braga). Other outlaws arrive and enjoy the libidinal delights in a scene that recalls Jonathan Harker and the three vampire women in *Bram Stoker's Dracula*. When Johnny and Esmeralda arrive, along with Esmeralda's brutal father, the vampires attack, taking Esmeralda away with them; in a ceremony, she is revealed by Quixla to be the vampire princess, Santanico Pandemonium. More gory killings and dismemberments follow, until Bierce and Johnny Madrid emerge from the building into the sunlight. Esmeralda, left behind as a vampire, calls out, 'Johnny, don't leave me!' This prequel to the other two *From Dusk Till Dawn* films is a kind of reconfiguration of Bierce's famous story, 'An Occurrence at Owl Creek Bridge' (1891), which it cites at the beginning: a story about a Confederate sympathiser (just as Bierce is in sympathy with Mexican revolutionaries) who imagines, wrongly, that he has escaped his own hanging. But it is Esmeralda who is condemned in the film, as Bierce and Johnny walk away. It is typical of the misogyny of these Tex Mex vampire films that men are free to take to the road, while women remain at home or in the strip joint to be exploited. But this is also a generic feature of the vampire film broadly speaking, as I have from time to time wanted to suggest: that to become a vampire is in fact to *lose* one's freedom, not to gain it: to be condemned to repeat the same thing over and over, while everyone else seems to move on.

The gore-sleaze-violent shoot-'em-up aesthetic of the three *From Dusk Till Dawn* films also distinguishes the first film in another Tex Mex vampire trilogy, *John Carpenter's Vampires* or *Vampires* (1998). Like Wes Craven to whom he is often compared, John Carpenter has directed a large number of low-budget horror films, including the 'slasher' film *Halloween* (1978). As the director of *Vampires*, and then as executive producer of the sequels – his name effectively working as a brand and a form of cinematic typecasting – his role exactly mirrors that of Tarantino and Rodriguez with the *From Dusk Till Dawn* films. The first two films in the trilogy were produced by Storm King Productions which is managed by Sandy King, Carpenter's wife; also typically Carpenter composed the musical score for *Vampires* himself, playing guitar and synthesisers in his band, The Texas Toad Lickers. Like the *From Dusk Till Dawn* films, Carpenter's *Vampires* trilogy is drive-in movie fodder. The first film is an adaptation of John Steakley's *Vampire$* (1990), which introduces Jack Crow, a professional vampire slayer who himself faces the threat of extinction: an 'idealized version of the Vietnam vet' who 'fight[s] on, unacknowledged, in a war no one wants to admit is happening'.[54] In Carpenter's film, Crow is played by James Woods, a cigar-smoking, cussing ('Godammit!') hunter in jeans and sunglasses for whom Mexican vampires or 'goons' are like closer-to-home versions of the Viet Cong. 'Another New Mexican shithole', he says, bringing a huge armoured truck and a team of hunters carrying high-tech weaponry to a small house in a stark desert landscape. 'Perfect spot for a nest.' Killing vampires is literally sexually exciting for Crow, who keeps asking others if they get 'a little wood' when they do it. Inside the house, they kill a female vampire ('Open wide, baby!') and stake a Mexican vampire over and over: 'Not only is he ugly', Crow sneers, 'he smells bad!'

Vampires is almost unrelentingly macho, racist and misogynist; as slayers go, Crow and his friend Montoya (Daniel Baldwin) are the complete opposites of Fran Rubel Kuzui's enlightened Buffy. Daniel Bernardi rightly notes that the film 'portrays vampires in ways that suggest illegal immigration over the US–Mexico border'.[55] Its treatment of women like the prostitute Katrina (Sheryl Lee), who is tied naked and face-down on the bed by Montoya when she is bitten by a vampire, is equally disdainful. Typically for Carpenter, the

film is also a tribute to the frontier tough-guy Western, with its desert settings, homestead raids and massacres. Joseph Maddrey in fact sees it as a remake of John Ford's *The Searchers* (1956), with Crow as a modern version of John Wayne's Ethan Edwards, a character who is 'consumed with bitterness toward "savage" Native Americans and over-civilized Union soldiers'.[56] In *Vampires* Crow is a similar kind of white American relic, his own team destroyed early on by the vampire Valek (Thomas Ian Griffith), a tall Goth-like figure who is searching for the 'black cross' that will enable him to walk in the sunlight. Crow is employed by a corrupt Catholic cardinal who betrays him to Valek; the black cross, Crow is told, 'was … shipped to the New World' and 'moved from one Spanish mission to another', which is about the closest this film gets to the colonial narrative that opens *Cronos*. By the end of the film, Crow has lost everything, tied to a cross as part of a sacrificial ritual. 'You are alone, crusader', Valek accurately observes. *Vampires* partially redeems itself at this point, as Katrina bites Montoya (he seems to like it, finding peace for a moment) and Crow is freed, only to watch his friend leave him for a female vampire he now seems to respect and admire. 'Wherever you go', Crow tells them, 'I will find you. I will hunt you down, and I will kill you.' But the threat is hollow now, and the newly created vampire couple leave almost with his blessing. All that Crow is left with at the end is the memory of how sexually arousing his violent encounters with vampires had been.

Tommy Lee Wallace's sequel, *Vampires: Los Muertos* (2002) – Wallace has had a long cinematic association with Carpenter – is a much quieter, more restrained affair, shifting the focus away from Mexican vampires to vampires who kill Mexicans: which makes the work of professional slayer Derek (Jon Bon Jovi) less Manichaean and a little more politically correct. 'Welcome to Mexico', the film announces in both English and Spanish. 'Be careful.' In pursuit of a gang of youthful, marauding vampires – not a horde or swarm this time – Derek gathers together a makeshift team of assistants: a boy, Sancho (Diego Luna, from Mexico City); Zoe (Natasha Wagner), a girl who has been bitten by a vampire during sex but is managing her condition with some prescribed drugs; Rodrigo (the Chilean actor Cristian de la Fuente), a handsome young man who is posing as a priest; and Roy (Darius McCrary), a macho African-American professional slayer who is, significantly, the first to be turned and killed. This is a thoughtful film that moves away from overwrought high-tech weaponry and bloodthirsty shootouts to concentrate on character development. 'Sometimes you need less than you think … less ammo, less courage', says Rodrigo at one point, giving expression to this film's rejection of the noisy posturing of its predecessor. When the female vampire Una (the Spanish actor Arly Jover) steals Zoe's pills – in this film, vampires once again want to leave the shadows and walk freely in the sun, like humans – Derek thinks Zoe can catch a bus to Mexico City to get some more. 'Derek', she tells him, echoing Jonathan Harker's view of Eastern European train timetables in Stoker's *Dracula*, 'a bus schedule in Mexico is more like … a suggestion.' But this film is not especially interested in presenting Mexico as a backward, primitive place. When Derek and his team go into a village on the Mexican Day of the Dead, they are helped by an old man who later asks Derek to make sure the young boy Sancho has an economic future: a poignant moment that allows the film, just for a moment, to gesture towards a national allegory. In the meantime, the elegant, fashionable lesbian Una is killed and staked, as if the film is obliged to make one last stand for misogyny and bad taste; the gang of young American vampires seems forgotten about; and Derek, who has absorbed some of Zoe's blood in order to fight Una, drives away with Zoe at the end, the couple now both needing 'good medicine' (a reference to one of Bon Jovi's musical hits) in order to survive in the daylight.

The third film in the *Vampires* trilogy, Marty Weiss's *Vampires: The Turning* (2005), takes the action out of Mexico and into Thailand, effectively putting an end to this sequence of Tex Mex or 'Mexploitation' vampire films. Connor (Colin Egglesfield) and his older girlfriend Amanda (Meredith Monroe) are American tourists in Bangkok. As they watch a Thai kickboxing tournament, Amanda – who disapproves of the physical violence – is suddenly splashed with blood from one of the fighters in a kind of splatter version of the money shot: as if (to recall *Texas Blood Money*) porn really does seem to shadow the bottom end of this genre. 'How can this appeal to you?' she asks Connor afterwards, sounding a bit like Michael at the cinema in *New Moon*. 'All it is is brutal fighting!' Leaving him, she walks through the Bangkok streets on her own, attracting the interest of a Thai vampire, Niran (Dom Hetrakul) the leader of a vampire motorcycle gang, who bites her (she barely puts up a struggle) and takes her away with him. *The Turning* could have followed her and made her the centre of the narrative, as *The Addiction* did with Kathy, but in these films the focus is always on the men. Connor himself is a bit like Edward in *New Moon* here, watching his girlfriend ride away on the back of someone else's motorcycle. Trained as a kickboxer in the United States, however, he fights the local gang members as he goes in search of Amanda; one scene in which he faces a trail-bike-riding vampire with a samurai sword explicitly references Ridley Scott's *Black Rain* (1989), a film about two New York cops fighting yakuza in Japan. Another group of vampires who live together and have sworn never to drink human blood – a bit like the Cullens – get involved in the hunt for Niran, led by Kiko (Roger Yuan) and the beautiful, 800-year-old Sang (Stephanie Chao). By this time, the resolute professional slayers at the centre of Carpenter's first film in the *Vampires* trilogy have receded to the edges: here, it is a secretive group led by the ageing American, Reins, played by the Belgian actor Patrick Bachau, known much earlier on for his roles in two French New Wave films by Eric Rohmer, *La Carrière de Suzanne* (1963) and *La Collectionneuse* (1967). Connor finds himself attracted to Sang, sexually aroused by her as she slips out of a traditional Thai costume. At the centre of *The Turning* is a character's encounter with an exciting, orientalised vampire who draws him in, to the extent that he wants to become like her – just at the moment that she wants to be human, like him. An extremely soft-focus, coyly edited sex scene brings them together; it could not be more different to the moment when Amanda, earlier on, was splattered with blood. But the climactic martial-arts fight between Connor and Niran at the end is cut short when Reins and his slayers indiscriminately open fire on all the vampires, killing Kiko and Sang in the process: as if this old professional slayer has blindly ruined everything.

Connor's girlfriend Amanda is almost forgotten in the midst of all this, a whimpering, abject figure who is unfavourably contrasted with Sang's strength and Old Thai elegance. Both Amanda and Connor are transformed by their experiences in Thailand, but in opposite ways. Whereas Amanda had wanted to go home – and remains a prisoner in Thailand, unable to move until Connor rescues her – Connor becomes exuberant, discovering hidden parts of the city and immersing himself in its generically exoticised culture, his training as a kickboxer (the thing that so appalled Amanda) effectively enabling him both to blend in and be noticed in Bangkok. The third film in Carpenter's trilogy is literally miles away from the previous two, its Jack Crow figure now embittered and cynical, unable to distinguish one foreign vampire from another as he gives the order to shoot them all down. The hero is instead a young American tourist who is intrigued by vampires, who fights like them, against them, and with them. It would be difficult to read *The Turning* as an allegory for America's international obligations, however. All three films in the *Vampires* trilogy look

as if they will play out a crude Manichaean struggle between Americans and vampires: and they do. But they each end by folding the two together as if – by 'turning' – some Americans, at least, can come to love the thing they would otherwise hold in contempt. Carpenter's film had closed with Montoya and Katrina driving away into the Mexican distance, romantically linked as two newly turned vampires. *Vampires: Los Muertos* had similarly closed with Derek and Zoe driving away, sharing the same vampirish condition and romantically connected. The last film in the trilogy ends with Connor sitting beside Amanda on a flight back to the United States, the couple now estranged from each other and awkwardly silent: with only Amanda's face reflected in the airplane's window. Perhaps the film's allegorical imperative is at its most suggestive here, as a young American's traumatic adventures in another country tap into something old and residual and bring some of that back home as a catastrophe waiting to happen.

DIMINISHING VAMPIRES

Blade, *Blade II* and *Blade: Trinity*
Underworld, *Underworld: Evolution* and
 Underworld: Rise of the Lycans
Ultraviolet, *The Breed*, *Perfect Creature*, *Daybreakers*

In so many vampire films from the 1990s and 2000s, the vampire is imagined not as a solitary figure but as a species – and above all, a species that anxiously plans for its own future. The *Twilight* films touch on this, as they tie their vampire family to a set of ethical practices designed to ensure its survival in the modern world: to be self-restraining, to self-regulate, to not antagonise other species/races, to blend in. Vampires are conventionally understood as proliferating, excessive creatures, embodiments of social anxieties about invading multitudes, swarms, copies: always threatening to turn 'us' into 'them'. This is certainly true of films about 'feral' vampires, like *30 Days of Night* or *From Dusk Till Dawn*. But more often than not, as we have seen, being a vampire means being perilously close to the point of extinction, melancholy and alone. Some vampire films show their ancient protagonists trying to adapt to the modern world and failing: like Louis in *Interview with the Vampire*. Others, like *Let the Right One In*, show that a vampire is condemned always to rely on someone else, living out a precarious and rudimentary (co-)existence from which there is no escape. And in *Blood: The Last Vampire* or *Vampire Hunter D: Bloodlust*, the 'last vampires' live as a kind of coda or postscript, barely visible any more or perhaps disappearing altogether. Vampires may be immortal for the time being, but they also carry with them a heightened sense of change, death and loss. This is the direction vampire films routinely take, in fact: offering the possibility of immortality and then cruelly snatching it away, or turning it into something that vampires cannot bear. In *Thirst*, a vampire and his young, energetic lover commit suicide, simply unable to go on any more. The vampire suicide is something quite new, going utterly against the grain of the popular cliché that these creatures want to 'live forever'. Vampires may indeed have lived for a very long time, but the chances of an equally long future life expectancy – the kind of thing Hervé Juvin describes as typical of our modern age, reflected through our obsession with looking young, with plastic surgery, fitness, diets and so on[1] – are generally slim. It is not for want of trying, however, and in the films I discuss in this chapter, we shall see that vampires are just as much caught up in the drive to create sustainable futures for themselves as anyone else.

Vampire films have also had a remarkably long life, something this book pays tribute to. Because their generic features are so clearly signposted, and so constantly replicated, they therefore always run the risk of appearing simply to have done much the same sort of thing over and over again. As I have noted before, this is something that reviewers and commentators continually remark upon, sliding back and forth across the very same binary of exhaustion (that the genre is tired, clichéd, etc.) and regeneration (that such-and-such a vampire film, against the odds, does something new or different) that vampire films themselves conventionally stage and narrativise.

The increasingly diminished lives of the 'last vampires' in these films can seem to speak for the predicament of the genre itself; where, in spite or perhaps even *because* of their exhaustion, they somehow continue and persist. As I had suggested in Chapter 2, it might therefore be useful to think of vampire films as if they perpetually play out the cultural logic of the *sequel* – as a kind of permanently defiant reaction to Zoe's complaint in *Irma Vep*, 'Why do we do what's already been done?' Some vampire films quite literally work as sequels, of course, signalling a process of narrative serialisation through the arrangement of their titles – *Twilight*, *New Moon* and *Eclipse*, for example, or *Night Watch* and *Day Watch* – or else being loosely tied together as a series and brand under an umbrella title, like the *From Dusk Till Dawn* series. But I also mean *sequel* in its broader sense. This book began with an account of a cinematic adaptation of Stoker's early novel (*Bram Stoker's Dracula*) and a vampire film about the making of a much earlier vampire film (*Shadow of the Vampire*). From a certain perspective, both of these films behave precisely like sequels, that is, as 'site[s] … by which the experience of an "original" may be extended, revisited, and heightened'.[2] In vampire films, the invocation of something 'original' is crucial to their (in)authenticity effect, whether it is an ancient vampire, an historical beginning, a source urtext (like Stoker's *Dracula*) or an earlier, iconic cinematic moment. There is something parasitical about vampire films in this respect, which accumulate around these things, exhausting/regenerating them simultaneously, giving them just that extra bit of life, or half-life. The original vampire and the 'last vampire' bleed into each other; sequel and original soon become difficult to distinguish, just as parasite and host, vampire and victim, the remote and the proximate, periphery and centre, likewise converge and fold together.

Blade, *Blade II* and *Blade: Trinity*

For the three *Blade* films, the source urtext is a relatively obscure Marvel comic from July 1973 titled *The Tomb of Dracula*, created by Marv Wolfman and Gene Colan, which first introduces the slayer and half-vampire Blade, a knife-wielding, Afro hair-styled black American. A minor character at first, Blade was reputedly modelled in part on Jim Brown, an acclaimed US athlete and the star of an early blaxploitation film, *Slaughter* (1972), about a man who takes his revenge on Mafia criminals who killed his parents. *Slaughter* was released the same year as *Blacula*, and as Adilifu Nama notes, the early comic-book versions of *Blade* 'signified a similar racial message' by imagining 'black racial revenge in the form of an antiestablishment black superhero stalking and killing pale white vampires'.[3] Blade's mother, the prostitute Tara Brooks, is bitten and killed during childbirth by the vampire Deacon Frost; interestingly, this takes place in Soho, London, in 1929. Later, Blade is raised and trained by an old Harlem-based vampire hunter called Jamal Afari, pursuing Frost in a meandering set of stories that also sees him face off against Dracula, his greatest enemy. In *Blade: Trinity* (2004) – the only film in the trilogy to use the introductory Marvel logo – one of the Nightstalkers, Hannibal King (Ryan Reynolds), shows Blade (Wesley Snipes) what seems to be an original copy of *The Tomb of Dracula* issue in which Blade first appears – although in fact it is a later number in the series (not #10 but #55). This is a peculiar postmodern moment which sees an adaptation come face to face with its own (inauthentic) origins. Naturally, Blade reacts with incredulity – 'You gotta be kidding me!' – contemptuously throwing the comic away as if it has no place at all in his film.

Perhaps he is simply unable to recognise himself as he once was. The *Blade* films certainly put some distance between themselves and the original comic-book hero. Snipes's Blade is completely redesigned (as the character was in later comic incarnations, too): for example, the Afro is gone, replaced by a short, cropped and sculptured haircut and a series of elongated blue-hued tattoos around the back of the neck that a character in *Blade: Trinity* identifies as Balinese. He wears a rather long, open black leather coat with red lining, anticipating Neo's look in *The Matrix* (1999) but also recalling Bela Lugosi. Underneath, his costume consists of trademark sunglasses, a vest and armour chest plates, high-waisted trousers and boots. (The first glimpse of him is from the boots up.) Blade and other vampire hunters in these films have an elaborate array of hi-tech weapons, put together by a small army of designers. Prolonged martial-arts fighting sequences are crucial to the *Blade* films, and Snipes is himself trained in karate, hapkido, kung fu and the African/Brazilian capoeira. One of the films' producers (he created his own production company, Amen Ra Films, in 1991), Snipes plays Blade as a grim, relentless vampire slayer who talks only sparingly; he is even supposed to have trimmed what little dialogue he was actually given by screenplay writer David S. Goyer. Blade is the complete opposite of his contemporary, the chattering, wise-cracking Buffy from the television series that began in 1997, the year before the first *Blade* film; he has more in common with the sultry, silent Saya in *Blood: The Last Vampire*, who he anticipates by two years. What these vampire slayers do all share, however, is their sheer enslavement to the task they were chosen for, and (if we think of Buffy, or of the live-action remake of *Blood*) their shared traumatic experience of loss, especially the loss of parent figures. Like Saya, Blade is a remorseless, brooding vigilante with a samurai sword, a black American vampirish version of Frank Miller's Batman – as one of the characters in *Blade II* (2002) notes when Blade enters a building through the roof. One of the questions that the films raise about Blade is: is he pathological? It is partly answered by another, even earlier source film that takes us again to Japan, identified by Blade's stunt coordinator, Jeff Ward, in one of *Blade*'s DVD special feature commentaries: Kihachi Okamoto's *Sword of Doom* (1966). This film is about an utterly emotionless master swordsman and killer who destroys everything in his path; there is no dead mother to avenge here, he just does what he does as if he is condemned to do it, always.

Stephen Norrington's *Blade* was a remarkably successful mainstream vampire film, almost doubling its budget of over US$40 million in its gross US earnings alone and taking another US$40 million worldwide. It opens with a pre-credits moment of origin, as Blade's mother, Vanessa Brooks (Sanaa Lathan), gives birth to her son – whose real name, disappointingly perhaps, turns out to be Eric. This is also the film's opening historical moment, a generic feature it shares with many other vampire films except that here it is much closer to its present day: '1967' (closer, actually, to *Sword of Doom* than anything else, and around forty years after Blade's date of birth in the comics – and just five years after Snipes himself was born). After red credits over a black background and time-lapse photography showing shadows moving across city buildings as night arrives – the familiar clichés of so many vampire films across the last two decades – the film shifts to 'NOW' as a seductive woman (Traci Lords) leads an eager young man through a meat market full of carcasses in plastic bags ('What the fuck is that?') to a hideaway nightclub. The scene that follows inverts the opening nightclub sequence in *The Hunger* where confident, attractive vampires moved through a crowd of human dancers; in *Blade*, the nightclub is full of vampires, and the young human is alone, confused and disoriented. Blood drips onto his hand

and then suddenly pours out of the sprinkler systems above, driving the vampires into a frenzy. As the young man is kicked to the ground, Blade appears and proceeds to kill the vampires spectacularly with his guns and sword and a lethal little boomerang. As they die, they turn into animated skeletons (Norrington has a background in animatronics and FX design), spraying out tiny spheres of blood and green gore and sparkler-like fire. This is not exactly 'splatter': the animations are too cartoon-like, true to the film's comic-book origins, and much cleaner – one of the points here is that a dead vampire doesn't leave any trace, much like killings in a violent computer game. Compared to John Carpenter's *Vampires*, for example, the vampires die crisply (literally, burnt to a crisp), and the hi-tech weaponry is generally small and compact, not big and lumbering.

Weapons design is important to the *Blade* films, which build this into the character of Whistler (Kris Kristofferson), a Vietnam vet-type figure who could not be more different to Blade: white and ageing, with long, straggly hair, dishevelled old clothes, a debilitating limp, a cancerous smoker's cough. When Blade returns to the factory hideout they share, Whistler is welding to the sounds of Creedence Clearwater Revival's 1969 swamp-rock hit, 'Bad Moon Rising'; later, as part of his defiantly old-fashioned political incorrectness, he smokes a cigarette while he fills Blade's car with petrol. Whistler seems to stand for old technology, rather than new: Blade's black car, for example, is a modified 1968 Dodge Charger, one of several things in the *Blade* films that owe something to George Miller's *Mad Max* (1979). Even so, he seems to be Blade's resident technician, rather like James Bond's Q. He also functions as a surrogate father to Blade, someone who has been around even longer than a half-vampire (who, we are told, in fact ages normally). On the other hand, the films stage his death several times over. After Whistler is brutally beaten by Frost, Blade allows him to shoot himself in a scene that is modelled on an early moment from *Sword of Doom*. In *Blade II*, Whistler is hidden away and tortured, becoming a vampire. In *Blade: Trinity*, he is killed off again, although he reappears later when Dracula possesses his body. It is as if the *Blade* films cannot quite let their old technician, and their old technologies, go. Blade's car, the rundown factory, Creedence Clearwater's song, *Sword of Doom*: the trilogy continues to invoke these things even as it also turns to state-of-the-art design, techno, hip-hop and eurodance music, and sleek young vampires with ambitions for the future.

Blade is about a power struggle between the young, brash Deacon Frost (Stephen Dorff) and a group of much older vampires called the Vampire Nation, presided over by Dragonetti, played by Udo Kier. We have seen Kier before, in *Shadow of the Vampire*; in *Blade*, the German actor resurrects his role as the vampire in Paul Morrissey's much earlier film, *Blood for Dracula*, even striking some of the same poses. The older vampires meet around a table, like a board of directors in a large multinational corporation; actually, as they gather to reprimand the ambitious Frost, they explicitly recall the old yakuza and their dealings with the brash, young Sato (Yusaku Matsuda) in Ridley Scott's *Black Rain*. There is even an ancient Japanese vampire in attendance: 'You are a disgrace to the Vampire Nation', he tells Frost. This is where the catastrophic effects of the meeting between the old and the new – the residual and the emergent – play themselves out. The old vampires are pure-blood, but Frost is like Blade, part-human. It turns out that the Vampire Nation owns the police, who work for them, as well as all the blood banks and a great deal of American finance and real estate. 'Our livelihood', Dragonetti tells Frost, 'depends on our ability to blend in.' One of the interesting things about the *Blade* films is that they tie their vampires to corporate capitalism and law enforcement (in *Blade: Trinity*,

this includes FBI agents); without exception, the police operate as the vampires' 'familiars', doing their coercive work for them and protecting their vested interests. When Blade says at the end of the first film, 'There's still a war going on', he could be talking as much about the police and boardroom capitalism in America, as about vampires. Frost, on the other hand, is much more open about his ambitions, which are feudal by comparison: he wants to 'rule over' humans and feed on them, attempting to resurrect an ancient 'Blood God' in order to make himself all-powerful. In a scene on a beach, the colour washed out, Frost brings Dragonetti forward and extracts the old vampire's teeth, letting him incinerate as the sun rises. Later, Frost appears on the street during the day in front of Blade, clutching a Japanese schoolgirl as hostage – the film constantly cites Japan as a point of reference. 'Spare me the Uncle Tom routine, okay?' he taunts. 'You think the humans will ever accept a half-breed like you? They can't. They're afraid of you.' Frost is an impish, malevolent half-vampire who is able to diagnose Blade's sheer alienation, hunted as Blade is by other vampires and the police, and ignored by the humans he tries to protect who barely appear to notice him at all. (He rescues the Japanese schoolgirl, who runs off into the crowd.) In William Crain's *Blacula*, the black vampire was linked to a potent kind of authentic African masculinity that was unable to survive in a modern, diasporic America. But despite the fact that he kills so many vampires – and one or two of their police-familiars – there is something *impotent* about Blade, something sterile. He is certainly able to survive, but it also seems that he has no future.

Is Blade a virgin, like Edward in the first three *Twilight* films? Pete Falconer thinks so: 'Blade ... with his muscular physique, black leather trench coat, and phallic weaponry', he writes, 'may seem an unlikely virgin, but there are many signs within the film that suggest he is.'[4] Living in 'a highly disciplined, almost monastic fashion' with Whistler, clenching his teeth and cricking his neck before he fights, Blade can seem to be deeply repressed; as if to demonstrate this, in several scenes he is 'literally strapped in', wrapped in body armour or else tied up with cords and unable to move.[5] When a hematologist at the local hospital, Karen Jenson (N'Bushe Wright), is bitten by a vampire, Blade brings her back to his factory hideout. 'Bringing strangers home now?' Whistler asks, like a protective, disapproving father – as if Blade has never brought a girl home before. Whistler has been developing a serum to prevent vampirism from taking over the body, helping Blade to continue to restrain himself: which means that Blade is continually under medication. Karen herself is vaccinated as soon as she arrives, spending her first evening with Blade under sedation. Soon afterwards, she experiences her generic moment of recognition. 'You're one of them, aren't you?' she asks. 'No', says Blade, obliquely. 'I'm something else.' (Compare Eli in *Let the Right One In*: 'I'm nothing.') Attracted to Blade, Karen can get nothing out of him. 'You know', she tells him, 'my mother used to say a cold heart ... is a dead heart.' Capturing her later on, Frost taunts her about Blade: 'Blade not giving it to you? ... I'd like to see you happy, that's all'.

Since Frost had bitten Blade's mother during childbirth ('frost-bitten'), he is literally – more than Whistler – Blade's father, making him what he is. No wonder Blade is cold-hearted. The film throws up a host of negative metaphors about mothers and fathers, sources and origins. 'Vampires like you aren't a species', Karen tells Frost. 'You're just ... infected. A virus. A sexually transmitted disease.' From this perspective, Blade is the self-denying outcome of his mother and father's promiscuity. Later, Blade's mother reappears to him, a seductive vampire emerging out of a white bed in a white room. 'I came back, Eric', she tells him, 'and Deacon welcomed me into his arms.' When Blade is chained to

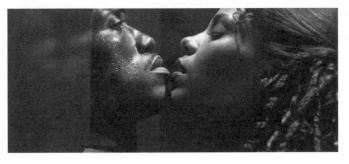

Stephen Norrington, *Blade* (1998): Blade is close to his mother

the wall by Frost, his mother appears again, stripping her son's vest away and brushing her lips provocatively against his face. 'Don't touch me', he says, recoiling. Imprisoned and drained of his blood, Blade is freed by Karen, who lets him feed on her to recover his strength, initially holding him just as a mother might hold a child. This is as close as the film gets to a sex act, with Blade refusing at first and then – keeping his trousers on all the while – leaning over Karen and almost thrusting as he drinks her blood, her breathing increasingly orgasmic. Satiated, he kneels up and howls. But his mother, it turns out, has watched the whole thing, in a kind of reversal of Freud's primal scene. 'How was it?' she asks, looking pleased with her son (rather than, say, traumatised), approving of what she has just seen. Blade then fights her, and she draws him close one last time, embracing him erotically before he finally kills her. 'I must release you', he says, disgusted by his mother's promiscuity; then he goes on to kill Frost, who bursts into an animated bubble of blood. The first film in the *Blade* trilogy therefore has its vampire slayer kill both his parents, an incestuous, sexually provocative mother and a father who Karen had described as 'a sexually transmitted disease'. As he determinedly wipes out the history of his birth into a modern, viral America (as vampires, his dead parents literally leave no trace), it seems that Blade is trying to return to the pure, authentic world of Blacula but cannot quite get there. The problem for him is that, as he tries to suppress his own viral, mixed-species condition with even stronger medication, he simply makes himself anachronistic, a strange kind of modern anomaly.

The *Blade* films take up the idea of a species' future and turn it into a perpetual struggle. 'You may wake up one day', Frost rather awkwardly tells the ageing, corrupt Dragonetti, 'and find yourself extinct!' On the other hand, Frost's ambition is to turn *everyone* into vampires, as if extinction or complete species domination are the only available options. 'How are you going to cure the whole fucking world?' he asks Karen, who is working on a genetic solution to vampirism. In Guillermo del Toro's *Blade II*, the virus of vampirism is indeed spreading worldwide, or at least into Eastern Europe. Filmed in Prague, *Blade II*'s worldwide earnings tripled its budget of just over US$50 million, making it del Toro's most financially successful film. It opens in a vampire-owned blood bank full of homeless men. A mysterious new donor, Jerod Nomak (Luke Goss), turns on the vampires and kills them, his mouth opening up like a gate as he bites, rather like the aliens in the *Predator* films. Nomak turns out to be a 'reaper', a new mutated strain of vampire virus that feeds on vampires and humans alike. Soon, they are swarming through the tunnels and sewers of the city, primitive, animated figures who seem insatiable; a character later compares them to crack addicts. In the meantime, Blade has found Whistler and brought him

back to his hideaway where a young technician, Scud (Norman Reedus), is developing new weapons and surveillance systems. Two ninjas appear in black wetsuits and goggles – interestingly anticipating the look of Abe Sapien in del Toro's later fantasy film, *Hellboy* (2004) – and after a long, partly animated swordfight they announce that they represent the Vampire Nation, which wants to collaborate with Blade to destroy Nomak's reapers ('something worse than you').

Blade II is a grimier, moister film than the slicker, often blue-washed *Blade*, favouring rusty bronze and puce green and constant night rain: typical of del Toro's earlier horror/fantasy aesthetic. The Vampire Nation is now presided over by an ancient creature, Eli Damaskinos (Thomas Kretschmann), who introduces Blade to a colourful group of trained fighters – including the surly Reinhardt, played by del Toro regular Ron Perlman, who wears sunglasses like Blade and faces off against him as his white, racist mirror image. Damaskinos's daughter Nyssa (Leonor Varela) also fights with them, unexpectedly drawing out some warmer, protective feelings from Blade – who feeds his blood to her when she is hurt. It turns out that Damaskinos had engineered the reaper strain, producing Nomak himself: so that Nomak is the son he has now disowned and rejected. The body of a reaper is dissected in one scene, the heart resembling what one reviewer has accurately called 'an enormous anus'.[6] As proliferating, hungry creatures that swarm out of the sewers and feed indiscriminately on anything that moves, it isn't difficult to read the reapers – a 'mutant' strain traced back to one man, etc. – as a hyperbolically conceived, AIDS-era (or post-AIDS) gay plague. Their link to homeless men and drug addicts, seen as equally disposable and exploitable by the vampires and the police, is also important here. The war on the reapers turns out to be an orchestrated one, overseen by Damaskinos and enforced by his police-familiars: as if the entire (vampire) nation is against them. But the film has some sympathy for Nomak. When he asks Blade, 'Is the enemy of my enemy my friend? Or my enemy?' he gives the confused black vampire slayer a chance to take a side. After a prolonged fight between Blade and Reinhardt and others, the film boils itself down to a family confrontation as Nyssa and Nomak face up to their father's heartless betrayal of them. Nomak remains driven and vicious, killing Damaskinos and biting his sister. In a long, exhausting swordfight with Nomak, Blade finally stabs the reaper in the heart/anus: a climactic moment between two socially reviled men that is tempting to read metaphorically as this film's only sex scene. Knowing that Nyssa has been infected with the reaper strain, Blade then tenderly carries her outside so she can see her first sunrise as she dies – cutting short any possibility of a relationship between them, but also bearing out Blade's bleak moral view that death is a better option than a viral future in the modern world.

The *Blade* films tend to be enjoyed by film reviewers almost entirely at the level of action and design: the 'look' of the characters, the choreographed fight sequences, the way the films embody their comic-book medium's 'pulse-pounding spiritedness and silliness'.[7] Stephen Hunter is an American pulp novelist who also won the Pulitzer Prize for film criticism in 2003. His review of del Toro's *Blade II* in the *Washington Post* is a gleeful expression of his pulp/genre film disposition that works (conventionally enough) by setting itself apart from serious film appreciation. These two worlds are in stark contrast to one another, the latter valuing restraint and subtlety, while the former revels in the primal pleasures of pure excess:

> I like to think of the great humanist French film critic André Bazin. I like to think of his belief
> in the truth of cinema, his conviction that through cinema could the world be healed.

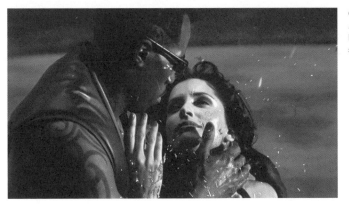

Guillermo del Toro, *Blade II* (2002): Blade holds Nyssa as she burns

Then I like to think of him seeing *Blade II*.

I think it would go something like this:

'AIEEEEEEEEEEEEE-AHHHHHHHHHHHHHHHHHH!'

There is no possible adult justification for the picture. It is pure pagan glee, a raptor's flesh fest, a zesty paprika of cannibal stew, stylized toward almost total abstraction, beyond describing, beyond imagining except by its makers.

And that is why it's so good … . This movie is for a variety of segmented audiences: children whose souls have been leeched by MTV, folks with IQs under 100 and geniuses with IQs over 150. You normal people stay away: You won't get it, you won't like it, and you'll feel violated by it.[8]

In his review of David S. Goyer's sequel *Blade: Trinity* (2004), however, Hunter is much less exuberant: loyal to Wesley Snipes's character, he recognises that the vampire slayer's time is now almost up. 'When he lets go, in full "Blade" splendor, a fusion of action, fury and righteousness', Hunter writes,

he's the best thing in the film. But mostly Snipes is in the background as Jessica Biel and Ryan Reynolds take the forefront … somehow you feel his discomfort with his premature retirement: the movie needed more of him and less of the kids'.[9]

Biel and Reynolds play two young Nightstalker vampire slayers in *Blade: Trinity*, the archer Abi Whistler (Whistler's daughter) and Hannibal King, a character lifted from the early *Tomb of Dracula* comic books. Rescuing Blade from the sleazy Goth vampire woman Danica Talos (Parker Posey), Whistler and King take him to their floating hideout – an actual abandoned barge, moored in Vancouver where the film was shot – with its own resident technician and weapons designer, the blind woman Hedges (Patton Oswalt). The transition from Whistler's old factory to this new hideout is starkly drawn: when Whistler's factory is raided by the police, he sets all his old PCs to self-destruct; Abi and King's hideout, on the other hand, is full of brand new iMacs and iPods, all in conspicuous product placement. They tell Blade that they are the Nightstalkers. 'Sounds like rejects from a Saturday morning cartoon', he contemptuously replies, in one of his longest sentences in the film. King is a wise-cracking young slayer, more along the lines

of Buffy. He also carries much of the film's explanatory dialogue, and there is a lot to explain as Danica and her group of vampires are busily resurrecting Dracula (Dominic Purcell), the original vampire. King's chatter, jibes and comebacks irritate Blade, casting the two slayers as complete opposites: white and black, young and older, verbose and silent, comical and serious. 'You think this is a joke? You think this is a fucking sitcom?' Blade snaps at him, as if, when he sees King, he is barely able to recognise his own genre any more.

Blade: Trinity was Goyer's first film direction, after writing the screenplays for *Blade* and *Blade II*. It was the most expensive film of the trilogy with a budget of around US$65 million, its worldwide gross earnings just managing to double this at around US$132 million. The film begins with helicopters landing somewhere in the 'Syrian Desert' (actually, the Mohave Desert in California), with what look like armed American soldiers disembarking close to some old ruins. The soldiers turn out to be Danica and her vampires, who are searching for Dracula's body in 'the cradle of civilization'. Later in the film, around the time he surprises Blade with the *Tomb of Dracula* comic, King explains that Bram Stoker's novel is 'just a tiny piece of the mosaic', hardly original at all. Dracula, he advises (in synch with the genre's modern bid to make vampires as ancient as possible), is in fact much older, born in 'ancient Sumaria' and 'found in Iraq about six months ago'. The change of location from Iraq here to the Syrian Desert at the beginning of the film was no doubt partly intended both to invoke the US occupation of Iraq (which began in March 2003), and to provide some distance from it, to disavow the 'political' connection even as it is made. The discovery of Dracula's monstrous body emerging from the ruins may even reference the Americans' discovery of Saddam Hussein in the notorious 'spider hole' near his home town of Tikrit. It is difficult to know what to make of this weak 'allegorical' link, however; perhaps it simply helps to underline the point that Dracula, too, will have no future. Brought back to Vancouver, the vampire wanders the city as a 'daywalker' like Blade; unusually, he is tall and muscular, casually dressed with close-cropped hair (rather than, say, a slender, long-haired dandy). He stops at a Goth pop-culture shop that sells all sorts of vampire gifts and toys, and goes inside. A boy behind the counter is eating 'Count Chocula' cereal; an eager Goth girl shows the vampire 'Dracula lunchboxes ... key chains ... even vampire vibrators'. Just as Blade is appalled by the *Tomb of Dracula* comic book (his 'origins'), so Dracula is horrified by the extent of his sheer debasement by modern commodity capitalism (his destination). He throws the boy through the window (the boy's over-the-counter remark, 'Wanna kiss me, pretty boy?' may not have helped) and bites the Goth girl on the neck, roaring out his masculine, heterosexual rage. This is *Blade: Trinity*'s 'cinematographic' moment, except there is no cinema and not much of a seduction: just a scattering of degraded, cartoon-like images of himself that remind Dracula that he really doesn't belong among these wonders of the civilised world.

Blade and Dracula have their anachronism in common. At the end of a wonderful chase across buildings and through apartments, kitchens, bedrooms and so on (after which Blade is literally left holding the baby), Dracula stands on a rooftop and looks at the pedestrians below. 'They don't know anything about honour', he tells Blade, 'about living by the sword ... like you and I do.' It is as if they are two Japanese samurai, just like the hero of *Sword of Doom*. In their climactic struggle at the end of the film, Dominic Purcell is supposed to have done all his own swordfighting and stunts. According to Goyer in one of the DVD commentaries on the film, Jessica Biel and Ryan Reynolds did almost all their own stunts and movements, too, even during Reynolds's fight with the huge vampire Jarko

David S. Goyer,
Blade: Trinity (2004):
Blade holds a copy of
The Tomb of Dracula,
with Hannibal and Abi

Grimwood, played by the professional wrestler Triple H. By contrast, many of Snipes's stunts and action scenes were filmed with stunt doubles, including much of the final swordfight with Purcell/Dracula. Perhaps this is also a reflection of Blade's position in the film, increasingly assisted, and sidelined, by the bustle and energy of his two, younger colleagues: the thing Hunter had complained about in his review. Other reviewers agree. For Nick Schager, Biel and Reynolds's presence 'pushes Blade to the story's periphery';[10] for Cynthia Fuchs, Blade 'looks tired … weary. He's been fighting vampires for three films now, and it shows.'[11] The film itself certainly helps these impressions along. In the climactic fight against Dracula, Blade is supported by Abi, as well as Hedges's synthetic virus which eats away at Dracula's blood cells, suggesting that the ageing slayer can no longer succeed on his own. Earlier, King had teased Blade about his future, wondering what he will do when all the vampires (and there are fewer and fewer of them in each film) are finally killed: 'Somehow I don't picture you teaching karate at the local Y.' King is one of several characters in the film who also analyse Blade and think about his future. 'You know', he tells him, 'at some point you might wanna consider sitting down with somebody … you know, having a little share-time … get in touch with your inner child, that sort of thing.' A psychiatrist who is also a vampire's familiar, Dr Vance (John Michael Higgins), does indeed sit down in front of Blade and offers another, more provocative diagnosis, asking about the lure of a vampire's 'nocturnal visit' with its 'promise of sexual intimacy'. Blade looks bored and disdainful until Dr Vance wonders about his relationship with his mother – 'Were the two of you very close?' – whereupon he snarls angrily at the psychiatrist who is sent scurrying out of the room. *Blade: Trinity* is a playful, self-aware film that builds itself around a deadly serious character who is at the same time incapable of self-reflection. It certainly enjoys his discomfort around the younger cast. But it retains his inscrutability, refusing to resolve the nagging question of whether Blade is empty of content or unfathomably deep. After the final credits of the last film are over, there is a brief glimpse of Blade in his 1968 Dodge Charger, leaving the city behind but going nowhere in particular.

Underworld, *Underworld: Evolution* and *Underworld: Rise of the Lycans*

In the *Blade* films, there is a lot of darkness and flickering shadow; but there are also prolonged moments of bright light, especially when Blade emerges during the day. The

Len Wiseman,
Underworld (2003):
Selene looks down on
the city below

rooftop scene with Blade and Dracula in *Blade: Trinity*, for example, indicates sunny blue skies in Vancouver during its shooting, the colours bleached and stark. In the *Underworld* films, however, there are no daywalkers and the night prevails, their vampire heroine, Selene (Kate Beckinsale), taking her name from the moon deity in Greek mythology. Each film is uniformly coloured blue-black, whether outside on the streets or in forests, or inside in tunnels, dungeons, chambers and so on. The only colour that properly stands out in this blue-black world is red, and variations like crimson or maroon: especially splashes of dark red blood. The vampires themselves wear blue contact lenses, usually – but not always – with long, wet, straggly dyed-black hair, their costumes mostly just one or two shades darker than the *mise en scène*.

The *Underworld* films are designed around a 'Goth-chic' aesthetic that developed during the 1980s and 1990s through music and lifestyle subcultures attracted to 'the dark side of glamour'.[12] As Selene strides purposefully into the great hall of the old vampire mansion in *Underworld* it looks as if she enters a kind of MTV Goth-glam music clip, with languid twenty-something vampires milling around, doing very little except drinking wine (or blood) and looking disdainful, permanently dressed in their evening wear – corsets, ornate dark dresses, black shirts, velvet jackets, tight leather or latex costumes, long coats, and so on. Blue-black is a good colour for computer-generated special effects, and there are a lot of these in the *Underworld* films. *Underworld* itself was shot in Budapest, its old streets and buildings chosen for their Gothic appeal: tall, antiquated, rundown, imposing. It opens with Selene crouching on a stone balcony at the top of an old building like a gargoyle, the rain dripping off her fingers as she looks down onto the street below, her black leather coat billowing in the wind. Her rather monotonal voiceover establishes the historical 'origins' of the film's fantasy world, a species war between vampires and lycans or werewolves that took place 600 years ago. After the war, she says, vampires hunted the remaining lycans one by one, 'a most successful campaign. Perhaps too successful. For those like me, a Death Dealer, it signaled the end of an era. Like the weapons of the previous century, we too had become obsolete. Pity, because I lived for it.' It is certainly interesting to identify the warrior heroine as 'obsolete' right at the beginning of a projected trilogy of new films; in this respect, and in others, Selene has something in common with Blade. The streets below are full of people in coats sheltering from the rain under their umbrellas as they walk along. Selene watches them carefully through hi-tech binoculars, carefully trying to work out who is human, and who isn't. It would be difficult not to recall Descartes' famous observation from his *Meditations on First Philosophy* (1641) here:

when I look from a window at beings passing by on the street below, I ... normally say that it is men I am seeing ... [But] what do I see from the window beyond hats and cloaks which might cover automatic machines?[13]

This well-known expression of seventeenth-century paranoia is restaged in *Underworld*, as Selene tries to get under the surface of things (literally, to the 'underworld'), to see things as they really are. Gates and elaborate locks and keys are therefore important to the film, which gets Selene to excavate, to open things up, to read ancient books and access computer archives, to look at things more closely – certainly, more closely than the other, dreamy vampires around her who seem to focus on nothing much at all and who therefore remain, like docile, obedient subjects, unenlightened and soon forgotten. It turns out that two of the cloaked pedestrians on the street are lycans, while another is Michael Corvin (Scott Speedman), a descendant of the oldest vampire in the world, Alexander Corvinus. As for Descartes' anxiety about hats and cloaks concealing 'automatic machines', almost everyone in this film turns out to be carrying a small arsenal of weaponry underneath their coats, which they show off almost immediately as Selene and other vampires fight the lycans in a subway gun battle.

The *Underworld* films attempt to chart their own 'original' history of vampires, making the familiar generic bid for something much older than Dracula, who they never mention. The species war they chart between vampires and lycans might well recall the antagonism between vampires and wolves in the *Twilight* films, which is also traced a long way back and is again to do with the vampires as conquerors and rulers, and the lycans as enslaved and 'savage'. Of course, the *Twilight* films are bright and sunny a lot of the time, with luscious rural settings, tall forests and snowy mountains; the vampires sparkle and the wolves are computer-generated to look as much like actual (albeit much larger) wolves as possible, with a split-second metamorphosis that avoids all the usual paraphernalia of human/wolf transformation. The *Underworld* films, by contrast, are almost relentlessly dark, the vampires scowling and angry, and the lycans computer-generated to look like ferocious, semi-upright werewolves, dripping with saliva. The transformation from human to lycan doesn't take long in *Underworld*, but in some sequences the various stages of metamorphosis are shown in detail – owing much to John Landis's *An American Werewolf in London* (1981) – with characters like Michael having the chance to give full expression to his physical pain as it happens. The *Twilight* films showed their vampires and wolves bonding 'organically' (although uneasily) through Bella. In the *Underworld* films, however, the question of the survival of species is paramount, and the problem of what might happen when the two species intermingle triggers off a wave of hysteria among older vampires that lasts through the entire trilogy and directs the course of events.

The 'original concept' behind the films came from the prolific American comic-book writer, Kevin Grevioux, who wrote *Underworld*'s screenplay with the first-time director, Len Wiseman – and who played the muscular, black lycan Raze, a character with a remarkably deep, sonorous voice that sounds computer-modified but is apparently entirely his own. As we have seen in earlier chapters, however, what is 'original' and what is derivative can be difficult to determine in vampire films. Just like Murnau's *Nosferatu* in relation to Bram Stoker's estate back in the early 1920s, two weeks before its release in September 2003 *Underworld* found itself involved in a copyright-infringement action by a large American role-playing game company, White Wolf, best known for its *World of Darkness* series. The series began with the games, *Vampire: The Masquerade* (1991) and *Werewolf: The*

Apocalypse (1992), built around clans and tribes and bloodlines, with a modern 'Gothic-punk' aesthetic: dark colours, generic heavy-metal soundtracks and so on. In 2003, White Wolf relaunched updated versions of these games, *Vampire: The Requiem* and *Werewolf: The Forsaken*. With the fantasy writer Nancy C. Collins, who had written an inhouse romance between a vampire and werewolf, the RPG company alleged seventeen counts of copyright infringement and sixty points of 'unique similarity' between *Underworld* and their games and stories. In a fascinating analysis of the case, Rachel Mizsei Ward looks at the way fans of the role-playing games did not always approve of the company's legal action; instead, they seemed to suggest that White Wolf had as much of a claim on 'authenticity' here as anyone else, apparently wanting their 'supply of Gothic-punk mater-ial' to continue to flow freely and continuously right across the board.[14] The case was set-tled out of court and the results, and costs, were not made public. 'This may imply', Ward suggests, 'that both sides of the suit felt their case was not strong enough to guarantee a win':[15] as if the difference between the original and the copy is indeed impossible to determine. In the event, *Underworld* was released on schedule, its worldwide gross earn-ings almost four times as much as its relatively modest budget of around US$22 million.

Selene is a vampire warrior and an action heroine, dressed a tight black latex catsuit and, much of the time, a long black coat, shooting her two powerful guns over and over (compulsively, even), fighting hand to hand, high-kicking and leaping. If she is 'obsolete' in one sense, she is hi-tech and modern in another, using her Sony PC (the *Underworld* films were released by Sony Pictures) to trace identities and monitor movements, and talking to her own resident lab technician, Kahn (Robbie Gee), about new weapons, new serums and so on. She shares her grim, humourless determination with Blade, although she has much more to say and is much sleeker, petite and feline. Whereas Blade drives a loud, modified old Dodge Charger, for example, Selene drives a Maserati 3200 GT and a black Jaguar XJ series 3. Ward notes that fans had sometimes remarked on Selene's resemblance to Trinity (Carrie-Ann Moss) in *The Matrix* (1999), implying that this is the real source of *Underworld*'s plagiarism, not White Wolf's RPG games.[16] *Underworld* certainly owes a great deal to *The Matrix*; its opening fight scene in the subway references the subway fight between Neo (Keanu Reeves) and Agent Smith (Hugo Weaving), although it could just as well be referencing similar subway fight scenes in *Blade*, *Blood: The Last Vampire*, and so on: since these things are already in circulation across a range of action films. Unlike Trinity, however, Selene is at the centre of *Underworld*, its protagonist. It is probably more useful to see her in a broader framework of catsuited action heroines that stretches back to Emma Peel (Diana Rigg) of *The Avengers* (1961–9) and includes Maggie Cheung's Irma Vep, discussed in Chapter 3. Jeffrey A. Brown has noted that the early- to mid-2000s in fact saw a number of slinky, lethal cinema action heroines that include Abi in *Blade: Trinity*, as well as Angelina Jolie in *Lara Croft: Tomb Raider* (2001) and *Lara Croft Tomb Raider: The Cradle of Life* (2003), Uma Thurman in the *Kill Bill* films (2003, 2004), Halle Berry in *Catwoman* (2004), Charlize Theron in *Aeon Flux* (2005), Jennifer Garner in *Elektra* (2005) and Milla Jovovich in *Ultraviolet* (2006). For Brown, the catsuited action heroine is a kind of 'butch-femme' combination:[17] tough but feminine, sexy and yet often rather prim or cold (as Beckinsale's Selene is), dominant and lethal and yet conventional in many respects (maternal, for example), capable of projecting fragility or vulnerability. In *Underworld*, Selene is also the only female warrior among powerful vampire men. The ambitious, duplic-itous Kraven (Shane Brolly) tries to control her: 'you take this warrior business far too seri-ously', he suggests, while she scornfully dismisses him as a 'bureaucrat'. Kraven hits

Selene twice in the film; the first time, she reacts by going down to the vampire mansion's shooting range, enraged, and firing off some bullets; the second time, she retaliates and knocks him over. Seeking help, Selene prematurely wakes up an ancient vampire, Viktor (Bill Nighy), who had adopted her as his daughter long ago. For Viktor, the rules and rituals established by the vampire elders must always be obeyed, which means that Selene – a young woman outside the vampires' patriarchal, sovereign law – has acted improperly. Brown notes that the modern action heroine's adventures 'are intricately bound up with a quest for self-discovery'.[18] This is certainly true for Selene, who goes on to discover that Viktor had killed her family and that the lycans she had been taught to despise and kill are in fact innocent of the crimes the vampires accuse them of. The film puts the young Selene into conflict with a world managed by a cruel, ageing male vampire – rather like Eli Damaskinos in *Blade II* – who has betrayed his own children. It ends with Selene taking a spectacular revenge, as she leaps over Viktor, slicing off half his head with her sword.

Underworld works in the same way as *Queen of the Damned*, where a younger vampire (Selene, Lestat) summons an older vampire (Viktor, Akasha), triggering off something catastrophic. Viktor's premature awakening allows the film to explain Grevioux's 'original concept', casting it as the source of everything that follows: that a fifth-century 'Hungarian warlord' called Alexander Corvinus survived a viral plague and became immortal, fathering three sons, 'one bitten by bat, one by wolf, one a human'. When he hears all this from a lycan doctor, Viktor's comment – 'It's a *ridiculous* legend!' – runs the risk of expressing what some viewers might very well be thinking. One of the odd things about the *Underworld* films is that they either confuse the details of this legend or ignore it completely, concentrating instead on the 'species war' between the vampires and the lycans. *Underworld* was pitched as a 'Romeo and Juliet' story about vampires and werewolves: something else it has in common with the *Twilight* films. The lycans want to locate Michael Corvin, who is identified by their doctor – a sort of creepy Josef Mengele figure – as a 'carrier', a source for the original virus that might somehow be used to combine the 'bloodlines' of lycans and vampires and bring the war between these creatures to an end. The gentlemanly leader of the lycans, Lucian (Michael Sheen), finds Michael and bites him, taking a sample of his blood for further laboratory experimentation. Trying to protect Michael from the lycans *and* the vampires, Selene begins to fall in love with him. This is not *quite* a vampire/werewolf romance, because Michael is a blend of species. He works structurally as a trigger for Selene's self-discovery, her exploration of the truth behind the legend. Taking him to a 'safe house' where vampires interrogate and torture lycans, Selene and Michael talk about the species war. 'Why do you hate them so much?' Michael asks. 'I've already told you', says Selene, 'we're at war.' 'So you're just following orders?' Selene doesn't reply: she likes to think of herself as autonomous, self-governing. She tells Michael about the murder of her human family and her sense that Viktor had saved her from the lycans, turning her so that she would have the strength and longevity to avenge their deaths. 'Since then', she says, recalling the driven single-mindedness of Blade after his mother's death, 'I've never looked back'. Michael's subsequent account of his wife's death in a car crash gives both characters a shared sense of family trauma. 'Have you … moved on?' she asks. 'Have you?' he replies. Michael soon realises that Selene is trapped in a mythology (or, a legend) handed down to her by Viktor. 'Who started the war?' he asks. 'They did', she replies, shifting her position a little. 'Or at least that's what we've been led to believe. Digging into the past is forbidden.'

In this interesting scene, the secret safe house, the apparatus of torture and interrogation, the question of war, its origins and what one believes to be true – along with Selene's remote surveillance of ordinary citizens, her room searches, eavesdropping and monitoring of locations and identities – all work to situate this film in the wake of George W. Bush's 2001 declaration of a 'war on terror', the USA Patriot Act, the CIA's 'stress and duress' activities, the 2003 invasion of Iraq, and so on. *Underworld* buries these contexts in a different way to *Blade: Trinity*, however. As they talk and her self-discovery begins, Selene bonds romantically with Michael, excited by him: literally taken out of herself and her own species, no longer believing the war propaganda she had taken for granted for so long (around 800 years). But as they kiss, she chains him to the interrogator's chair, prolonging the 'us and them' binary of the species war and adding a soft kind of dominatrix frisson to the mix. Viktor is tied to his own throne-like chair during this time, with long, thin tubes pumping blood into his body as he awakens. The film puts the sovereign and the enslaved into proximity with each other here, with Selene releasing one (Viktor) and imprisoning the other (Michael): not quite enlightened, or not quite *political*, enough yet to know what she is doing or which side she is on.

Wiseman's sequel, *Underworld: Evolution* (2006), cost twice as much to make as *Underworld*, demonstrating an increased confidence in the commercial success of the franchise. It begins by repeating the trilogy's 'original concept', naming Alexander Corvinus's two immortal sons as Marcus (Tony Curran) (a vampire) and William (Brian Steele) (a lycan). Returning to the year '1202' – as good as any other medieval year, I suppose – the film's generic opening historical moment shows Marcus and Viktor battling lycans in a village and capturing William, who they chain to a tree. Viktor and Marcus argue about what to do with him; finally, they agree to imprison the lycan 'for all time'. Shifting to the present day, Selene is now enlightened: 'In one night', she says, 'the lies that united our clan had been exposed.' But she is also hunted, on the run with Michael in what looks like a forest somewhere in Eastern Europe – one reviewer calls it 'some crypto-Transylvania'[19] – although *Underworld: Evolution*, like *Blade: Trinity*, was in fact shot in and around Vancouver. Selene and Michael are *personae non gratae* in this film: a vampire who is no longer (thinking like) a vampire, and a lycan who isn't quite a lycan. 'There really is no going back, Michael', Selene says, giving expression to their transformation, their political distinction, the fact that they are now distanced from their own species precisely by having *become* political. The romantic theme of the film means that they are therefore drawn to one another, as if they are all they have. Healing each other after a battle, they take refuge in a large shed and have sex in a coyly edited, slo-mo love scene that all-too-conventionally (or generically) fades to black at the end. In the meantime, Marcus awakens as Viktor had in *Underworld*, and proceeds to search for Selene and Michael, killing all the vampires who get in his way. A winged figure, Marcus sometimes resembles Dracula's bat-like incarnation in *Bram Stoker's Dracula*; the creature designs were supervised by Patrick Tatopoulos, who had in fact assisted with design and props in Coppola's earlier film. Marcus uses a computer to find the couple, pressing his clawed fingertip onto the keyboard; but vampires in the *Underworld* films can also get their information from another vampire's blood, a novel feature that turns this species into a sort of interconnected network or archive, where a bite is something like a download. CCTV footage, safe houses, computer tracking and monitoring: these things continue to direct events, helped along as Alexander Corvinus (Derek Jacobi) himself arrives, on board a hi-tech surveillance ship that docks at an unnamed port presumably not far away.

Len Wiseman,
Underworld: Evolution
(2006): Selene in the
daylight

But because these are vampire films, modern technologies are also cast as premodern, ancient. Selene and Michael visit Tanis (Steven Mackintosh), the 'official historian of the covens', who enjoys a decadent lifestyle in an old monastery that is also typically filled with security devices, surveillance cams and so on. 'So your eyes are finally open', he tells Selene. In an ancient book she sees a woodcut of William's prison, built by her own father centuries ago; Viktor had her family killed in order to keep the location of the prison a secret. It turns out that Marcus wants to free his lycan brother to begin 'a new race'. He battles Michael and Selene, and then confronts his father, Corvinus, who he mortally wounds. Selene had been reprimanding Corvinus for not having killed Marcus and William much earlier on, for letting them roam free: identifying him as a weak, indulgent father, the opposite of Viktor (which would imply, oddly, that Selene prefers Viktor as a father-type). Jacobi lends his usual thespian gravitas to the character of Corvinus, an acting style that is not entirely out of place in this bombastic, 'Shakespearean' B-movie. Very little is made of Marcus's parricide, however. Corvinus is in fact the opposite of Freud's tyrannical primal father, and Marcus (although typically an outcast, rebel son) feels no remorse. Interestingly, there are no mothers – and therefore no Oedipal struggle – in the *Underworld* films, where bloodlines can only be understood as patriarchal. But Selene is the character who brings this transmission to an end. Dying, Corvinus gives her some of his blood to drink. 'What will I become?' she asks. 'The future', he tells her, shortly before he blows up his surveillance ship and kills himself, effectively wiping out everything associated with the ancient vampire patriarchs. Marcus later finds William's underground prison and releases the lycan, who bursts into life. Selene follows in a military helicopter and descends into the tunnels of an old castle – the same set as *Underworld* – to pursue them. A long battle ensues that sees Selene's character reference the gun-toting Ripley (Sigourney Weaver) in Ridley Scott's *Aliens* (1986), except the monsters are male here, and Selene doesn't have any maternal instincts, at least not yet. Michael kills William and Selene kills Marcus, who is dismembered by the helicopter's rotor blades. The film ends by normalising the couple as they embrace and kiss, the rising sun beaming down above them and – as Selene realises she can live in the daylight – the blue-black rinse fading out as some colour is finally restored. As *Underworld: Evolution* wipes out all traces of its ancient vampires, it comes back to life, to normality: looking up towards the world *above* at the end. 'An unknown chapter lies ahead', Selene's voiceover concludes, as if the possibility of a third film in the franchise is still open at this point, but unplanned. 'But for now, for the first time, I look into the new light with hope.'

In the event, *Underworld: Rise of the Lycans* (2009) is a prequel, not a sequel: rather than moving ahead to an 'unknown chapter', it returns to the familiar faux-medieval history of the 'original concept', with the opening historical moment of *Underworld: Evolution* now stretching across the length of an entire film. *Rise of the Lycans* was directed by Patrick Tatopoulos, whose working relationship to the *Underworld* films – production and creature designer in the first two – might compare to David S. Goyer's career shift from scriptwriter to director in the *Blade* trilogy. Len Wiseman, the director of *Underworld* and *Underworld: Evolution*, had met Kate Beckinsale on the set of the first film while she was still in a relationship with Michael Sheen, who had played the lycan leader, Lucian (and who went on to play Aro, the leader of the Volturi, in the *Twlight* film, *New Moon*). Wiseman and Beckinsale married in 2004. Neither of them is associated with *Rise of the Lycans*, which instead brings back Sheen as Lucian and Bill Nighy as Viktor: the two most charismatic actors in the *Underworld* franchise. Filmed in New Zealand on a budget of around US$35 million – more than *Underworld*, less than *Underworld: Evolution* – *Rise of the Lycans* owes more to Peter Jackson's earlier *Lord of the Rings* trilogy (2001–3) than to *The Matrix*. A dark 'medieval' fantasy, the film begins with some gory woodcut drawings from an ancient book, the voiceover announcing: 'Two decades had passed since the creation of both species. The war had begun …'. This is a much simpler film, built around a Manichaean distinction between civilised vampires, who live like feudal barons in a castle, and 'savage' lycans who roam the forests nearby – a distinction the film then inverts, as it reveals the cruelty of the vampires under Viktor's rule. Viktor has spared the life of Lucian, unable to kill him as a baby: just as he had spared the young Selene after killing her family. The vampires enslave some of the lycans, putting them to work, but they also worry about how to manage them. In the meantime, Lucian grows up into a strong young man – the vampires' blacksmith, made to wear a neck brace to stop him from turning into a lycan – who attracts the attention of Viktor's warrior daughter, Sonja (Rhona Mitra). Their romance is another 'Romeo and Juliet' affair, their secret lovemaking revealed in a short sex scene that offers brief, coy glimpses of the lovers, fading to black in between edits, with groaning musical crescendos; interestingly, at one point it looks like Sonja is sexually penetrating Lucian as he leans back over a precipice. Later, a family of human nobles ride by coach through the dark forest to Viktor's castle, leading human slaves behind them as if they are just as feudal as the vampires. Humans are a complication in this Manichaean fantasy, and their role is unclear. With the exception of Michael, they are incidental to the entire *Underworld* trilogy. Humans are never turned by vampires in these films; in one scene in *Underworld*, the vampire Erika (Sophia Myles), when she glimpses Michael's bloodied wounds as he sleeps, is actually repelled, leaping up to the ceiling and hissing like a cat. It is as if vampires have no interest in adding to their numbers, preferring simply to protect the few remaining interests they have left. Humans tend instead to be turned into lycans – which is why the lycans are such a problem for vampires. As the coach makes its way through the forest, packs (or swarms) of lycans attack. Sonja rides out to help the humans; Lucian follows, his neck brace removed; turning into a lycan himself, he commands the others to withdraw. When they return to the castle, Viktor reprimands his daughter and reminds Lucian that he is a slave, sentencing him to thirty lashes. 'You were like a son to me, I gave you life', he says, as Lucian is strung up – the vampire patriarch establishing himself as the opposite to Corvinus, cruel and punishing rather than indulgent.

Rise of the Lycans is a dark 'medieval' species war fantasy that also owes something to Stanley Kubrick's *Spartacus* (1960), as Lucian goes on to lead a lycan slave uprising

against the decadent vampire overlords. His rousing speeches to the slaves ('We will not leave our brothers', etc.) similarly work to contrast slave solidarity (like the 'I'm Spartacus' scene in Kubrick's film) with the various political divisions among the vampires. In an interesting reconfiguration of the vampire-in-the-bedroom scene, Viktor goes into Sonja's bedroom to confront her about her love for Lucian and bites his daughter's neck to gain access to her secret. 'You have betrayed me … to be with an animal!' he cries, enraged, his mouth covered with blood − Nighy's performance here mimicking Udo Kier's crazed reactions to the two promiscuous Di Fiore daughters in Paul Morrissey's *Blood for Dracula*. Later on, Lucian tries to rescue Sonja, but Viktor captures them both. Sonja fights her father, finally telling him that she is pregnant. But this only enrages Viktor all the more ('That thing inside you … it's a monstrosity!'), and he commits his daughter to trial and condemns her to death. In a genuinely touching scene, Lucian is forced to watch as Sonja is shackled to a pole and a window is opened above her, letting in sunlight that burns her alive. The rest of the film involves the freed lycan slaves storming the castle, and a bereft Lucian battling Viktor and defeating him − for the moment, at least. In *Underworld: Evolution*, Marcus committed parricide, killing Corvinus. In *Rise of the Lycans*, Viktor commits filicide, looking only momentarily regretful the next morning as he sees Sonja's charred remains. Vampires can seem like their own worst enemy in the *Underworld* films, turning against their species, exposing the lies behind their 'legends', killing their fathers, sacrificing their children. It is a rather stark version of the predicament we have seen elsewhere in other vampire films, too, where the 'original' vampire is also the 'last vampire', already melancholy and disenchanted, and where the end of the (blood)line is written into vampires right at the beginning.

Ultraviolet, The Breed, Perfect Creature, Daybreakers

A number of vampire films − we have already seen some of them − imagine possible but precarious futures for their vampires, who increasingly struggle for space and recognition: as if they are not just a species, but an *endangered* species. There are two contradictory cultural logics in these films worth noting here. One establishes a framework for vampires that is now defined by scarcity, loss and restraint, where these melancholy creatures live out their slow decline and deterioration. The other persists with the familiar tropes of mimicry, plagiarism, citation, '(re)awakening', copying − the kind of thing Marcus Boon, in his book *In Praise of Copying* (2010), links to a *lack* of restraint, to proliferation, excess and abundance.[20] Folded together, these things define the vampire as *modern*. A brief comparison of two minor vampire films − Kurt Wimmer's *Ultraviolet* (2006) and Michael Oblowitz's *The Breed* (2001) − shows how differently these cultural logics play themselves out.

Shot in Hong Kong, Shanghai and Los Angeles, *Ultraviolet* is a 'Pacific rim' vampire film; set in the year 2078, it imagines its anonymously 'Asian' city spaces as hi-tech and heavily policed, shiny and bright, the malls and thoroughfares crowded with people wearing white face-masks to indicate that the region is now completely viral and contagious. The government is run by a group of medical technicians under Vice Cardinal Ferdinand Daxus (Nick Chinlund), who are trying to regulate and destroy a rare infection that has turned people into hemophages, or vampires, giving them extra strength and speed. The vampires themselves are fighting back in what the media call a 'Blood War', although their numbers

are small. The impressively named Violet Song Jat Shariff (Milla Jovovich) is a hemophage who had lost her baby earlier on. Fighting Daxus's black-clad police, she discovers a secret weapon, a boy called Six (Cameron Bright), who appears to be the living host for a virus that will kill vampires. Violet bonds with the boy and protects him, and is devastated when he suddenly dies. As she weeps over him in a children's playground, mourning the loss of her own child as well, Daxus shoots her. Violet's friends bring her back to life, but she is bereft, melancholy. Later, she breaks into Daxus's compound – 'Single female intruder', the intercom announces, 'please remain calm!' – and kills the Vice Cardinal, her tears (rather than, say, her blood) reawakening the boy, saving him. It turns out that Six contains the possibility of a cure for the hemophages, and for Violet; but it is fragile, and the film ends with a low-key message of hope, the vampires' world contracting down to another set of lab experiments that are yet to take place (designed, in fact, to put an end to their condition).

Violet is a catsuited female warrior, the last in the list I outlined above, and one of the most stylised or abstracted: going through a number of coloured costume changes, her toned midriff always bare, walking like a supermodel, her face airbrushed, defeating hordes of police in bloodless, repetitive battle sequences that might as well be completely digital. This earnest, glossy, sentimental action film – which just broke even on its US$30 million budget – was universally condemned by reviewers. Jovovich seemed to be reproducing her role as Alice in the *Resident Evil* films, which began in 2002; *Ultraviolet* was also often accused of imitating *Aeon Flux*, another, earlier 'future shock' designer-virus film with another slender, catsuited action heroine.[21] It looked like *Ultraviolet* was a comic-strip adaptation or perhaps a movie preamble to a PlayStation game; it was in fact neither of these, although it did produce a novelisation as well as an offshoot anime series, *Ultraviolet: Code 044* (2008). It seemed to reviewers that *Ultraviolet* was one future shock virus film too many, a film that went automatically through its motions, stylish but empty of content. Wimmer had claimed that the film was inspired by John Cassavetes's *Gloria* (1980), about an ex-mobster woman who tries to protect a six-year-old boy from the Mafia in New York. For the horror novelist and aficionado Kim Newman, however – in a review of *Ultraviolet* in *Sight and Sound* – 'the plot nugget of a female criminal forced to become a surrogate parent while on the run from killers is the least significant aspect of this threadbare patchwork of borrowings'.[22] Going on to list more examples of things 'lifted' from other films, Newman pushes the melancholy of *Ultraviolet* aside, seeing it only in terms of its plagiarisms and repetitions, as if it is pure surface, completely derivative.

Oblowitz's *The Breed* was made for US$4 million – it could hardly be any cheaper – and shot in Budapest, the site location for *Underworld* two years later. Set in 'the near future', *The Breed* cheerfully plagiarises Terry Gilliam's *Brazil* (1985), developing a 1940s retro 'look' that is centred around a large bureaucracy, the National Security Agency (NSA), which looks like a relic of Hungary's postwar Communist regime. It is sometimes noted that vampires once embodied stereotypical anti-Semitic images of European Jews.[23] In *The Breed*, vampires *are* Jews, many of them living in a Budapest ghetto called Serenity, dressed in long coats and black, wide-rimmed hats. The film gives its Budapest location a set of historical referents, even invoking the deportations of Jews by the Nazis during the war; Oblowitz's parents were Eastern European Jews, a genealogy he has been touched by, dedicating the film to the memory of his father, Sidney.[24] At the same time, *The Breed* also treats Budapest as if it is a New York precinct, introducing a black American cop, Steven Grant (Bokeem Woodbine), whose partner is murdered by a rogue vampire. Vampires, one of the NSA officials tells Grant, are 'capable of blending in just like

New Vampire Cinema

Michael Oblowitz,
The Breed (2001):
Aaron and Grant
interrogate Dean Fusco

an ordinary human'; they have actually initiated a programme of 'vampire/human integra-tion' designed to make themselves appear just like everyone else. Grant, on the other hand, stands out. The NSA partners him to a vampire cop, Aaron Gray (Adrian Paul), whose family was pursued and killed by the Nazis during the war, and together they inves-tigate the rogue vampire's crimes.

This is a 'police procedural' vampire film, a subgenre we shall see again below with *Perfect Creature* (2006). In fact, it has a great deal in common with that later film, includ-ing its retro-future look, its account of vampires as 'a cell mutation of the human species' and its narrative about a murderous rogue vampire who threatens to release a virus that can kill humans. But despite these themes and its sombre representation of the ghettoed vampires-as-Jews, *The Breed* is completely playful, a generic pastiche. The two cops are led through a series of encounters that work as pure citations: a murder victim called 'Barbara Steele', a psychiatrist called Graf Orlock (Istvan Goz) who works in the 'Freudian Building' (and is born in 1856, the same year as Freud), and the rogue vampire himself, Dr Freidrich (*sic*) Wilhelm Cross (Peter Halasz), whose first names are the same as F. W. Murnau's. Murnau's *Nosferatu* is itself invoked through the appearances of Orlock and Cross. The names of other characters are citations that reference all sorts of vampirish things: the NSA's Dr Bathory (Dianna Camacho) for example, or Calmet (Paul Collins) (after Dom Augustin Calmet, who wrote a dissertation about vampires in Hungary and elsewhere in 1746), or Lucy Westenra, played by Bai Ling as a seductive Chinese vampire who invites Grant into her mansion. 'Are you *serious*?' he asks, hardly able to believe (or take seriously) what is happening to him. Later, Aaron and Grant question an Italian vam-pire, Dean Fusco (William Hootkins), an actor who quotes and impersonates almost at ran-dom: extracts from Christopher Marlowe's *Doctor Faustus* (1604), Coppola's *Apocalypse Now*, Lenin and so on. 'I can be anyone I wish to be', he proudly tells them, announcing the kind of 'postmodern' cultural logic of performativity and replication that the film itself puts into play. At one point, Aaron – who looks like a young John Waters – asks Grant, 'Don't you get the feeling that we're being led around by the nose?' Viewers might say something similar as the film romps its way towards its conclusion, blowing up the rogue vampire (Dr Cross) with a grenade and ending with a coda that sees Grant and Lucy pair off romanti-cally but also rather poignantly, with Lucy weeping over her sense that nothing will last. *The Breed* has this final bit of melancholy in common with *Ultraviolet*. But although they share their generic predicament, it is also the opposite of this film: playful rather than

humourless, disarming and likeable rather than affected, shabby rather than airbrushed, with cheap special effects (a few ropes, etc.) rather than seamless computer-generated effects; its protagonists constantly assailed (and bemused) by the film's various plagiarisms and citations, rather than oblivious to it all.

I want to conclude this chapter – and this book – with a discussion of two antipodean vampire films that look more closely at the future of the vampire in a world now defined by scarcity and antagonism between species, self-consciously turning these predicaments into a form of social critique that is buried in one case, and all-too-visible in the other. Glenn Standring's *Perfect Creature* (2007) is a New Zealand vampire film, shot on location in Dunedin, Oamaru and Auckland in 2004. A UK/New Zealand co-production, the New Zealand Film Commission (NZFC) contributed to its US$20 million budget: a huge amount of money by local standards, around ten times the cost of most locally produced films. Industrially speaking, *Perfect Creature* was no doubt an attempt to compete with, or join, a series of internationally successful fantasy films shot in New Zealand around this time, including Peter Jackson's *Lord of the Rings* trilogy and Andrew Adamson's *The Chronicles of Narnia: The Lion, the Witch and the Wardrobe* (2005). Like Adamson and Jackson, Standring is New Zealand-born; some of his technical and production crew had in fact worked on the *Lord of the Rings* films. But his film is similarly transnational, too, with a number of British actors in the principal cast, post-production in the UK, a sales deal with the California-based Arclight Films and distribution rights for the US picked up by Twentieth Century-Fox. The film's global release outside the US and the UK earned it US$1 million; in the event, however, Fox finally decided not to release it in the US, sending it straight to DVD in July 2007 where relatively strong sales recouped around US$15 million. For Duncan Petrie, *Perfect Creature* is an example of 'peripheral cinema' attempting to embrace 'the neoliberal priorities of globalization':[25] successful from an aspiring local perspective (and certainly, from the upbeat perspective of the NZFC) but a failure in terms of its US/global distribution, which only worked to underscore the 'peripheral' identity it already had.

Part of the film's problem – and what makes it interesting – is that it immerses its predicament as a New Zealand film into its generic identity as a film about vampires in some near, or perhaps remote, future. *Perfect Creature* creates 'a world not unlike our own', a dark urban location that owes a lot to Ridley Scott's *Blade Runner* (1982) – introduced with an aerial shot of the city lights at night, and a Vangelis-type single synthesiser note on top of a deep synth bass. This is certainly a derivative film; but it marks out some of its distinction by developing a 'steampunk' aesthetic for its city that oscillates between a stereotyped Victorian London and London during the Great War, with zeppelins in the sky instead of spaceships, police cars driven by steam, and a 1940s 'look' that might also recall *Brazil*, with retro bronze metal instruments (one of which resembles Guillermo del Toro's Cronos device), old black-and-white television screens, and so on. The cityscape is really what could be described as 'Pacific Victorian', showcasing the old buildings of Oamaru and Dunedin, the streets populated with English bobbies, a Maori police driver, Oliver Twist-like street urchins, Maori street vendors; among the characters, New Zealand accents ('Albert' becomes 'Elbert', etc.) come and go. To confuse matters further, the location is called Jamestown: a famous settlement established in the early 1600s in the colony of Virginia, in the United States. The film opens with two originating moments. The first announces the creation, through genetic engineering, of 'an advanced species of Homo sapiens known as The Brotherhood', priestly figures who have lived in harmony with, but

separate from, humans for 300 years. The second presents a poor, desolate woman who has just given birth to a baby boy, Edgar. A medical officer (the 'Identifier General') in a Dickensian sort of institution tells her that her child will be taken away: 'You don't need to worry. The Brotherhood will take him. Raise him in the church. It's a blessing really. Want for nothing. Not like the rest of us.' Soon afterwards, as his older brother Silas (Shannon Hirst) watches, a wonderful close-up of the crying baby's mouth reveals tiny vampire teeth. The film then moves 100 years into the future, where Edgar (Leo Gregory) is now running amok through the slums of Jamestown, killing humans. His brother Silas (Dougray Scott) is partnered with a human police officer, Lilly (Saffron Burrows), in an attempt to stop him – which also makes this a 'police procedural' buddy-cop kind of vampire film, just like *The Breed*.

Perfect Creature is at one level an obvious critique of the Catholic church, with the priestly Brotherhood both enriched by (it 'wants for nothing') and remote from the sufferings of ordinary life, covering up Edgar's crimes for as long as possible. The Brothers drink the blood of their parishioners like wine, but they give their own blood, too, claiming that humans 'have visions from it'. The Brotherhood tells itself that it 'serves' and 'protects' humanity, although it is difficult to know how: humans in Jamestown live in abject poverty, constantly sick from influenza, heavily policed by the government. The discovery of a new 'species' – a 'new race of beings', as the head of the Brotherhood, Augustus (Stuart Wilson), puts it – might suggest the possibility of a colonial allegory in this New Zealand film, an allegory of the colonial encounter which, in this case, seems to have produced an uneasy mix of integration and segregation between Brothers and humans. Duncan Petrie has suggested that New Zealand cinema is defined by the way it expresses its proximity to this encounter: in some cases, this can lead to 'forms of amnesia or [a] covering up of the trauma of the process of settlement'.[26] In *Perfect Creature*, the original moment of encounter is certainly a repressed memory, as Augustus reminds Silas. 'For centuries we Brothers have served mankind, and them us', he says. 'The great union. But you need to remember your history. Three hundred years ago, when our kind were first born into this world, they burnt our children as monsters.' Augustus's history might very well be a vampirish version of the violence of the colonial encounter. Certainly, there are traces of New Zealand's colonial past in the film: the outbreaks of influenza, for example, which had devastated the Maori population in the nineteenth century, and which devastate the human slum-dwellers of Jamestown in the film.[27] Lilly has lost her husband and daughter to influenza, too. It seems that no one is immune or exempt now except the priestly Brothers: as if whatever colonial allegory there is in this film has also been inverted, the Brotherhood

persecuted in the beginning but privileged now. Lilly knows that the Brotherhood has been covering up Edgar's Jack the Ripper-like murders: 'Seems the Church is able to do whatever it wants', she says. Later on, Edgar attacks her and bites her neck, drinking her blood; Silas then saves Lilly by getting her to drink his blood in turn, suggesting that the Brotherhood is now something of a mixed blessing to the humans who live nearby.

The Brotherhood might tap their human parishioners' blood, but in other respects they are the opposite of what vampires traditionally ought to be. 'No Brother has ever taken a human life', Silas claims, 'not in the three hundred years since we began. Not one. Our role has been to maintain and preserve the human life, not take it.' The darker side of this philanthropic mission, of course, is that the Brothers are also preserving their blood supply in order to survive. The Brotherhood is exhausted and in decline; women are only bearing male children for them, not female. Edgar has been trying to change this through further genetic experimentation, but he has infected himself in the process — and is now overcome with bloodlust. One of the Brothers announces: 'He says he will drink us all dry.' From one perspective, Edgar is what a vampire *ought* to be, expansive, excessive, aggressive, dedicated to instant self-gratification (draining blood now) rather than self-restraint (preserving blood for the future). Like Stoker's Dracula, he aims to turn everyone else into copies of himself: 'Everything flows from me', he writes. 'My blood will change the world.' From Silas's restrained perspective, however, Edgar is 'aberrant', an anomaly. Silas is an institutional creature, dutiful, reserved, loyal to the Brotherhood, conservative, but also deeply repressed. In this film's generic vampire-in-the-bedroom scene, Silas kneels beside Lilly's bed as she sleeps, smells the scent of her hand, then imagines that they kiss — until another police officer rudely interrupts his genteel fantasy. Edgar has already taken Lilly, however. 'I will have her again', he brags to Silas, also urging his brother to be like him. 'I will see you drink your policewoman.' Edgar is a sort of raw version of Selene in *Underworld*, a vampire who has slipped outside of the prevailing (vampire) ideology, hunted by the Brotherhood but not human, *persona non grata*. Leaning over Lilly, he makes one of the longest speeches in the film.

> Do you know the sum of our existence? When we are born, we are taken from our mothers, forced into a life of loneliness and denial. A life born only to serve. Can you imagine a life like that?

Even though Lilly is his prisoner — and has lost her family from influenza — Edgar is the one who speaks from the position of subaltern here, drawing attention once more to the film's buried colonial allegory. 'Each day', Augustus complains, Edgar 'shares his blood with more of them … even though they are locked in their homes!' It seems like Edgar is now everywhere, his subaltern influence (his infected blood) spreading across the slums of Jamestown, dripping through the water supply. The problem shifts from 'containment' to what Augustus calls 'eradication', as he instructs the government to burn the Jamestown slums to the ground. In the meantime, Edgar and Silas battle over Lilly; Lilly manages to kill Edgar; and Silas and Lilly finally kiss, rather like Selene and Michael at the end of *Underworld: Evolution*, an apparently normative couple now, the colonial allegory finally laid to rest. Even so, they have been transformed by their encounter with Edgar, taken out of themselves. A baby girl is born in the slums, 'an accident' — offering some hope of renewal to the Brotherhood. But Silas goes into hiding with her, leaving the Brotherhood 'and all its lies'. Hunted by the Brothers as a 'heretic', he inherits Edgar's position as *persona non*

grata, a vampire who is no longer a vampire, turning his back on his own species and condemning them to a long, slow extinction.

Perfect Creature is worth comparing to *Daybreakers* (2009), an Australian vampire film directed by the Brisbane-born twin brothers, Michael and Peter Spierig. The budgets for both films were the same, around US$20 million, and *Daybreakers* was also shot locally, in 2007, in Brisbane and at the Warner Roadshow Studio on Queensland's Gold Coast. Like *Perfect Creature*, *Daybreakers* was in receipt of state funding, from Film Finances Corporation Australia and the then Queensland-based Pacific Film and Television Commission. But – picked up by Lionsgate, a successful US/Canadian independent film distributor and entertainment company, and the independent US production company, Furst Films – it gained UK and US releases, and went on to earn a worldwide gross of over $50 million. This is remarkably successful for an Australian film. *Daybreakers* is too large in scale, and too much of a genre film, to sit comfortably under the banner of 'national cinema'; its aspirations lay elsewhere. But it plays out a different version of 'peripheral cinema' embracing the 'neoliberal priorities of globalization' to *Perfect Creature*. For one thing, it signals its US affiliations much more clearly: beginning with the American flag that flies outside the rural property at the beginning of the film. Whereas *Perfect Creature* mixed New Zealand actors with relatively unknown British actors, *Daybreakers* mixes an Australian cast with American actors who are already box-office successes: Ethan Hawke as Edward Dalton, and Willem Dafoe – Orlok in the earlier *Shadow of the Vampire* – who plays a character nicknamed Elvis. The film was in fact released in the US in 2010 on Elvis Presley's birthday: 8 January. *Daybreakers* also cast the globally recognised New Zealand actor, Sam Neill; on the other hand, it shored up its identity as a Pacific Rim genre film by casting actors such as the Samoan-Australian Jay Laga'ala, who had himself already gained popular global recognition through his role as Captain Typho in the *Star Wars* films, *Attack of the Clones* (2002) and *Revenge of the Sith* (2005).[28] All the actors, including Neill and the Australian cast, speak as if they are American. The Americanisation of an Australian genre film might recall the treatment of George Miller's *Mad Max* on its US release in 1980, where the Australian dialogue was almost completely revoiced to suit the new market. In *Daybreakers*, Daimler Chrysler is a sponsor and both classic and futuristic Chryslers – rather than *Mad Max*'s Holdens, Ford Falcons, Valiants, etc. – are conspicuously present. But the car chases in particular owe a lot to *Mad Max*; and the ending of *Daybreakers* is a respectful nod to Miller's early 'Ozploitation' film, as Elvis, Edward Dalton and Audrey (Claudia Karvan) drive off into the sunrise along a straight outback road in a customised black car that clearly recalls Max's iconic Interceptor.

Coming in the distant wake of *Mad Max*, already Americanised and with a relatively large budget, we might instead think of *Daybreakers* as a 'post-Ozploitation' genre film. It is in part a battleground action B-movie, much noisier and more visceral than the slow-moving *Perfect Creature*, with soldiers wielding guns and crossbows, some thrilling road sequences, a lot of crimson splatter as dying vampires explode and blood sprays everywhere, and a number of startle effects: beginning with the sudden flight of a bat across the screen as the credits unfold (red, over black background) and the sun begins to rise over a large country property. A girl is writing a note in her bedroom: a suicide note, as it turns out. Her calendar identifies the date as April 2019: the near future, rather than, as in so many vampire films, a remote historical moment. The girl goes outside as the sun comes up, the camera focusing on her yellow eyes and vampire teeth, and in a few

moments she begins to burn, her screams introducing the film's title (also in red). This is an unusual place for a vampire film to begin, starting more or less where a film like *Thirst* ends: with a vampire who can no longer go on, who refuses to live as a vampire any longer. The film then shifts into a modern city and flashes a number of media reports on video screens, newspapers and placards: 'The Outbreak 10 Years on', 'How a Single Bat Started It All', 'German Blood Substitute Fails', 'Blood Shortage Cripples Third World', and so on. What makes *Daybreakers* unusual among vampire films is that vampires are now everywhere, and they are starving. There are very few humans left on the planet; most of those that remain are 'farmed' for their blood by vampires in large processing plants. Usually, it is vampires who are hunted and persecuted. But in *Daybreakers*, it is humans, now identified as an increasingly rare and precious resource by a predatory species that is living longer and needing more. Declared 'enemies of the state', humans have fled the cities; well-armed vampire soldiers pursue them under orders from an unspecified government that might as well be American (an Uncle Sam poster declares, 'Capture Humans! Join Us Now!'). In their place, vampires now inhabit the cities just like ordinary citizens and commuters, in suits and brimmed hats or fine dresses and coats: completely normal in appearance, except for the yellow eyes and vampire teeth. Vampire children hang around railway platforms, smoking and sullen, just like ordinary teenagers who need worry no longer about the warning that 'smoking kills'. It seems as if vampires have exactly copied humans, or the future of humans; but their increased life expectancy, the thing that humans normally aspire towards (to realise one's return on investments, etc.), is presented here as an increasing drain on what little resources remain. Poorer vampires are going hungry, unable to afford the ever-rising cost of blood. Becoming increasingly feral, living under the streets, they turn into 'subsiders', raiding well-to-do homes for whatever blood they can find or feeding on themselves when nothing is available. News reports announce government austerity measures, a 'controversial new blood rationing scheme' in London and so on. Soon there are 'blood riots'; middle-class commuters are affected, too. At a soda fountain (another Americanism in the film), a famished vampire demands 'some more fucking blood in my coffee'. When the waitress reminds him about the restrictions, other customers attack, blood is splattered across the counter and military forces arrive, subduing the rioters and taking them away.

Like the *Underworld* films and *Perfect Creature*, *Daybreakers* gives us a vampire who is no longer a vampire, turning against his own species. Edward Dalton is a hematologist – a shared profession among vampires in recent films, it seems – trying to develop a blood substitute for a medical corporation called Bromley Marks that also 'farms' human blood, run by Charles Bromley (Sam Neill). Bromley puts plenty of blood in his coffee, rich enough not to be troubled about the blood shortage. His daughter Alison (Isabel Lucas) is still human, however. Edward is increasingly distanced from Bromley's corporation, refusing to drink human blood – not entirely unlike his namesake in the *Twilight* films. His brother Frankie (Michael Dorman), a soldier, has access to human blood and enjoys it; for a while the two brothers fall out over the issue, playing out a milder version of the dispute between Edgar and Silas in *Perfect Creature*. In the meantime, Edward meets Audrey, a human who asks for his help and then leads him out of town into the countryside, where he meets Elvis – a worldly wise veteran with a woeful American South accent, played by Dafoe as if he is a younger version of Kristofferson's Whistler in the *Blade* films. Elvis was once a vampire but unexpectedly became human after a brief exposure to sunlight. (There is an obvious joke here about Elvis as undead – Elvis lives!) Hiding out in an old winery,

Michael and Peter Spierig, *Daybreakers* (2009): Alison in chains, about to burn

Edward helps the humans find a cure for vampirism, becoming human himself. In the meantime, Alison is captured and brought to her father, who gets Frankie to forcibly turn her into a vampire. Appalled at what she has become, Alison refuses to drink her 'blood ration', feeding on herself instead and soon becoming a feral subsider. To reduce the collective demand on blood, vampires turn on the subsiders, rounding them up in chains and leading them into the sun. Frankie watches in dismay as Bromley's daughter is led outside with them and incinerates, with Bromley cast as yet another heartless vampire father who sacrifices his own child. The burning of the chained subsiders is a moving sequence; for Australian viewers it might recall familiar images of Aboriginal men taken in chains from their communities and led to remote prisons, removed from sight.[29] In *Daybreakers*, it also amounts to a turning point for the vampires, as they kill the most dispensable members of their own species and, as the blood supply dwindles still further, face up to the possibility of their own extinction. 'Every day, the sun comes up', Elvis says. 'And every day, the vamps have to hide. Vampires can never survive.'

Daybreakers is about as close to a political allegory as a vampire film could be. Much more than any other vampire film discussed in this book, it is about resources: blood as a base commodity, like oil, or water. It may embrace the 'neoliberal priorities of globalization', but it also rides the wave of the global financial crisis of 2007–8, which saw – in the first world, the West – massive drops in the value of assets (savings, investments, pensions), serious declines in household wealth, bank failures, cutbacks in government spending, state austerity programmes, a growing awareness of ecological scarcity and a further increase in the divisions between the poor and the wealthy. For the vampire CEO Charles Bromley, the discovery of a workable blood substitute would mean that 'deprivation' could be 'a thing of the past', putting an end to the crisis in the hope that, afterwards, consumer capitalism might simply resume as normal. 'It's never been about a cure', he tells Edward. 'It's about business.'

But in *Daybreakers*, what is normal is the crisis itself, which steadily escalates as the film unfolds. It turns out that vampires are no different from humans here, just a generic way of drawing direct attention to the sheer fragility of the supply-demand chain in an age of austerity capitalism. Their longer life expectancy brings with it diminishing, not greater, returns, which means learning to cope with much less as one gets older. On the other hand, vampires continue to consume excessively as if they are still young, seeking immediate gratification. This impossible combination in vampires of the realities of age (austerity, self-restraint) and the pleasures of youth (abundance, self-gratification) is what produces the film's catastrophe. The vampires' deployment of what Samir Amin calls

'crisis management' only makes matters worse where, far from stabilising consumer capitalism, it 'sinks ever deeper into chaos'.[30] Amin has talked about 'obsolescent capitalism', the visible signs that capitalism is now old and exhausted; but *Daybreakers* knows that capitalism constantly renews itself, too, as if it is (or imagines itself to be) eternally young. The two predicaments blur spectacularly into each other in a wonderful sequence at the end of the film. Charles has bitten Edward, who is now human, and Charles becomes human as a result: this is his 'cure'. But it only makes matters worse. 'Now you get to die', Edward says, tying him to a chair, placing him in a lift, and sending him down to meet a group of vampire soldiers who work for the corporation. Seeing a human – a rare commodity now – the otherwise loyal soldiers fall on their CEO in a feeding frenzy. Frankie, a soldier himself, is also human now, and arrives at the scene. 'Don't do this. There's a cure!' he pleads, as the soldiers fall on him as well, biting and feeding. The soldiers then turn human themselves; more vampire soldiers arrive and feed on the human soldiers, and they turn into humans, too. In a slo-mo splatterfest of feasting, an eternal cycle of consumption is played out, potentially without end: so that it seems for a moment that supply-and-demand capitalism really could go on forever. The circuit is finally broken when a vampire scientist from Bromley Marks runs in and shoots the remaining humans: 'There can't be a cure!' he cries. 'I can't let you do it!' He is killed in turn by Elvis, as Edward mourns the death of his brother and the sun begins to rise. In *Daybreakers*, vampires – like consumer capitalism itself, or like a virus – seem to be everywhere. They have adjusted to the modern world with great success, and yet their grip on it could not be more fragile. There is the possibility of a cure for vampirism, but it is both offered and withdrawn; there is a cure, but there can't be a cure. Like the young girl at the beginning of the film, some vampires seem to realise this and simply refuse to go on. But for most of the rest, there is no end in sight: even as the blood drains away, they keep doing what vampires have always done as if, no matter how little there is left to draw on, they cannot stop.

Notes

PREFACE

1. To cite some recent examples: Alain Silver and James Ursini, *The Vampire Film: From Nosferatu to Twilight*, fourth edition (Milwaukee, WI: Limelight Edition, 2010); John Edgar Browning and Caroline Joan (Kay) Picart, *Dracula in Visual Media: Film, Television, Comic Book and Electronic Game Appearances, 1921–2010* (Jefferson, NC: McFarland & Co. Ltd, 2011); and Kim Newman, *Nightmare Movies: Horror on Screen since the 1960s* (London: Bloomsbury, 2011).
2. See Annette Kuhn, 'Introduction', in Annette Kuhn (ed.), *Alien Zone: Cultural Theory and Contemporary Science Fiction Cinema* (London and New York: Verso, 1990), p. 10.
3. Robert B. Ray, 'Mystery Trains', *Sight and Sound* vol. 10 no. 11 (November 2000): www.bfi.org.uk/sightandsound/feature/69/.
4. Tom Gunning, *The Films of Fritz Lang: Allegories of Vision and Modernity* (London: BFI, 2000), p. x.

1 INAUTHENTIC VAMPIRES

1. Gene D. Phillips, *Godfather: The Intimate Francis Ford Coppola* (Lexington: University Press of Kentucky, 2004), p. 298.
2. Christopher Sharrett, 'The Fall of Francis Coppola', *USA Today* vol. 121 no. 2574 (March 1993), p. 61.
3. Vincent Canby, 'Coppola's Dizzying Vision of Dracula', *New York Times*, 13 November 1992: movies.nytimes.com/movie/review?res=9E0CE2D61539F930A25752C1A964958260.
4. David Denby, 'Bad Blood', *New York Magazine*, 16 November 1992, p. 72.
5. Jonathan Romney, '*Bram Stoker's Dracula*', *New Statesman & Society*, 29 January 1993, p. 42.
6. Grant Edmond, '*Bram Stoker's Dracula*', *Films in Review* vol. 44 nos 3/4 (1 March 1993), p. 2.
7. Thomas Elsaesser, 'Specularity and Engulfment: Francis Ford Coppola and *Bram Stoker's Dracula*', in Steve Neale and Murray Smith (eds), *Contemporary Hollywood Cinema* (London: Routledge, 1998), p. 191.
8. Steven Jay Schneider, *New Hollywood Violence* (Manchester: Manchester University Press, 2004), p. 8.
9. Elsaesser, 'Specularity and Engulfment', p. 191.
10. Ibid., p. 194.
11. Ibid.
12. Ibid., p. 196.
13. Ibid., p. 206.
14. Dianne F. Sadoff, *Victorian Vogue: British Novels on Screen* (Minneapolis: University of Minnesota Press, 2009), p. 130.
15. Ibid.
16. See Jeffrey Richards, *Sir Henry Irving: A Victorian Actor and His World* (London and New York: Continuum, 2007), p. 158.

17. Tom Gunning, 'An Aesthetic of Astonishment: Early Film and the (in)Credulous Spectator', in Linda Williams (ed.), *Viewing Positions: Ways of Seeing Film* (Piscataway, NJ: Rutgers University Press, 1995), pp. 116, 129.
18. Ibid., p. 123.
19. Sadoff, *Victorian Vogue*, p. 131. Sadoff mistakenly suggests that Van Helsing is referring to Mina when he tells Morris about 'the devil's concubine'.
20. Ibid., p. 132.
21. Elsaesser, 'Specularity and Engulfment', p. 204.
22. The word 'symphonic' is used by Julian Sands to describe Ken Russell's *Gothic*: see Joseph Lanza, *Phallic Frenzy: Ken Russell and His Films* (Chicago, IL: Chicago Review Press, 2007), p. 268.
23. Lisa Hopkins, *Screening the Gothic* (Austin: University of Texas Press, 2005), p. 112.
24. Denby, 'Bad Blood', p. 72.
25. Frank Rich, 'The New Blood Culture', *New York Times*, 6 December 1992; cited in Janet L. Beizer, *Ventriloquized Bodies: Narratives of Hysteria in Nineteenth-century France* (Ithaca, NY: Cornell University Press, 1994), p. 264.
26. Ibid., p. 265.
27. Margaret Montalbano, 'From Bram Stoker's *Dracula* to *Bram Stoker's Dracula*', in Robert Stam and Alessandra Raengo (eds), *A Companion to Literature and Film* (Oxford: Wiley-Blackwell, 2004), p. 392.
28. Ibid.
29. Glennis Byron, *Bram Stoker* (Basingstoke: Palgrave Macmillan, 1999), p. 203.
30. Barbara Creed, *Phallic Panic: Film, Horror and the Primal Uncanny* (Melbourne: Melbourne University Press, 2005), p. 89.
31. Thomas Austin, *Hollywood, Hype and Audiences: Selling and Watching Popular Film in the 1990s* (Manchester: Manchester University Press, 2002), p. 125.
32. Ibid., p. 117.
33. Cited in ibid., p. 131.
34. Erik Marshall, 'Defanging Dracula: The Disappearing Other in Coppola's *Bram Stoker's Dracula*', in Ruth Bienstock and Douglas L. Howard (eds), *The Gothic Other: Racial and Social Constructions in the Literary Imagination* (Jefferson, NC: McFarland & Co. Ltd, 2004), p. 289.
35. Robert Spadoni, *Uncanny Bodies: The Coming of Sound Film and the Origins of the Horror Genre* (Berkeley: University of California Press, 2007), p. 1.
36. Elsaesser, 'Specularity and Engulfment', p. 197.
37. Cited in Bertlomiej Paszylk, *The Pleasure and Pain of Cult Horror Films: An Historical Survey* (Jefferson, NC: McFarland & Co. Ltd, 2009), p. 190.
38. Chris C. Wehner, '*Shadow of the Vampire*: An Interview with Steven Katz', in *Who Wrote That Movie?: Screenwriting in Review: 2000–2002* (Bloomington, IN: iUniversie, 2003), p. 33.
39. Ibid., p. 34.
40. Lisa Kennedy, 'Out Front Film', *Out*, December 2000, p. 42. There is a brief scene in a Berlin cabaret (rather like the scenes in the 'decadent' cinematograph in Coppola's film) during which Murnau buries his face in a woman's bare backside.
41. This is a poem connected to other vampires, too: Whitley Strieber uses some lines from 'Tithonus' as an epigraph to his novel, *The Hunger* (1981).
42. Sadoff, *Victorian Vogue*, pp. 126–7.
43. Cited in Thomas Elsaesser, 'No End to Nosferatu', in Noah William Isenberg (ed.), *Weimar Cinema: An Essential Guide to Classic Films of the Era* (New York: Columbia University Press, 2009), p. 90.

44. Jacques Rancière, *Film Fables*, trans. Emiliano Battista (Oxford and New York: Berg, 2006), p. 40.

45. Elsaesser, 'No End to Nosferatu', p. 90.

46. See, for example, Steven Jay Schneider, *Horror Film and Psychoanalysis: Freud's Worst Nightmare* (Cambridge: Cambridge University Press, 2004), pp. 230–1; Stacey Abbott, *Celluloid Vampires: Life after Death in the Modern World* (Austin: University of Texas Press, 2007), p. 43.

47. Slavoj Zizek, *For They Know Not What They Do: Enjoyment as a Political Factor*, second edition (London and New York: Verso, 2002), pp. xciv–cv, note 7.

48. Hal Hinson, 'Buffy the Vampire Slayer', *Washington Post*, 31 July 1992: www.washingtonpost.com/wp-srv/style/longterm/movies/videos/buffythevampireslayerpg13hinson_a0a790.htm.

49. David Lavery and Cynthia Burkhead (eds), *Joss Whedon: Conversations* (Jackson: University Press of Mississippi, 2011), p. 45.

50. In Roz Kaveney's *Teen Dreams: Reading Teen Film from* Heathers *to* Veronica Mars (London and New York: I. B. Tauris, 2006), Buffy is described as positioned 'as part of a clique somewhere between the social aggression of the *Heathers* and the fluffy likeability of the central group in *Clueless*', p. 88.

51. Compare the scene in the live-action remake of *Blood: The Last Vampire* (2009), where the slayer/vampire Saya (Gianna Jun) fights two schoolgirl vampires in a high school gym to the sound track of Deep Purple's 'Space Truckin''.

52. Murray Pomerance, *Sugar, Spice, and Everything Nice: Cinemas of Girlhood* (Detroit, MI: Wayne State University Press, 2002), p. 132.

53. Timothy Shary, *Generation Multiplex: The Image of Youth in Contemporary American Cinema* (Austin: University of Texas Press, 2002), p. 71.

54. Cited in Sharon Marie Carnicke, 'Screen Performance and Directors' Visions', in Cynthia Baron, Diane Carson and Frank P. Tomasulo (eds), *More than a Method: Trends and Traditions in Contemporary Film Performance* (Detroit, MI: Wayne State University Press, 2004), p. 62.

55. Harry M. Benshoff, *Monsters in the Closet: Homosexuality and the Horror Film* (Manchester: Manchester University Press, 1997), p. 270.

56. Ibid., p. 272.

57. Anne Stockwell, 'Blood and Lust', *Advocate*, 13 December 1994, p. 63.

58. Although they are not explicit, these two films are characterised as 'self-aware' and playful in terms of their homoerotics in Benshoff, *Monsters in the Closet*, pp. 250–3.

59. Stockwell, 'Blood and Lust', p. 64.

60. Ibid., p. 272.

61. Ibid., p. 271.

62. David Denby, 'Good Sports', *New York Magazine*, 16 December 1996, p. 60.

63. Martha Frankel, 'Interview with the Author of *Interview with the Vampire*', in George Beahm (ed.), *The Unauthorized Anne Rice Companion* (Kansas City, KA: Andrews and McMeek, 1996), pp. 178–9.

64. Cited in Rachel Abramowitz, 'The Vampire Chronicles', *Premiere: The Movie Magazine*, February 1995, p. 70.

65. Anne Rice, 'To My Readers: A Personal Statement by Anne Rice Regarding the Motion Picture *Interview with the Vampire*', in George Beahm, *The Unauthorized Anne Rice Companion*, pp. 185–6.

66. For a longer discussion of Anne Rice's various positions on the film, and Cruise's 'impersonation' of Lestat, see Ken Gelder, *Popular Fiction: The Logics and Practices of a Literary Field* (Abingdon: Routledge, 2004), pp. 120–4.

67. Set in '1870', the play predates the Theatre du Grand-Guignol in Pigalle, Paris, by seventeen years. But the playhouse in the film, designed to resemble a chapel with a large church organ at the back, clearly references the Grand-Guignol theatre, which 'was formerly a small chapel', a feature that enhanced 'the morally dubious but quasi-religious experience' of the plays: something the Theatre des Vampires' performance (combining horror and erotic excitement) also gestures towards. See Karoline Gritzner, *Eroticism and Death in Theatre and Performance* (Hatfield: University of Hertfordshire Press, 2010), p. 73.

68. A sample of typically critical reviews includes: Damien Cave, 'Queen of the Damned', *Salon.com*, 23 February 2002: entertainment.salon.com/2002/02/22/queen_of_damned/; David Perry, 'Queen of the Damned', *Cinema.Scene.com* vol. 4 no. 8: www.cinema-scene.com/archive/04/08.html; Total Film, 'Queen of the Damned', *Total Film: The Modern Guide to Movies*, 12 April 2002: www.totalfilm.com/reviews/cinema/queen-of-the-damned.

69. Abbott, *Celluloid Vampires*, p. 218.

2 OUR VAMPIRES, OUR NEIGHBOURS

1. Andrew Tudor, 'Genre', in Barry Keith Grant (ed.), *Film Genre Reader III* (Austin: University of Texas Press, 2003), p. 5.

2. Ibid., p. 7.

3. Jenny Kwok Wah Lau, 'Besides Fists and Blood: Michael Hui and Cantonese Comedy', in Poshek Fu and David Desser (eds), *The Cinema of Hong Kong: History, Arts, Identity* (Cambridge: Cambridge University Press, 2002), p. 164.

4. Rick Altman, 'Conclusion: A Semantic/Syntactic/Pragmatic Approach to Genre', in Julie F. Codell (ed.), *Genre, Gender, Race, and World Cinema: An Anthology* (Oxford: Blackwell Publishing, 2007), p. 14.

5. Peter Hutchings, 'Monster Legacies: Memory, Technology and Horror History', in Lincoln Geraghty and Mark Jancovich (eds), *The Shifting Definitions of Genre: Essays on Labeling Films, Television Shows and Media* (Jefferson, NC: McFarland & Co. Ltd, 2007), pp. 216–28.

6. Peter Hutchings, *The Horror Film* (Harlow: Pearson Education Ltd, 2004), p. 33.

7. Rick Altman, 'A Semantic/Syntactic Approach to Film Genre', in Grant, *Film Genre Reader III*, p. 31.

8. Altman, 'Conclusion', p. 22.

9. Edward Buscombe, 'The Idea of Genre in the American Cinema', in Grant, *Film Genre Reader III*, p. 12.

10. Ibid., p. 25.

11. Linda Ruth Williams, *The Erotic Thriller in Contemporary Cinema* (Bloomington: Indiana University Press, 2005), pp. 22–3.

12. Ibid., p. 17.

13. Susan Hayward, *Cinema Studies: The Key Concepts* (London: Taylor & Francis, 2006), pp. 163–4.

14. Jacques Derrida and Derek Attridge, *Acts of Literature* (London and New York: Routledge, 1992), pp. 224–5.

15. Ibid., p. 231.

16. John Frow, *Genre* (Abingdon: Routledge, 2006), p. 26.

17. Cited in ibid., p. 25.

18. See Georg Simmel, 'The Stranger', in Kurt H. Wolff (ed.), *The Sociology of Georg Simmel* (New York: Free Press, 1950). Simmel's essay was first published in 1908.

19. Thorolf Hillblad, *Twilight of the Gods* (Solihull: Helion & Co. Ltd, 2004), p. 11.

20. Ibid., p. 10.

21. 'Exclusive Interview with Anders Banke, Director of *Frostbite*', www.eatmybrains.com 3 December 2006: http://www.eatmybrains.com/showfeature.php?id=60.

22. Ibid.

23. Jussi Parikka, *Insect Media: An Archaeology of Animals and Technology* (Minneapolis: University of Minnesota Press, 2010), p. 66; see Giorgio Agamben, 'The Tick', *The Open: Man and Animal* (Stanford, CA: Stanford University Press, 2004), pp. 45–8.

24. John Ajvide Lindqvist, *Let the Right One In* (Melbourne: Text Publishing Company, 2007), pp. 1–2.

25. Bran Nicol, '"Police Thy Neighbour": Crime Culture and the *Rear Window* Paradigm', in Bran Nicol, Eugene McNulty and Patricia Pulham (eds), *Crime Culture: Figuring Criminality in Fiction and Film* (London and New York: Continuum, 2011), p. 196.

26. John Calhoun, 'Childhood's End: *Let the Right One In* and Other Deaths of Innocence', *Cineaste*, Winter 2009, p. 31.

27. Simmel, 'The Stranger', p. 405.

28. Calhoun, 'Childhood's End', p. 31.

29. Anthony Quinn, 'Blood in a Cold Climate', *Independent*, 10 April 2009: www.independent.co.uk/arts-entertainment/films/reviews/let-the-right-one-in-15-1666629.html.

30. Ryan Gilbey, 'Scare Tactics', *New Statesman & Society*, 15 November 2010, pp. 42–3.

31. Terrence Rafferty, 'Chilling Enough to Deserve a Remake', *New York Times*, 12 September 2010, p. 36.

32. Nina Auerbach, *Our Vampires, Ourselves* (Chicago, IL: University of Chicago Press, 1995), p. 187.

33. Ibid., p. 9.

34. Sigmund Freud, *Civilization and Its Discontents*, trans. James Strachey (New York: W. W. Norton & Company, Inc., 1962), p. 57.

35. Ibid., p. 58.

36. Jules Zanger, 'Metaphor into Metonymy: The Vampire Next Door', in Veronica Hollinger (ed.), *Blood Read: The Vampire as Metaphor in Contemporary Culture* (Philadelphia: University of Pennsylvania Press, 1997), p. 19.

37. Ibid.

38. Ibid., p. 22.

39. Slavoj Zizek, 'Afterword: Lenin's Choice', in Vladimir Lenin and Slavoj Zizek, *Revolution at the Gates: A Selection of Writings from February to October 1917* (London and New York: Verso, 2004), p. 213.

40. Eric L. Santner, 'Miracles Happen: Benjamin, Rosenzweig, Freud, and the Matter of the Neighbour', in Slavoj Zizek, Eric L. Santner and Kenneth Reinhard, *The Neighbour: Three Inquiries in Political Theology* (Chicago, IL: University of Chicago Press, 2005), p. 119.

41. Eric L. Santner, *On Creaturely Life: Rilke/Benjamin/Sebald* (Chicago, IL: University of Chicago Press, 2006), p. xx.

42. Eric L. Santner, *On the Psychotheology of Everyday Life: Reflections on Freud and Rosenzweig* (Chicago, IL: University of Chicago Press, 2001), pp. 31, 36.

43. Ibid., p. 31.

44. Ibid., p. 36.

45. Carolyn Jess-Cooke, *Film Sequels: Theory and Practice from Hollywood to Bollywood* (Edinburgh: Edinburgh University Press, 2009), p. 111.

46. John Lyttle, 'Not since Battleship Potemkin', *Economist* vol. 373 no. 8390, 28 August 2004, p. 74.

47. 'From Russia, with Cult: Interview: Daywatch Director Timur Bekmambetov', *Screenjabber.com*, undated: www.screenjabber.com/daywatch_feature.

48. Anthony Lane, 'Evil Touch', *New Yorker*, 27 February 2008: www.newyorker.com/archive/2006/02/27/060227crci_cinema?currentPage=2.

49. See, for example, Giorgio Hadi Curti, 'Beating Words to Life: Subtitles, Assemblage(s)capes, Expression', *Geojournal* vol. 74 no. 3, pp. 201–8.

50. James Hoberman, 'Altered States', *Village Voice*, 7 February 2006: www.villagevoice.com/2006-02-07/film/altered-states/.

51. Vlad Strukov, 'The Forces of Kinship: Timur Bekmambetov's *Night Watch* Cinematic Trilogy', in Helena Goscilo and Yana Hashamova (eds), *Cinepaternity: Fathers and Sons in Soviet and Post-Soviet Film* (Bloomington: Indiana University Press, 2010), p. 212.

52. Ibid., p. 199.

53. This scene is only shown in the international release of *Night Watch*: see film-censorship.com/report.php?ID=2891.

3 CITATIONAL VAMPIRES

1. Meaghan Morris, 'Introduction: Hong Kong Connections', in Meaghan Morris, Siu Leung Li and Stephen Chan Ching-kiu (eds), *Hong Kong Connections: Transnational Imagination in Action Cinema* (Durham, NC: Duke University Press, 2005; Hong Kong: Hong Kong University Press, 2005), p. 7.

2. Vicki Callahan, *Zones of Anxiety: Movement, Musidora, and the Crime Serials of Louis Feuillade* (Detroit, MI: Wayne State University Press, 2005), p. 87.

3. Olivier Assayas, 'Regarding Maggie' (Zeitgeist Video, DVD film notes, 1997), n.p.

4. Adrian Martin, 'At the Edge of the Cut: An Encounter with the Hong Kong Style in Contemporary Action Cinema', in Morris *et al.*, *Hong Kong Connections*, p. 177. See also Nicole Brenez's chapter in the same collection, 'The Secrets of Movement: The Influence of Hong Kong Action Cinema upon the Contemporary French Avant-garde', which begins with a version of the young interviewer's distinction in *Irma Vep*:

> There is seemingly nothing more remote from the action cinema of Hong Kong than French avant-garde cinema. One is an industrial, hierarchical cinema, organized by laws of iconography. It's a cinema of archetypes, fit for universal acceptance and universally loved. The other is an artisanal cinema, composed of singular initiatives, devoted to questioning and criticizing all and every cinematic law … . There should be no connection between these two continents of cinema. (p. 164)

Brenez's thesis, however, is that 'Hong Kong action cinema supplies French experimental cinema with a liberating lever [with which] to reconstruct the problem of movement …' (p. 164).

5. Hong Kong viewers in touch with their own, local cinema traditions may, on the other hand, be encouraged by *Irma Vep* to recall Chor Yuen's *The Black Rose* (1965), with its wealthy cat burglar heroines who similarly dress in tight black costumes and black masks. I am indebted to Meaghan Morris for this reference. A series of parodic, comical 'Black Rose' remakes were produced much later on, beginning with *Hak Mooi Gwai Dui Hak Mooi Gwai* (1992).

6. W. J. T. Mitchell, *Cloning Terror: The War of Images, 9/11 to the Present* (Chicago, IL: University of Chicago Press, 2011), p. 29.

7. Olivia Khoo, *The Chinese Exotic* (Hong Kong: Hong Kong University Press, 2007), pp. 99, 103.
8. Dale Hudson, '"Just Play Yourself, 'Maggie Cheung'": *Irma Vep,* Rethinking Transnational Stardom and Unthinking National Cinemas', *Screen* vol. 47 no. 2 (Summer 2006), p. 232.
9. Ibid., p. 225.
10. Ibid., p. 232.
11. Jonathan Rosenbaum, *Essential Cinema: On the Necessity of Film Canons* (Baltimore, MD: Johns Hopkins University Press, 2004), p. 168.
12. Elizabeth Ezra, 'The Case of the Phantom Fetish: Louis Feuillade's *Les Vampires*', *Screen* vol 47 no. 2 (Summer 2006), p. 201.
13. Ibid., p. 202.
14. Ibid., p. 206.
15. See, for example, Colette Balmain's chapter 'Horror after Hiroshima', in *Introduction to Japanese Horror Film* (Edinburgh: Edinburgh University Press, 2008), pp. 304–9.
16. Adam Lowenstein, *Shocking Representation: Historical Trauma, National Cinema and the Modern Horror Film* (New York: Columbia University Press, 2005), p. 91.
17. See Fredric Jameson, 'Third-World Literature in the Era of Multinational Capitalism', *Social Text* vol. 15 (Autumn 1986), p. 69:

> Third-world texts, even those which are seemingly private and invested with a properly libidinal dynamic – necessarily project a political dimension in the form of national allegory: *the story of the private individual destiny is always an allegory of the embattled situation of the public third-world culture and society.* (Jameson's italics)

18. Eric L. Santner, 'History beyond the Pleasure Principle: Some Thoughts on the Representation of Trauma', in Saul Friedlander (ed.), *Probing the Limits of Representation: Nazism and the 'Final Solution'* (Cambridge, MA: Harvard University Press, 1992), p. 144.
19. See, for example, Lang Phipps, 'Is Amano the Best Artist You've Never Heard Of?', *New York Magazine*, 6 October 1997, p. 46.
20. Christopher Bolton, 'The Quick and the Undead: Visual and Political Dynamics in *Blood: The Last Vampire*', in Frenchy Lunning (ed.), *Mechademia 2: Networks of Desire* (Minneapolis: University of Minnesota Press, 2007), p. 126.
21. Ibid., pp. 126, 139.
22. Ibid., p. 133.
23. Ibid., p. 139.
24. Ibid., p. 140.
25. Vadim Rizov, '*Blood: The Last Vampire*', *Sight and Sound* vol. 19 no. 8 (August 2009), p. 53.
26. Sun Jung, *Korean Masculinities and Transcultural Consumption: Yonsama, Rain, Oldboy, K-Pop Idols* (Hong Kong: Hong Kong University Press, 2010), p. 3.
27. Nikki J. Y. Lee, 'Salute to Mr Vengeance!: The Making of a Transnational Auteur Park Chan-Wook', in Leon Hunt and Leung Wing-Fai (eds), *East Asian Cinemas: Exploring Transnational Connections on Film* (London and New York: I. B. Tauris, 2008), p. 206.
28. Kim Hyun Kyung, *The Remasculinization of Korean Cinema* (Durham, NC: Duke University Press, 2004), p. 11.
29. Anne Cieko and Hunju Lee, 'Park Chan-Wook', in Yvonne Tasker (ed.), *Fifty Contemporary Film Directors*, second edition (Abingdon: Routledge, 2011), p. 320.

30. James Bell, interview with Park Chan-Wook, *Sight and Sound* vol. 19 no. 11 (November 2009), p. 43.

31. Amy Taubin, 'Cannes: On the Riviera This Year, If It Bled, It Led' (2009): filmlinccom.site protect.net/fcm/ja09/cannes1.htm.

32. Park Chan-Wook, 'Park Chan-Wook: An Exclusive Interview', *eastern kicks.com*, 14 October 2009: www.easternkicks.com/features/park-chan-wook-exclusive-interview.

33. Ewa Mazierska and Laura Rascaroli, *From Moscow to Madrid: Postmodern Cities, European Cinema* (London and New York: I. B. Tauris, 2003), pp. 118–19.

34. Kim, *The Remasculinization of Korean Cinema*, p. 9.

4 VAMPIRES IN THE AMERICAS

1. Auerbach, *Our Vampires, Ourselves*, p. 6.

2. Ibid.

3. Ibid., p. 7.

4. See, for example, Rob Latham, *Consuming Youth: Vampires, Cyborgs, and the Culture of Consumption* (Chicago, IL: University of Chicago Press, 2002), p. 80: in *The Hunger*, he suggests, 'the figure of the yuppie vampire emerges as an exalted representative of the so-called economic revival that marked the Reaganite 1980s'. See also Nicola Nixon, 'When Hollywood Sucks, or, Hungry Girls, Lost Boys, and Vampires in the Age of Reagan', in Veronica Hollinger (ed.), *Blood Read: The Vampire as Metaphor in Contemporary Culture* (Philadelphia: University of Pennsylvania Press, 1997), pp. 115–28.

5. David Sterritt and John Anderson (eds), *The B List: The National Society of Film Critics on the Low-budget Beauties, Genre-bending Mavericks, and Cult Classics We Love* (Cambridge, MA: Da Capo Press, 2008), p. 186.

6. Dale Hudson, 'Vampires of Colour and the Performance of Multicultural Whiteness', in Daniel Bernardi (ed.), *The Persistence of Whiteness: Race and Contemporary Hollywood Cinema* (Abingdon: Routledge, 2008), pp. 138–9.

7. Ibid., p. 141.

8. Ibid., p. 127.

9. Roger Ebert, '*Nadja*', rogerebert.com, 1 September 1995: rogerebert.suntimes.com/apps/pbcs.dll/article?AID=/19950901/REVIEWS/509010301/1023.

10. Catherine Spooner, *Contemporary Gothic* (London: Reaktion Books, 2006), p. 57.

11. See, for example, Caryn James, 'Those Who Kiss Her Half-live to Regret It', *New York Times*, 25 August 1995: movies.nytimes.com/movie/review?res=990CE3DF1530F936A1575BC0 A963958260.

12. Auerbach, *Our Vampires, Ourselves*, p. 1.

13. Ibid., p. 7.

14. Ibid., p. 2.

15. Quoted in Gregory Lamberson, *Cheap Scares!: Low Budget Horror Filmmakers Share Their Secrets* (Jefferson, NC: McFarland & Co. Ltd, 2008), p. 143.

16. Abbott, *Celluloid Vampires*, p. 150.

17. See, for example, Caryn James, 'A Philosophy Student Who Bites', *New York Times*, 4 October 1995: movies.nytimes.com/movie/review?res=980CE3D81539F937A35753C1A963958260.

18. Justin Vicari, 'Vampire as Metaphor: Revisiting Abel Ferrara's *The Addiction*', *Jump Cut: A Review of Contemporary Media* vol. 49 (Spring 2007): www.ejumpcut.org/archive/jc49.2007/addiction/index.html.

19. Ibid.

20. Kathleen Canning, *Weimar Publics/Weimar Subjects: Rethinking the Political Culture of Germany* (Oxford: Berghahn Books, 2010), p. 40.

21. Nicole Brenez, *Abel Ferrara* (Champaign: University of Illinois Press, 2007), p. 18.

22. Ibid., p. 30.

23. See Lowenstein, *Shocking Representation*, pp. 111–43. Lowenstein's allegorical readings of horror cinema have already been noted in Chapter 3. He sees Craven's *Last House on the Left*, which is built around the rape and murder of two teenage girls and the subsequent revenge-slaughter of their killers by one of the girl's parents, in terms of its evocations of American trauma over President Nixon's escalation of the Vietnam War. His reading of the film is similar to Brenez's allegorical reading of Kathy in *The Addiction*: 'The film locates the grim consequences of these profound social upheavals … on the body of a teenage girl' (p. 115).

24. Leslie Tannenbaum, 'Policing Eddie Murphy: The Unstable Black Body in *Vampire in Brooklyn*', in James Craig Holte (ed.), *The Fantastic Vampire: Studies in the Children of the Night* (Westport, CT: Greenwood Publishing Group, 2002), p. 69.

25. Leerom Medovoi, 'Theorizing Historicity, or, The Many Meanings of *Blacula*', *Screen* vol. 39 (Spring 1998), p. 12.

26. Ibid., p. 17.

27. See, for example, Steffen Hantke, *Horror Film: Creating and Marketing Fear* (Jackson: University Press of Mississippi, 2009), p. 86: the 'event movie' becomes a 'cultural force', involving other agencies,

> some of them with a direct commercial stake in the success of the film product (advertising agencies, merchandising tie-in companies, and the like) and others who do not profit directly from the film's revenue but have an active interest in using the film's public profile (critics, feature writers, academics, and so forth) for their own agendas … . An event movie may be intended to create a movie franchise [by relying] … on the strength and name-recognition of a pre-existing proven commodity, e.g. a beloved television series or durable comic book series.

Hantke talks about the 'horror event movie' in his book: like *Interview with the Vampire*.

28. Melissa A. Click, Jennifer Stevens Aubrey and Elizabeth Behm-Morawitz, *Bitten by Twilight: Youth Culture, Media, and the Vampire Franchise* (New York: Peter Lang, 2010), p. 3.

29. Nikki Finke, 'New Moon Shreds Movie Records!', *Deadline*, 21 November 2009: www.deadline.com/2009/11/phenomenal-breaking-records-new-moon-doing-dark-knight-midnight-numbers/.

30. Nikki Finke, 'Eclipse Keeps Breaking Records', *Deadline*, 1 July 2010: www.deadline.com/2010/07/first-record-eclipse-opens-to-biggest-domestic-release-in-hollywood-history/.

31. See Sanjiv Bhattacharya, 'Robert Pattinson Interview: Reality Bites', *Observer*, 6 November 2011: www.guardian.co.uk/film/2011/nov/06/robert-pattinson-interview-reality-bites.

32. See 'Interview with Jeff Kovel', *Design Tavern.com*, 9 February 2009: www.designtavern.com/2009/02/interview-with-jeff-kovel-the-architect-of-the-cullen-house-hoke-house-from-twilight/; and '*Twilight: New Moon* House for Sale', *Freshome.com*: freshome.com/2009/11/21/twilight-new-moon-film-house-for-sale/.

33. See the 'history' entry in *Quileute Nation*: www.quileutenation.org/culture/history: 'According to their ancient creation story, the Quileutes were changed from wolves by a wandering Transformer.' The name 'Quileute' is supposed to come from the tribe's word for wolf, *Kwoli*.

34. Natalie Wilson, 'Civilized Vampires versus Savage Werewolves: Race and Ethnicity in the Twilight Series', in Click *et al.* (eds), *Bitten by Twilight*, p. 55.
35. Natalie Wilson, 'It's a Wolf Thing: The Quileute Werewolf/Shape-shifter Hybrid as Noble Savage', in Maggie Parke and Natalie Wilson (eds), *Theorizing Twilight: Critical Essays on What's at Stake in a Post-vampire World* (Jefferson, NC: McFarland & Co. Ltd, 2011), pp. 194–5.
36. Jason Wood, *Talking Movies: Contemporary World Filmmakers in Interview* (New York: Wallflower Press, 2006), p. 38.
37. Guillermo del Toro, 'Director's Perspective' (2003), *Cronos* DVD special features (Alliance Atlantis Vivafilm, Inc., Montreal).
38. Wood, *Talking Movies*, p. 30.
39. David Greven, 'Angels and Insects: The Cinematic Spawn of Guillermo Del Toro', *Slant Magazine*, 17 November 2008: www.slantmagazine.com/house/2008/11/angels-and-insects-the-cinematic-spawn-of-guillermo-del-toro/.
40. Paul Virilio, *The Aesthetics of Disappearance*, trans. Philip Beitchman (Los Angeles, CA: Semiotext[e], 2009), p. 37.
41. Wood, *Talking Movies*, pp. 34–5.
42. John Kraniauskas, '*Cronos* and the Political Economy of Vampirism', in Francis Barker, Peter Hulme and Margaret Iverson (eds), *Cannibalism and the Colonial World* (Cambridge: Cambridge University Press, 1998), p. 155.
43. Paul Julian Smith, 'Ghost of the Civil Dead', *Sight and Sound*, December 2001: www.bfi.org.uk/sightandsound/review/1904/.
44. Ann Marie Stock, 'Introduction', in Ann Marie Stock (ed.), *Framing Latin American Cinema: Contemporary Critical Perspectives* (Minneapolis: University of Minnesota Press, 1997), p. xxvi.
45. Tim Lucas, 'Under the Influence', *Sight and Sound*, February 2011, p. 88.
46. Del Toro might also have had Coppola's *Bram Stoker's Dracula* in mind for this scene, as a kind of polar opposite. In an interview, he has said: 'Most of us would love to bite Winona Ryder, but not everyone would lick the floor of a toilet. To me, it represents the purest moment of … the urge and the hunger.' See Staci Layne Wilson, 'Go, Guillermo!', *Horror.com*, 2003: horror.com/php/article-282-1.html.
47. Jonathan Romney, '*Cronos*', *New Statesman & Society*, 2 December 1994, p. 34.
48. Wood, *Talking Movies*, p. 34.
49. See, for example, Jeffrey Dawson, *Quentin Tarantino: The Cinema of Cool* (Montclair, NJ: Applause, 1995).
50. Vicari, 'Vampire as Metaphor'.
51. Geoff King, *New Hollywood Cinema: An Introduction* (London: I. B. Tauris, 2002), p. 117.
52. Ibid., p. 122.
53. See Doyle Greene, *Mexploitation Cinema: A Critical History of Mexican Vampire, Wrestler, Ape-Man, and Similar Films, 1957–1977* (Jefferson, NC: McFarland & Co. Ltd, 2005). One of the best-known examples of an earlier gore-sleaze Mexican vampire film is Juan Lopez Moctezuma's *Alucarda* (1975), with its lesbian vampires in a convent setting: also starring *Cronos*'s Claudio Brook.
54. William Patrick Day, *Vampire Legends in Contemporary American Culture: What Becomes a Legend Most* (Lexington: University Press of Kentucky, 2002), p. 145.
55. Bernardi, *The Persistence of Whiteness*, p. 156, n. 61.
56. Joseph Maddrey, *Nightmares in Red, White and Blue: The Evolution of the American Horror Film* (Jefferson, NC: McFarland & Co. Ltd, 2004), p. 139.

5 DIMINISHING VAMPIRES

1. See Hervé Juvin, *The Coming of the Body* (London and New York: Verso, 2010).

2. Carolyn Jess-Cooke and Constantine Verevis, 'Introduction', in Carolyn Jess-Cooke and Constantine Verevis (eds), *Second Takes: Critical Approaches to the Film Sequel* (New York: SUNY Press, 2010), p. 5.

3. Adilifu Nama, *Super Black: American Pop Culture and Black Superheroes* (Austin: University of Texas Press, 2011), pp. 138–9.

4. Pete Falconer, 'Fresh Meat? Dissecting the Horror Movie Virgin', in Tamar Jeffers McDonald (ed.), *Virgin Territory: Representing Sexual Inexperience in Film* (Detroit, MI: Wayne State University Press, 2010), p. 128.

5. Ibid., p. 129.

6. Laura Miller, '*Blade II*', *Salon Magazine*, 22 March 2002: www.salon.com/2002/03/22/blade_ii/.

7. Elvis Mitchell, 'Snuffing Out Vampires When a Stake Won't Do', *New York Times*, 22 March 2002: movies.nytimes.com/movie/review?res=9407E0D61138F931A15750C0A9649C8B63.

8. Stephen Hunter, '*Blade II*: A-Positive', *Washington Post*, 22 March 2002: www.washingtonpost.com/wp-dyn/content/article/2002/03/22/AR2005033116440.html.

9. Stephen Hunter, 'Young Blood Lacks Bite in *Blade: Trinity*', *Washington Post*, 8 December 2004: www.washingtonpost.com/wp-dyn/content/article/2004/12/08/AR2005033114790.html.

10. Nick Schager, '*Blade: Trinity*', *Slant Magazine*, 6 July 2004: www.slantmagazine.com/film/review/blade-trinity/1075.

11. Cynthia Fuchs, '*Blade: Trinity*', *Pop Matters*, 2004: popmatters.com/film/reviews/b/blade-trinity.shtml.

12. Paul Hodkinson, 'Goths', in Valerie Steele (ed.), *The Berg Companion to Fashion* (London: Berg, 2010), p. 376.

13. René Descartes, *Meditations*, trans. John Veitch (New York: Cosimo, 2008), p. 84.

14. Rachel Mizsei Ward, '*Underworld* vs the *World of Darkness*: Players and Filmgoers Respond to a Legal Battle', *Networking Knowledge: Journal of the MeCCSA Postgraduate Network* vol. 2 no. 1 (2009), p. 8: journalhosting.org/meccsa-pgn/index.php/netknow/article/view/52/89.

15. Ibid., p. 12.

16. Ibid.

17. Jeffrey A. Brown, *Dangerous Curves: Action Heroines, Gender, Fetishism, and Popular Culture* (Jackson: University Press of Mississippi, 2011), pp. 185–6.

18. Ibid., p. 228.

19. Wesley Morris, 'In *Evolution*, Blood Flows but the Story Doesn't', *Boston Globe*, 21 January 2006: www.boston.com/movies/display?display=movie&id=7426.

20. See Marcus Boon, *In Praise of Copying* (Cambridge, MA: Harvard University Press, 2010), pp. 41–7.

21. Mark Kermode is one of a number of film reviewers who are scathing about *Ultraviolet*: 'If *Aeon Flux* was *The Matrix* for fetishists, then *Ultraviolet* is *Aeon Flux* for fools.' See Mark Kermode, '*Ultraviolet*', *Observer*, 25 June 2006: www.guardian.co.uk/film/2006/jun/25/actionand adventure.sciencefictionandfantasy.

22. Kim Newman, '*Ultraviolet*', *Sight and Sound* vol. 16 no. 7 (July 2006), p. 78.

23. See, for example, Anton Kaes, *Shell Shock Cinema: Weimar Culture and the Wounds of War* (Princeton, NJ: Princeton University Press, 2011), pp. 111–12.

24. For a brief account of Oblowitz's interest in the plight of Eastern European Jews during the Holocaust, see Clive Leviev-Sawyer, '"These Are My Roots"', *Sofia Echo*, 18 March 2004: sofiaecho.com/2004/03/18/632719_these-are-my-roots.

25. Duncan Petrie, 'Cinema in a Settler Society: Brand New Zealand', in Dina Iordanova, David Martin-Jones and Belén Vidal (eds), *Cinema at the Periphery* (Detroit, MI: Wayne State University Press, 2010), p. 73.

26. Ibid., p. 74.

27. See, for example, Michelle Keown, *Postcolonial Pacific Writing: Representations of the Body* (Abingdon: Routledge, 2005), pp. 131–2: 'In New Zealand, respiratory diseases such as tuberculosis and influenza … have played a central role in the radical depopulation of New Zealand Maori since the arrival of the Europeans.'

28. In an interview about *Daybreakers*, Peter Spierig has said,

> Our goal is to get big American money and make films here [in Australia], using local crews and as many local actors as possible … . Our ambition is to do a similar thing to what Peter Jackson has done in New Zealand … . That is, go and get the money from wherever we have to.

Paul Hayes, '*Daybreakers*: True (Aussie) Blood', *Encore: Media, Entertainment & the Business of Storytelling*, 19 January 2010: www.encoremagazine.com.au/daybreakers-true-aussie-blood-195. This article typically juxtaposes US-funded Australian genre films aimed at global audiences with locally funded examples of 'national cinema' aimed at local audiences.

29. See, for example, Geoffrey G. Gray, *A Cautious Silence: The Politics of Australian Anthropology* (Canberra: Aboriginal Studies Press, 2007), p. 203: a commentary from the mid-1940s in Australia reads, 'The men you see in neck chains in this picture are Australian aborigines. They are in Australia – the country that presents itself in international councils on its solicitude for minorities and backward peoples …'.

30. Samir Amin, *Obsolescent Capitalism: Contemporary Politics and Global Disorder* (London: Zed Books, 2003), p. 17.

Bibliography

Agamben, Giorgio, 'The Tick', *The Open: Man and Animal* (Stanford, CA: Stanford University Press, 2004).

Abbott, Stacey, *Celluloid Vampires: Life after Death in the Modern World* (Austin: University of Texas Press, 2007).

Abramowitz, Rachel, 'The Vampire Chronicles', *Premiere: The Movie Magazine*, February 1995.

Altman, Rick, 'A Semantic/Syntactic Approach to Film Genre', in Barry Keith Grant (ed.), *Film Genre Reader III* (Austin: University of Texas Press, 2003).

Altman, Rick, 'Conclusion: A Semantic/Syntactic/Pragmatic Approach to Genre', in Julie F. Codell (ed.), *Genre, Gender, Race, and World Cinema: An Anthology* (Oxford: Blackwell Publishing, 2007).

Amin, Samir, *Obsolescent Capitalism: Contemporary Politics and Global Disorder* (London: Zed Books, 2003).

Assayas, Olivier, 'Regarding Maggie' (Zeitgeist Video, DVD film notes, 1997).

Auerbach, Nina, *Our Vampires, Ourselves* (Chicago, IL: University of Chicago Press, 1995).

Austin, Thomas, *Hollywood, Hype and Audiences: Selling and Watching Popular Film in the 1990s* (Manchester: Manchester University Press, 2002).

Balmain, Colette, 'Horror after Hiroshima', in *Introduction to Japanese Horror Film* (Edinburgh: Edinburgh University Press, 2008).

Banke, Anders, 'Exclusive Interview with Anders Banke, Director of *Frostbite*', *eatmybrains.com*, 3 December 2006: www.eatmybrains.com/showfeature.php?id=60.

Beizer, Janet L., *Ventriloquized Bodies: Narratives of Hysteria in Nineteenth-century France* (Ithaca, NY: Cornell University Press, 1994).

Bekmambetov, Timur, 'From Russia, with Cult: Interview: Daywatch Director Timur Bekmambetov', *Screenjabber.com*, undated: www.screenjabber.com/daywatch_feature.

Bell, James, interview with Park Chan-Wook, *Sight and Sound* vol. 19 no. 11 (November 2009).

Benshoff, Harry M., *Monsters in the Closet: Homosexuality and the Horror Film* (Manchester: Manchester University Press, 1997).

Bernardi, Daniel, *The Persistence of Whiteness: Race and Contemporary Hollywood Cinema* (London and New York: Routledge, 2008).

Bhattacharya, Sanjiv, 'Robert Pattinson Interview: Reality Bites', *Observer*, 6 November 2011: www.guardian.co.uk/film/2011/nov/06/robert-pattinson-interview-reality-bites.

Bolton, Christopher, 'The Quick and the Undead: Visual and Political Dynamics in *Blood: The Last Vampire*', in Frenchy Lunning (ed.), *Mechademia 2: Networks of Desire* (Minneapolis: University of Minnesota Press, 2007).

Boon, Marcus, *In Praise of Copying* (Cambridge, MA: Harvard University Press, 2010).

Brenez, Nicole, 'The Secrets of Movement: The Influence of Hong Kong Action Cinema upon the Contemporary French Avant-garde', in Meaghan Morris, Siu Leung Li and Stephen Chan Ching-kiu (eds), *Hong Kong Connections: Transnational Imagination in Action Cinema* (Durham, NC: Duke University Press, 2005; Hong Kong: Hong Kong University Press, 2005).

Brenez, Nicole, *Abel Ferrara* (Champaign: University of Illinois Press, 2007).

Brown, Jeffrey A., *Dangerous Curves: Action Heroines, Gender, Fetishism, and Popular Culture* (Jackson: University Press of Mississippi, 2011).

Browning, John Edgar and Picart, Caroline Joan (Kay), *Dracula in Visual Media: Film, Television, Comic Book and Electronic Game Appearances, 1921–2010* (Jefferson, NC: McFarland & Co. Ltd, 2011).

Buscombe, Edward, 'The Idea of Genre in the American Cinema', in Barry Keith Grant (ed.), *Film Genre Reader III* (Austin: University of Texas Press, 2003).

Byron, Glennis, *Bram Stoker* (Houndmills: Palgrave Macmillan, 1999).

Calhoun, John, 'Childhood's End: *Let the Right One In* and Other Deaths of Innocence', *Cineaste*, Winter 2009.

Callahan, Vicki, *Zones of Anxiety: Movement, Musidora, and the Crime Serials of Louis Feuillade* (Detroit, MI: Wayne State University Press, 2005).

Canby, Vincent, 'Coppola's Dizzying Vision of Dracula', *New York Times*, 13 November 1992: movies.nytimes.com/movie/review?res=9E0CE2D61539F930A25752C1A964958260.

Canning, Kathleen, *Weimar Publics/Weimar Subjects: Rethinking the Political Culture of Germany* (Oxford: Berghahn Books, 2010).

Carnicke, Sharon Marie, 'Screen Performance and Directors' Visions', in Cynthia Baron, Diane Carson and Frank P. Tomasulo (eds), *More than a Method: Trends and Traditions in Contemporary Film Performance* (Detroit, MI: Wayne State University Press, 2004).

Cave, Damien, 'Queen of the Damned', *Salon.com*, 23 February 2002: entertainment.salon.com/2002/02/22/queen_of_damned/.

Cieko, Anne and Lee, Hunju, 'Park Chan-Wook', in Yvonne Tasker (ed.), *Fifty Contemporary Film Directors*, second edition (Abingdon: Routledge, 2011).

Click, Melissa A., Aubrey, Jennifer Stevens and Behm-Morawitz, Elizabeth, *Bitten by Twilight: Youth Culture, Media, and the Vampire Franchise* (New York: Peter Lang, 2010).

Creed, Barbara, *Phallic Panic: Film, Horror and the Primal Uncanny* (Melbourne: Melbourne University Press, 2005).

Curti, Giorgio Hadi, 'Beating Words to Life: Subtitles, Assemblage(s)capes, Expression', *Geojournal* vol. 74 no. 3.

Dawson, Jeffrey, *Quentin Tarantino: The Cinema of Cool* (Montclair, NJ: Applause, 1995).

Day, William Patrick, *Vampire Legends in Contemporary American Culture: What Becomes a Legend Most* (Lexington: University Press of Kentucky, 2002).

Del Toro, Guillermo, 'Director's Perspective', *Cronos* DVD special features (Alliance Atlantis Vivafilm, Inc., Montreal, 2003).

Denby, David, 'Bad Blood', *New York Magazine*, 16 November 1992.

Denby, David, 'Good Sports', *New York Magazine*, 16 December 1996.

Derrida, Jacques and Attridge, Derek, *Acts of Literature* (London and New York: Routledge, 1992).

Descartes, René, *Meditations*, trans. John Veitch (New York: Cosimo, 2008).

Design Tavern, 'Interview with Jeff Kovel', *Design Tavern.com*, 9 February 2009: www.designtavern.com/2009/02/interview-with-jeff-kovel-the-architect-of-the-cullen-house-hoke-house-from-twilight/.

Ebert, Roger, 'Nadja', rogerebert.com, 1 September 1995: rogerebert.suntimes.com/apps/pbcs.dll/article?AID=/19950901/REVIEWS/509010301/1023.

Edmond, Grant, '*Bram Stoker's Dracula*', *Films in Review* vol. 44 nos 3/4 (1 March 1993).

Elsaesser, Thomas, 'No End to Nosferatu', in Noah William Isenberg (ed.), *Weimar Cinema: An Essential Guide to Classic Films of the Era* (New York: Columbia University Press, 2009).

New Vampire Cinema

Elsaesser, Thomas, 'Specularity and Engulfment: Francis Ford Coppola and *Bram Stoker's Dracula*', in Steve Neale and Murray Smith (eds), *Contemporary Hollywood Cinema* (London and New York: Routledge, 1998).

Ezra, Elizabeth, 'The Case of the Phantom Fetish: Louis Feuillade's *Les Vampires*', *Screen* vol. 47 no. 2 (Summer 2006).

Falconer, Pete, 'Fresh Meat? Dissecting the Horror Movie Virgin', in Tamar Jeffers McDonald (ed.), *Virgin Territory: Representing Sexual Inexperience in Film* (Detroit, MI: Wayne State University Press, 2010).

Finke, Nikki, 'New Moon Shreds Movie Records!', *Deadline*, 21 November 2009: www.deadline. com/ 2009/11/phenomenal-breaking-records-new-moon-doing-dark-knight-midnight-numbers/.

Finke, Nikki, 'Eclipse Keeps Breaking Records', *Deadline*, 1 July 2010: www.deadline.com/ 2010/07/first-record-eclipse-opens-to-biggest-domestic-release-in-hollywood-history/.

Frankel, Martha, 'Interview with the Author of *Interview with the Vampire*', in George Beahm (ed.), *The Unauthorized Anne Rice Companion* (Kansas City, KA: Andrews and McMeek, 1996).

Freshome, '*Twilight: New Moon* House for Sale', *Freshome.com*, 21 November 2009: freshome.com/2009/11/21/twilight-new-moon-film-house-for-sale/.

Freud, Sigmund, *Civilization and Its Discontents*, trans. James Strachey (New York: W. W. Norton & Company, Inc., 1962).

Frow, John, *Genre* (Abingdon: Routledge, 2006).

Fuchs, Cynthia, '*Blade: Trinity*', *Pop Matters*, 2004: popmatters.com/film/reviews/b/blade-trinity.shtml.

Gelder, Ken, *Popular Fiction: The Logics and Practices of a Literary Field* (Abingdon: Routledge, 2004).

Gilbey, Ryan, 'Scare Tactics', *New Statesman & Society*, 15 November 2010.

Gray, Geoffrey G., *A Cautious Silence: The Politics of Australian Anthropology* (Canberra: Aboriginal Studies Press, 2007).

Greene, Doyle, *Mexploitation Cinema: A Critical History of Mexican Vampire, Wrestler, Ape-Man, and Similar Films, 1957–1977* (Jefferson, NC: McFarland and Co. Ltd, 2005).

Greven, David, 'Angels and Insects: The Cinematic Spawn of Guillermo Del Toro', *Slant Magazine*, 17 November 2008: www.slantmagazine.com/house/2008/11/angels-and-insects-the-cinematic-spawn-of-guillermo-del-toro/.

Gritzner, Karoline, *Eroticism and Death in Theatre and Performance* (Hatfield: University of Hertfordshire Press, 2010).

Gunning, Tom, 'An Aesthetic of Astonishment: Early Film and the (in)Credulous Spectator', in Linda Williams (ed.), *Viewing Positions: Ways of Seeing Film* (Piscataway, NJ: Rutgers University Press, 1995).

Gunning, Tom, *The Films of Fritz Lang: Allegories of Vision and Modernity* (London: BFI, 2000).

Hantke, Steffen, *Horror Film: Creating and Marketing Fear* (Jackson: University Press of Mississippi, 2009).

Hayes, Paul, '*Daybreakers*: True (Aussie) Blood', *Encore: Media, Entertainment & the Business of Storytelling*, 19 January 2010: www.encoremagazine.com.au/daybreakers-true-aussie-blood-195.

Hayward, Susan, *Cinema Studies: The Key Concepts* (London: Taylor & Francis, 2006).

Hillblad, Thorolf, *Twilight of the Gods* (Solihull: Helion & Co. Ltd, 2004).

Hinson, Hal, 'Buffy the Vampire Slayer', *Washington Post*, 31 July 1992: www.washingtonpost. com/wp-srv/style/longterm/movies/videos/buffythevampireslayer pg13hinson_a0a790.htm.

Hoberman, James, 'Altered States', *Village Voice*, 7 February 2006: www.villagevoice.com/2006-02-07/film/altered-states/.

Hodkinson, Paul, 'Goths', in Valerie Steele (ed.), *The Berg Companion to Fashion* (London: Berg, 2010).

Hopkins, Lisa, *Screening the Gothic* (Austin: University of Texas Press, 2005).

Hudson, Dale, '"Just Play Yourself, 'Maggie Cheung'": *Irma Vep*, Rethinking Transnational Stardom and Unthinking National Cinemas', *Screen* vol. 47 no. 2 (Summer 2006).

Hudson, Dale, 'Vampires of Colour and the Performance of Multicultural Whiteness', in Daniel Bernardi (ed.), *The Persistence of Whiteness: Race and Contemporary Hollywood Cinema* (Abingdon: Routledge, 2008).

Hunter, Stephen, '*Blade II*: A-Positive', *Washington Post*, 22 March 2002: www.washingtonpost.com/wp-dyn/content/article/2002/03/22/AR2005033116440.html.

Hunter, Stephen, 'Young Blood Lacks Bite in *Blade: Trinity*', *Washington Post*, 8 December 2004: www.washingtonpost.com/wp-dyn/content/article/2004/12/08/AR2005033114790.html.

Hutchings, Peter, *The Horror Film* (Harlow: Pearson Education Ltd, 2004).

Hutchings, Peter, 'Monster Legacies: Memory, Technology and Horror History', in Lincoln Geraghty and Mark Jancovich (eds), *The Shifting Definitions of Genre: Essays on Labeling Films, Television Shows and Media* (Jefferson, NC: McFarland & Co. Ltd, 2007).

James, Caryn, 'Those Who Kiss Her Half-Live to Regret It', *New York Times*, 25 August 1995: movies.nytimes.com/movie/review?res=990CE3DF1530F936A1575BC0A963958260.

James, Caryn, 'A Philosophy Student Who Bites', *New York Times*, 4 October 1995: movies.nytimes.com/movie/review?res=980CE3D81539F937A35753C1A963958260.

Jameson, Fredric, 'Third-world Literature in the Era of Multinational Capitalism', *Social Text* vol. 15 (Autumn 1986).

Jess-Cooke, Carolyn, *Film Sequels: Theory and Practice from Hollywood to Bollywood* (Edinburgh: Edinburgh University Press, 2009).

Jess-Cooke, Carolyn and Verevis, Constantine, 'Introduction', in Carolyn Jess-Cooke and Constantine Verevis (eds), *Second Takes: Critical Approaches to the Film Sequel* (New York: SUNY Press, 2010).

Jung, Sun, *Korean Masculinities and Transcultural Consumption: Yonsama, Rain, Oldboy, K-Pop Idols* (Hong Kong: Hong Kong University Press, 2010).

Juvin, Hervé, *The Coming of the Body* (London and New York: Verso, 2010).

Kaes, Anton, *Shell Shock Cinema: Weimar Culture and the Wounds of War* (Princeton, NJ: Princeton University Press, 2011).

Kaveney, Roz, *Teen Dreams: Reading Teen Film from* Heathers *to* Veronica Mars (London and New York: I. B. Tauris, 2006).

Kennedy, Lisa, 'Out Front Film', *Out*, December 2000.

Keown, Michelle, *Postcolonial Pacific Writing: Representations of the Body* (Abingdon: Routledge, 2005).

Kermode, Mark, '*Ultraviolet*', *Observer*, 25 June 2006: www.guardian.co.uk/film/2006/jun/25/actionandadventure.sciencefictionandfantasy.

Khoo, Olivia, *The Chinese Exotic* (Hong Kong: Hong Kong University Press, 2007).

Kim Kyung Hyun, *The Remasculinization of Korean Cinema* (Durham, NC: Duke University Press, 2004).

King, Geoff, *New Hollywood Cinema: An Introduction* (London: I. B. Tauris, 2002).

Kraniauskas, John, '*Cronos* and the Political Economy of Vampirism', in Francis Barker, Peter Hulme and Margaret Iverson (eds), *Cannibalism and the Colonial World* (Cambridge: Cambridge University Press, 1998).

Kuhn, Annette, 'Introduction', in Annette Kuhn (ed.), *Alien Zone: Cultural Theory and Contemporary Science Fiction Cinema* (London and New York: Verso, 1990).

Lamberson, Gregory, *Cheap Scares!: Low Budget Horror Filmmakers Share Their Secrets* (Jefferson, NC: McFarland & Co. Ltd, 2008).

Lane, Anthony, 'Evil Touch', *New Yorker*, 27 February 2008: www.newyorker.com/archive/2006/02/27/060227crci_cinema?currentPage=2.

Lanza, Joseph, *Phallic Frenzy: Ken Russell and His Films* (Chicago, IL: Chicago Review Press, 2007).

Latham, Rob, *Consuming Youth: Vampires, Cyborgs, and the Culture of Consumption* (Chicago, IL: University of Chicago Press, 2002).

Lau, Jenny Kwok Wah, 'Besides Fists and Blood: Michael Hui and Cantonese Comedy', in Poshek Fu and David Desser (eds), *The Cinema of Hong Kong: History, Arts, Identity* (Cambridge: Cambridge University Press, 2002).

Lavery, David and Burkhead, Cynthia (eds), *Joss Whedon: Conversations* (Jackson: University Press of Mississippi, 2011).

Lee, Nikki J. Y., 'Salute to Mr Vengeance!: The Making of a Transnational Auteur Park Chan-Wook', in Leon Hunt and Leung Wing-Fai (eds), *East Asian Cinemas: Exploring Transnational Connections on Film* (London and New York: I. B. Tauris, 2008).

Leviev-Sawyer, Clive, '"These Are My Roots"', *Sofia Echo*, 18 March 2004: sofiaecho.com/2004/03/18/632719_these-are-my-roots.

Lindqvist, John Ajvide, *Let the Right One In* (Melbourne: Text Publishing Company, 2007).

Lowenstein, Adam, *Shocking Representation: Historical Trauma, National Cinema and the Modern Horror Film* (New York: Columbia University Press, 2005).

Lucas, Tim, 'Under the Influence', *Sight and Sound*, February 2011.

Lyttle, John, 'Not since Battleship Potemkin', *Economist* vol. 373 no. 8390, 28 August 2004.

Maddrey, Joseph, *Nightmares in Red, White and Blue: The Evolution of the American Horror Film* (Jefferson, NC: McFarland & Co. Ltd, 2004).

Marshall, Erik, 'Defanging Dracula: The Disappearing Other in Coppola's *Bram Stoker's Dracula*', in Ruth Bienstock and Douglas L. Howard (eds), *The Gothic Other: Racial and Social Constructions in the Literary Imagination* (Jefferson, NC: McFarland & Co. Ltd, 2004).

Martin, Adrian, 'At the Edge of the Cut: An Encounter with the Hong Kong Style in Contemporary Action Cinema', in Meaghan Morris, Siu Leung Li and Stephen Chan Ching-kiu (eds), *Hong Kong Connections: Transnational Imagination in Action Cinema* (Durham, NC: Duke University Press, 2005; Hong Kong: Hong Kong University Press, 2005).

Mazierska, Ewa and Rascaroli, Laura, *From Moscow to Madrid: Postmodern Cities, European Cinema* (London and New York: I. B. Tauris, 2003).

Medovoi, Leerom, 'Theorizing Historicity, or, The Many Meanings of *Blacula*', *Screen* vol. 39 (Spring 1998).

Miller, Laura, '*Blade II*', *Salon Magazine*, 22 March 2002: www.salon.com/2002/03/22/blade_ii/.

Mitchell, Elvis, 'Snuffing Out Vampires When a Stake Won't Do', *New York Times,* 22 March 2002: movies.nytimes.com/movie/review?res=9407E0D61138F931A15750C0A9649C8B63.

Mitchell, W. J. T., *Cloning Terror: The War of Images, 9/11 to the Present* (Chicago, IL: University of Chicago Press, 2011).

Montalbano, Margaret, 'From Bram Stoker's *Dracula* to *Bram Stoker's Dracula*', in Robert Stam and Alessandra Raengo (eds), *A Companion to Literature and Film* (Oxford: Wiley-Blackwell, 2004).

Morris, Meaghan, 'Introduction: Hong Kong Connections', in Meaghan Morris, Siu Leung Li and Stephen Chan Ching-kiu (eds), *Hong Kong Connections: Transnational Imagination in Action*

Cinema (Durham, NC: Duke University Press, 2005; Hong Kong: Hong Kong University Press, 2005).

Morris, Wesley, 'In *Evolution*, Blood Flows but the Story Doesn't', *Boston Globe*, 21 January 2006: www.boston.com/movies/display?display=movie&id=7426.

Nama, Adilifu, *Super Black: American Pop Culture and Black Superheroes* (Austin: University of Texas Press, 2011).

Newman, Kim, '*Ultraviolet*', *Sight and Sound* vol. 16 no. 7 (July 2006).

Newman, Kim, *Nightmare Movies: Horror on Screen since the 1960s* (London: Bloomsbury, 2011).

Nicol, Bran, '"Police Thy Neighbour": Crime Culture and the *Rear Window* Paradigm', in Bran Nicol, Eugene McNulty and Patricia Pulham (eds), *Crime Culture: Figuring Criminality in Fiction and Film* (London and New York: Continuum, 2011).

Nixon, Nicola, 'When Hollywood Sucks, or, Hungry Girls, Lost Boys, and Vampires in the Age of Reagan', in Veronica Hollinger (ed.), *Blood Read: The Vampire as Metaphor in Contemporary Culture* (Philadelphia: University of Pennsylvania Press, 1997).

Parikka, Jussi, *Insect Media: An Archaeology of Animals and Technology* (Minneapolis: University of Minnesota Press, 2010).

Park Chan-Wook, 'Park Chan-Wook: An Exclusive Interview', *eastern kicks*, 14 October 2009: www.easternkicks.com/features/park-chan-wook-exclusive-interview.

Paszylk, Bertlomiej, *The Pleasure and Pain of Cult Horror Films: An Historical Survey* (Jefferson, NC: McFarland & Co. Ltd, 2009).

Perry, David, 'Queen of the Damned', *Cinema.Scene.com* vol. 4 no. 8, 2002, www.cinema-scene.com/archive/04/08.html.

Petrie, Duncan, 'Cinema in a Settler Society: Brand New Zealand', in Dina Iordanova, David Martin-Jones and Belén Vidal (eds), *Cinema at the Periphery* (Detroit, MI: Wayne State University Press, 2010).

Phillips, Gene D., *Godfather: The Intimate Francis Ford Coppola* (Lexington: University Press of Kentucky, 2004).

Phipps, Lang, 'Is Amano the Best Artist You've Never Heard Of?' *New York Magazine*, 6 October 1997.

Pomerance, Murray, *Sugar, Spice, and Everything Nice: Cinemas of Girlhood* (Detroit, MI: Wayne State University Press, 2002).

Quinn, Anthony, 'Blood in a Cold Climate', *Independent*, 10 April 2009: www.independent.co.uk/arts-entertainment/films/reviews/let-the-right-one-in-15-1666629.html.

Rafferty, Terrence, 'Chilling Enough to Deserve a Remake', *New York Times*, 12 September 2010.

Rancière, Jacques, *Film Fables*, trans. Emiliano Battista (Oxford and New York: Berg, 2006).

Ray, Robert B., 'Mystery Trains', *Sight and Sound* vol. 10 no. 11 (November 2000): www.bfi.org.uk/sightandsound/feature/69/.

Rice, Anne, 'To My Readers: A Personal Statement by Anne Rice Regarding the Motion Picture *Interview with the Vampire*', in George Beahm (ed.), *The Unauthorized Anne Rice Companion* (Kansas City, KA: Andrews and McMeek, 1996).

Rich, Frank, 'The New Blood Culture', *New York Times*, 6 December 1992.

Richards, Jeffrey, *Sir Henry Irving: A Victorian Actor and His World* (London and New York: Continuum, 2007).

Rizov, Vadim, '*Blood: The Last Vampire*', *Sight and Sound* vol. 19 no. 8 (August 2009).

Romney, Jonathan, '*Bram Stoker's Dracula*', *New Statesman & Society*, 29 January 1993.

Romney, Jonathan, '*Cronos*', *New Statesman & Society*, 2 December 1994.

Rosenbaum, Jonathan, *Essential Cinema: On the Necessity of Film Canons* (Baltimore, MD: Johns Hopkins University Press, 2004).

Sadoff, Dianne F., *Victorian Vogue: British Novels on Screen* (Minneapolis: University of Minnesota Press, 2009).

Santner, Eric L., 'History beyond the Pleasure Principle: Some Thoughts on the Representation of Trauma', in Saul Friedlander (ed.), *Probing the Limits of Representation: Nazism and the 'Final Solution'* (Cambridge, MA: Harvard University Press, 1992).

Santner, Eric L., *On the Psychotheology of Everyday Life: Reflections on Freud and Rosenzweig* (Chicago, IL: University of Chicago Press, 2001).

Santner, Eric L., 'Miracles Happen: Benjamin, Rosenzweig, Freud, and the Matter of the Neighbour', in Slavoj Zizek, Eric L. Santner and Kenneth Reinhard, *The Neighbour: Three Inquiries in Political Theology* (Chicago, IL: University of Chicago Press, 2005).

Santner, Eric L., *On Creaturely Life: Rilke/Benjamin/Sebald* (Chicago, IL: University of Chicago Press, 2006).

Schager, Nick, '*Blade: Trinity*', *Slant Magazine*, 6 July 2004: www.slantmagazine.com/film/review/blade-trinity/1075.

Schneider, Steven Jay, *Horror Film and Psychoanalysis: Freud's Worst Nightmare* (Cambridge: Cambridge University Press, 2004).

Schneider, Steven Jay, *New Hollywood Violence* (Manchester: Manchester University Press, 2004).

Sharrett, Christopher, 'The Fall of Francis Coppola', *USA Today* vol. 12 no. 2574 (March 1993).

Shary, Timothy, *Generation Multiplex: The Image of Youth in Contemporary American Cinema* (Austin: University of Texas Press, 2002).

Silver, Alain and Ursini, James, *The Vampire Film: From Nosferatu to Twilight*, fourth edition (Milwaukee, WI: Limelight Edition, 2010).

Simmel, Georg, 'The Stranger', in Kurt H. Wolff (ed.), *The Sociology of Georg Simmel* (New York: Free Press, 1950).

Smith, Paul Julian, 'Ghost of the Civil Dead', *Sight and Sound*, December 2001: www.bfi.org.uk/sightandsound/review/1904/.

Spadoni, Robert, *Uncanny Bodies: The Coming of Sound Film and the Origins of the Horror Genre* (Berkeley: University of California Press, 2007).

Spooner, Catherine, *Contemporary Gothic* (London: Reaktion Books, 2006).

Sterritt, David and Anderson, John (eds), *The B List: The National Society of Film Critics on the Low-budget Beauties, Genre-bending Mavericks, and Cult Classics We Love* (Cambridge, MA: Da Capo Press, 2008).

Stock, Ann Marie, 'Introduction', in Ann Marie Stock (ed.), *Framing Latin American Cinema: Contemporary Critical Perspectives* (Minneapolis: University of Minnesota Press, 1997).

Stockwell, Anne, 'Blood and Lust', *Advocate*, 13 December 1994.

Strukov, Vlad, 'The Forces of Kinship: Timur Bekmambetov's *Night Watch* Cinematic Trilogy', in Helena Goscilo and Yana Hashamova (eds), *Cinepaternity: Fathers and Sons in Soviet and Post-Soviet film* (Bloomington: Indiana University Press, 2010).

Tannenbaum, Leslie, 'Policing Eddie Murphy: The Unstable Black Body in *Vampire in Brooklyn*', in James Craig Holte (ed.), *The Fantastic Vampire: Studies in the Children of the Night* (Westport, CT: Greenwood Publishing Group, 2002).

Taubin, Amy, 'Cannes: On the Riviera This Year, If It Bled, It Led', 2009: filmlinccom.siteprotect.net/fcm/ja09/cannes1.htm.

Total Film, 'Queen of the Damned', *Total Film: The Modern Guide to Movies*, 12 April 2002: www.totalfilm.com/reviews/cinema/queen-of-the-damned.

Tudor, Andrew, 'Genre', in Barry Keith Grant (ed.), *Film Genre Reader III* (Austin: University of Texas Press, 2003).

Vicari, Justin, 'Vampire as Metaphor: Revisiting Abel Ferrara's *The Addiction*', *Jump Cut: A Review of Contemporary Media* vol. 49 (Spring 2007): www.ejumpcut.org/archive/jc49.2007/addiction/index.html.

Virilio, Paul, *The Aesthetics of Disappearance*, trans. Philip Beitchman (Los Angeles, CA: Semiotext[e], 2009).

Ward, Rachel Mizsei, '*Underworld* vs the *World of Darkness*: Players and Filmgoers Respond to a Legal Battle', *Networking Knowledge: Journal of the MeCCSA Postgraduate Network* vol. 2 no. 1, 2009: journalhosting.org/meccsa-pgn/index.php/netknow/article/view/52/89.

Wehner, Chris C., '*Shadow of the Vampire*: An Interview with Steven Katz', in *Who Wrote That Movie?: Screenwriting in Review: 2000–2002* (Bloomington, IN: iUniversie, 2003).

Williams, Linda Ruth, *The Erotic Thriller in Contemporary Cinema* (Bloomington: Indiana University Press, 2005).

Wilson, Natalie, 'Civilized Vampires Versus Savage Werewolves: Race and Ethnicity in the Twilight Series', in Melissa A. Click, Jennifer Stevens Aubrey and Elizabeth Behm-Morawitz (eds), *Bitten by Twilight: Youth Culture, Media and the Vampire Franchise* (New York: Peter Lang, 2010).

Wilson, Natalie, 'It's a Wolf Thing: The Quileute Werewolf/Shape-shifter Hybrid as Noble Savage', in Maggie Parke and Natalie Wilson (eds), *Theorizing Twilight: Critical Essays on What's at Stake in a Post-vampire World* (Jefferson, NC: McFarland & Co. Ltd, 2011).

Wilson, Staci Layne, 'Go, Guillermo!', *Horror.com*, 2003: horror.com/php/article-282-1.html.

Wood, Jason, *Talking Movies: Contemporary World Filmmakers in Interview* (New York: Wallflower Press, 2006).

Zanger, Jules, 'Metaphor into Metonymy: The Vampire Next Door', in Veronica Hollinger (ed.), *Blood Read: The Vampire as Metaphor in Contemporary Culture* (Philadelphia: University of Pennsylvania Press, 1997).

Zizek, Slavoj, *For They Know Not What They Do: Enjoyment as a Political Factor*, second edition (London and New York: Verso, 2002).

Zizek, Slavoj, 'Afterword: Lenin's Choice', in Vladimir Lenin and Slavoj Zizek, *Revolution at the Gates: A Selection of Writings from February to October 1917* (London and New York: Verso, 2004).

Index

LIST OF ILLUSTRATIONS

While considerable effort has been made to correctly identify the copyright holders, this has not been possible in all cases. We apologise for any apparent negligence and any omissions or corrections brought to our attention will be remedied in any future editions.